P9-DYZ-437

096
R636

Phillips Library
Bethany College

DISCARD

DISCARD

THE

Rohan Master

THE

Rohan Master

A BOOK OF HOURS

BIBLIOTHEQUE NATIONALE, PARIS
(M.S. LATIN 9471)

INTRODUCTION BY MILLARD MEISS

INTRODUCTION AND COMMENTARIES BY MARCEL THOMAS

GEORGE BRAZILLER

NEW YORK

Reproduced from the Illuminated Manuscript (Ms. latin 9471)
Belonging to the Bibliothèque Nationale, Paris, France

Translated from the French by Katharine W. Carson

Published in 1973

All rights reserved. No part of this book
may be reproduced without the written consent of the
publisher, George Braziller, Inc.
One Park Avenue, New York, N.Y. 10016

Library of Congress Catalog Number: 73-77880
Standard Book Number: 0-8076-0690-1

Printed in France by Draeger Frères, Paris
Book Design by Vincent Torre
Slipcase and Binding Design by Oscar Ratti

Contents

096
R636

INTRODUCTIONS

INTRODUCTION I

1. The Art of the Rohan Master

LIKE all the painting of its period the *Grandes Heures de Rohan* began to attract attention outside a very small circle of historians and bibliophiles when in 1904 it was included in the first exhibition ever held of French "primitives"—that is, paintings on panel and in books of the fourteenth and fifteenth centuries. At that time Emile Mâle, the great historian of iconography who wrote very little about style, was so impressed by the manuscript that he described it as "one of the most surprising masterpieces of French art." With this high estimate the later twentieth century fully agreed—indeed, the *Grandes Heures de Rohan* has become one of the most famous of all illuminated manuscripts. But why surprising? Mâle did not say, but for several reasons he chose his words well.

As in all major artistic centers—and in the early fifteenth century Paris was, along with Florence, the greatest in Europe—the leading masters in the French capital exchanged ideas and tended to share certain basic values. This they did despite different personal gifts and the exceptionally diverse origins that enriched the art of the city then precisely as in later times, especially in the early twentieth century. Thus the best illuminators of the period, the Boucicaut Master who first learned his craft probably in Bruges (now in Belgium), and the three Limbourg brothers who came to Paris from Nijmegen in Gelders (now in Holland), strove for similar achievements throughout their careers. They sought a more naturalistic art, developing for this purpose linear and atmospheric perspective. They explored nuances of texture and the modification of color by light. To give their religious and secular stories more telling action they studied, primarily in earlier Italian paintings, the structure of the human body and the ways in which it might be made to move. To communicate their sense of order in the world they gave their compositions geometric designs.

The styles of the Boucicaut Master and the Limbourgs, related in these respects, constituted the dominant trend in Parisian painting. Their purposes guided many of the illuminators working in the metropolis, and they were shared by the painters of panels, including Jean Malouel. Already in the first decade of the century, however, two impressive illuminators—the Apocalypse Master and the Medallion Master—largely rejected these models for an art of stronger feeling. They transformed the style of the Boucicaut Master and the Limbourgs into patterns of clamorous color and swirling line. The revolution they began was completed by the chief illuminator of the *Grandes Heures de Rohan*, the greatest expressionist in France in the fifteenth century.

If, then, the emergence of the Rohan Master was not as unprepared as Emile Mâle thought, the degree to which this powerful artist controverted the prevailing principles of Parisian painting nevertheless seems to us, as it no doubt seemed to his contemporaries, surprising indeed. In the *Annunciation* in the *Rohan Hours*, for example, he adopted a kind of building favored by the Limbourgs as a solid, spacious setting for their saints or sacred events (Pl. 43). In the *Rohan Hours* it still retains suggestions of enclosure and of depth; indeed the floor is composed not of flat tiles but of strongly plastic cubes. They rise, however, almost vertically, carrying the

head of the Virgin close to the vaults. Similarly, the spindly columns as well as the red vaults edged in gold function less as architectural elements than as shapes in an exciting linear pattern. Though the angel and to a lesser degree the Virgin are rounded figures it is their outlines that are most telling, and the heads of both are in perfect profile. So active and compelling is the pattern that it readily assimilates, even as a normal and necessary element, the bust of the prophet Isaiah, for which there would certainly be no place in any rational tridimensional space.

Throughout the composition vestiges of naturalistic and rational canons serve to create surprise and tension when they are denied. The building itself does not even rest on the ground. Below it, as on the three other sides, angels flutter and declaim in a blue sky. Possibly the painter intended to allude to the miracle of the house of the Annunciation in Nazareth, which angels later carried across the Mediterranean to Loreto. In any event, the entire environment of the large structure is celestial and supernatural. In a sense the heavens invade the room, occupying the broad open area behind Gabriel from which, presumably, he has come. Scrolls wave outside as well as inside, and the flashing tiles of the floor are repeated by the small gold clouds. The alignment of these clouds in rows that are oblique (and never parallel) to the rectangle of the building and the folio creates an unstable, sliding field.

In a similar way the Virgin's chair arouses an expectation that is largely unfulfilled. For the first time, to my knowledge, in an Annunciation the chair is turned inward, whereas Mary, who is averted, appears largely in profile. This posture is significant not only for the kind of outline it permits but for the expressiveness of the Virgin's face and hands. Gabriel, too, is represented in profile—and how magnificently! Just ending his flight, his locks and mantle still streaming, he lifts his eager face, the strain of bearing the message released as, with parted lips, he begins to speak.

The designs of the Rohan Master always culminate in the face and the gesture. The dour countenance of Isaiah turns almost into full profile, and his pointing hand is emphasized by the deep blue of his mantle. Both the Boucicaut Master and the Limbourgs, concerned with volume and space, tended to avoid profile; furthermore, they usually represented forms and figures within one space on a similar scale, subject only to the diminution of perspective. Even the sacred figures, when appearing at a distance, are frequently smaller in size. The Rohan Master, however, reduced the scale of Isaiah, compared to the two principal figures, even though he is nearer the beholder. On the other hand God the Father, who with the prophet establishes a diagonal opposite to that of Gabriel and Mary, is represented on the largest scale in the painting —a scale that is more strongly felt because he is squeezed into the small space between the building and the corner of the picture. Such differences of scale, associated in earlier painting with the varying religious significance of the figures, acquire in this more naturalistic context a peculiar expressive value.

From the figure of the Ancient of Days golden rays pour into the room, and within them a soaring angel points vehemently toward the Virgin while a small Holy Ghost flies in the same direction. At this moment she is, of course, the principal person, but with her relatively flat mantle, her long neck, small head, and enigmatic face she is far less interesting than Gabriel, who is surely one of the most beautiful messengers ever conceived. His tunic and mantle still preserve some of the textural richness and subtly modulated planes of the Limbourgs and the Boucicaut Master.

The reader may already have wondered about the qualitative difference between the two principal figures, and there can really be no doubt that the Rohan Master himself painted Gabriel while leaving the Virgin to an assistant—a surprising conclusion, which has however already been approximated by the author of the most comprehensive earlier study of the

illuminator.[1] The Rohan Master, who no doubt designed the entire composition, was responsible for the execution of only one other figure, the Deity; his workshop painted the rest. This kind of collaboration, almost incomprehensible in modern times, was less extraordinary in the early fifteenth century. It recurs in other miniatures in the *Rohan Hours*, and, as I shall show in my forthcoming study of the Rohan Master, in other manuscripts by this artist and his assistants.[2]

The Rohan Master has portrayed an especially grave, agitated, and troubled Annunciation. It cannot be an accident that two of only three miniatures in the manuscript he chose to execute entirely with his own brush are concerned with death (Pls. 57, 63). One of these miniatures adopts for the Office of the Dead (Pl. 63) a form of illustration that had been developed by the Boucicaut Master in the second decade of the century.[3] In this iconography, which replaced both the older funeral ceremony around the bier and the newer burial service in a cemetery, the dying man lies naked and alone on the ground while angels and devils fight for his soul under the eyes of the distant Deity.

All these elements the Rohan Master brought together into an unprecedented confrontation. The body, reminiscent of the emaciated *transi* that appeared at this time on French tombs, lies on a rich blue cloth surrounded by skulls and bones—a contrast between the sensuous pleasures of the earthly past and the lifeless present. The man still clings to the beautiful shroud with pitiful spidery fingers at the end of a shrunken arm. The body seems thrust upward for a closer colloquy with Christ, an enormous old man, white-haired like God the Father, who emerges from a swarm of angels. His personal solicitude is reassuring, and the probable victory of Michael and his aides over the blood-stained devil gives the man reason for ultimate hope. This is confirmed by the content of the unprecedented dialogue. The man addresses Christ, committing to him his spirit in the words of the Psalm that are part of the Last Sacraments for the Dying. Christ replies that, after penance for sins, "On the Day of Judgement you will be with me." We cannot fail to marvel at the fact that the corpse speaks the language of the Church and of all well-educated Europeans, Latin, whereas the Deity replies in French. The use of the vernacular localizes Christ's words, and thus gives another sign of his intimate relation with the dying Frenchman.

In the miniature representing the Last Judgement, the moment to which Christ's words refer, the Judge, now spattered with blood from his wounds, is again relatively close to the seven resurrected bodies (Pl. 61). Most of them do not, in conformity with tradition, rise in the prime of life; two of them are even aged, with white hair and beards. To youth, so prominent in the art of the early fifteenth century, the Rohan Master preferred age. The most striking of the resurrected figures, larger than the others and even overlapping the frame, struggles mightily to raise himself from the ground. He is almost identical with a lame man engaged in a similar struggle in a drawing by the Rohan Master of the Miracle of Bethesda.

The entirely novel composition with which the Rohan Master chose to illustrate the Hours of the Cross shows, like the Office of the Dead, a corpse stretched on the ground (Pl. 57). Now, however, blood streams from many wounds, and the oversize celestial figure is God the Father, hailing the sacrifice undertaken by his son for the redemption of man. Mary nevertheless wilts under the unbearable impact of her loss, and John, holding her tightly, turns his plain, strange, querulous countenance toward the originator of the entire plan. Like Gabriel and the annunciate Mary, the two principal figures are in perfect profile, but the heads here are turned in opposing directions to heighten the strain that is central to the design. The body of the Virgin is as limp as that of Christ is rigid. In this miniature the Rohan Master has created one of the most memorable of all images of sorrow and death.

Under the brush of this extraordinary painter even a subject such as the Madonna nursing

11

her child, normally expressive of tender and joyous maternal feelings, is permeated by a strange disquiet and melancholy (Pl. 36). Mary, far from conforming with the contemporary ideal of a perfect woman, has unnaturally short, spindly arms and a greatly swollen head. Indeed, we recognize here that the Rohan Master works not only with differences in scale between several figures in a composition, as we have observed earlier, but also with disproportions in a *single* figure. Unlike his predecessors and contemporaries he was more interested in faces than in bodies. He cared less about what people do than what they feel. Like other artists at all times who seek enhanced expressiveness, he employed the kind of surprising disproportion and deformation that, before the twentieth century, was most familiar in caricature. For the painter's contemporaries as for us the full impact of his distortions depends on an awareness of the conventions he disregarded. In his search for the unexpected he even made a formal zodiacal sign of the calendar serve as a wild animal in the desert: the lion of *July*, for example, struts across the landscape of the *Flight into Egypt* (Pls. 13, 53).

2. The Manuscript, the Problem of the Patron, and the Career of the Illuminator

The arms of the Rohan family, which have given a name to the manuscript, are not those of the original owner. Who that was, no written evidence tells us; nor do we possess any records in this or related manuscripts that identify the illuminator. Only two manuscripts with miniatures in the style of this illuminator—a Boccaccio in Paris and a Hunting Book in Dresden—can be dated on external evidence, and neither contains a major work by the master himself.[4] For knowledge, therefore, about time and place and the patron we are more than usually dependent upon stylistic distinctions, iconographic relations, and in general the history of contemporary painting.

From the fact that the prayers of the *Rohan Hours* are for the use of Paris we may infer only that the original owner was attached by residence or by sentiment to the Parisian region. For more than this meager information we must, as so often, turn to the illumination. We can readily learn that the work was done after about 1415–1416, because some figures derive from miniatures in the *Très Riches Heures* that were painted at that time. Thus the horsemen in the *Flight into Egypt*—soldiers witnessing miraculously grown grain (Pl. 53)—are copies of a Magus and a member of his retinue in the *Meeting of the Magi* in the *Très Riches Heures*. Of course the kind of white mane curving out from the hat of the aged soldier as well as the dense red, blue and green of the figures are contributions of the Rohan workshop. In the *Annunciation to the Shepherds* (Pl. 46) the woman calmly milking a sheep with (to judge from the size of her jug) rather surprising expectations—an unprecedented chore performed at this important moment—was probably inspired by the woman shearing sheep in *July* in the *Très Riches Heures*. She seems unaware of the message read by the angels, and we cannot be quite sure what animates her relatively enormous companion. To the tune of his pipe he jigs with a kind of melancholy glee. Even the behavior of the dog with the red spiked collar seems ambiguous. Is this the only creature who attends to the angels, as has been said? Or is he merely howling, perhaps in response to the pipe?[5]

From such adaptations we learn that the Rohan Master had seen the *Très Riches Heures*. It may have been this manuscript, too, that suggested to him the use for his principal miniatures

of very narrow frames and empty, undecorated borders. The Rohan Master did not adopt these for their original purpose of enhancing the spatial illusion; indeed, he preserved the script the Limbourgs had banished entirely, inserting it in a novel way on a small rectangle within the miniature. He sought only to increase the size of the pictorial field almost to the dimensions of the folio. Thus his strong rhythms and bold color attained a maximum effect.

Although it clearly reflects the *Très Riches Heures*, the *Rohan Hours* depends to a greater extent upon the earlier Book of Hours of the Limbourgs. The heavenly host, for example, painted by his workshop (Pl. 34) is a copy, with the familiar distortions (see the Magdalene!), of a miniature in the *Belles Heures* painted by Paul de Limbourg for All Saints. The peasant lying on a sheaf of grain in the *Flight into Egypt*—diminutive compared to his companion, not to mention the huge figures and the ass deepest in the space (Pl. 53)—was clearly drawn from the miniature for *July* in the *Belles Heures*. The sower of the *Belles Heures* stalks the land of *September* in the *Rohan Hours* like an uncouth giant (Pl. 17). These and numerous other borrowings provide an important clue. The Rohan Master and his assistants first began to feel the strength of the *Belles Heures* when, about 1415, they were illuminating the *De Buz Hours* now at Harvard, but they must have had an opportunity to study the manuscript at leisure after that date. By good luck we happen to know in whose possession it then was. A few months after the death of the Duke of Berry in June 1416 the Duchess Yolande of Anjou, the wife of his nephew, Duke Louis II, borrowed it and soon bought it.

There are other connections of the *Rohan Hours* and similarly late manuscripts by the Rohan workshop with the Duchess Yolande. First of all, two miniatures in the *Rohan Hours*, the *Crucifixion* and the *"Vesperbild,"* (Pls. 33, 41) as well as the long sequence of marginal illustrations, were based on a *Bible moralisée* that was illuminated in Naples, capital of the kingdom which Duke Louis II spent much of his life in a vain effort to reclaim.[6] Although the Duke of Berry possessed an outstanding Neapolitan manuscript, this Bible was not listed in his inventories, and the most likely owner in metropolitan France was a Duke of Anjou. More solid is the fact that a Book of Hours (Bibl. nat., lat. 1156 A) illuminated by the Rohan workshop bears Angevin armorials, emblems, mottoes, and even a portrait of Louis II. A third Book of Hours in the Rohan style (and containing one miniature by the master himself) has a text for the use of Angers (private collection—formerly Martin le Roy). A fourth, very fine prayer book of the same kind, now in the Fitzwilliam Museum in Cambridge and somewhat earlier in date, bears the arms of a later owner who married into a family connected with the Anjou.

Taking account of these facts nearly thirty years ago Jean Porcher proposed that Yolande of Anjou, becoming acquainted in Paris with manuscripts illuminated by the Rohan workshop, invited the master to Angers, where, far from the turmoil of the capital at that time and assured of the support of a powerful and discriminating patron, he produced his best work. Part of this hypothesis is probably correct, but some facts not hitherto considered open new perspectives. When in 1416 Yolande acquired the *Belles Heures* she was indeed spending much of her time in or near Angers, the capital of Anjou, where her husband, Duke Louis II, died on April 29, 1417. During the next two, very troubled years, however, Yolande moved about from Anjou (including her own chateau of Saumur), to the Touraine, and to Mehun-sur-Yèvre near Bourges, the famous chateau of the late Jean Duke of Berry. This chateau became at that time the residence of her daughter Marie, fiancée of Charles. Charles, who was Dauphin of France from April 5, 1417, a month later became Duke of Berry.

For years Yolande had been the boy's principal protectress and counselor, and since Paris was then convulsed by the conflict between the Burgundians and the Armagnacs, she brought him to Angers and then followed him and her daughter to Bourges and the chateau of

Mehun, his newly acquired possessions in Berry. In 1420 the English occupied Paris, in 1422 King Charles VI died, and the Dauphin became Charles VII—the King of Bourges, he was called. Yolande had departed in 1419 with her son Duke Louis III for Provence, a possession of the Anjou. There they raised funds for another of those vain Angevin campaigns to recover the kingdom of Naples—a campaign from which Louis returned only in 1426. Yolande remained as administrator of Provence until 1423. Coming north in that year she again became deeply involved in affairs of state and she often lived with the court at Mehun or at Bourges until 1427.[7]

Between 1419 and 1427, then, Yolande was either continuously in Provence or frequently in Berry, and these are the years when the evidence of style indicates that the *Rohan Hours* and the manuscripts most closely related to it were illuminated. Thus the number of possible centers of activity of the master increase, but it is premature to speculate about the most likely. Perhaps he worked in Angers and for a time between 1423 and 1427 in Bourges. It is droll, in any event, to imagine him not only building his style upon the achievements of Jean de Berry's painters and then denying their basic values but even perhaps doing some of this within the Duke's own buildings, on the very site of the great artistic triumphs that he was vehemently criticizing.

Dauphin Charles became the Duke of Berry in 1417 a few months after Yolande acquired the *Belles Heures*, one of the most beautiful manuscripts of the great Jean. The reasons for her interest in this Book of Hours certainly became more than purely artistic. Possibly she even gave it to Jean de Berry's young successor, although later fifteenth-century copies of its miniatures in manuscripts produced in the west and northwest of France seem to indicate that it was for a time in that region, most likely Angers. Since the prayers in the *Rohan Hours* are in masculine form it might have been made, on Yolande's order, for this very youth, her protegé and her daughter's fiancé. The importance for this young couple of illuminated prayer books is shown by the fact that in 1418 Marie herself received a large sum from King Charles VI to purchase one.[8] This acquisition might conceivably have been the fine Book of Hours by the Rohan Master and his workshop now in the Fitzwilliam Museum, which I would in any event date ca. 1418.

If the *Grandes Heures de Rohan* was made for Charles, Duke of Berry and from October 1422 King of France, the abundance of quotations from the *Belles Heures*, altogether exceptional in the work of the Rohan Master, probably reflected the political and cultural circumstances of the patron. The same concerns perhaps affected another unusual aspect of the *Rohan Hours*—the long cycle copied from a Neapolitan Bible, which therefore alluded to the Angevin past, artistic and religious as well as dynastic. The universally recognized intelligence and political acumen of Duchess Yolande justify such speculation. The relationship with the Bible (but not with the *Belles Heures*) would have retained its special meaning if the *Rohan Hours* had been produced, on the other hand, for Yolande's son, Duke Louis III. He might have received it in Italy, where he remained from 1420 to 1426.

Scholars are agreed that the Rohan Master himself painted only a small number of the miniatures in the *Grandes Heures*, though there have been differences of opinion about the precise number. In 1912 Durrieu ascribed to him all eleven full-page miniatures and three others. In 1932 Miss Heimann, in her comprehensive study, reduced the number to three and part of a fourth.[9] My own conclusions are quite similar. Entirely by the Rohan Master, in my view, are only the *Madonna* (Pl. 36), the *Lamentation* (Pl. 57), and the *Dying Man before Christ* (Pl. 63). In other miniatures he painted only certain figures: Gabriel and God the Father, as we have seen, in the *Annunciation* (Pl. 43), the shepherds in the *Annunciation to the Shepherds* (Pl. 46), the High Priest in the *Presentation in the Temple* (Pl. 50), some apostles

in *Pentecost* (Pl. 58), and Christ in the *Last Judgement* (Pl. 61). He certainly drew the designs for these miniatures and for many more in which he did little, if any, painting. In this group I would include *St. John* (Pl. 25) and *St. Matthew* (Pl. 27), with their soaring, tangled buildings, as exciting as Piranesi's *Carceri*; the *Visitation* (Pl. 45), in which the angel is a duplicate of the one by the master in the *Annunciation* (Pl. 43); and the *Flight into Egypt* (Pl. 53). The judgement that the Rohan Master was responsible for these designs is based upon their strength and their similarity to the compositions that he also clearly executed. It is not easy to determine whether—or how much of—the underdrawings partially visible in many miniatures are his. Certainly conformity of the final painted surface with the drawing is no criterion. The folds of the drapery of the Virgin and God in the *Lamentation* (Pl. 57) or of God when he appears to the dying man (Pl. 63), all painted by the Rohan master himself, are different from the underdrawing.

The nature of the relation of the Rohan Master to the production of the *Rohan Hours* is not peculiar to this book. His participation in other manuscripts, such as the Fitzwilliam Hours and the *Heures d'Angers*, ranged equally from the execution of the principal figures in a few miniatures to varying degrees of supervision of the rest.[10] He worked closely with certain assistants, who even completed his own miniatures. Other followers, such as the one in the *Rohan Hours* responsible for most of the Suffrages, went ahead on their own, although they drew on a common stock of patterns. Even a surviving panel which was in part painted by the Rohan Master shows a related kind of collaboration. It can also be discerned in the earliest works in the Rohan manner, the Giac and Harley Hours,[11] where the style of the master himself, still undergoing rapid change, is more difficult to disengage. There is, however, only one great painter involved in these works and he provided the impetus for the new style.

The role of the Rohan Master in the design and painting of the miniatures in the *Rohan Hours* is larger than in any other manuscript, except his earliest ones. Still, even if we include supervision of the entire work, his own contribution was limited. Why was this so, especially in a manuscript made for a great patron? Why did he even turn over to assistants miniatures he had himself partly painted? These questions, which have never been asked, are not easy to answer. Perhaps he was overseeing the production of several manuscripts at the same time. This would be an adequate explanation for the years before ca. 1416 when he was apparently acting as the head of a workshop, like that of the Boucicaut Master, in Paris. When, however, he succeeded in finding great patrons, apparently the Anjou, one would have expected him to become more personally involved.

Two objects indicate an explanation of another kind. They prove that the activity of the Rohan Master was not limited to the illumination of books; he worked on a larger scale. A panel by his workshop, over three feet long, survives in the Museum at Laon, as Grete Ring first observed.[12] The impressive inner face of this panel was, in my opinion, designed and at least in part painted by the Rohan Master himself, although somewhat crudely. Assistants executed the outer face. A superb drawing of the Miracle of Bethesda in the Museum at Braunschweig is one of the master's greatest surviving works.[13] Characteristically it makes far more vivid the frightful disease and deformity of the poor creatures gathered around the pool than the healing which is the point of the story. The large size of the drawing—about 6 by 10 inches—and the high finish of most of the figures seems to indicate that it was a study not for a miniature but for a work on a larger scale—a scene, perhaps, in the story of the cross for a mural cycle, for stained glass, or a large altarpiece. Probably then it was not in a book but in a monumental work that the Master of Catherine of Cleves saw the *Miracle of Bethesda* by the Rohan Master which he utilized for a miniature in a manuscript now in the Morgan Library.

15

In 1912, long before the Laon panel or the Braunschweig drawing had been connected with the Rohan Master, the extraordinary Paul Durrieu suggested that the character of the painter's miniatures implied that he worked on larger scale.

Other painters of this period in metropolitan France—the Parement Master, for example, and probably Jacquemart de Hesdin—worked both in the book and on panel or the wall, and they too depended to an unusual degree on assistants. The Rohan Master could rely on them still more because the effect of his painting derived far less from subtleties of shape, color, or finish. Although he modulated his own surfaces with great refinement he was willing to allow his associates to present broad, flat areas of strident, even raw color. Indeed, such surfaces clearly had their own emotional impact.

Since the expressionist miniatures of the Apocalypse Master and the Medallion Master, to which we referred above, are not well known, the Rohan Master has seemed to be more of a maverick in the Parisian region than he actually was. Still, his singularity cannot be denied, and it is attested by the universal belief that he came from Spain or Germany or the Netherlands— almost anywhere but France. No specific origins for his style in those countries, however, have yet been cited. Indeed the foreign character has not been discerned in his early work, where it would normally appear more clearly, but in late paintings, especially in the *Rohan Hours*, as though some native propensity were emerging late in his career. This is a difficult hypothesis, and objectionable when it implies a hereditary national character. The art of El Greco, for example, does indeed possess, as has been suggested, the passionate intensity of the Rohan Master, but this "Spanish painter par excellence" was born in Crete and formed in—of all places—Venice!

Better knowledge of early fifteenth-century illumination throughout Europe might provide the decisive evidence we now lack about the origins of the Rohan Master's early style. If we turn to his first known work—the *Giac Hours* in Toronto, I believe—we can discern relationships with the color and form of two regions not hitherto educed: Provence, represented, for instance, by the Book of Hours, Walters Art Gallery 237; and Champagne. Provence was Angevin territory, and Duchess Yolande lived there not only from 1419 to 1423 but around 1409, during, presumably, the early career of the Rohan Master. The relationship of this master with an illuminator active in Champagne, probably at Troyes and whom I have therefore called the Troyes Master, is especially interesting because no less than nine Books of Hours illuminated in the Rohan workshop are for the use of Troyes. The links are not very strong, but they permit a tentative hypothesis that the Rohan Master began in Provence and then worked in Troyes (with visits to Paris) from about 1410 to 1414. By the latter date he and one or two of his assistants had moved to the capital and collaborated with ateliers established there, such as that of the Boucicaut Master or the like-minded Apocalypse Master and painters of the Bedford trend.

It was only through study of the painting of the great metropolitan French masters that the art of the Rohan Master attained the strength we recognize in the *Grandes Heures de Rohan*. Although he was one of the most inventive of painters his imagination was, paradoxically, stimulated to an exceptional degree by the work of others, and he continually found in their forms elements with which to create new combinations of his own. One instance of such an adoption is exceptionally meaningful; it concerns the master's miniature of the Lamentation, which we have already discussed (Pl. 57). The group of St. John embracing the Virgin protectively and gazing back at Christ on the cross occurs in a number of fourteenth-century representations of the Crucifixion. The half-dozen examples hitherto cited are German, but the Rohan Master was probably most impressed by the version of an earlier French illuminator,

the Passion Master, who employed the group in the *Crucifixion* in his superb Passion cycle in the *Petites Heures* of Jean de Berry. The Rohan Master would surely have been attracted by this highly congenial art, similarly emotional, mercurial, and querulous. There he would have found an equally querulous St. John and dozens of ugly roguish faces of the kind he himself introduced in Pentecost (Pl. 58). Equally significant is the fact that the Rohan Master revived the background filled with angels, which was common in the paintings of the Passion Master and related illuminators of his period but outmoded in the early fifteenth century.

It is a striking fact that the ugly, often irreverent saints of the Rohan Master, the insistent color and wild pathos should have found favor with a great princely house. Art produced for courts was not always what is called Court Art—it was not necessarily elegant, decorous, and restrained. Perhaps the turmoil in France not only influenced the Rohan Master's work but created an audience for it. He proved that the long, flowing lines of the lyric, more Gothic trend in early fifteenth-century painting could be utilized for sombre moods and extreme emotions. Whereas his great predecessors, the Boucicaut Master and the Limbourgs, discovered unseen beauty in the natural world, he explored the realm of human feeling. They are most memorable for luminous color, monumental designs, and narrative spectacles, he for the depiction of pain, grief, and death. Their art led directly to the first Flemish panel painters, the Master of Flémalle and Jan van Eyck. His had only minor echoes, but diagrams of equally profound emotion appeared shortly in the painting of Roger van der Weyden.

MILLARD MEISS
Professor of the History of Art
The Institute for Advanced Study

17

NOTES

1. A. Heimann, "Der Meister der 'Grandes Heures de Rohan' und seine Werkstatt," *Städel-Jahrbuch,* VII–VIII, 1932, p. 24. Heimann saw in these two figures only the *participation* of the Rohan Master rather than, as proposed above, his exclusive authorship.

2. *French Painting in the Time of Jean de Berry. The Limbourgs and their Contemporaries.* In press.

3. See Meiss, *The Boucicaut Master*, London, 1968, pp. 32 f.

4. Paris, Bibliothèque nationale, fr. 226, and Dresden, Sächsische Landesbibliothek, ms. Oc 61.

5. Not infrequently animals respond to a supernatural apparition (see the dog in Taddeo Gaddi's *Annunciation to the Shepherds* in S. Croce, Florence), but normally the principal figures do also. The Rohan Master's shepherd is anticipated by a shepherd in the *De Buz Hours* in the Houghton Library, Harvard University.

6. Paris, Bibliothèque nationale, fr. 9561. See Meiss, *French Painting in the Time of Jean de Berry. The Late XIV Century and the Patronage of the Duke*, 1967, pp. 27–29, and F. Bologna, *I pittori alla corte angioina di Napoli*, Rome, 1969, pp. 311–320.

7. G. du Fresne de Beaucourt, *Histoire de Charles VII*, Paris, 1881–1882, 2v.; and P. Anselme, *Histoire généalogique et chronologique de la maison royale de France*, Paris, 3rd ed., I, 1726, p. 230.

8. King Charles gave Marie 200 *écus* (see Bibliothèque nationale, Ms. Bourgogne, vol. 100, p. 792).

9. P. Durrieu ("Le maître des 'Grandes Heures de Rohan' et les Lescuier d'Angers," *Revue de l'art ancien et moderne*, XXXII, 1912, p. 161 f.) ascribed the eleven full-page miniatures as well as the *Madonna*, the *Trinity*, and *St. Andrew* to the master, Heimann, *op. cit.*, 1932, pp. 19 ff., reduced the group to the *Office of the Dead*, the *Virgin and St. John*, the *Last Judgement*, and the *Madonna* (in part).

10. See my forthcoming *Limbourgs and their Contemporaries.*

11. Royal Ontario Museum and British Museum Harley 2934.

12. *A Century of French Painting*, London, 1949, p. 204.

13. Meiss, "Un dessin par le maître des Grandes Heures de Rohan," *Gazette des Beaux-Arts*, LXXVII, pt. 1, 1935, pp. 65–75.

INTRODUCTION II

THE illuminated manuscript from which the paintings in the present volume have been reproduced—MS. latin 9471 of the Bibliothèque Nationale—is traditionally known as the *Grandes Heures de Rohan*. That this designation is not entirely justified we shall soon see, but practical considerations preclude seeking another, since it has borne this name for so many years.

We have, in this manuscript, a superb Book of Hours, following the liturgical use of Paris, whose date, unfortunately, remains very uncertain. Professor Meiss has discussed this delicate point in his Introduction and has noted certain indications which might permit us to assign to this manuscript a date slightly prior to the years 1425–1430—the period during which its execution is generally considered to have been undertaken.

In his great repertory of manuscript Books of Hours preserved in the Bibliothèque Nationale, Canon V. Leroquais[1] has given an extremely precise analysis of the contents of the *Rohan Hours,* which it would be quite unnecessary to reproduce here in full. We shall, therefore, limit ourselves to enumerating the principal elements of the volume, comprising 239 folios (the modern numeration of which does not take into account certain early lacunae, to be noted later).

The contents of the *Rohan Hours* are as follows:

Calendar. For the use of Paris; it has no noteworthy characteristics.	Folios 1 –18
Fragments of the Four Gospels	19 –26
Fragments of the Passion According to St. John	27 –29
Various Prayers to Christ and to the Virgin	29v–41v
The Five Sorrows of the Virgin	41v–44
Hours of the Virgin (damaged by two lacunae—see below).	45 –112
Penitential Psalms	113 –126
Litanies of the Saints	126v–134
Hours of the Cross	134v–143
Hours of the Holy Spirit (incomplete at the end).	143 –147
The Fifteen Joys of the Virgin (incomplete at the beginning).	148 –153
The Seven Petitions to Our Lord	154 –158
Prayer to the True Cross	158v
Office of the Dead	158v–209
Suffrages	209v–236
Stabat Mater	236v

The codicological examination of the manuscript permits certain very important verifications, to which we shall return later. For this reason, it seems useful, notwithstanding the necessarily dry character of such an accounting, to indicate below the composition of the various quires that make up the volume. Our colleague, M. François Avril, has kindly taken charge of collating them and has authorized us to make use of his findings. In the course of that undertaking, he was able to determine that the manuscript had been copied by two scribes of unequal

ability. The first (Scribe A) seems relatively unskilled. The second (Scribe B) has a much more elegant and "Parisian" hand. We shall indicate below to which of the two scribes, according to M. Avril, each quire should be attributed. Quire I^{10} (folios 1–10, Scribe A); II8 (folios 11–18, A); III8 (folios 19–26, A); IV8 (folios 27–34, B); V^{10} (f. 35–44, A); VI8 (f. 45–52, B); VII8 (f. 53–60, B); VIII8 (f. 61–68, B); IX8 (f. 69–76, B); X^6 (f. 77–82, B—lacuna between ff. 79 and 80); XI7 (f. 83–89, B—one folio missing after f. 89); XII8 (f. 90–97, B); XIII8 (f. 98–105, B); XIV8 (f. 106–113, B); XV7 (f. 114–120, B—one folio missing before f. 114); XVI8 (f. 121–128, B); XVII8 (f. 129–136, B); XVIII8 (f. 137–144, B); XIX6 (f. 145–150, B—two ff. missing between ff. 147 and 148); XX8 (f. 151–158, B); XXI8 (f. 159–165, B—a mistake in pagination caused a f. 164bis to be added); XXII8 (f. 166–173, B); XXIII8 (f. 174–181, B); XXIV8 (f. 182–189, B); XXV8 (f. 190–197, B); XXVI6 (f. 198–203, B); XXVII6 (f. 204–209, A); XXVIII8 (f. 210–217, A); XXIX8 (f. 218–225, A); XXX8 (f. 226–233, A); XXXI6 (f. 234–239, A—unfinished).

*　*　*　*

The sumptuous illustration of the *Rohan Hours* has rightly made it one of the most famous manuscripts of the first third of the fifteenth century. In its richness, its variety, its originality, this illustration is truly exceptional. Classified according to their dimensions and their arrangement on the page, the paintings of this volume may be divided into three categories.

The most important (and naturally, the best known), numbering eleven at the present time, are full-page paintings:
folio 27, Pl. 33; f. 45, Pl. 43; f. 70, Pl. 45; f. 85v, Pl. 46; f. 94v, Pl. 50; f. 99, Pl. 53; f. 106v, Pl. 54; f. 135, Pl. 57; f. 143v, Pl. 58; f. 154, Pl. 61; f. 159, Pl. 63.

Ten of these are framed only by a double rectilinear border, composed of a thread of gold and a thread of white, underscored with a black line. The white borders which surround them and are free of any decoration vary in dimension from page to page, but they are always very narrow and often have been further trimmed by the binder's knife. In one particular case (f. 45, Pl. 43, the Annunciation), the narrow margin outside the frame, which was still usable, has been filled with a painted border representing angels—for iconographic reasons stated in the commentary for the plate in question.

At the bottom of each of these paintings appears a cartouche, framed with the same double border as the image, wherein can be read—traced in a different ink—the first words of the text taken up either on the opposite side of the folio or on the following one. The dimensions and arrangement of these cartouches were anticipated by the illuminator or illuminators, making allowances for the requirements of their composition, rather than for the convenience of the scribe entrusted with copying on each the fragment of the designated text. Often the scribe was obliged to drastically compress his graphic work (cf. f. 27, Pl. 33; f. 94v, Pl. 50; f. 106v, Pl. 54), or to enlarge it abnormally, or even to resort to filling up the space at the end of a line with decorative floral ornaments (cf. f. 70, Pl. 45; f. 85v, Pl. 46).

The series of paintings that has come down to us is assuredly not complete. In addition, several folios of the manuscript have disappeared—a fact that was established by the collation of the quires. Since it is utterly abnormal for a Book of Hours not to contain a single painting devoted to the Nativity, we may assume that in the *Rohan Hours,* this episode from the Gospels must have been illustrated by a full-page painting placed at the end of Quire X. Similarly, in Quire XI, there must have originally been a painting of the Epiphany. As for the folio whose absence today from Quire XV has been noted, it very likely contained a representation of King

David, to mark the beginning of the Penitential Psalms. In the opinion of Canon Leroquais,[2] the folio that disappeared from Quire XIX, must have been ornamented with a representation of the Virgin, to mark the beginning of the devotional text entitled "The Fifteen Joys of the Virgin." In its original state, the manuscript would then have contained fifteen full-page paintings.

Aside from those we have just mentioned, the volume contains fifty-four more "main" paintings, which occupy all the space on the page normally reserved for the column of text. Thus they are all longer than they are wide and are accompanied, on the right and left, by the same borders of ornamental flowers, foliage and gold dots which appear on the pages of text. There are only three of these paintings (f. 26v, Pl. 32; f. 33v, Pl. 36; f. 210, Pl. 79) which do not occupy the full length of the column. The first of these is abnormally wide, since it overflows onto the right margin, at the expense of the customary floral border, which has disappeared. This exceptional disposition may be due to the fact that this painting could be considered as a complement to the Crucifixion appearing on folio 27 (Pl. 33), facing it. In fact, the armorial banners which the angels are carrying (retouched at a later date) may not have been banners at all in their original form, but instruments of the Passion. It is not even impossible that, in the course of the retouching we have just mentioned, the painting could have been enlarged to the point where it spilled over a primitive border that may have been effaced.

A third series of paintings decorates the margins of all folios in the volume not occupied by full-page scenes. Framed in the same manner as the "main" paintings, they are approximately 8 cm. in length and 4 cm. in width (i.e., the same width as that of the floral border). They intersect the floral border in such a way as to leave about 3 cm. of its length above them and 5 cm. below. The border is thus divided in its height in the proportions of 3 to 8 to 5.

Each of these marginal paintings is accompanied by a legend in Old French, inscribed in a cartouche surrounded by the same border as the image and placed beneath it. These legends constitute a coherent and perfectly recognizable iconographic cycle, whose presence in a Book of Hours, however, is totally unexpected. From the end of the thirteenth century onward, this cycle is found in numerous manuscripts with or without illustrations, bearing the name of *Bibles moralisées,* or occasionally of *Bibles historiées, toutes figurées,* when the manuscripts are illustrated, as is more often the case.

In his classic study of these manuscripts, the Count de Laborde[3] made such a thorough analysis of their origin and structure that it would serve no purpose to repeat it here at any great length. He defined this work as "verses borrowed literally from the Vulgate, or extracts taken from several verses, badly joined together one with the other, and followed by an explanation having as its object to establish a rapprochement—which is sometimes very subtle—between one part taken from sacred history and another from the Gospels." Often there is also a rule of Christian morality drawn from a biblical text. The underlying idea is to constantly seek out, by means of such parallels, the "figures" in the Old Testament which announce the deeds or teachings contained in the New Testament.

One of the illustrated manuscripts of the *Bible moralisée* is a superb copy, decorated in Paris about the mid-thirteenth century (perhaps for the use of St. Louis, King of France), and divided today into three parts, preserved respectively in Oxford, Paris and London.[4]

Other copies of this gigantic work were executed at various periods, and it is known that the Limbourg Brothers partially decorated one belonging to the Duke of Burgundy. Another, which is preserved in the Bibliothèque Nationale (where it is catalogued as MS. fr. 9561), is of special interest to any study of the *Rohan Hours,* since it is this one which the illuminators, entrusted with the marginal decoration of the latter, took as their model.

Copied and decorated in Italy (or at least by Italian scribes and illuminators) in the course of the fourteenth century, this beautiful volume obviously found its way into the hands of the copyists and illuminators to whom we owe the *Rohan Hours*. Testimony to this fact may be seen not only in the kinship of the paintings in the two volumes, but also in the text of the Old French legends accompanying them. Those in the *Rohan Hours* reproduce—even down to their errors—the text found in the Italian manuscript.

The latter volume, by reason of its origin, might well have belonged to the House of Anjou,[5] and this would be additional justification for crediting Yolande of Aragon with having commissioned the *Rohan Hours*. For this reason it became customary to refer to this *Bible moralisée* as the *Angevin Bible*. We shall frequently have occasion to cite it in commenting on the illustrations of the *Rohan Hours* drawn from it.

Since all the pages of the *Rohan Hours* could not be reproduced in the present edition, it will come as no surprise to find numerous discontinuities between the various marginal paintings (themselves quite numerous) which have been retained as examples in our facsimile. The legends in Old French accompanying them in the manuscript have been transcribed, but not translated. As a rule, their text is quite easy to understand, even for the modern reader and, in any event, the commentaries provide a succinct paraphrase when the occasion demands. Where the marginal painting which has been reproduced illustrates a scene from the Old Testament, we have given the reference from the Vulgate. When the marginal painting constitutes a "moralization" on a passage from the Old Testament illustrated on a page that has not been reproduced, we have also indicated the reference to the passage in question.

* * * *

It requires only a rapid examination of all these paintings, both large and small, to determine that they were not all done by the same hand and that, in many cases, their quality is quite uneven.

The full-page paintings, which have rightfully earned for the *Rohan Hours* the eminent place it occupies in the history of art, are veritable monuments, not only of illumination, but of the art of painting, itself. In his Introduction, Professor Meiss points out what vigor and exceptional stylistic originality characterize the talent of the very great artist to whom these paintings are due; we, therefore, shall not dwell on this point.

It is nonetheless fitting, we think, to suggest certain opinions which may differ somewhat from those which have been asserted since the end of the last century, according to which the Rohan Master might have expressed, in his compositions, an inner obsession with death not experienced by his predecessors.

Essentially inspired by the admirable composition called the Judgement (Pl. 63), and by the abundance of funereal scenes illustrating the Office of the Dead, this opinion does not take into account two facts which, until now, have not received sufficient attention. First of all—and later we shall return to this point—the funeral processions and ceremonies that appear in such great number in the *Rohan Hours* are not from the hand of the Master, and we are by no means certain that he even supervised their execution. Furthermore, the iconographic theme of the corpse brought before the presence of the Sovereign Judge while the Archangel Michael fights with the Devil for the possession of his soul, was not invented by the Rohan Master. Professor Meiss has cited at least two manuscripts in which this composition appears;[6] both probably predate the Rohan Hours and are associated with the production of the Master of the *Boucicaut*

Hours. The same observation might also be made in relation to that very dramatic painting in which the Virgin and St. John are represented at the foot of the Cross (f. 237, Pl. 127).

As a rule, it is not the newness of the themes treated for which the Master's compositions are especially noteworthy. In the iconographic field, he shows himself to be relatively weak in creativity, and certain details of his work which, at first glance, are unexpected—for example, the presence of a shepherdess in the Announcement to the Shepherds (f. 85v, Pl. 46)—are most often derived from earlier models.[7] Since the commentaries which accompany each plate in the body of the present work refer to a great number of these features as they appear, this point need not detain us further.

The exact part played by the Rohan Master in the decoration of the manuscript to which he owes his name is an important problem and not an easy one to solve. Personally, and even if this statement may seem somewhat heretical, we would be inclined to attribute to him only ten of the full-page paintings of which we have just spoken. And we say ten, not eleven, because the Crucifixion on folio 27 (Pl. 33), which is directly inspired by a page in the *Angevin Bible* cannot, in our opinion, be consdered as his work.

Among the fifty-four "main paintings" in the manuscript, not many carry the mark of his genius or reveal the specific stroke of his brush. It seems difficult to believe that the pages from the Calendar, the Gospels, the Office of the Dead—and even less the Suffrages that conclude the volume—can be attributed to him. In our opinion, the only ones from the hand of the Master are the Virgin and Child of folio 33v (Pl. 36), the Trinity of folio 210 (Pl. 79), and the St. Andrew of folio 217 (Pl. 93).

Should not another painter altogether—albeit one who was very talented and very original, but of lesser genius than the Rohan Master—be credited with the great Crucifixion on folio 27 (Pl. 33), as well as with a large number of the main paintings in the volume? We are excluding, of course, the effigies of male and female saints which conclude the volume. These are the work of a third artist, one of much more modest endowments, whose characteristic manner may be found in the *Hours for the use of Angers*, called the *Hours of Martin Le Roy*.[8]

As for the marginal paintings constituting the cycle of the *Bible moralisèe*, they seem to reflect two or three different hands and their execution is often very imperfect, even though they conform to the decorative conventions observed in the workshop and followed by the second master, in the main paintings that we have attributed to him. These small paintings, whose considerable number easily explains the all too evident haste that accompanied their execution, were obviously entrusted to subordinate collaborators of the workshop—or perhaps, as we shall see, workshops—in which this enormous labor was accomplished. It seems to us nonetheless likely that the "second master" of the *Rohan Hours* painted a few of the images from the *Bible moralisée* at the beginning of the volume.

If one were to proceed from the hypothesis that the Rohan Master should not be credited with the execution or design of a large majority of the paintings in this manuscript (apart from those noted above), one would be led to revise certain traditionally held ideas regarding the elaboration of the volume itself.

In point of fact, it has always been assumed that the best, the most gifted of the artists who collaborated on the project—the one to whom we shall, of course, continue to refer as the Rohan Master—could only have been the head of the workshop to which this imposing task had been entrusted. It would thus follow that he alone ought to have been credited with the conception and the responsibility of the whole undertaking. However, if one looks more closely, it would seem that this is perhaps too hasty an assumption and that it cannot be accepted unreservedly.

23

We might note, first of all, that the codicological examination of our manuscript has brought to light certain troublesome discoveries. The ten full-page paintings that can unhesitatingly be attributed to the Rohan Master all appear in the Quires copied by Scribe B. The same is true for the paintings which have disappeared and which we may reasonably suppose to have been executed by him. The lacunae established in the manuscript are, in fact, found in Quires X, XI, and XV, as we have already pointed out. It should be recalled that it is Scribe B who had, by far, the surest hand.

Then again, there are only three Quires (IV, XII, and XXVIII) in which paintings of the Rohan Master and those of another artist (excluding, of course, the small marginal illustrations) are found simultaneously. In Quire IV, the Virgin and Child of folio 33v (Pl. 36), is painted on a bifolium which contains no other painting; the same holds true in Quire XII, the Presentation of folio 94v (Pl. 50). Finally, in Quire XXVIII, the Trinity and St. Andrew are painted on an identical bifolium, and this Quire is the only one copied by Scribe A in which a work of the Master appears.

Consequently, might we not assume that the Rohan Master did not work in the same place, or at least not in the same immediate location, as the other collaborators of the *Rohan Hours?* The structure of the manuscript, in any event, appears to have been planned so as to facilitate the division of labor and the circulation of the quires between two distinct workshops, perhaps a considerable distance apart.

It would then remain to determine which workshop had the responsibility for the whole undertaking and which artists collaborated merely as "subcontractors" (if we may be permitted this neologism), once its general conception had been stipulated in detail.

In this connection, it might be useful to review rapidly the question of the "iconographic sources" of the *Rohan Hours,* that is, the models from which the Hours were derived.

It is now some time since indisputable rapprochements were established between various paintings of the *Rohan Hours* and certain pages in the *Belles Heures* of Jean de Berry which, as is well known, was illustrated by the Limbourg Brothers. As a matter of fact, these relationships between the two manuscripts are so numerous (we shall point them out in the course of this work, in our commentaries on the pages reproduced in the body of the book, and it can be affirmed that they are found even more frequently than had been previously supposed) that it seems impossible to believe that the *Rohan Hours* could have been executed without the collaborating artists having had the *Belles Heures* before their eyes and, one might say, in their hands.

Since it has, furthermore, been determined that the *Belles Heures* passed into the hands of Yolande of Aragon after the death of Jean de Berry,[10] it has rightly been concluded that the *Rohan Hours* was executed, if not for her, at least at her behest, and that she took an active part in the direction of the project.

One fact, however, has not been sufficiently stressed, we believe, in spite of its significance —namely, that these echoes of the *Belles Heures* were not found in any of the full-page paintings which all agree should be attributed to the greatest of the three masters.

His work reveals only two indisputable imitations of the Limbourgs: the motif of the knights pursuing the Holy Family on the page devoted to the Flight into Egypt and the Miracle of the Field of Grain (f. 99, Pl. 53), and the two Apostles kneeling at the feet of the Trinity, surrounded by seraphim, in the painting devoted to the Pentecost (f. 143v, Pl. 58). Loosely speaking, we might also consider as an imitation of a model inherited from the Limbourgs, the shepherdess who is busy milking a goat, in the Announcement to the Shepherds (f. 85v, Pl. 46).

The knights in the Flight into Egypt are derived from a page in the *Très Riches Heures*[11]

while the Apostles of the Pentecost are inspired by two pages painted subsequently by the Limbourgs, in the *Très Belles Heures de Notre Dame*.[12] As for the shepherdess, she might possibly have been borrowed from a page in the *Très Riches Heures*,[13] but she could just as easily have been inspired by a model from the Bedford workshop.[14]

These findings only complicate the problem, since there is no proof that the *Très Riches Heures* ever passed into the hands of Yolande of Aragon, and we know, furthermore, that during the lifetime of Jean de Berry the *Très Belles Heures de Notre Dame* was given by him to one of his officers, named Robinet d'Etampes.[15] It is true that Robinet d'Etampes outlived his lord by many years and that various historical documents confirm that he was living in Bourges around the years 1420–1430, and that while there, he was still in the service of the French Crown and the Dauphin Charles.[16] This last fact, together with other indications noted by Professor Meiss in his Introduction, would thus tend to identify Bourges, rather than Anjou, as the location of the workshop or workshops where the *Rohan Hours* was produced.

The possibility should not be excluded that the Rohan Master was inspired, in the cases we have just cited, not by the manuscripts themselves, but by outlines or sketches of the Limbourgs. In any event, it is advisable to bear in mind that the paintings of the Rohan Master, as we shall have several occasions to point out, present undeniable iconographic relationships with Parisian manuscripts of the same, or a slightly earlier date.

One such case is the architectural decor framing, on the left, the scene of the Presentation at the Temple (f. 94v, Pl. 50): it is found again—identical down to the smallest detail—not only in a painting from the Stuart Hours, which was certainly done by the same artist, but also, with minute variations, in three manuscripts from the workshop of the Master of Bedford.[17]

We have already noted that the iconographic theme of the Judgement (f. 159, Pl. 63) was found in manuscripts related to the production of the Master of the *Boucicaut Hours*: the same could be said of the Triumph of the Virgin (f. 106v, Pl. 54) and of the Resurrection and Judgement of the Dead (f. 154, Pl. 61). To a certain degree, the famous *Pietà* of folio 135 (Pl. 57) is, itself, also associated with Parisian iconography.

Two other models to which the Rohan Master may obviously have had recourse are of a still more surprising nature, because this time we are not dealing with manuscripts. The first of these is a drawing preserved in Brunswick, undoubtedly constituting a preliminary sketch for a panel devoted to the Miracle of Bethesda which, in the opinion of Professor Meiss, is from the hand of the Rohan Master. It has, in any event, been repeated in the Resurrection and Judgement of the Dead in the *Rohan Hours* (f. 154, Pl. 61)—not without a certain awkwardness, to be sure. The second is a wood engraving—or else some lost work constituting its prototype—which is generally considered to be of German origin and which presents striking analogies with the Virgin of folio 33v (Pl. 36).

To sum up, we can then say that, whenever he has recourse to identifiable models (and that occurs often) the Rohan Master never borrows from the *Belles Heures*, whereas for the other two painters collaborating with him, that volume represents an essential and almost constant source of inspiration. Once more we are, therefore, tempted to conclude that the three artists were not working side by side and did not belong to the same workshop. Two of them derive inspiration, often in a somewhat servile fashion, from two firmly established and constantly accessible manuscripts (the *Belles Heures* and the *Angevin Bible*), since those manuscripts belonged to the family for whom the *Rohan Hours* is considered to have been executed. On the other hand, for a small number of paintings which are exceptional in every respect, the third artist (and possibly his assistants) draws upon a much broader and more varied repertory of forms.

In addition to the observations we have already made concerning the codicological structure of the *Rohan Hours*, this affirmation would lead us to doubt that the Rohan Master was the head of the workshop commissioned to produce the manuscript which has earned him his name. On the contrary, certain evidence would seem to indicate that, in order to further embellish a volume which was intended to be superb, an artist of renown, who was deploying his talents elsewhere—and possibly in other media—was employed to produce a relatively limited number of pages. The strong possibility that some lesser artist occasionally completed the work of the Rohan Master, even in the full-page paintings, is not in contradiction with that theory. It would not be impossible that, after having drawn his composition, he should entrust someone else (even in another workshop) with the more routine task of coloring part of the sketch—or even the whole of it. That would explain why some faces in the full-page paintings seem to be executed with less skill and minute attention to detail than others.

Such a hypothesis would help to resolve the numerous problems posed by the subsequent activity attributed to the workshop (or workshops) of which the Rohan Master has been considered the head.

* * * *

We cannot, at this point, take up the discussion of the numerous and very delicate questions raised by the chronology and the localization of the manuscripts attributed to the "Rohan Workshop," a list of which has been drawn up by A. Heimann, E. Panofsky, J. Porcher, and many other scholars.[18] That list, as it stands, is very long (too long, perhaps) and relatively fluid. Professor Meiss will deal with these problems at length in his forthcoming work, *French Painting in the Time of Jean de Berry—The Limbourgs and Their Contemporaries*. Meanwhile, we would venture to suggest that several volumes that have, thus far, been grouped together because they reveal certain similar models, styles or decorative mannerisms, ought to be redistributed between several distinct workshops.[19]

Thus, certain mysteries might be better explained, notably the sort of ubiquity which has been ascribed to one workshop and one Master, who has been credited with laboring—in succession, or indeed concurrently—in Troyes, Paris, Anjou, or Brittany, and indeed, even in Bourges!

It seems, after all, surprising that any artist of such far-flung activities as have been attributed to the Rohan Master (considered the head of a prolific workshop) should very seldom have reached such artistic heights as he did in the *Rohan Hours*. With the exception of the *Rohan Hours*, it is difficult to discern his hand and his genius. Only one page from the *Stuart Hours*—a page that is unique and whose very presence in that volume represents a certain anomaly—can with absolute certainty be attributed to him.

As to the relationships that have been legitimately established between the *Rohan Hours* and other very similar manuscripts (the *Heures de Buz,* the *Giac Hours,* Manuscript 67 of Chantilly, the *Hours of Angers,* called the *Hours of Martin Le Roy,* etc.), could it not be argued that these relationships, with rare exceptions, concern principally the pages painted not by the Rohan Master himself, but by the other artists from whom we have tried to distinguish him?[20]

The *Hours of René d'Anjou*[21] contain, to be sure, certain paintings which might be attributed to the Rohan Master—notably a Man of Sorrows (f. 82), a Nativity (f. 48), and a Virgin and Child (f. 18)—but we would be tempted to see in them copies rather than original works. Moreover, it is copies—and obvious ones—of works of the Rohan Master which one encounters in the pages of the *Hours of René d'Anjou* devoted to the Pentecost (f. 87v) and to the Visita-

26

tion (f. 39). The large Nativity of the *Rohan Hours* has unfortunately disappeared, but it may be supposed that it constituted the model for that found in the *Hours of René d'Anjou*.

If one were to accept the hypothesis that the Rohan Master had personally labored on the latter manuscript, would it not be surprising that he should have been willing to entrust to a mediocre collaborator the task of copying the masterworks he had conceived for the *Rohan Hours*!

The very minimal participation of the Rohan Master in the works emanating from the workshop whose direction has been attributed to him would be, on the other hand, more understandable if one agreed, with Paul Durrieu and Professor Meiss,[22] that the Master was not so much an illuminator by profession as an artist who was simultaneously involved in other modes of pictorial expression. This would provide a much better explanation for the characteristics which have won for the talent of the Rohan Master a very special place in the history of illuminated art.

What immediately strikes the most unsuspecting eye is the exceptional dimension the Master likes to confer upon his figures—figures which, furthermore, he has difficulty containing within decor conceived on a completely different scale. This difficulty is especially perceptible in The Presentation at the Temple of the *Rohan Hours* (f. 94v, Pl. 50) and in the Virgin and Child of the *Stuart Hours*. It is a curious fact that the architectural decor within which these two scenes are inscribed, as we have already noted, are identical (that of the *Stuart Hours* is animated by small figures painted on a reduced scale, undoubtedly by another artist, and the Virgin seems a little artificially recessed in a framework not suited to her).

Similarly, in the Flight into Egypt of the *Rohan Hours* (f. 99, Pl. 53), the dimension given by the Master to the Holy Family—a dimension that is exaggerated in comparison to the personages in the foreground—can surely be explained because the fugitives play a preeminent role in the scene; but one cannot fail to recall that in contemporary tapestries (of which, alas, very few have been preserved) a corresponding transposition of dimensions is often found between the figures in the foreground and those placed further back. This procedure is perhaps explained by a desire to make the upper part of a panel that has been hung fairly high on a wall more easily discernible to an observer standing at ground level.

The hypothesis that the Rohan Master was a painter of panels (a hypothesis which, furthermore, is confirmed by the attribution to him of a painting preserved in the Museum of Laon[23]) and possibly the creator of tapestry sketches, who only on rare occasions agreed to participate in the decoration of a manuscript, will perhaps not gain wide support. One is at least entitled to note in passing that nothing in the "artistic sociology" of the period would render such a theory unacceptable. We know that some years before, Jean de Berry had frequently encouraged gifted artists to move in this manner from one medium of expression to another. Andre Beauneveu was a sculptor and architect, Jacquemart de Hesdin, a painter of panels and frescoes, before their enlightened patron urged them to become illuminators as well. If the Limbourgs are known to us today only as extraordinary illuminators, we are nonetheless aware that they also contributed to decorating the residences of their protector with mural paintings.

Therefore, it would not be at all surprising if Yolande of Aragon, in turn, had had the idea of incorporating into a manuscript of the first order, some works by a great contemporary artist whose name, like that of so many others, unfortunately has not come down to us.

Certainly, we would then have to relinquish the notion that the Rohan Master was the leader of an important school of illumination; but, in compensation, it would be demonstrated once again that today this art is worthy of being considered no longer as a minor art, but as one of the principal means of plastic expression known to the Middle Ages in Europe.

The fortunes of the *Rohan Hours* after its completion are no less mysterious than its execution in the first place. Its first owner still remains unknown to us. If we can, in fact, consider it likely that Yolande of Aragon commissioned the work from the artists and copyists about whom we have spoken (perhaps acting through the agency of a sort of responsible editor), she must have intended, in any event, to present it to some important member of her family, rather than keep it for herself, since the various prayers contained in the *Rohan Hours* are worded in the masculine, not the feminine form.

It has often been thought that she intended the volume for a member of the House of Anjou, and more especially, for one of her two sons, Louis or René. But Professor Meiss has pointed out in his Introduction that the donor could just as well have wished to present it to the Dauphin Charles (the future Charles VII), who was betrothed to her daughter, Marie.

In commenting on the pages of the manuscript containing the arms of the Rohan Family (gules with seven gold macles), we shall point out that wherever they appear, they have been superimposed, at an undetermined date, upon the original illumination.

The arms probably identify a later owner of the volume, Alain IX, Viscount of Rohan, who had married Marie of Lorraine, the daughter of Antoine de Vaudémont. The latter, an adversary of Rene d'Anjou, had defeated him at the Battle of Bulgneville, in 1431, and had taken him prisoner, only releasing him upon payment of a heavy ransom.[24] From this fact to a conjecture that the *Rohan Hours* made up part of that ransom is only a step—but perhaps it would be unwise to take it too quickly.

It is to its passing into the hands of one of the members of the illustrious House of Rohan that our manuscript, in any case, owes the name which thereafter became irrevocably attached to it, even though the designation of *"Hours of Yolande of Aragon"* might seem more appropriate today.

How this magnificent volume, after a more or less prolonged sojourn in Brittany, found its way to the library of *"la maison professe"* of the Jesuits in Paris, where it was kept in the eighteenth century—as is attested to by an inscription placed at the top of its first page—remains an enigma. A short time later it passed into the collection of the Duke de La Vallière, and the duke's librarian, the Abbé Rive, conceived the idea of publishing it in facsimile, of which at least one plate was engraved.[25] Acquired by the Bibliothèque du Roi at the sale of the La Vallière Collection, it has never since left the shelves of the Manuscript Department of that institution, the present Bibliothèque Nationale.

It was materially impossible, as we have already noted, to reproduce all the pages of the volume in the present edition. Consequently, it will not be found to contain the complete iconographic cycle of the *Bible moralisée* which ornaments its outer margins. Nonetheless, a substantial selection from these pages of text will enable the reader to appreciate the importance and the variety of this supplementary, and most unusual, decoration of an altogether exceptional Book of Hours. All of the "main paintings" and, of course, all of the "full-page paintings" in the manuscript have been reproduced.

Thus, as they turn the pages and gaze upon the *Rohan Hours*, the general public will be able to perceive, for the first time, the full extent of the splendid illumination which characterizes one of the most beautiful and unusual, but also one of the most enigmatic masterworks which fifteenth-century France has bequeathed to us.

MARCEL THOMAS
Keeper of Manuscripts,
Bibliothèque Nationale

NOTES

1. See Appendix, *Selected Bibliography*.
2. See Appendix, *Selected Bibliography*.
3. See Appendix, *Selected Bibliography*.
4. See Appendix, *List of Related Manuscripts*.
5. Cf. J. Porcher, *The Rohan Book of Hours*, p. 6.
6. Cf. M. Meiss, . . . *The Boucicaut Master*, Pls. 153, 164, 165.
7. In several manuscripts from the workshop of the Master of Bedford will be found an Annunciation to the Shepherds in which one shepherd, little concerned with the angelic message, seems more interested in the charms of a shepherdess, whom he is obviously courting. (Cf. M. Meiss, *The de Lévis Hours*, Pls. 30 and 31). This theme was probably introduced into illuminated art under the inspiration of performances of theatrical works (*Jeux de la Passion*, etc.).
8. See Appendix, *List of Related Manuscripts*.
9. Cf. J. Porcher, Two models—in *Journal of the Warburg and Courtauld Institutes*, VIII (1945), I.
10. Ibid.
11. Chantilly, Condé Museum, *"Très Riches Heures,"* folio 51v.
12. Bibliothèque Nationale MS. newly acquired lat. 3093, 225.
13. *"Très Riches Heures,"* folio 7v.
14. See, for example, folio 70v of British Museum MS. Add. 18850, reproduced by M. Meiss, *The de Lévis Hours*, Pl. 31.
15. M. Meiss, *French Painting . . . the Late XIVth Century . . .* , p. 108.
16. Cf. R.P. Anselme, *Histoire généalogique . . .* Vol. VI, 541.
17. M. Meiss, *The De Lévis Hours*, Pls. 18, 19 and 20.
18. See Appendix, *Selected Bibliography*.
19. Notably a characteristic way of treating the clouds, the backgrounds starred or decorated with flights of golden angels on a field of azure, the backgrounds of very small checker-work, the gilded embroideries on the clothing, the straw hats with wide, upturned brims, the checkered design for the pavement, etc.
20. See Appendix, *List of Related Manuscripts*.
21. Bibliothèque Nationale, MS. lat. 1156A.
22. See Introduction I, p. 16
23. See Introduction I, p. 15
24. Cf. J. Porcher, *The Rohan Book of Hours*, p. 6.
25. For this item of information we are indebted to M. F. Avril. The plate in question is included in a compilation in the Department of Manuscripts (Facsimile Folio 145, Pl. I).

PLATES AND
COMMENTARIES

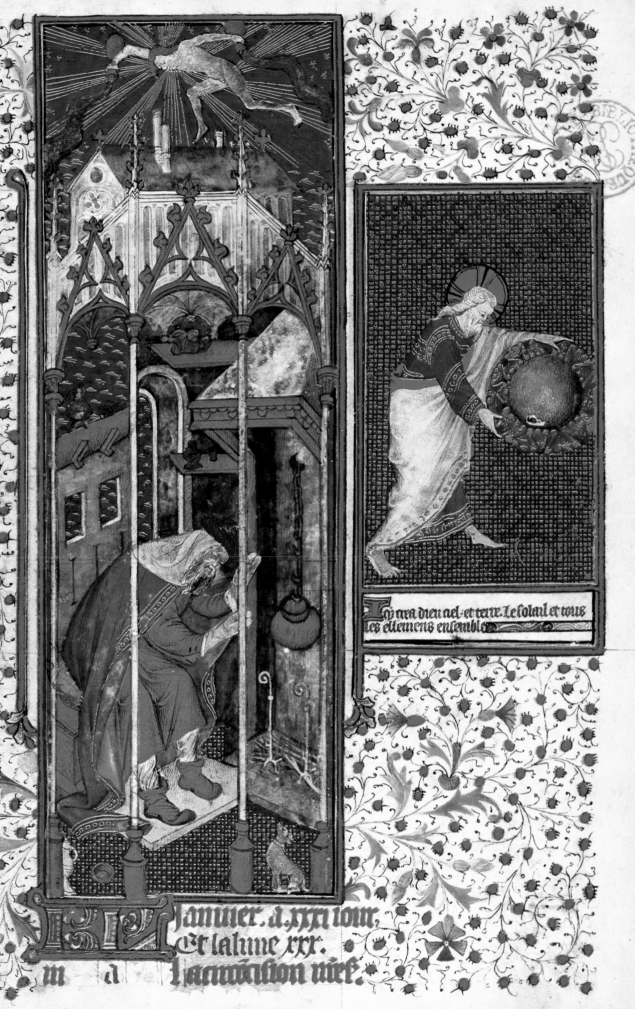

Icy cra dieu ciel et terre. Le ſoleil et tous les eſtemens enſemble

Janvier. a. xxxi iour,
Et la lune xxx.
m d l aetiuiſion uierl.

Suppl. l. 676.

Pl. 1

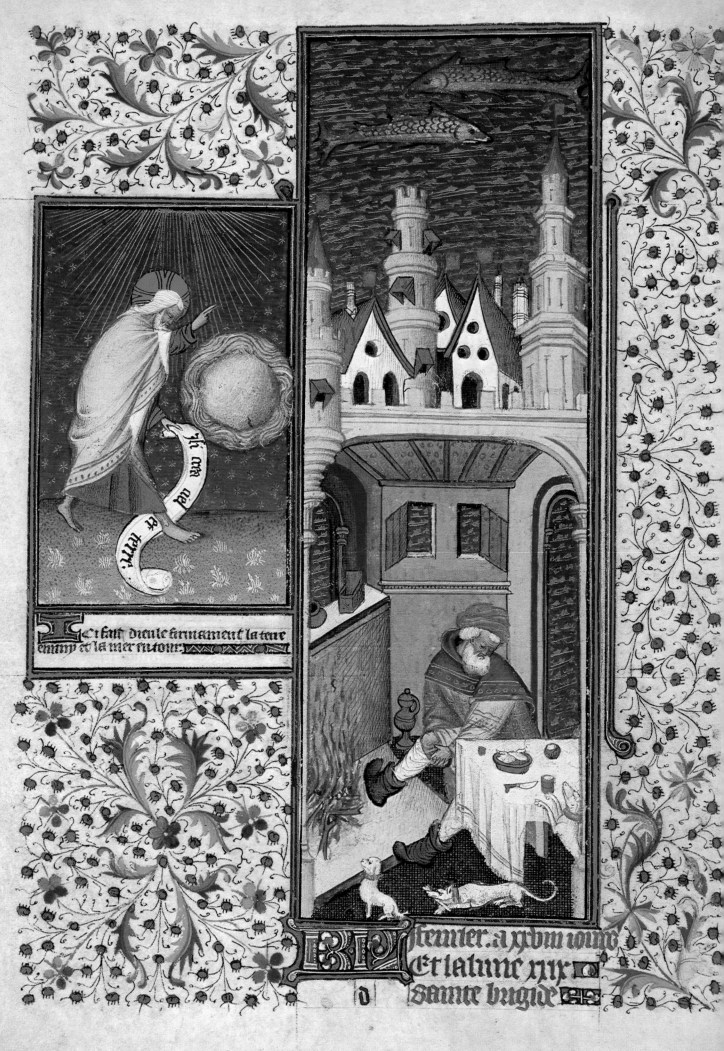

Cenfaitdieu le firmament la terre
enmy et la mer futour.

feurier. a xxbiii iourp
Et la lune rrir.
Sainte brigide

Pl. 2

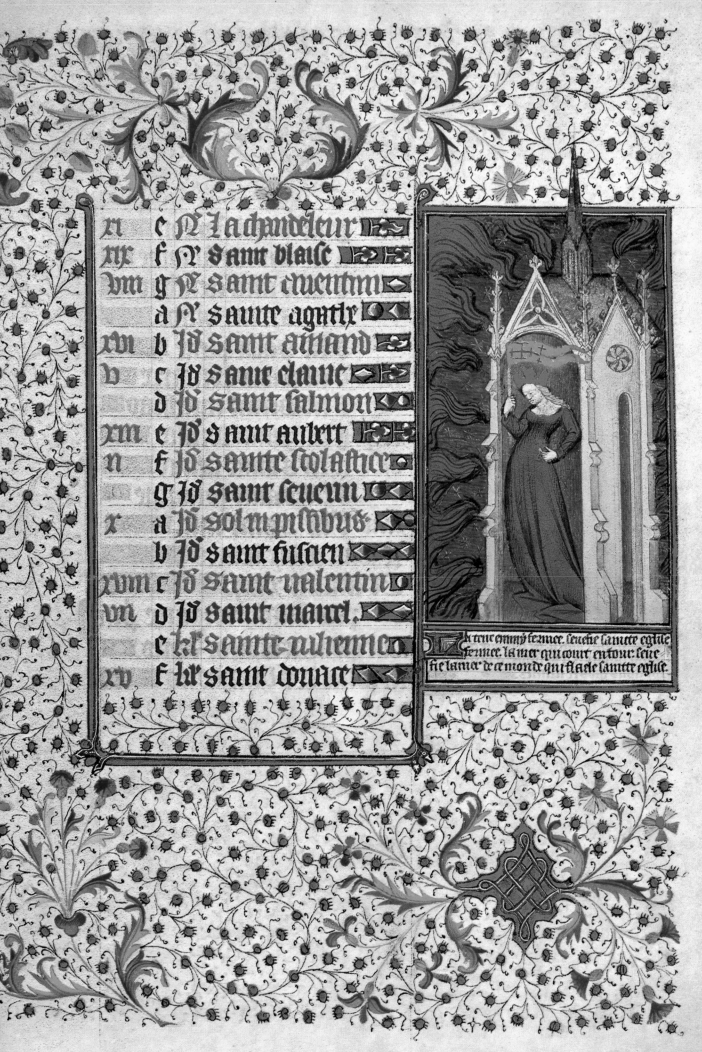

xi	e	iiij N̄	La chandeleur
xix	f	iij N̄	Saint blaise
viij	g	ij N̄	Saint erwentin
	a	N̄	Sainte agathe
xvi	b	id	Saint amand
v	c	iiij id	Saint elaine
	d	id	Saint salmon
xiij	e	iiij id	Saint aubert
ij	f	id	Sainte scolastice
	g	id	Saint seuerin
x	a	id	Sol in pisabus
	b	id	Saint fuscien
xviij	c	id	Saint valentin
vij	d	id	Saint mautt
	e	kł	Sainte iuliennne
xv	f	kł	Saint donace

ul tour emuy fermee. senefie sainte eglise
fermee. la mer qui court entour. senie
fie la mer de ce monde qui bat le sainte eglise.

Pl. 3

1. *January*

MAIN PAINTING

A bearded peasant of advanced years, still wearing a felt hat atop the cowl of his long enveloping cloak, warms his hands (protected by heavy mufflers) near a fire which burns in a monumental chimney surmounted by a large metal hood. Above the log fire, a large kettle supported by tall andirons hangs from a chimney hook. At the right, a little dog seated on his hind legs watches his master.

In the sky above the roof of the dwelling (whose elegant architecture and slender colonnettes suggest a Gothic chapel rather than a rustic cottage, and which the artist has constructed in the style of a loggia in order to permit a view of the interior) a nude figure, holding in each hand an amphora from which he pours the contents, symbolizes the sign of Aquarius in the zodiac.

This peasant in front of his chimney, evoking the coldness of winter, has been imitated (not without a certain awkwardness) in the *Hours of Martin Le Roy* (f. 2), whose style is closely related to that of the workshop of the *Rohan Hours* (see Introduction, II). The representation of the Water Bearer is quite exceptional. It is not impossible that this elegant nude, whose attitude is original and full of life, was inspired by a lost work of the Limbourg Brothers (see Introduction, II).

MARGINAL PAINTING. Bible moralisée. Genesis I, 6–10, 16.

LEGEND *"Icy crea Dieu ciel et terre, le solail et tous les ellemens ensemble."*

This little painting opens the iconographic cycle of the *Bible moralisée* borrowed by the artists of the Rohan workshop from an Italian manuscript called the *Angevin Bible,* (MS. Bibliothèque Nationale, fr. 9561) which they obviously had before their eyes as they worked (see Introduction, II). In this cycle, an image illustrating a passage from the Bible is followed by another consisting of a visual representation of the moral application which may be drawn from the sacred text. Here we see a scene from the Creation standing out against a checkered background. In His hands, God the Father holds the globe of the Universe surrounded by a ring whose stereotyped undulations, in the tradition of illuminators, symbolize the heavens. The legend sums up in a single sentence successive episodes in the Creation cycle: that of the firmament, the earth, the sun, and the diverse elements. (f. 1)

2. *February*

MAIN PAINTING

Within a dwelling which is built in the style of a loggia as in the preceding plate—but which conveys the impression of a hall in a chateau or in a rich bourgeois home—an old man with white hair and beard, wearing a round hat with an upturned brim, holds his feet before the fire while loosening his shoes (undoubtedly wet) to better dry his legs. Nearby, a table has been laid. On the embroidered tablecloth can be seen a plate containing pieces of fowl, a knife, a goblet, a piece of bread, and a salt-celler [?]. A jug of wine is being warmed, not far from the fire. Three dogs in different attitudes animate the scene. The upper part of the edifice bristles with towers and pointed gables which have been brought together with no great concern for architectural probability, but simply to provide a background. The pennants bearing the arms of the Rohan (see Introduction, II) were repainted after the original decoration of the manuscript had been completed.

In the sky, two fishes facing each other are a reminder that the month of February falls under the sign of Pisces in the zodiac.

MARGINAL PAINTING. Bible moralisée. Genesis I, 7–10

LEGEND *"Ici fait Dieu le firmament, la terre emmy et la mer entour."*

On the phylactery which the Creator holds in His left hand can be read: *"Isi crea ciel et terre"* ("Here He created heaven and earth").

Without any strict adherence to the biblical text, God is represented here creating the earth, which is surrounded on all sides by the sea. The background of the picture is a sky set with stars, and golden rays of light streaming from its zenith recall that the stars have already been created—which was not yet the case in the preceding picture, the latter having been painted, accordingly, on a checkered, purely decorative background.

(f. 2v)

3. *February*

MARGINAL PAINTING. Bible moralisée.

LEGEND *"La terre emmy fermee senefie saincte eglise fermee. La mer qui court entour senefie la mer de ce monde qui flaele saincte eglise."*

The earth, which we have seen created by God on the preceding folio, is, we are told, a symbol of the Church encompassed, like a beseiged fortress, in the midst of a hostile world. It is represented here in the form of a woman crowned, leaning on a lance, and standing inside a chapel with solid buttresses. To the left of the edifice, a series of threatening waves, rising one above the other over the upper part of the painting, come to batter its ramparts. These waves symbolize the ambitions, the preoccupations of the world, which are a constant danger to the Church and to the faithful.

(f. 3)

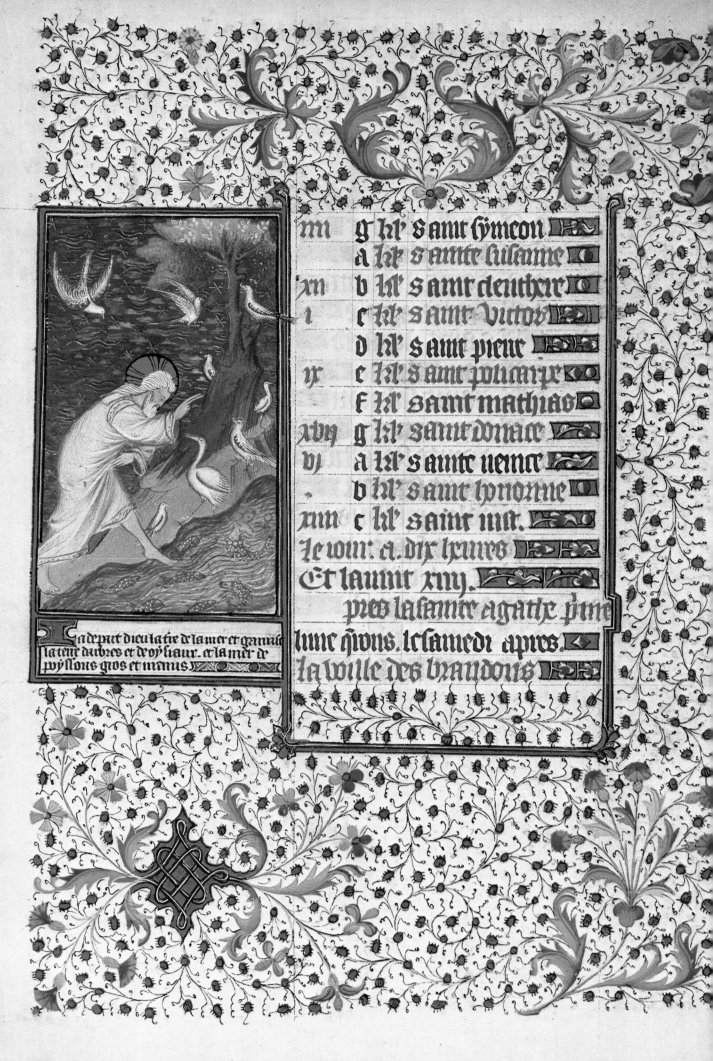

Ga depart dieu la tie de la mer et garnist
la tene d…bres et de oyseaur. et la mer de
pyssons gios et menus

Pl. 4

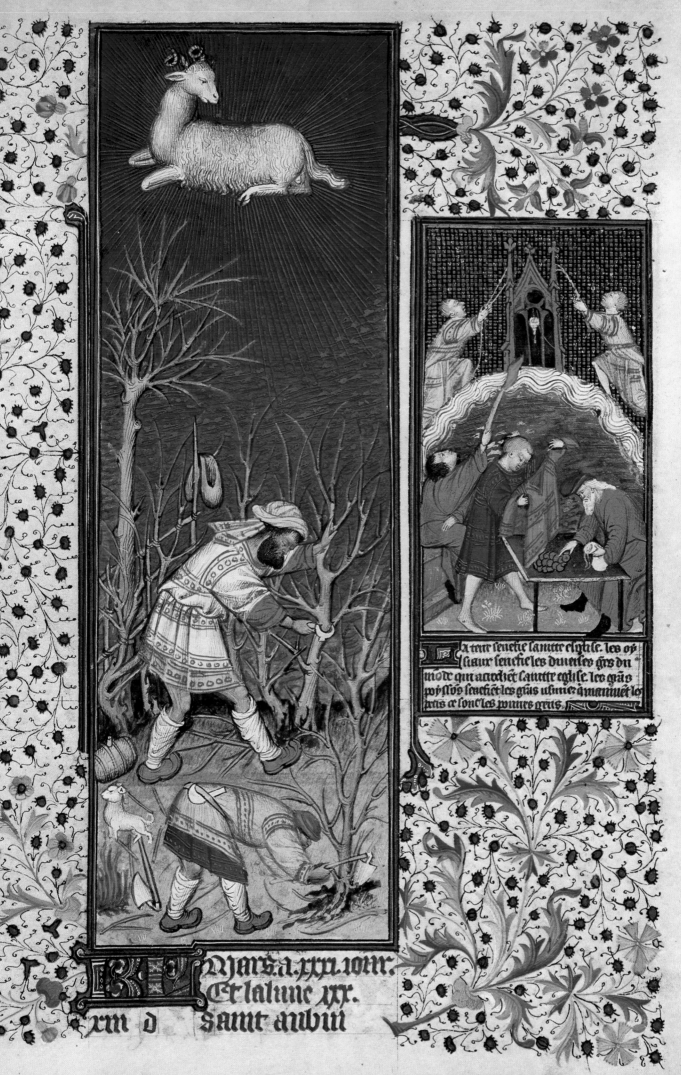

Pl. 5

4. *February*

MARGINAL PAINTING. Bible moralisée. Genesis I, 9–12, 20–21

LEGEND *"Ici depart Dieu la terre de la mer et garnist la terre d'arbres et de oysiaux et la mer de poyssons gros et menus."*

We see here the continuation of the Creation cycle. Several verses from Genesis have been arbitrarily combined. God the Father is represented while separating the earth from the sea and, at the same time, filling the one with trees and birds and the other with fish of every sort. Various birds (including a long-legged wader) either poised or in flight, animate the scene. Among the fish seen swimming in the waters we can distinguish a siren—a fantastic creature with the torso of a woman and the tail of a fish. In her hand she holds a round mirror in which she gazes at herself. This attitude was traditionally given her by illuminators, who often represented sirens in the margins of manuscripts decorated with "grotesques." (f. 3v)

5. *March*

MAIN PAINTING

In the cycle of labors appropriate to each month, March is dedicated here to the care of fruit trees. In the foreground a peasant, bending over near the foot of a young tree, turns up the soil with a hoe. In the background, another peasant (whose silhouette, by its dimensions, betrays a certain contempt for perspective on the part of the artist) trims a tree with a pruning knife. He has hung his sack on the pole supporting the trellis to which other trees are attached. The contents of the small cask which has been set down on the ground will soon be used to slake the thirst of the two companions, who have brought their dog along with them; he watches the burning of the discarded branches.

In the sky, aglow with golden rays, a reclining ram evokes the sign in the zodiac to which he has given his name. A very faithful replica of this motif is to be found in manuscript 5140 of the Library of Lyons (f. 4v), whose relationship to the *Rohan Hours* has already been mentioned (see Introduction, II).

MARGINAL PAINTING. Bible moralisée.

LEGEND *"La terre senefie saincte eglise, les oysiaux senefie les diverses gens du monde qui acrochent saincte eglise, les grans poyssons senefient les grans usuriez qui manjuent les petis, ce sont les povres gens."*

This image is a "moralization" on the biblical text illustrated in f. 3v (Pl. 4). A small church, curiously constructed on the celestial vault, represents the Church of God. Two impious persons try to overturn the pinnacles by pulling on ropes, while a third attempts to set them afire. It is these persons who are symbolized by the birds with which God has filled the air. The large fish, who pitilessly swallow up the small ones, evoke for us the "great moneylenders" who prey upon the poor. To the right, one of them, a sack of gold in his hand, is dispensing a few coins to the owner of an embroidered robe who is regretfully stripping it off. (f. 4)

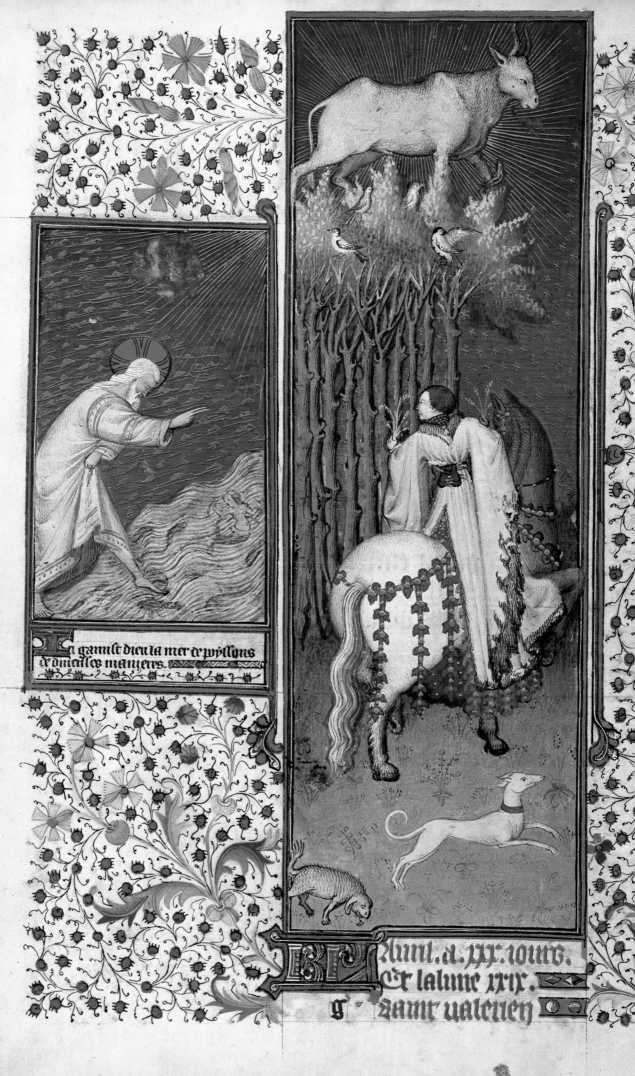

a garnist dieu la mer de poissons
et doiselles manieres.

Aouil. a. xxx. iours.
Et la lune xxix.
s. saint ualentin

Pl. 6

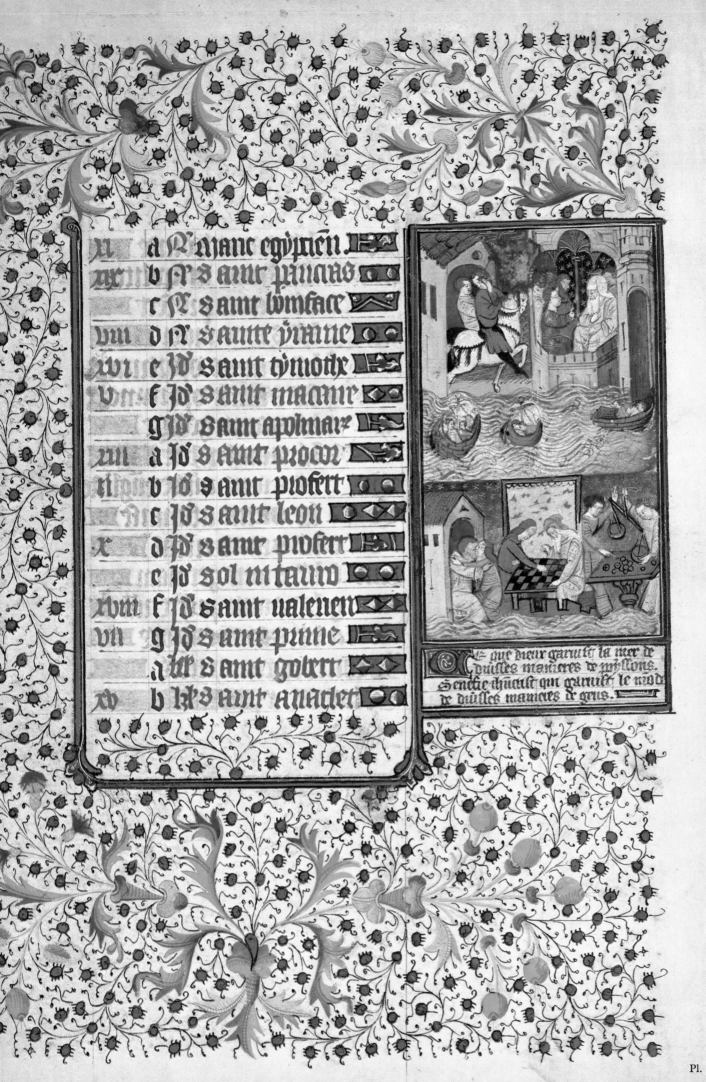

xi	a	Marianne egyptien	
xix	b	iijs samt pancras	
	c	iij samt bonisace	
viii	d	vij samte prisine	
xvi	e	id samt tymothe	
v	f	id samt macaire	
	g	id samt apolinar	
xiii	a	id samt procor	
ij	b	id samt prosett	
	c	id samt leon	
x	d	id samt prosett	
	e	id sol intauro	
xviii	f	id samt valentin	
vij	g	id samt prinne	
	a	kl samt gobert	
xv	b	kl samt anaclet	

Es que dieux garnist la mer de
duisses manieres de poissons.
Senesie tmeust qui garnist le mōd
de duisses manieres de gens.

Pl. 7

6

6. *April*

MAIN PAINTING

To illustrate the month of April, the artist has painted a young and elegant gentleman, dressed in one of those outer coats with flowing sleeves that were the fashion from about 1405 to 1420. In each hand he holds a bouquet of lilies of the valley, which might suggest that the artist has utilized a model here which was actually intended to represent the month of May. The attitude of the horse (of which we are given a three-quarter view) recalls, notably by the twist of its neck, a painting from the *Belles Heures* (f. 72) which represents David seeking help from the Lord. However, in that model the image is inverted, as is so often the case.

In the sky, a bull whose leanness accentuates its powerful frame, symbolizes the zodiacal sign of Taurus.

MARGINAL PAINTING. Bible moralisé. Genesis I, 20–21

LEGEND *"Ici garnist Dieu la mer de poyssons de diverses manieres."*

Once again, and no doubt inadvertently, the artist has reproduced the same model as in f. 3v (Pl. 4). The gesture of the Creator who fills the sea with fish of every sort is identical in the two paintings: He lifts up His robe with His left hand while advancing His left leg in the same manner. The sea occupies the same triangular space in each painting. And, once again, we see a siren, amid fishes of an even greater variety, but this time she is holding a small fish in each hand. (f. 5v)

7. *April*

MARGINAL PAINTING. Bible moralisée.

LEGEND *"Ce que Dieux garnist la mer de diverses manieres de poyssons senefie Jhesu Crist qui garnist le monde de diverses manieres de gens."*

This "moralization" on the biblical text illustrated in f. 5v (Pl. 6) explains that the various fishes with which God has stocked the sea represent the different types of men with whom Christ has peopled the actual world. A series of little scenes, juxtaposed on two levels, evoke the activities of various sorts in which human beings engage. Thus we find, from left to right, and from top to bottom, two riders on a prancing white horse; doctors receiving instruction from the Child Jesus; mariners and fishermen in three vessels being buffeted by the waves; two lovers clasped in an ardent embrace; two men playing checkers; two money changers weighing coins. (f. 6)

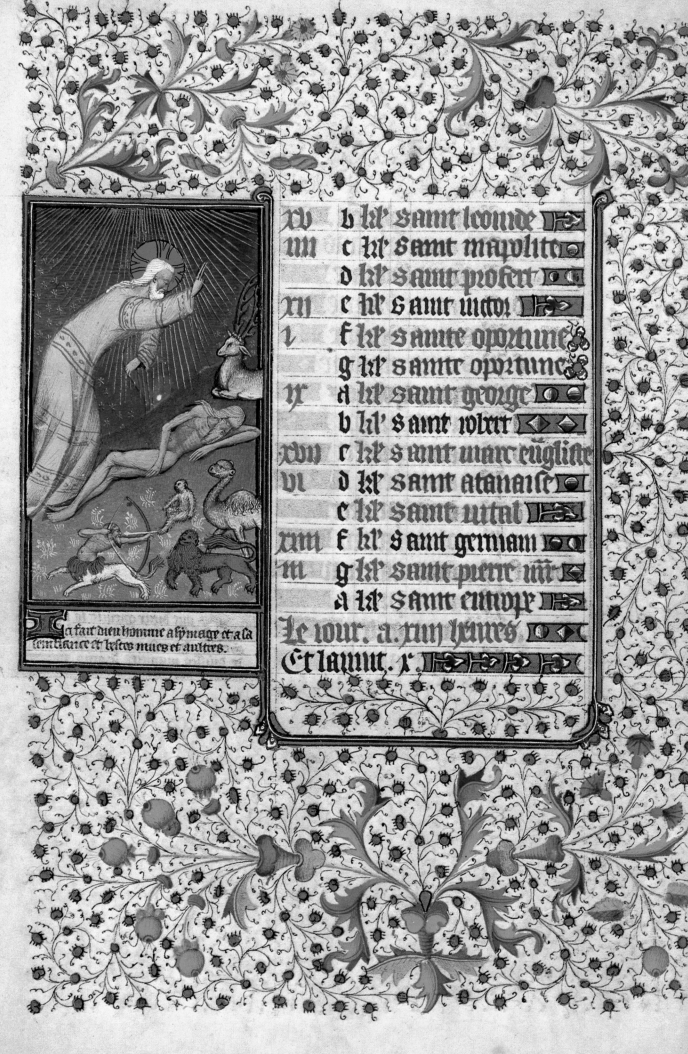

xv	b	kl	saint leonide
iiii	c	kl	saint mapolite
	d	kl	saint profert
xii	e	kl	saint victor
i	f	kl	sainte oportune
	g	kl	sainte oportune
ix	a	kl	saint george
	b	kl	saint robert
xvii	c	kl	saint marc euglite
vi	d	kl	saint atanaise
	e	kl	saint vital
xiii	f	kl	saint germain
iii	g	kl	saint pierre m̄
	a	kl	saint eutvpt

Le iour. a. xiiii heures

Et la nuit. x.

Il a fait dieu homme a sy mage et a la semblance et bestes mues et aultres.

Pl. 8

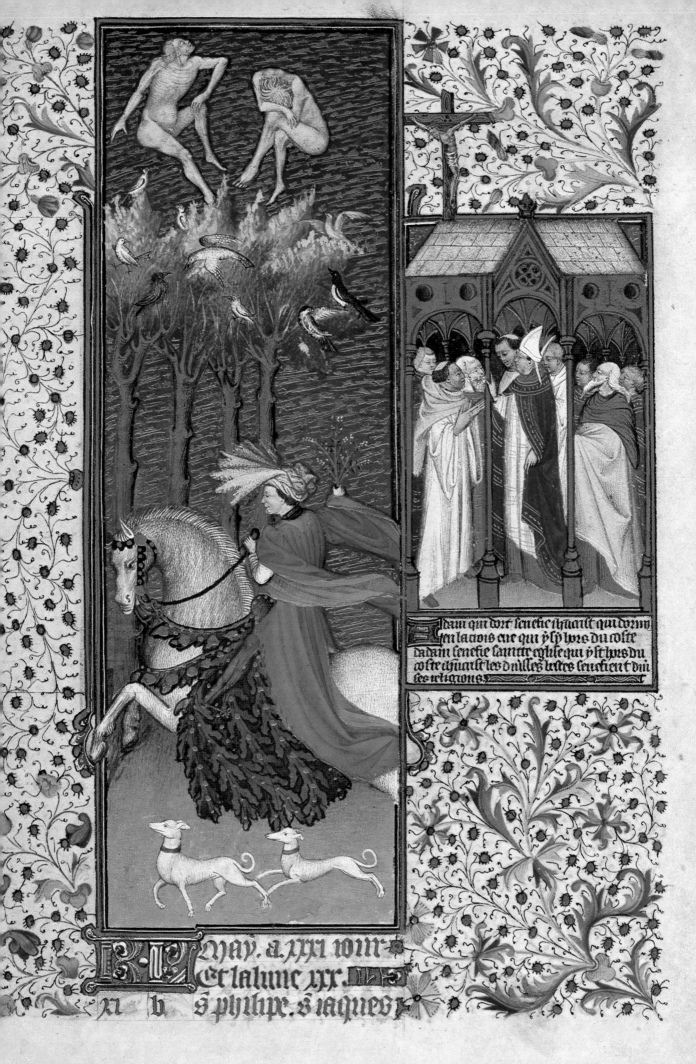

May. a. xxi iolir̃
Et la lune xx.
n. b. S. phelipe. S. iaques.

Pl. 9

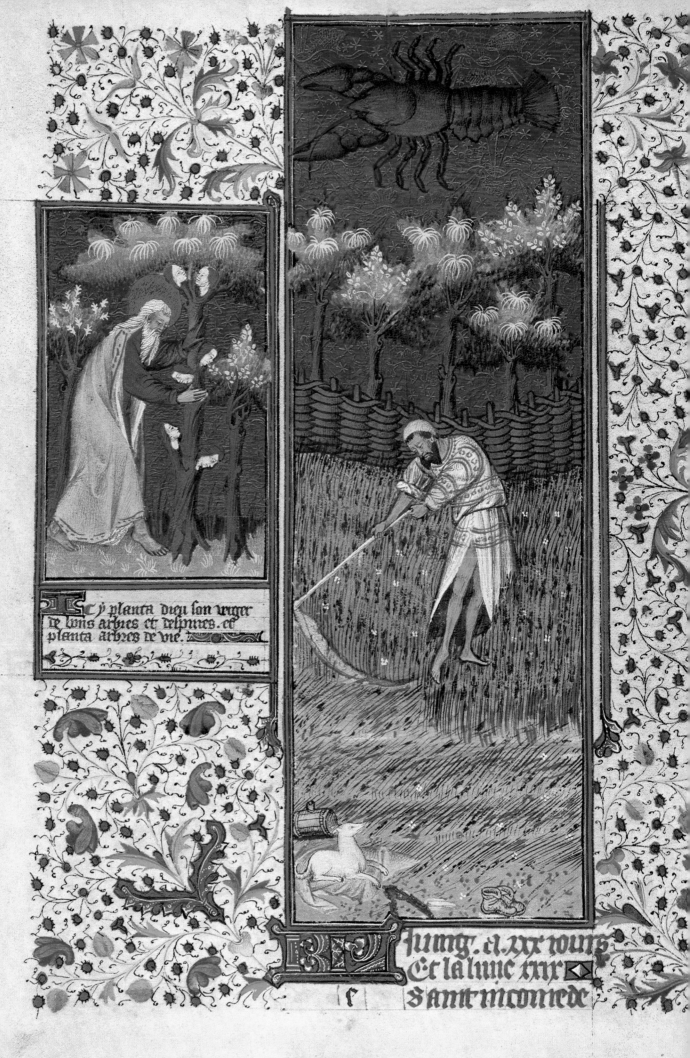

Cy planta dieu son verger
de bons arbres et delicieux. et
planta arbres de vie.

Juing. et .xxx. iours
et la lune .xxix.
Saint nicomede

Pl. 10

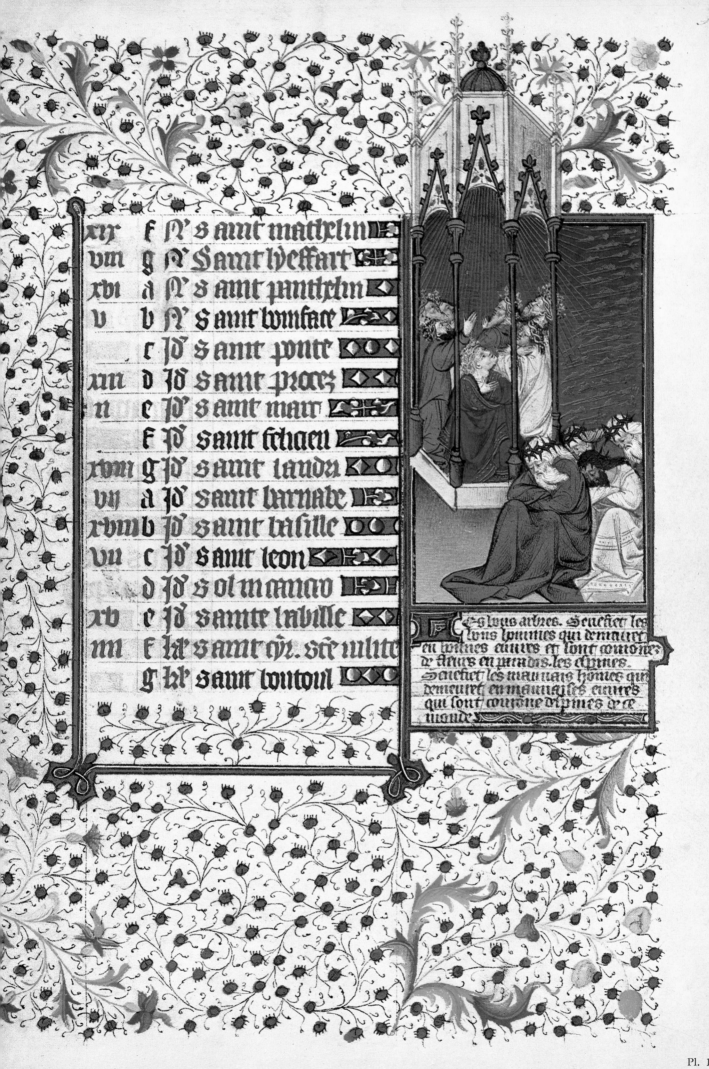

Pl. 11

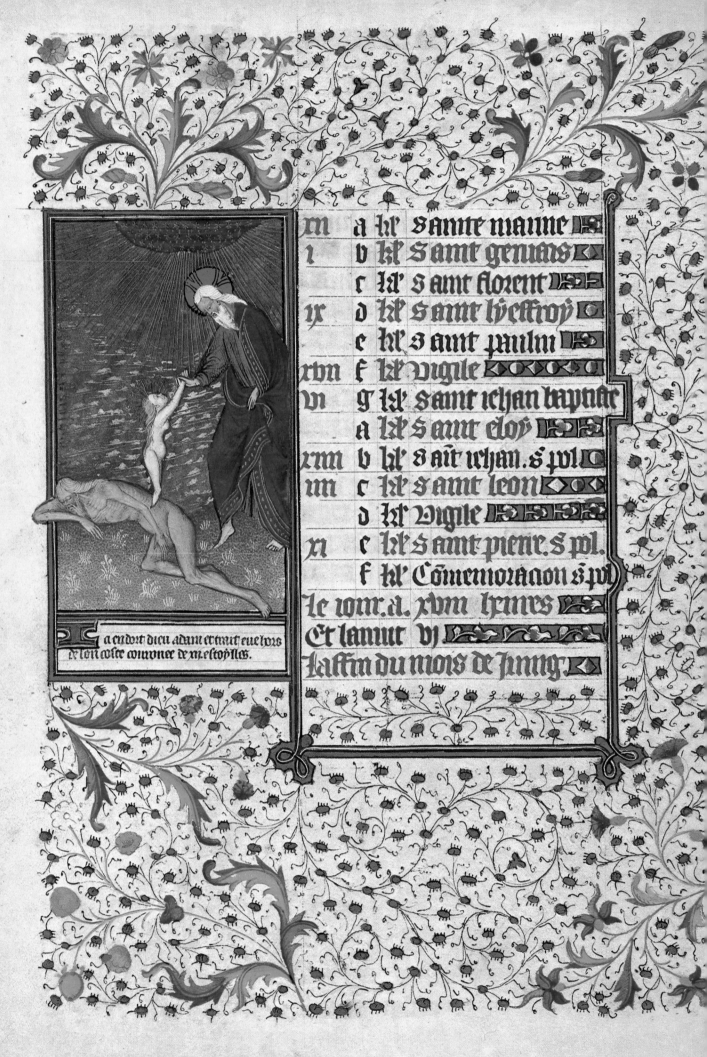

a cuidoit dieu adam et trait eue hors de son coste couronee de xii. estoylles.

m	a	kl	SANTE MANNE
l	b	kl	Saint genias
	c	kl	Saint florent
ix	d	kl	Saint bestroy
	e	kl	Saint paulin
xviii	f	kl	Vigile
vii	g	kl	Saint ichan baptiste
	a	kl	Saint eloy
xiiii	b	kl	S aint ichan. S pol
iiii	c	kl	Saint leon
	d	kl	Vigile
xi	e	kl	Saint piene. S pol.
	f	kl	Commemoracion s pol

le iour. a. xviii. heures

Et la nuit. vi

la fin du mois de iuing.

Pl. 12

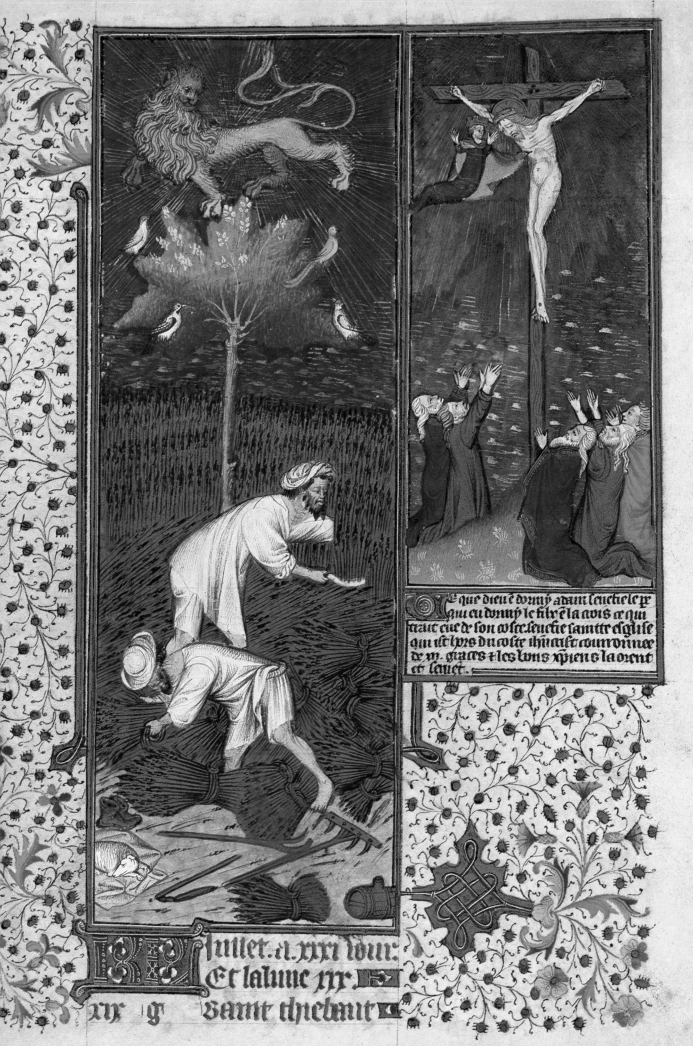

Pl. 13

8. April

MARGINAL PAINTING. Bible moralisée. Genesis I, 24–27.

LEGEND *"Ici fait Dieu homme a s'ymage et a sa semblance et bestes mues et aultres."*

In a single image, the artist has simultaneously evoked the creation of terrestrial animals and of man. In this visualization, an error had initially caused him to represent the creation of woman as well, a theme which reappears in a more appropriate fashion in f. 9v. This is the explanation for the abnormal attitude of the sleeping Adam and the indistinct silhouette (imperfectly covered by retouching) of Eve coming forth from Adam's rib. Among the quadrupeds (deer, monkey, dromedary, and lion) chosen to represent all the "dumb beasts" mentioned in the legend, we note the presence of a centaur drawing his bow. He has been given the aspect of Sagittarius frequently encountered in medieval calendars. (f. 6v)

9. May

MAIN PAINTING

Once again, it is an elegant gentleman on horseback (Pl. 6) who evokes here the activities of the month of May. Holding in his right hand a large bouquet of lilies of the valley, he gallops over the vernal countryside, accompanied by two dogs. His vividly-colored garments, his ample hood, recall the costumes adorning the personages in Jean de Berry's *Très Riches Heures*, painted by the Limbourg Brothers a few years earlier. The birds who sing and flutter about in the newly green trees further enliven the scene. In the firmament, two male nudes represent Gemini, the sign of this month in the zodiac. The knowledge of design which is evinced in these two figures and the studied elegance of their attitudes suggest an Italian or italianized model, perhaps conveyed to the Rohan workshop by some lost sketch of the Limbourgs. In fact, in the *Très Riches Heures* one encounters nudes of a very similar inspiration—for instance, Adam and Eve in the Garden of Eden.

MARGINAL PAINTING. Bible moralisée.

LEGEND *"Adam qui dort senefie Jhesu Crist qui dormi en la crois; Eve qui ysy hors du costé d'Adam senefie saincte eglise qui yst hors du costé Jhesu Crist; les diverses bestes senefient diverses religions."*

This "moralization" is applied to the biblical scene represented in f. 6v (Pl. 8), as it was before being retouched. The sleeping Adam prefigures Christ on the Cross, whom we perceive above the edifice symbolizing the Church, which has issued from His side. The bishop, monks, and priests whom this building shelters, correspond in their diversity to the multiple species of animals created by God. (f. 7)

10. June

MAIN PAINTING

Barefooted, a bearded peasant dressed in a long shirt (frayed, but curiously embroidered in gold) mows a meadow enclosed, in the background, by a row of trees supported by a wattle-work fence. The tall grass of the meadow is flecked with multicolored flowers: cornflowers, daisies, and poppies. In the foreground, a dog lying on his master's cloak [?] watches his master's shoes as well as the small cask whose contents will permit the peasant to refresh himself. In the sky, a crayfish painted with great attention to naturalistic accuracy, symbolizes the sign of Cancer (more often represented by a crab). In MS. 5140 of the Lyons Library, whose relationship to the *Rohan Hours* has already been pointed out, there is also a crayfish which, in f. 7v, evokes the same zodiacal sign.

MARGINAL PAINTING

LEGEND *"Icy planta Dieu son verger de bons arbres et d'espines et planta arbres de vie."*

In the Garden of Eden, that "orchard of delights" upon which medieval biblical commentators have so unreservedly exercised their imaginations, God causes trees of every sort to grow—even thornbushes. Two trees endowed with quasi-magical properties are mentioned in the Bible: the tree of knowledge and the tree of life. It is this latter tree which we see rather curiously represented here, bearing human heads in the guise of fruit. This iconographical tradition is not widespread. Here, the artist has followed the model in the *Angevin Bible* (MS. fr. 9561, f. 7), but the latter work was, in this detail, innovative in comparison with the Latin *Bible moralisée* of the thirteenth century. (f. 8v)

11. June

MARGINAL PAINTING. Bible moralisée.

LEGEND *"Les bons arbres senefient les bons hommes qui demeurent en bonnes euvres et sont couronnez de fleurs en Paradis. Les espines senefient les mauvais hommes qui demeurent en mauvaises euvres qui sont couronné d'espines de ce monde."*

The passage from Genesis illustrated in the preceding folio (Pl. 10) finds its symbolic explanation here. In the upper part of the image, a sort of chapel in the form of an open loggia (whose vault is supported by slender colonettes) shelters the just, who have been admitted to Paradise in reward for their good works. Crowned with flowers, like "good trees," they see celestial graces showering down upon them, like golden rain. The wicked, hardened in their sin (which has earned them a crown of sharp thorns) are represented in an attitude of confusion and sadness, outside Paradise, which remains forever forbidden to them. These are the ones foreshadowed by the thorns which were not lacking in the Garden of Eden. (f. 9)

12. June

MARGINAL PAINTING. Bible moralisée. Genesis II, 21–22

LEGEND *"Ici endort Adam et trait Eve hors de son costé, couronée de xii estoylles."*

The creation of Eve, whom God draws from the side of the sleeping Adam, is presented here in its logical place. Thus the initial error made by the illuminator in f. 6v (Pl. 8) is corrected. Adam is represented in an almost identical attitude in both paintings, but in this folio the position of his body is reversed.

Neither the sacred text nor the thirteenth-century Latin *Bible moralisée* mentions the twelve stars with which, according to the illustration and its legend, Eve was supposedly crowned at the time of her creation. Here we are undoubtedly dealing with a commentary made by a later biblical commentator. (f. 9v)

13. July

MAIN PAINTING

Two reapers, barefooted and in shirt sleeves, are cutting the wheat and tying it in sheaves. A dog, half-asleep, guards their clothing; nearby we see a flail, a wooden rake, and the cask that will allow them to quench their thirst. On the branches of a tree which provides some shade in the middle of the field, four birds are perched. In the sky, amid the golden rays of an invisible sun, is the zodiacal lion.

Certain details of this painting are found in other manuscripts executed in the same workshop, or at least derived from the same models. For instance, the reaper engaged in cutting the wheat has been imitated, not without a certain clumsiness, in the *Hours of Martin Le Roy* (f. 8). A lion quite close to the one we see here is found in MS. 5140 of the Library of Lyons (f. 8v).

MARGINAL PAINTING. Bible moralisée.

LEGEND *"Ce que Dieu endormy Adam senefie le Pere qui endormy le Filx en la Crois; ce qui trait Eve de son costé senefie saincte Eglise qui ist hors du costé Jhesu Crist courronnee de xii graces et les bons Christiens l'aorent et servent."*

This "moralization" brings together (perhaps somewhat artificially) the creation of Eve, represented on the preceding page (Pl. 12), and the relationship of the Church to Christ. The sleeping Adam prefigures the Son ("the new Adam") expiring on the Cross. Just as Eve came forth from the side of the first man, we are shown here the Church, appearing in the form of a woman crowned, issuing from the wound Christ received in His side. Her crown is made of the "twelve graces", set in parallel with the twelve stars encircling the head of Eve in the preceding image. At the foot of the Cross, the good Christians are shown venerating and serving Christ and His daughter, the Holy Church. (f. 10)

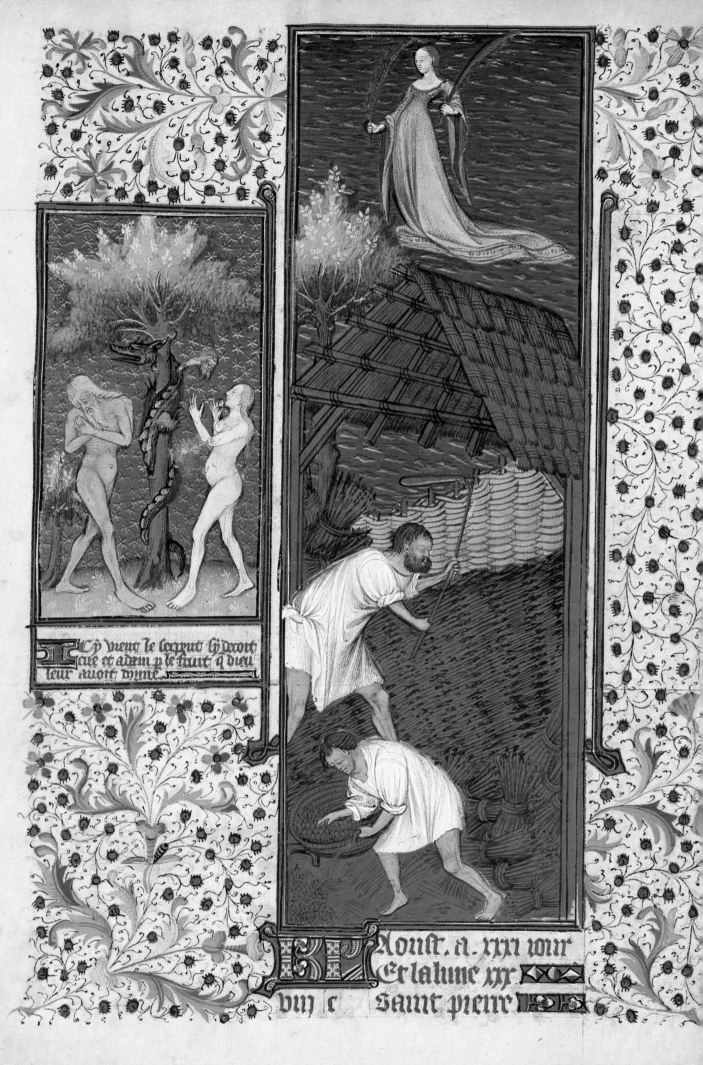

Cy vient le serpent cy drout sue et adam p le fruit q dieu leur auoit dyne.

Aoust. a. xxxi iour
Et la lune xxx
viij c · saint pierre

Pl. 14

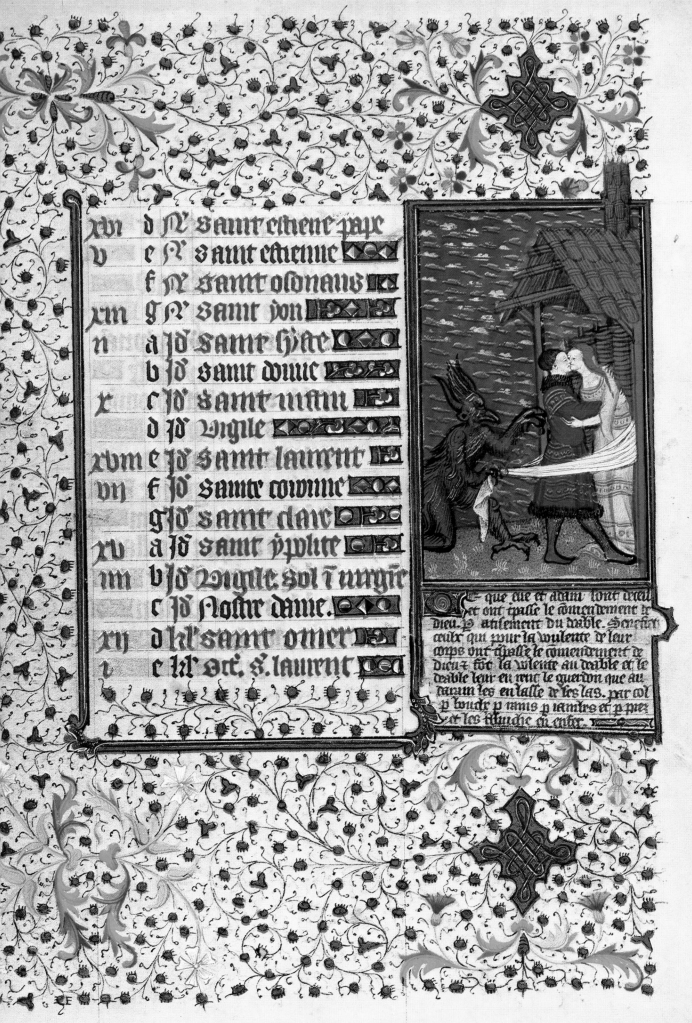

xvi	d	N̄	ſaint eſtene pape	
v	e	N̄	ʒ̃ant eſtenne	
	f	N̄	ʒaint oldnans	
xm	g	N̄	ʒaint don	
n	a	Id	ſamt hiſte	
	b	Id	ſaint douue	
x	c	Id	ſaint uſtin	
	d	Id	vigile	
xvm	e	Id	ſamt laurent	
vn	f	Id	ſamtr coiunne	
	g	Id	ʒ̃amt clare	
xv	a	Id	ʒamt ypolite	
m	b	Id	vigile. ſol t urgie	
	c	Id	Noſtre dame.	
xy	d	kl̄	ʒamt omer	
i	e	kl̄	oct̄. S. laurent	

Et que eue et adam ſont decu
et ont trpaſſe le comendement de
dieu. Ꝑ atilement du dable. Sereteir
ceulx qui pour la voulente de leur
corps ont chaſſe le comendement de
dieuz ꝓ la uilente au dable et le
dable leur en vuit le guerdon que au
darain les enlaſſe de ſes las. par col
ꝑ bouche ꝑ mains ꝑ iambes et ꝑ piez
et les blanche en enter.

Pl. 15

14. *August*

MAIN PAINTING

On the threshing floor of a rustic shed with thatched roof and a side wall made of simple wattle-work, we find two peasants very similar in appearance to those already encountered at other forms of labor. Their costume has been reduced to a shirt of white linen which hangs down to their knees and whose sleeves they have tucked up. One of them beats the grain with a flail; the other fans out the chaff. Sheaves that have been piled up await threshing.

In the sky, a maiden in a long gown, holding a palm branch in each hand like the martyrs of medieval iconography, symbolizes the sign of Virgo. An identical representation is contained in MS. 5140 of the Library of Lyons (f. 9v).

MARGINAL PAINTING. Bible moralisée. Genesis III,1–6

LEGEND *"Icy vient le serpent; sy déçoit Eve et Adam par le fruit que Dieu leur avoit donné."*

In the Garden of Eden, Adam and Eve, placed on either side of the tree of knowledge of good and evil, are about to yield to temptation. Coiled around the tree, the Serpent is represented here in a somewhat unusual guise. He has two heads, and the one he is turning toward Adam (who holds an apple in his hand, contemplating it with a hesitant expression) is that of a horrible dragon. His other head, which stares intently at Eve as she lifts the forbidden fruit to her mouth, has the aspect of a human face. (f. 11v)

15. *August*

MARGINAL PAINTING. Bible moralisée.

LEGEND *"Ce que Eve et Adam sont deceu et ont trespassé le commendement de Dieu par atisement du deable senefie ceulx qui pour la voulenté de leur corps ont trespassé le commendement de Dieu et font la volenté au deable et le deable leur en rent le guerdon que au darain les enlasse de ses las par col, par bouche, par rains, par jambes et par piez et les trasbuche en enfer."*

This "moralization" on the fall of our first parents, represented on the preceding page, likens the original sin to the failings of the flesh. Two lovers entwined in a deep embrace are kissing each other's lips, but their love is illegitimate, and in surrendering to their desire they have violated Divine law and yielded to the Tempter. He himself will punish them by binding them in turn with his bonds, symbolized here by a sheet of bed linen. Upon their death, he will drag them off to Hell. (f. 12)

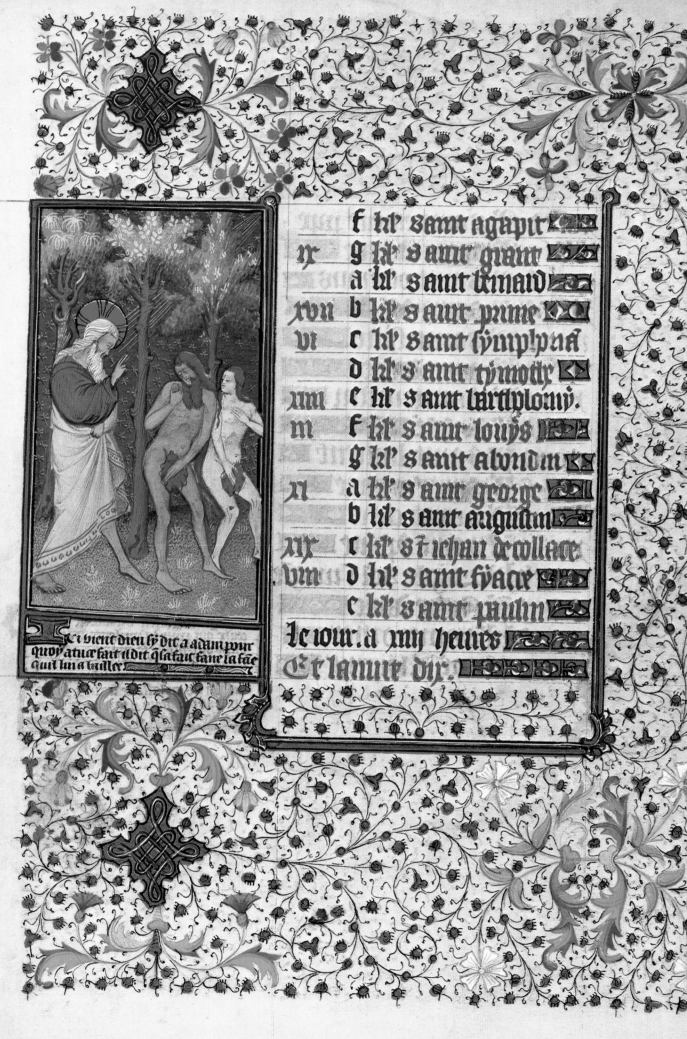

		f	kl̄	samt agapit
ix		g	kl̄	samt gram
		a	kl̄	samt urnaud
xvii		b	kl̄	samt prime
vi		c	kl̄	samt sympl̄pua
		d	kl̄	samt tymotir
xiiii		e	kl̄	samt lartplomy.
iii		f	kl̄	samt louys
		g	kl̄	samt alondm
xi		a	kl̄	samt george
		b	kl̄	samt augustin
xix		c	kl̄	st̄ ichan decollace
viii		d	kl̄	samt hyacr
		e	kl̄	samt paulm

le iour. a xiiii heures

Et lanuit dix.

Et vient dieu ly dit a adam pour
quoy a tu ce fait il dit q̄ la fac̄ faire la fae
quil lm a taille.

Pl. 16

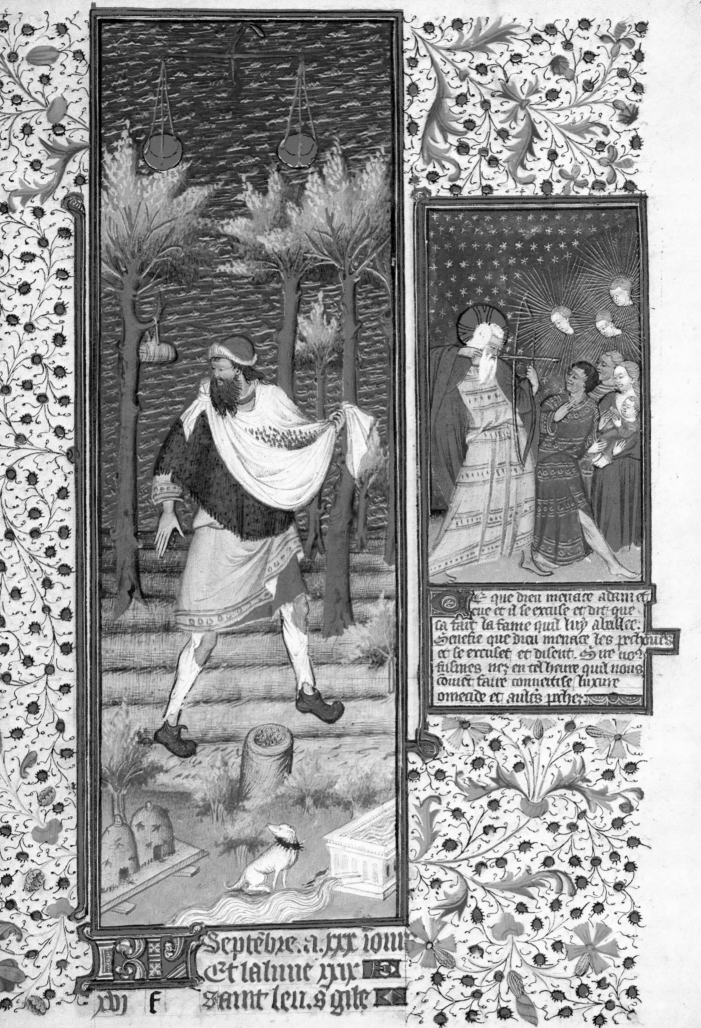

que dieu menace adam et
eue et il se excuse et dit que
ta fait la fame qui luy a baillee.
Senefie que dieu menace les pecheurs
et se excusent et disent. Sire nous
fusmes nez en tel heure qui nous
conuet faire conuoitise luxure
omecide et aultres peches.

Pl. 17

16. *August*

MARGINAL PAINTING. Bible moralisée. Genesis III, 11–12

LEGEND *"Ici vient Dieu, sy dit a Adam: 'Pourquoy a tu ce fait?' Il dit que l'a fait faire la fame qu'il lui a baillee."*

After their sin, the Lord comes to find Adam and Eve who, in confusion, are hiding their sex beneath some broad leaves. The Lord asks Adam, who still has the forbidden fruit in his hand, why he disobeyed His commands. Adam tries to shift the responsibility for his disobedience to Eve, who had given him the fruit. (f. 12v)

17. *September*

MAIN PAINTING

Heavily booted, a bearded peasant dressed in a rather strange fashion, takes seeds from a large sheet (one end of which is knotted around his neck and the other held in his left hand) and scatters them in the furrows which have been recently plowed. He is wearing a sort of embroidered robe and a fringed cape, but his breeches, which are full of holes, allow his bare knees to show through.

In the foreground we see two beehives, a sack of seed, a dog and a stone fountain from which flows an abundant stream of water. The cask which will permit the sower to refresh himself, once the task is completed, has been hung on a tree.

In the sky, a large scale evokes the sign in the zodiac under which the month of September falls.

It is worth noting that in the calendars of the type created by Jean Pucelle, it is the month of October which is illustrated by sowing. In the *Belles Heures* of Jean de Berry, in which a peasant of a type quite similar to this one can be found (f. 11), the month of September is devoted to the wine harvest.

MARGINAL PAINTING. Bible moralisée.

LEGEND *"Ce que Dieu menace Adam et Eve, et il se excuse et dit que l'a fait la fame qu'il luy a baillée senefie que Dieu menace les pechours et se excusent et disent: 'Sire, nous fumes nez en tel heure qu'il nous convient faire conveitise, luxure, omecide et aultres pechez.'"*

God threatens sinners, who have broken His law, with the bow of His vengeance. They, like Adam, who prefigures them (Pl. 16), seek an excuse and claim that the fact of having been born under such or such a star (the latter are represented here by human heads) predestines them inevitably to a certain type of sin. This "moralization," already encountered in the Latin *Bible moralisée* of the thirteenth century, thus amounts to a condemnation of astrology, whose arguments contradict the notion of responsibility and free will. (f. 13)

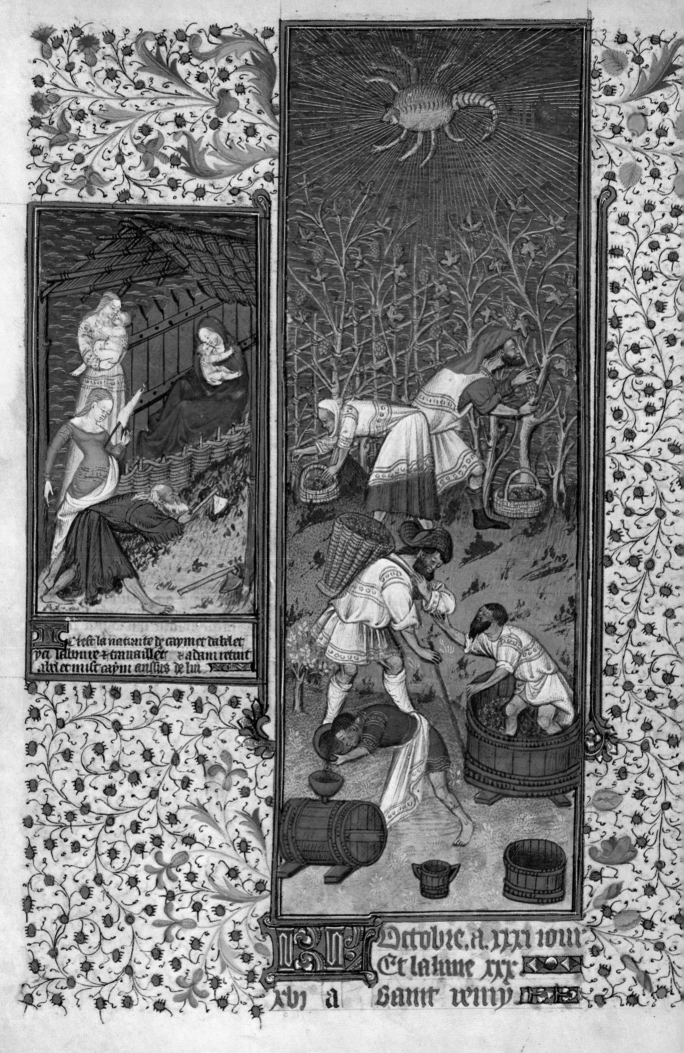

Pl. 18

vitp	b	A̅	saint legier	
xix	c	A̅	saint victor	
viii	d	A̅	saint francoiz	
	e	A̅	sainte cristine	
x	f	A̅	sainte foy	
	g	jo	saint mart	
xviii	a	jo	saint demettr	
vii	b	jo	saint denis	
	c	jo	saint geiron	
xv	d	jo	saint macaire	
iiii	e	jo	saint regnault	
	f	jo	saint aurien	
xii	g	jo	Sol in scorpione	
	a	jo	saint oian	
	b	jo	saint gabriel	
ix	c	jo	saint certon	

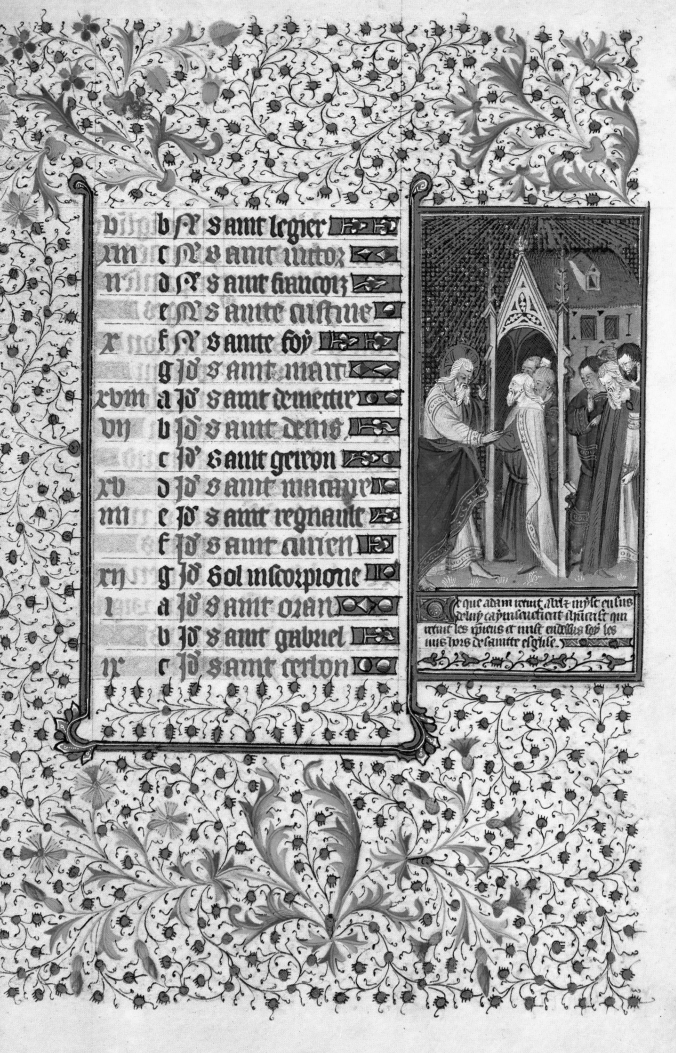

Et que adam receut abiez myste en sus
celuy capul sacrifient Anienist qui
receut les epicus et mist encelles sop les
inis lors desainttc esglise.

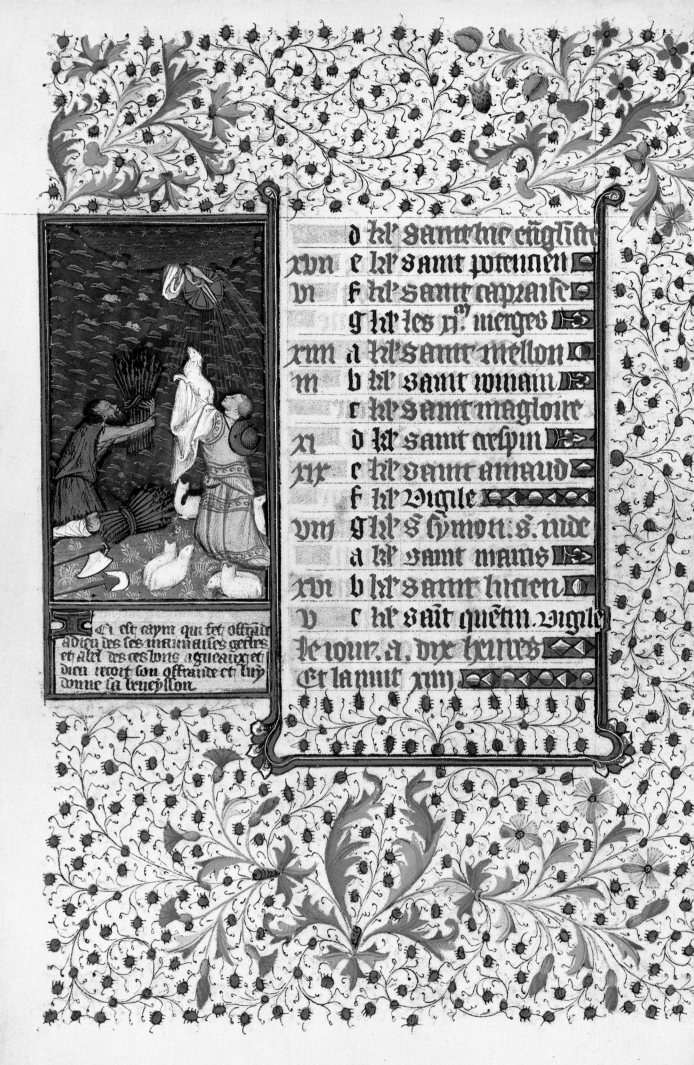

d kl̈ saint̃ hie euglidt̃

xvin e kl̈ saint potennen

vi f kl̈ saint caprais

g kl̈ les xi. verges

xiiii a kl̈ saint mellon

iii b kl̈ saint roman

c kl̈ saint magloire

xi d kl̈ saint crspm

xix e kl̈ saint amaud

f kl̈ vigile

vin g kl̈ s̃ hymon. s̃. iude

a kl̈ saint mams

xvi b kl̈ saint hilen

v c kl̈ sait questin. vigile

le iour. a. dix heures

Et la nuit xiiii

Ci est cppm que fet offrãde
a dieu des ses maurailses gestres
et aliel des ces bons agueaux et
dieu recoit son offrande et luy
donne la beneysson.

Pl. 20

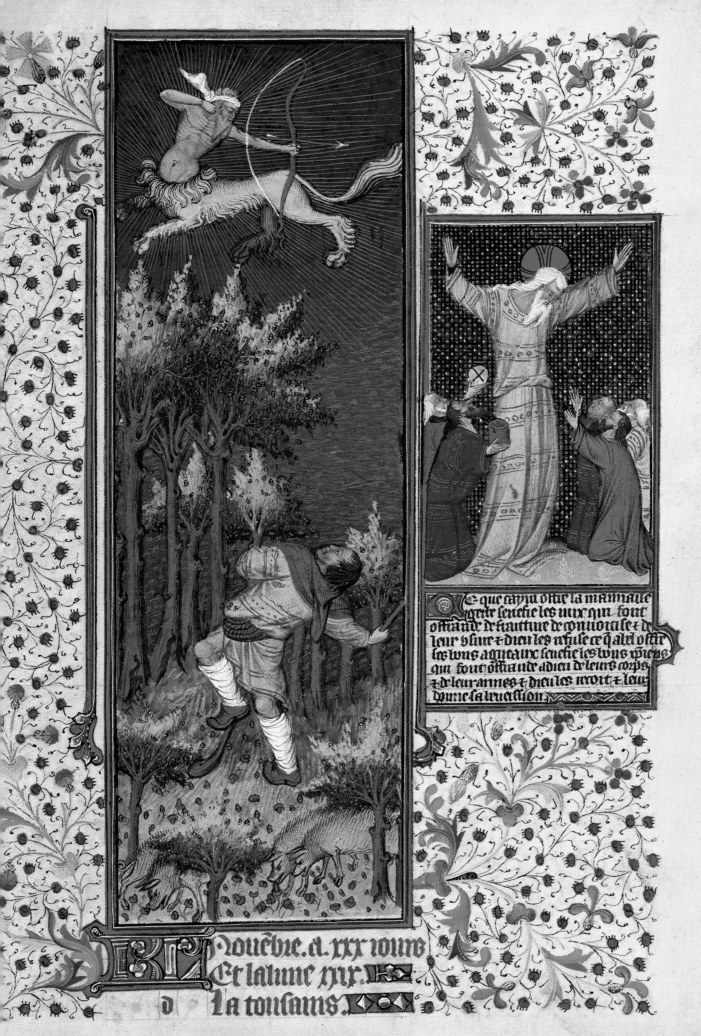

Que crapu offre la matynaie
grite feruefie les bins qui sont
offrande de siantture de conuoralse z de
leur bsuir z dieu les rsuse ce q̃ abel offre
les bins agnicaux seruefie les bins piens
qui sont offratide a dieu de leurs corps
z de leur armes z dicu les recoit z leur
donne sa benedistion

Nouebie. a. xxx iours
Et la lune xxx.
d · La tousains.

Pl. 21

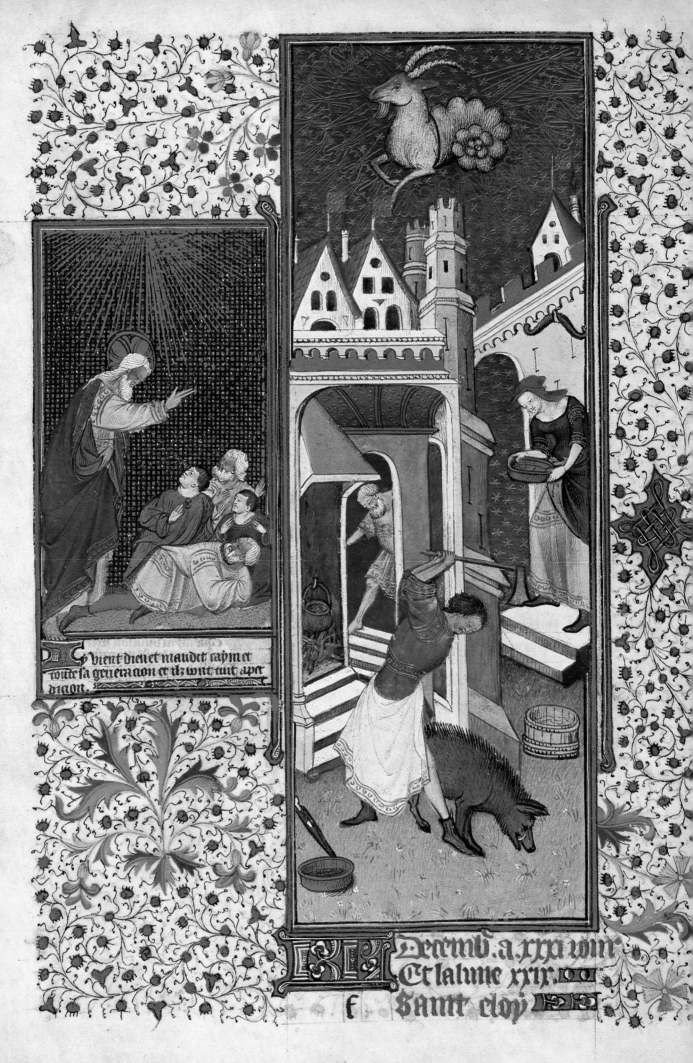

Qui vient dient maudit saijn et
toute sa generacion ce ilz wnt tuit aper
diaon.

Decemb. a. rrja wiir
Et la lune rrir.
f Saint eloy

Pl. 22

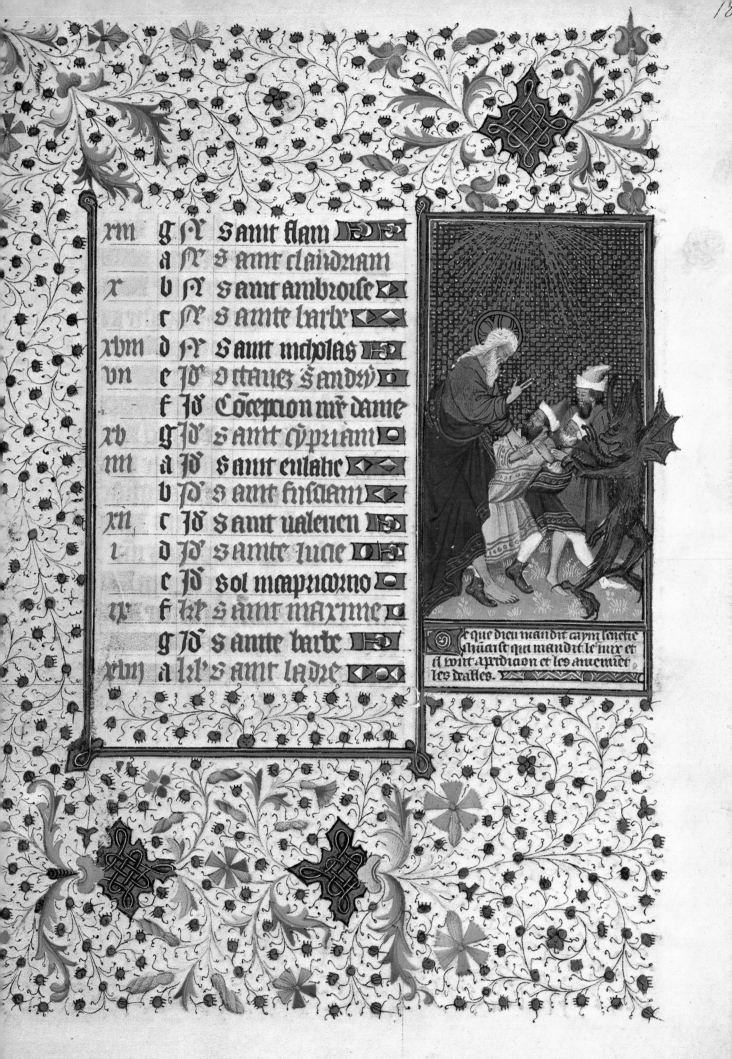

xviii	g	xx	saint flam	
	a	xx	s aint claudiam	
x	b	xx	s aint ambroise	
	c	xx	s aincte barbe	
xvi	d	xx	saint nicholas	
vii	e	id	Octauez s andru	
	f	id	Concepcion nre dame	
xv	g	id	s aint cyprian	
iiii	a	id	s aint eulalie	
	b	id	s aint fuldam	
xii	c	id	s aint ualerien	
i	d	id	s ainte lucie	
	e	id	sol in capricorno	
ix	f	kl	s aint maxime	
	g	id	s ainte barbe	
xviii	a	kl	s aint ladre	

le que dieu mandit cayn le nette
ghuarist qui mandit le nyx et
el sont apridiaon et les auenues
les dattes.

Pl. 23

18. *October*

MAIN PAINTING

Undoubtedly as the result of an error, it is in the month of October (rather than, as is customary, in the month of September) that this wine-harvesting scene has been placed. In the background, a peasant man and woman [?]—whose almost identical replicas can be found in the *Hours of Martin Le Roy* (f. 11)—are cutting bunches of grapes and piling them in baskets. In the foreground, another peasant, his back weighed down with a heavy wicker basket, prepares to empty it into the vat where the grapes will be pressed under the feet of another peasant, who is barelegged, his shirt tucked up to his thighs. In front of them, another vineyard worker is filling a barrel with grape juice, with the aid of a sieve and a funnel. Two other receptacles of varying size complete the decor.

In the sky is the representation of the animal who has given its name to the sign of Scorpio.

MARGINAL PAINTING. Bible moralisée. Genesis IV, 1–2.

LEGEND *"Ici est la nativité de Caym et d'Abel et yci laboure et travaillent et Adam retint Abel et mist Caym anssus de lui."*

Two episodes from the biblical narrative are regrouped here in a single image. In the foreground, Adam and Eve, driven out of the Garden of Eden, must now work hard to earn their living. Adam tills the soil and cuts down trees; Eve spins with the distaff. In the background, in the traditional decor of a rustic Nativity scene, Eve (who is seated and represented in the traditional garb of the Virgin Mary) holds her newborn child closely in her arms. To the side, but clad differently, it is again Eve whom we see, standing, with her other son in her arms.

The preference which Adam is supposed to have shown for his second son Abel, to the disadvantage of Cain, the elder son (according to the legend for this image) is not mentioned in the Bible, but the *Bible moralisée* of the thirteenth century alludes to it. (f. 14v)

19. *October*

MARGINAL PAINTING. Bible moralisée.

LEGEND *"Ce que Adam retint Abel et myst en sus de luy Caym senefient Jhesu-Crist qui retint les Christiens et mist en dessus soy les Juis hors de saincte Esglise."*

This "moralization" on the text of Genesis illustrated in f. 14v shows God receiving the Christians into His Church (represented here by an edifice resembling at one and the same time a chapel and a dwelling). They are led by an old man whose hands God takes in His own. To the right are those who are excluded—that is to say, the Jews—whose attitude expresses chagrin. The Latin *Bible moralisée* indicates more explicitly that the Jews were rejected because of their disbelief. (f. 15)

20. *October*

MARGINAL PAINTING. Bible moralisée. Genesis IV, 3–5

LEGEND *"Ici est Caym qui fet offrande a Dieu de ses mauvaises gerbes et Abel de ces bons agneaux et Dieu reçoit son offrande et luy donne sa beneysson."*

Cain, on the left, and Abel, on the right, offer God the fruits of their labors. Cain is represented as bearded, with somewhat brutal features. He is a farmer, as is shown by the spade and hoe lying near him on the ground, and it is a sheaf of grain which he offers to the Lord. Abel, on the other hand, is a shepherd. Surrounded by his flock, he wears a large shepherd's hat thrown back on his shoulders. He lifts a lamb toward the sky, his hands covered with a veil in keeping with an ancient ritual tradition largely echoed by medieval iconography. In the heavens, the hand of the Lord emerges from a cloud and turns toward Abel in a gesture of benediction.

It is worth noting that, undoubtedly to justify the Lord's choice, which might appear somewhat unfair, the legend deemed it proper to specify that the sheaves which Cain offered were "bad." The Bible says no such thing, but the thirteenth-century Latin *Bible moralisée* mentions the "bad fruits" offered by Cain. (f. 15v)

21. *November*

MAIN PAINTING

November, in the traditional iconographic cycle of labors for each month, is devoted to the acorn harvest in order to provide food for the hogs. Here the swineherd, in a gesture captured remarkably well, prepares to toss up the stick he holds in his right hand. Even down to the details of his clothing, this figure reproduces a model introduced by the Limbourgs into the calendar they painted for the beginning of the *Belles Heures* (f. 12). The figure of Sagittarius wears a Moorish-type turban, inspired by a model of Jean Pucelle, imitated by the painters of Jean de Berry and found in MS. 5140 of the Library of Lyons (f. 12), as well as—with a few variations—in the *Très Riches Heures* (f. 11v).

MARGINAL PAINTING. Bible moralisée.

LEGEND *"Ce que Caym offre la mauvaise gerbe senefie les Juix qui font offrande de fraitture, de convoitise de de leur usure et Dieu les refuse. Ce que Abel offre ses bons agneaux senefie les bons Christiens qui font offrande a Dieu de leurs corps et de leurs armes et Dieu les reçoit et leur donne sa beneisson."*

Cain's offering, rejected by God, is likened to the gifts of the Jews which—resulting from their confiscations, their thefts, and their usury—cannot please the Lord. Good Christians, for their part, do not offer ill-gotten riches but rather their bodies and their souls, and these God accepts. The Lord, in the center, turns away from the Jews, represented on His right, their hands full of gifts, in order to bless the Christians who, on His left, raise their empty hands toward Him in a gesture of supplication.

(f. 16)

22. *December*

MAIN PAINTING

In the country, the month of December is characterized by the slaughtering of hogs, whose meat (salted or smoked) will constitute a reserve of food for the whole year. In the foreground, a young man wearing a large apron tied behind his back, an axe lifted high above his head, obviously prepares to stun the hog and not to decapitate it, or split its skull. The same observation may be made in relation to the scene painted by the Limbourgs for the calendar of the *Belles Heures* (f. 13) which, whether directly or indirectly, doubtless served as the model for this rendition. In the background (in a house upon whose roof pennants bearing the "macles" of the House of Rohan have subsequently been repainted), a man comes to watch the boiler in which water is being heated to boil the meat after the hog has been slaughtered. A woman brings a basin in which to catch the blood of the animal. In the sky, Capricorn, with the aspect of a he-goat, is seen half-emerging from a gigantic shell. MS. 5140 of the Library of Lyons (f. 13v) contains an almost identical representation of this sign.

MARGINAL PAINTING. Bible moralisée. Genesis IV, 9–15

LEGEND *"Icy vient Dieu et maudit Caym et toute sa génération et ils vont tuit à perdicion."*

After the murder of Abel, Cain and his posterity are cursed by God: they will all go to their doom. Neither the Bible nor the Latin *Bible moralisée* expressly extends the divine curse to include Cain's posterity, but this idea, nevertheless, can logically be deduced from the fate of his descendants, as compared with those of his younger brother, Seth.

(f. 17v)

23. *December*

MARGINAL PAINTING. Bible moralisée.

LEGEND *"Ce que Dieu maudit Caym senefie Jhesu Crist qui maudit les Juix et il vont a perdicion et les amennent les deables."*

This moralization on the biblical text illustrated by the preceding painting likens the curse placed on Cain to that which will later be laid on the Jews for having refused to recognize the mission of Christ and for having put Him to death. The *Bible moralisée*, composed at the time of Saint Louis, betrays in many passages a pronounced anti-Semitism. Here we see three Jews, coiffed in pointed caps, being dragged off to Hell by a demon with horns on his head, the taloned feet of a bird of prey, and the wings of a bat. The hand of the Lord rests on the shoulder of one of the Jews, in a gesture which expresses not compassion but condemnation.

(f. 18)

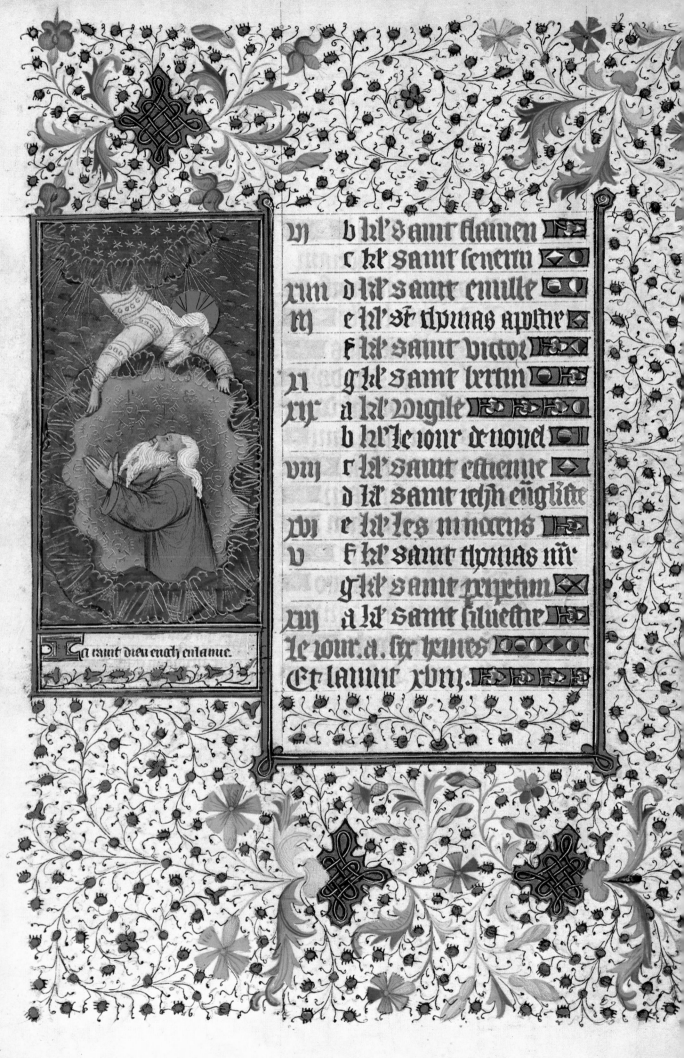

Ta saint dieu enach enlamue.

Pl. 24

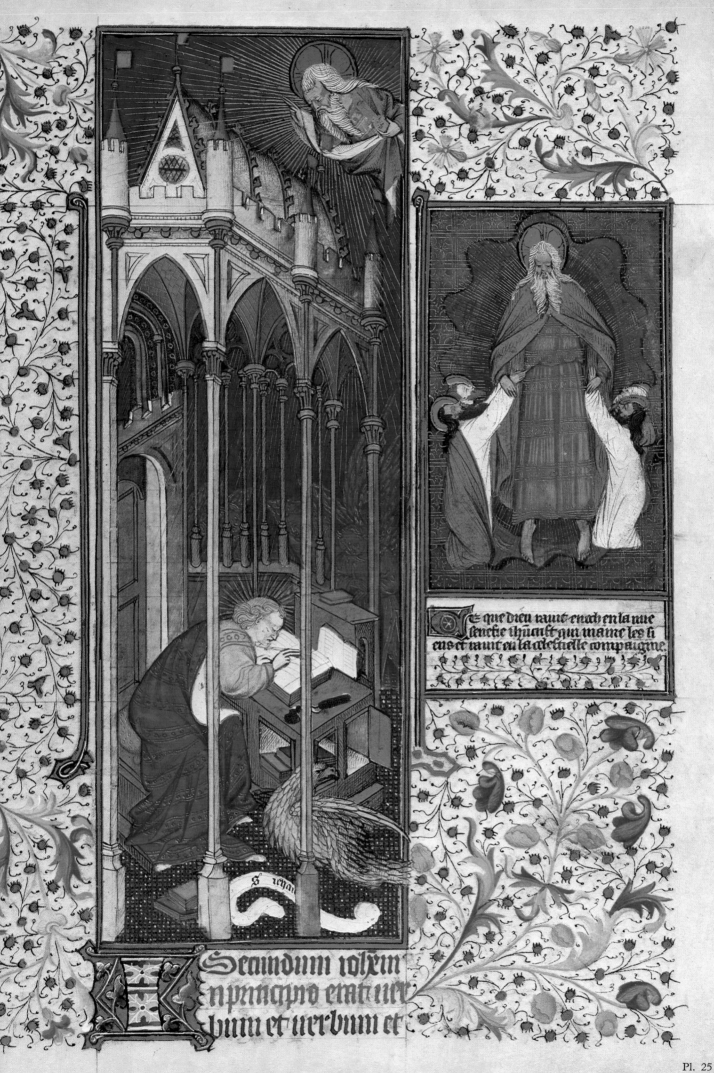

Ces que dieu raut enoch en la nue
Genese ihuist qui marie les si
eus et raut en la celestielle compaigne.

S. Jehan

Secundum iohem
In principio erat uer
bum et uerbum et

Pl. 25

24. *December*

MARGINAL PAINTING. Bible moralisée. Genesis V, 24.
LEGEND *"Ici ravit Dieu Enoch en la nue."*

God, half emerging from the firmament, envelops Enoch, Methuselah's father, in a cloud and draws him to Himself, making Enoch disappear forever from the eyes of men. (f. 18v)

25. *Fragments from the Gospels.*
The Gospel according to St. John, I.

MAIN PAINTING

In a chapel which is open on three sides and whose vaults are supported by slender colonnettes, Saint John, bending over a writing desk, copies the text of his gospel. He is observed by three angels, resting on their elbows on the low wall forming the stylobate which supports the interior columns of the building. At his feet is an eagle, which is the traditional symbol of Saint John. At the foot of the image, a phylactery specifies his identity: *"S. Jehan."* God the Father blesses him from on high. Floating above the towers of the chapel are the pennants bearing the arms of Rohan, which were added later to the original painting.

MARGINAL PAINTING. Bible moralisée.

LEGEND *"Ce que Dieu ravit Enoch en la nue senefie Jhesu Crist qui maine les siens et ravit en la célestielle compaignie."*

In the center of the image, God appears in a mandorla, drawing up to Heaven in His hand the elect, who have been given halos and who have been prefigured by Enoch in the preceding image (Pl. 24). His white beard seems to indicate, however (in contradiction to the text), that the artist wanted to represent God the Father here, and not God the Son. (f. 19)

Pl. 26

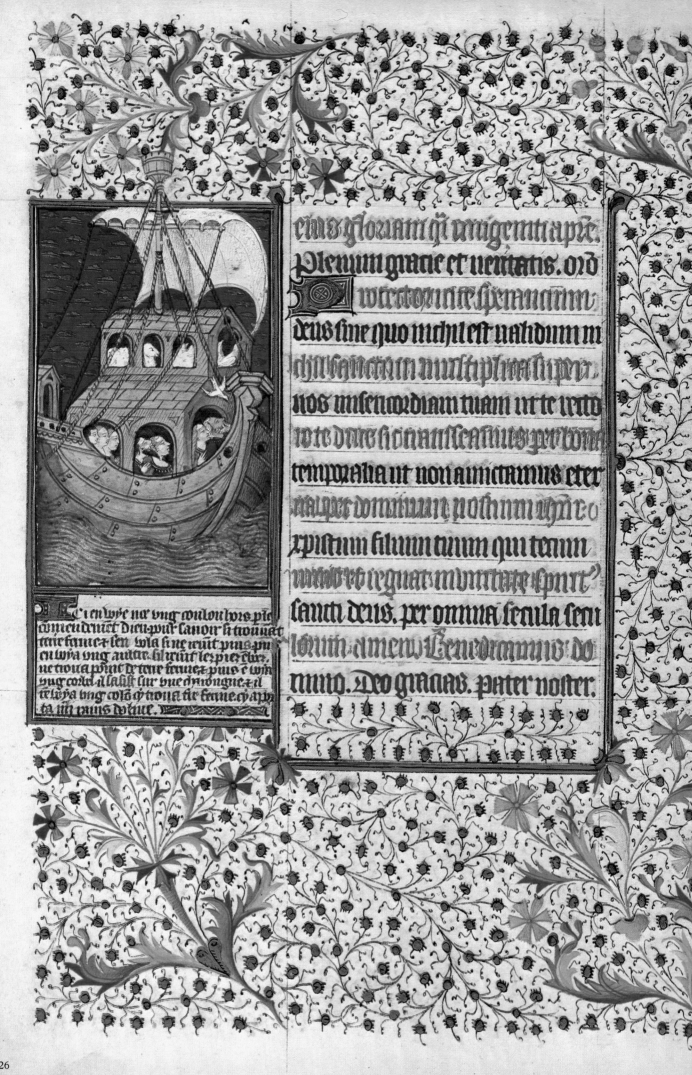

eius gloriam qui unigeniti a patre.
Plenum gratie et ueritatis. Ord
uisitatoni ite speraimatum
deus sine quo nichil est ualidum ni
chil sanctum in multipliratu supra
nos misericordiam tuam ut te rectto
re te ducre si oi transcatibus pur bona
temporalia ut non amictamus eter
nal per dominum nostrum ihm xro
xpistum filium tuum qui tecum
uiuit et regnat in unitate spirit
sancti deus. per omnia secula seu
lorum. amen. Benedicamus do
mino. Deo gratias. Pater noster.

Cy en wye us ung coulon lois ple
commendmet dieu pur lanoir fi trouuat
terre fermes sen wla fine ruit pius pui
en wya ung autre. il ruit les pies chr
ne trouia puint te terre ferme puis e twi
ung coral il lasist sur une chronque il
tere wya ung colo q trouia tie ferme ch api
ta III pains dolue.

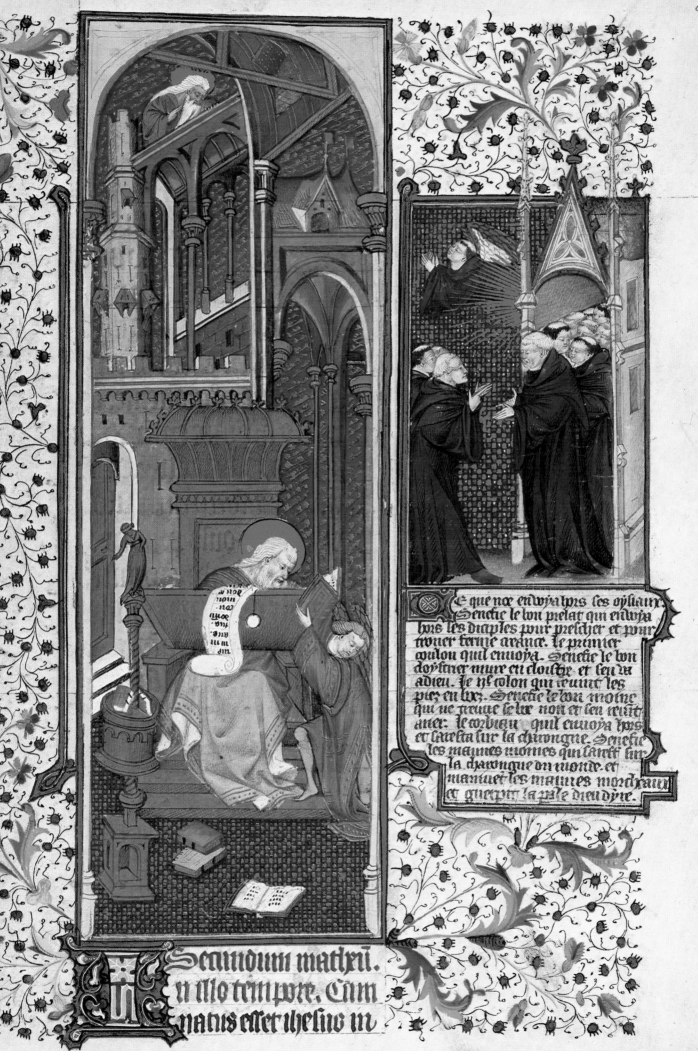

E que nor enwja tps les opfauix.
Senefie le bon prelat qui enwja
hors les diaples pour prescher et pour
trouer terme arance. le premier
colon qui enuoya. Senefie le bon
doystiner muir en clouche et seu ca
adieu. le iije colon qui reuint les
piez en luc. Senefie le bon moine
qui ne proure se luc non et sen reuiit
auer. le corbiau quil enuoya tps
et sareta sur la charongne. Senefie
les maluis moines qui sareff sur
la charongne du monde. et
manuiet les maluis mordraui
et guerpit la pale dieu dire.

Scaindum matheu.
n illo tempore. Cam
natis esset ihesus in

Pl. 27

26. *Fragments from the Gospels.*
Prayer.

MARGINAL PAINTING. Bible moralisée. Genesis VIII, 6–12

LEGEND *"Ici envoye Noé ung coulon hors par le commendement Dieu, pour savoir si trouvat terre ferme, et s'envola, si ne revint. Puis puis [sic] envoya ung aultre; s'il revint les piez emboez, ne trova point de terre ferme. Et puis envoya ung corbel. Il s'asist sur une charongne et il renvoya ung ung colom; cy trova terre ferme, cy aporta un rains d'olive."*

In the ark. Noah and his family anxiously watch the pigeon which is to apprise them of whether they will find dry land anywhere. The animals, among which we recognize a sheep, are lodged in the upper part of the vessel. In the lower right corner of the image, we can distinguish the raven who alighted on the carrion of a drowned animal, floating in the waters.

The legend here takes certain liberties with the biblical text: according to the latter account, Noah first sent out a raven as an emissary, then a dove, which returned to the ark, having found no ground on which to alight; then another dove, that did not return. The biblical text makes no mention of the "carrion" on which the raven alighted, but this detail appears very frequently in medieval iconography, notably in the Psalter of Saint Louis. Here, the legend states that first Noah sent out a dove which did not come back, then another one that came back with mud on his feet (proof that he could find no dry land), then a raven which dwelt on carrion, and finally a third dove that returned with a branch plucked from an olive tree. (f. 20v)

27. *Fragments from the Gospels*

The Gospel according to St. Matthew, II.

MAIN PAINTING

In a majestic hall, within a building from the heights of whose complicated architecture God the Father observes St. Matthew, the latter is copying onto a scroll the text he deciphers from a book which an angel (his traditional symbol) presents to him. In the foreground, a "book wheel" is surmounted by a blindfolded statuette, evoking the Synagogue, or the ancient law.

In his composition, and especially in the posture of St. Matthew—front face, half-concealed by the tilted board of his desk, where a weight suspended from a cord serves to keep the scroll in place—the artist was obviously inspired by the page of the *Belles Heures* of Jean de Berry (f. 94) wherein the Limbourg Brothers represented Diocrès teaching. An echo of it may also be found in MS. 5140 of the Library of Lyons (f. 18).

MARGINAL PAINTING. Bible moralisée.

LEGEND *"Ce que Noé envoya hors ses oysiaux senefie le bon prelat qui envoya hors le diciples pour prescher et pour trover ferme créance. Le premier coulon qu'il envoya senefie le le bon cloystrier muré en cloistre et s'en va à Dieu. Le deuxième colon qui revint les piés enboez senefie le bon moine qui ne treuve se boe non et s'en revint arier. Le corbiau qu'il envoya hors et s'aresta sur la charongne senefie les mauvés moines qui s'arestent sur la charongne du monde et manjuent les mauvés morcheaux et guerpit la parole Dieu dyre."*

The image devoted to the "moralization" on the episode from the story of Noah illustrated on the preceding folio (Pl. 26), shows a group of monks, some in the interior of a chapel, the others outside. Noah, dispatching his birds on a mission, prefigures "the good prelate" sending his disciples abroad to preach in order to discover a solid faith (the "firm land" hoped for by Noah). The good monk with the wings of an angel whom we see hovering in the upper part of the picture, is going straight to God and, like the first dove, will return no more. The second, who came back to the ark with mud on his feet, represents the good monk who, after having discovered life in the secular world, finds only filth there and returns to his brethren, determined (like the monk depicted in the left foreground) never to leave them. The raven symbolizes the wicked monks who, tempted by "the carrion of the world," abandon the service of the Lord forever. (f. 21)

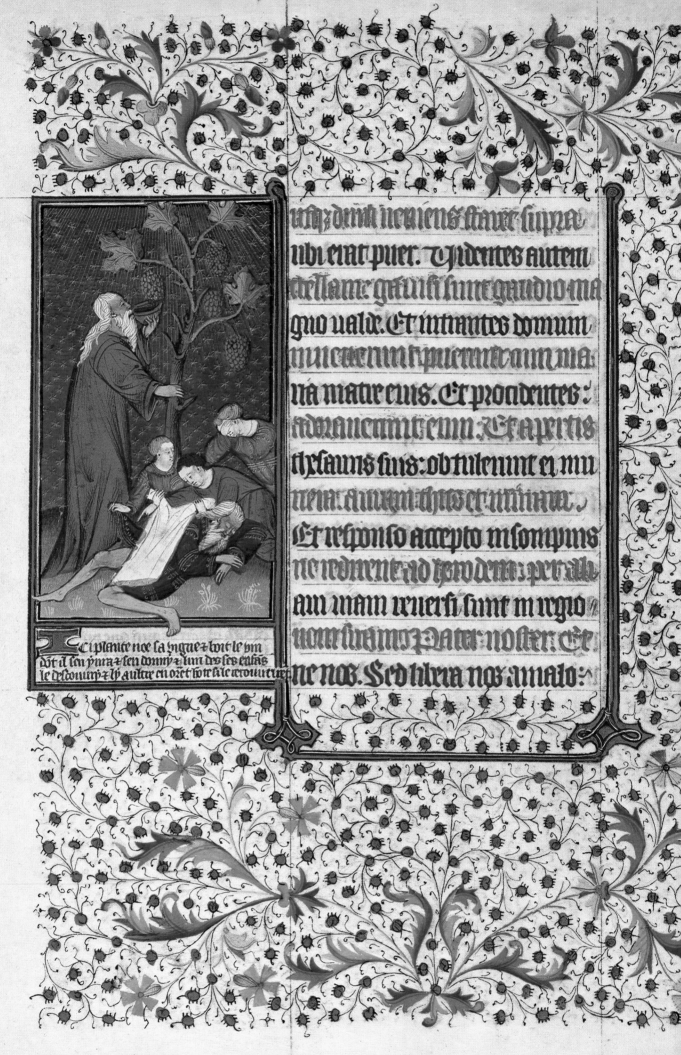

tur; donec veniens staret supra
ubi erat puer. Videntes autem
stellam: gavisi sunt gaudio ma
gno valde. Et intrantes domum
invenerunt puerum cum Ma
ria matre eius. Et procidentes:
adoraverunt eum. Et apertis
thesauris suis: obtulerunt ei mu
nera. aurum thus et mirram.
Et responso accepto in sompnis
ne redirent ad herodem: per ali
am viam reversi sunt in regio
nem suam. Pater noster. Et
ne nos. Sed libera nos a malo:

Pl. 28

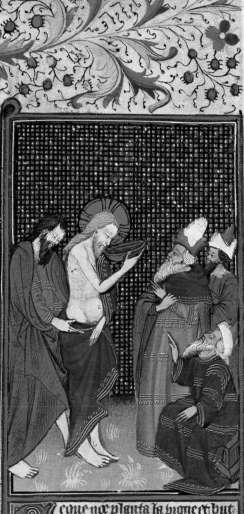

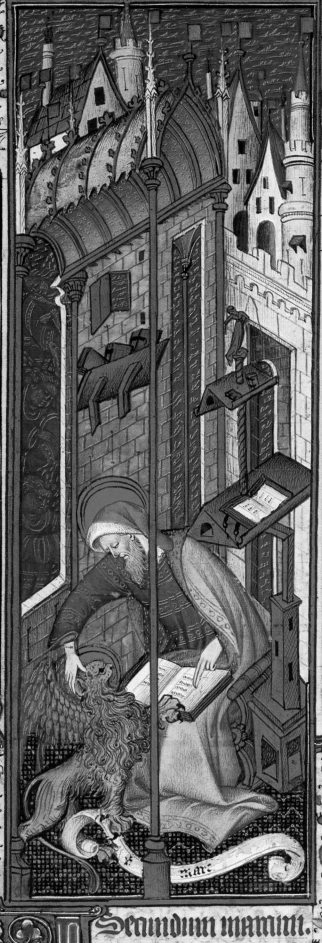

eque noe planta la vigne et but
du vin que lun mesmes planta.
seneue iehueust qui planta les uix et but de
mesmes le cep en la passion æque ly vings de
sires destourny noe æ ly aultis le couurp se
neue les uix q descouuriet la hute æharse
æ ly xpien la trouua meut.

Pl. 29

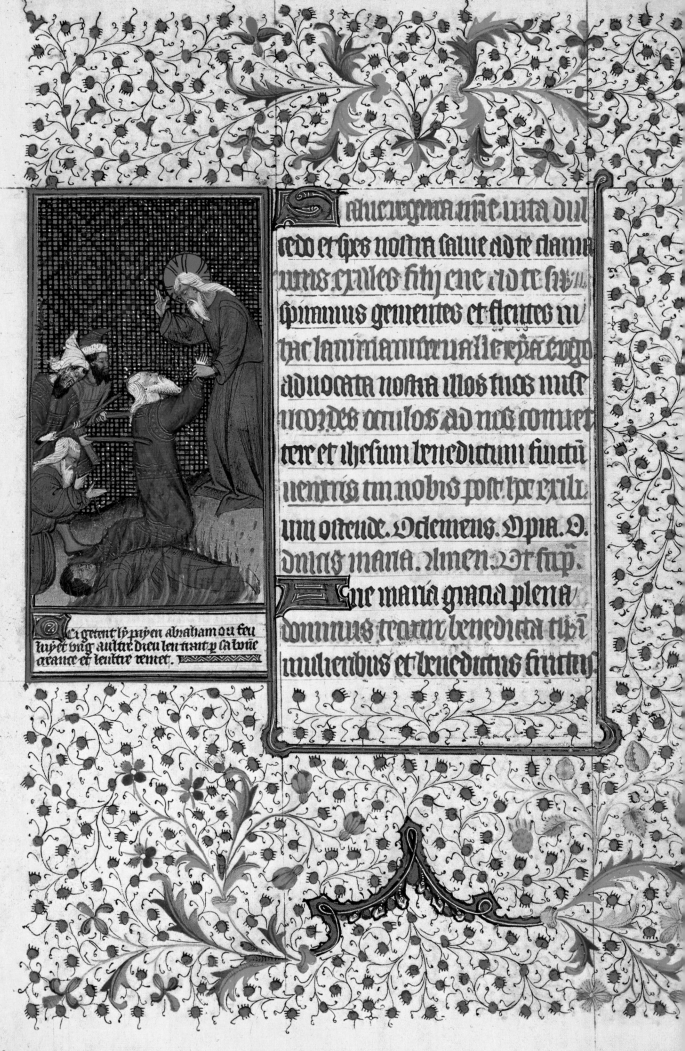

Salue regina mie vita dul
cedo et spes nostra salue ad te clama
mus exiles filij eue ad te su[s]
spiramus gementes et flentes in
hac lacrimarum valle eya ergo
advocata nostra illos tuos mise
ricordes oculos ad nos conuer
tere et ihesum benedictum fructum
uentris tui nobis post hoc exili
um ostende. O clemens. O pia. O
dulcis maria. amen. Et sup.

Aue maria gracia plena
dominus tecum benedicta tu in
mulieribus et benedictus fructus

Et pretent le pupen abraham qu feu
luy et ung aultre dieu len tirent p sa bone
craume et leultre remet.

Pl. 30

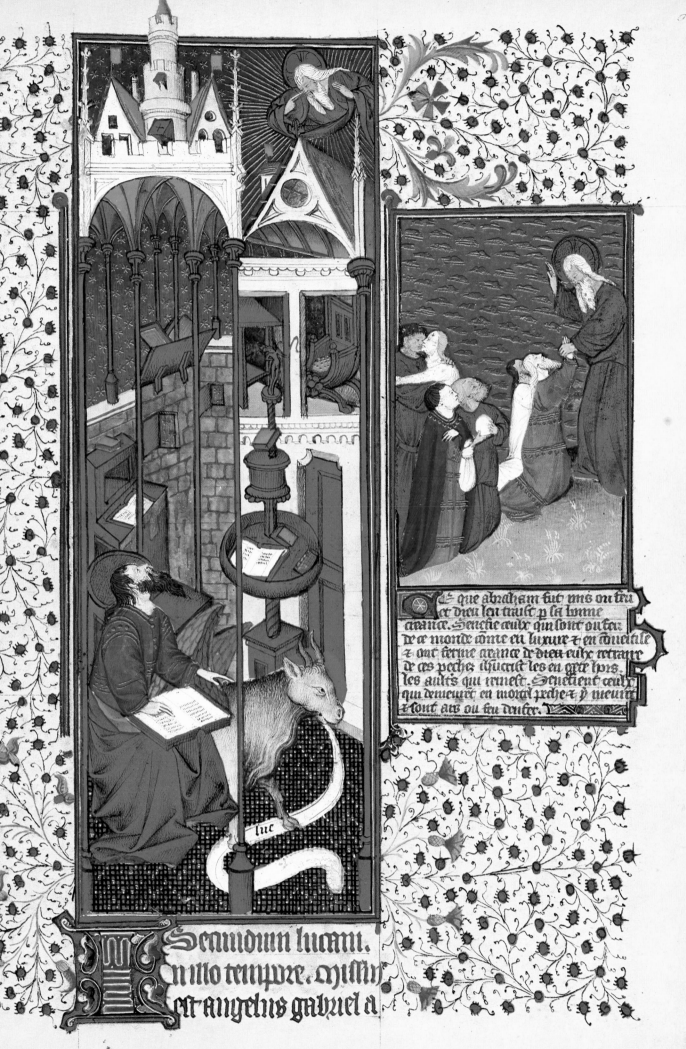

...que abraham tut vns ou tru
et dieu len trult p̄ sa bonne
creance. Senefie ceulx qui sont ou bon
de ce monde cõme eu luxure ⁊ en couoitise
⁊ ont ferme creance de dieu eulx retrayre
de ces peches ihūcrist les eu gēt hors
les auls qui iruuest. Senefient ceulx
qui demeurent en moral peche ⁊ y meurẽt
sont ars ou feu denfer.

Secundum lucam.
En illo tempore. Mistit
est angelus gabriel a

Pl. 31

concepit filium in senectute su
a. Et hic mensis est sextus illi que uo
catur sterilis: quia non erit impossibile
apud deum omne verbum. Dixit autem ma
Ecce ancilla domini: fiat mi
chi secundum verbum tuum.

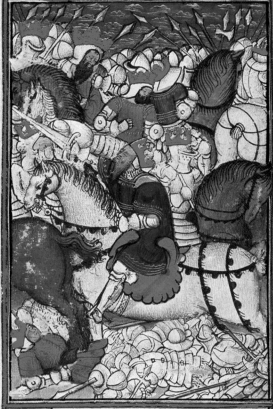

Cy desconfit. v. roys. iij. roys et
en manect. loth. lois vient abraha. Sy
d lcofut les v. roys et relquellit loth fou
tere.

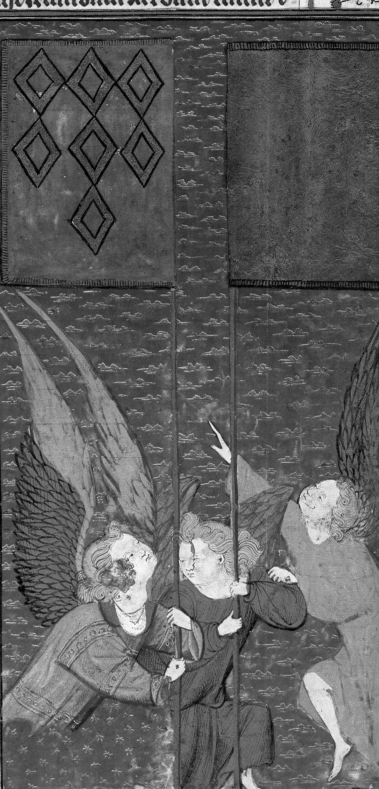

Pl. 32

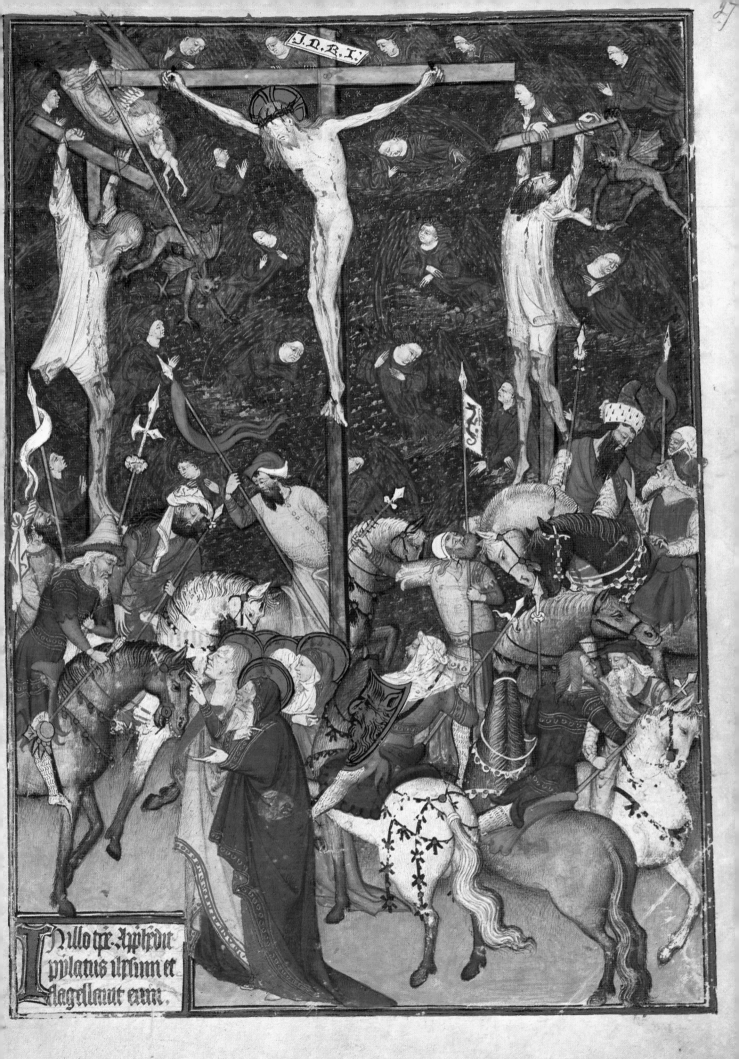

J . N . R . I .

In illo tpe. Apphedit
pylatus ihfum et
flagellauit eum.

Pl. 33

28. *Fragments from the Gospels—*
The Gospel according to St. Matthew, II.

MARGINAL PAINTING. Bible moralisée. Genesis IX, 20–23.

LEGEND *"Ici plante Noé sa vigne et boit le vin dont il s'enyvra et s'endormy et l'un de ses enfans le descouvry et ly aultre en orent honte si le recouvrirent."*

Two successive episodes in the story of Noah are combined here in a single image. After having planted a vineyard (which the painter has represented as immense and laden with enormous grapes) we see Noah, on the left side of the painting, standing and drinking the wine he has extracted from the grapes. Below, to the right, he has fallen into the heavy slumber of drunkenness. Ham, one of his sons, according to the legend, had then uncovered him, while another son, ashamed to see his father in this condition, had modestly covered him up again with a cloak. In point of fact the biblical account is slightly different: Ham, seeing his father naked, goes to tell his brothers Shem and Japheth. The latter walk backward toward Noah and cover him with a cloak while turning away their heads "in order not to see in him anything that modesty forbade them to see." This respectful attitude is evoked, however, by the artist, who has shown one of Noah's sons on the right, hiding his eyes with his hand. (f. 22v)

29. *Fragments from the Gospels—*
The Gospel according to St. Mark, XVI, 14.

MAIN PAINTING

Seated on a stool in a kind of chapel whose vault resembles the hull of a ship, and upon whose wall a bookshelf has been fastened, St. Mark, with his left hand on a large volume, follows the text of his gospel, while his other hand caresses the head of the winged lion—his symbol—whose paw rests on the book. To his left is a swivel desk of adjustable height, surmounted by a statue of a woman who is blindfolded, evoking the Synagogue. In the background, on the pennants adorning the architectural decor, the arms of the Rohan were painted at a later date.

MARGINAL PAINTING. Bible moralisée.

LEGEND *"Ce que Noé planta la vigne et but du vin que lui mesmes planta senefie Jhesu Crist qui planta les Jux et but de mesmes le cep* (corr. *la coupe?*) *en la passion. Ce que ly ungs des feres descouvry Noé et ly aultres le couvry senefie les Juix qui descouvrirent la bonté Jhesu Crist et ly Christien la recouvrirent."*

In the center, Christ, for whom Noah is a traditional "personification," drinks the cup of the Passion. He had "planted" the Jewish people in the Promised Land, as Noah had planted the vineyard, but from this people (represented by three men whose long robes and tall caps indicate their adherence to the Jewish religion) He has reaped only insults and derision. The Jews have lost the benefits of His goodness—this is the meaning of the word "uncovered" in the legend. On the contrary, the Christians (represented by the personage on the left) "recovered" it, that is to say, they regained its fruits. (f. 23)

30. *Prayer to the Virgin*
"Salve regina..."

MARGINAL PAINTING. Bible moralisée. Genesis XI, 28.

LEGEND *"Cci* [sic] *getent ly payen Abraham ou feu, luy et ung aultre. Dieu l'en trait par sa bonne creance et l'eultre remet."*

The episode of Abraham's being thrown by the idolatrous Chaldeans into the fire which he had refused to worship, and being saved by God while Aran, his companion, perished in the flames because he lacked faith, is not found in the Bible. St. Jerome, however, mentions this Hebraic tradition in one of his treatises. A passage from Petrus Comestor, whose *Histoire Scholastique* served as a source for numerous commentaries on the Bible and was widely drawn upon by the authors of the *Bible moralisée* (*Historia scholastica*; Book of Genesis, Chapter XLI), probably constitutes the text upon which the illustration is based. (f. 24v)

31. *Fragments from the Gospels.*
The Gospel according to St. Luke, I, 26.

MAIN PAINTING

In a great hall, on the ground floor of a two-story building sits St. Luke. On his knees, the saint holds a large book, while his left hand rests on the back of a winged bullock (his symbol). From the bullock's mouth issues a phylactery bearing the evangelist's name in French: "S. Luc."

MARGINAL PAINTING. Bible moralisée.

LEGEND *"Ce que Abraham fut mis ou feu et Dieu l'en traist par sa bonne creance senefie ceulx qui sont ou feu de ce monde comme en luxure et en conveitise et ont ferme creance de eulx retraire de ces pechez. Jhesu Crist les en gete hors. Les aultres qui remest senefient ceulx qui demeurent en mortel pechié et y meurent et sont ars ou feu d'enfer."*

According to the legend, Abraham, whom the Lord has saved from the flames (Pl. 30), represents those who, after having undergone "the fire of this world," that is, its temptations, allow themselves to be torn away from their sin by their faith in God. The two people kneeling before the figure of the Creator represent these repentent sinners. Those who hold sacks of gold are perhaps on the road to repentance. The two lovers undoubtedly represent sinners who do not succeed in tearing themselves away from their sin. (f. 25)

32. *Fragments from the Gospels.*
The Gospel according to St. Luke.

MAIN PAINTING

The arms of Rohan (see Introduction II), which decorate the banners the angels are carrying, do not appear to have been repainted over any others, but the completely opaque gold leaf which forms the background of the emblem might possibly conceal another coat-of-arms. However, one might wonder whether the angels had originally carried not banners but instruments of the Passion: the lance and the long reed used to raise a sponge dipped in vinegar to the lips of Christ on the Cross. The painting, according to this hypothesis, would constitute a symbolic complement to the full-page painting of the Crucifixion facing it.

MARGINAL PAINTING. Bible moralisée. Genesis XIV, 8–16

LEGEND *"Icy desconfirent v roys iiii roys et enmainent Loth. Lors vient Abraham sy desconfit les v roys et resquellit Loth son frere."*

The confused battle scene represented here illustrates two successive episodes from Genesis, condensed in a single image. At one and the same time, the kings of Sodom, Gomorrah, Adama, Seboim, and Bela (the five kings) are repulsed by the kings of Sennaar, Pontus, the Elamites, and the Nations (the four kings), who capture Abraham's brother Lot. Abraham pursues them with his troops as far as Dan, puts them to rout, and sets Lot free. (f. 26v)

33. *Fragment from the Passion.*
The Gospel according to St. John, XIX.

FULL-PAGE PAINTING

This remarkable Crucifixion, so full of movement, not to say agitation, is of great interest, even though it cannot be properly spoken of as an original work. It constitutes an excellent example of the tendency of the artists of the Rohan workshop to reutilize (by reinterpreting in their own manner) previous models. Obviously, it appears that they have followed here, point by point, the composition inserted by Italian illuminators in the *Angevin Bible* (Introduction II—MS. Bibliothèque Nationale, fr. 9561, f. 178v). The numerous individuals who occupy the foreground of the painting (Roman officers on horseback, Jewish dignitaries, holy women) are all found, identically placed, in the Italian illumination. However, proceeding from this model, the Rohan workshop was able, by making certain subtle modifications, to recompose a work which clearly bears its mark. For example, the colors and background employed are very different. The soul of the wicked thief, on the right, is carried off to Hell by a demon; that of the good thief is torn from another demon, just in time, by an angel who puts the latter to flight. This idea of salvation that can be won at the moment of death, through sincere repentance despite a life of sin, is found elsewhere in the "Last Judgement," (Pl. 63) one of the most famous pages of the *Rohan Hours.* (f. 27)

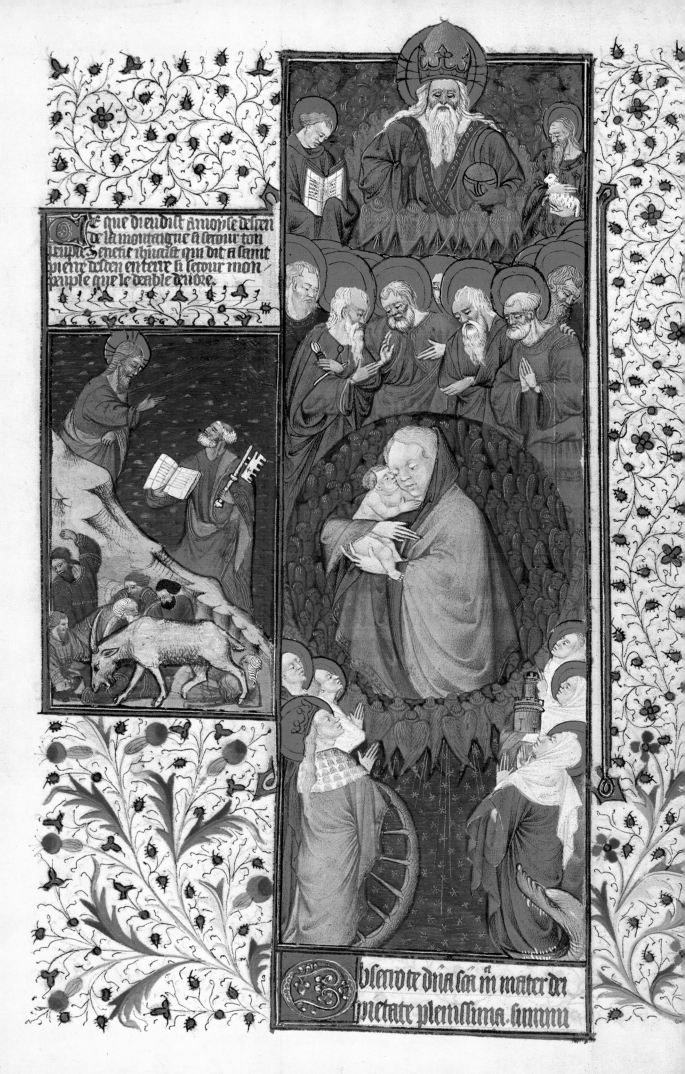

Pl. 34

rgis filia mater gloriosissima. ma
ter orphanorum. consolatio de
solatorum. via errantium. sa
lus in te sperantium. Virgo an
te partum. virgo in partu. virgo
post partum. Fons mie. fons sa
lutis fons gratie. fons pietatis et
leticie. fons consolationis et indul
gentie. Et per illam sanctam in
effabilem leticiam in qua exalta
uit spiritus tuus in illa hora qua
do tibi per gabrielem archangelii
annunciatus et conceptus est fi
lius dei in te. Et per illud diuinum

Lors vient moÿses de courouz quil
ot au peuple de ce quil ot meserie
si despeça les tables et le peuple hu
aia merui et le reprisca et en fit vnes
aultres par le commendement de
dieu

Pl. 35

34. *Prayer to the Virgin.*
"Obsecro te . . ."

MAIN PAINTING

In the center of the painting, in a circular medallion whose background is formed of a compact mass of heads and wings of seraphim, the Virgin, holding the Child Jesus in her arms, offers herself to the respectful adoration of the saints.

The lower part of the composition is reserved for the female saints, among whom we recognize St. Catherine, wearing a crown and with her wheel; St. Margaret and the dragon from whose entrails she miraculously escaped; St. Barbara with her tower.

Above the Virgin, the male saints: to the left, St. Paul, holding a sword; to the right, with hands clasped, probably St. Peter.

At the very top of the painting, God the Father, crowned with a tiara and haloed with a nimbus bearing a cross, holds a terrestrial globe in His left hand and, with His right, bestows His blessings upon the elect. A flock of angels sustains Him between St. John the Evangelist (on the left, holding a book) and St. John the Baptist (on the right, a lamb in his arms).

This composition is not original. It reproduces very faithfully another "Celestial Court" found in the *Belles Heures* of Jean de Berry (f. 218)—which is itself a point by point imitation of the frontispiece of a *Golden Legend* in French dating from 1405. (Bibliothèque Nationale MS. fr. 414, f. 1—see Introduction II.) The central medallion (Virgin and Child) is also found, isolated, in MS. n.a.1. 3107, f. 33 of the Bibliothèque Nationale.

The decision of the artists of the *Rohan Hours* to enclose their paintings in a frame of much greater height than width has, nevertheless, made necessary a certain lateral compression of the composition. This explains why the male saints are placed above the central medallion and the female saints below it, since, in the models mentioned above, the more horizontal disposition of the figures gave additional breadth and harmony to the painting.

MARGINAL PAINTING. Bible moralisée.

LEGEND *"Ce que Dieu dist à Moyse: 'Descen de la montaigne si secours ton peuple,' senefie Jhesu Crist qui dist à Saint Pierre: 'Descen en terre, si secour mon peuple que le deable devore.' "*

This moralization on the passage from Exodus (Ch. XIX), in which the Lord orders Moses to come down from Sinai and go to the aid of his people, shows Christ giving St. Peter and his successors the mission of aiding the Christian people who are exposed to the assaults of the Devil. On a mountain, Christ speaks to St. Peter, who holds a book and an enormous key, recalling the power given to him to bind and to loose. At the bottom of the picture, various individuals are attacked by the Devil (in the form of a gigantic he-goat) as he devours the unfortunate ones who have fallen to earth. (f. 29v)

35. *Prayer to the Virgin.*
"Obsecro te ..."

MARGINAL PAINTING. Bible moralisée. Exodus XXXII, 19 and XXXIV, 29

LEGEND *"Lors vient Moyses de couroux qu'il ot au peuple de ce qu'il ot meserré, sy despessa les tables et le peuple lui cria mercy et se rapaisa et en fist unes aultres par le commendement de Dieu."*

Two different episodes from Exodus are combined here in a single image. Irritated by the impiety of the Israelites who have worshiped the golden calf, Moses (whom we see here with a halo and bearing only a single horn on his forehead to symbolize the rays with which his head had been encircled since his meeting with the Lord on Sinai) has broken the Tables of the Law, the fragments of which are lying on the ground. A little later, nevertheless, he will be moved by the repentance of his people and will give them new tables, which can be seen in his left hand. (f. 30)

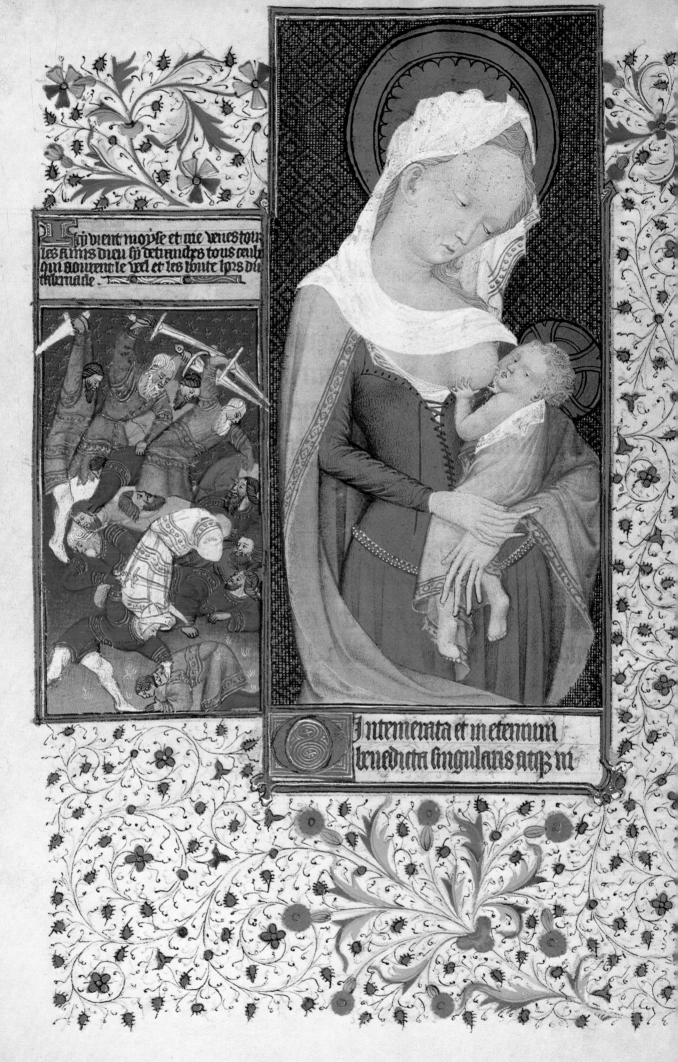

Pl. 36

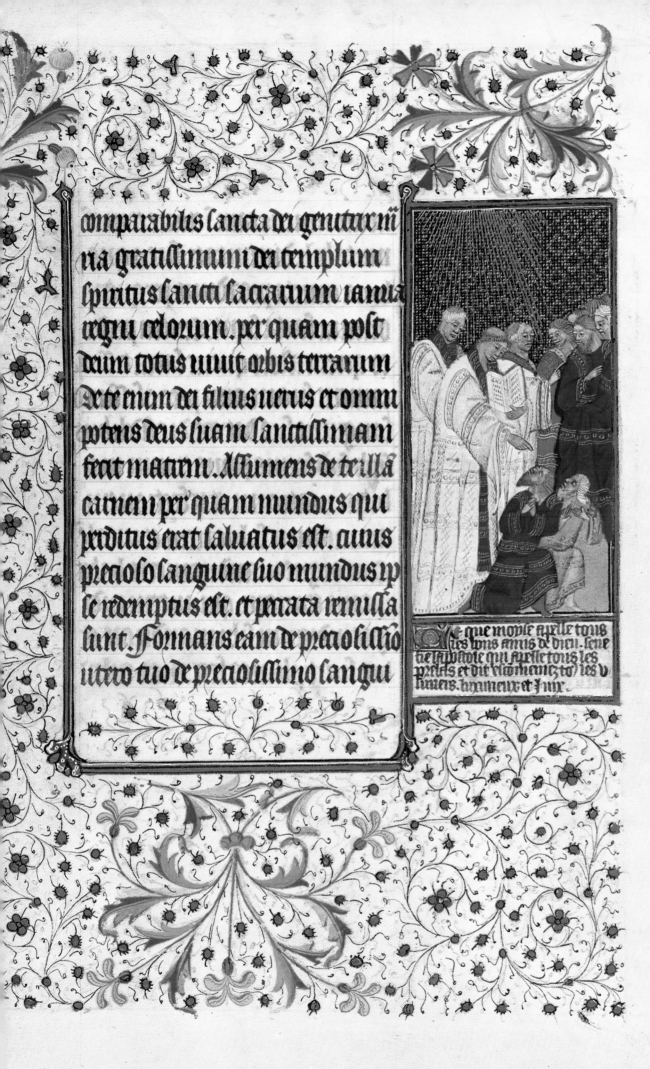

comparabilis lancta dei genitrix om
nia gratillimum dei templum
spiritus lancti lacrarium ianua
regni celorum. per quam post
deum totus uiuit orbis terrarum
de te enim dei filius uerus et omni
potens deus suam lanctillimam
fecit matrem. Allumens de te illa
carnem per quam mundus qui
perditus erat laluatus est. cuius
preciolo languine suo mundus ip
se redemptus est. et peccata remilla
lunt. Formans eam de preciolillio
utero tuo de preciolillimo langui

Le que mople apelle tous
les tous lemis de dieu. sene
be la prophete qui apelle tous les
prelas et dit clerement. tous les
liners. hymneur et Jour

Pl. 37

36. *Prayer to the Virgin.*
"O intemerata..."

MAIN PAINTING

This "Virgin of humility," a charming and tender representation of a young mother suckling her child, is from the brush of one of the best artists who collaborated on the *Rohan Hours*. Its style is strongly reminiscent of that of another "Virgin and Child" which forms the central motif of the most beautiful page of the *Stuart Hours* (f. 141b), in the Fitzwilliam Museum at Cambridge. However, in the latter painting, the Virgin is represented standing, her bodice is not yet unlaced, and the child is held horizontally in her arms. In both paintings, the blond color of the Virgin's hair, the curve of her forehead, her bodice which laces up, and the arrangement of the veil over her hair, are identical. It is interesting to compare these two Virgins with a colored woodcut which is evidently related to them, and of which we know only one copy to be preserved (in the Department of Prints of the *Bibliothèque Nationale*). Certain details, such as the lines in the Virgin's neck, the disposition of her veil and of her hair, and so forth, recur in the latter work. This engraving is generally dated between 1420 and 1430. It is sometimes attributed to a master from the North of France, and sometimes to a Rhenish engraver.

In this painting from the *Rohan Hours* we are thus confronted with a somewhat heterogeneous composition, involving preexisting elements. A Child Jesus—His shoulder exposed, His head turned three-quarters of the way around, and His feet turned so that the soles are visible—is found, identically, in the *Petites Heures* (f. 22) and in the *Grandes Heures* (f. 8) of Jean de Berry, as well as in several other contemporary manuscripts. Here He has been placed lower in relation to the Virgin, in order that His head may be on the same level as His mother's breast, which is overflowing with milk.

In the *Hours of René d'Anjou* (f. 18), a Virgin on a crescent seems to have been inspired by this same figure, but it is clearly the work of another artist.

MARGINAL PAINTING. Bible moralisée. Exodus XXXII, 26–27.

LEGEND *"Icy vient Moyse et crie: 'Venés touz les amis Dieu, sy detranchés tous ceulx qui aourent le veel et les bouté hors du tabernacle.'"*

The legend does not correspond exactly to the image. In point of fact, we see here the faithful "friends of God," answering the appeal of Moses to massacre (with great slashes of their swords) the worshipers of the golden calf; but Moses is not represented in the act of addressing his troops, nor does the golden calf itself figure in the scene. (f. 33v)

37. *Prayer to the Virgin.*
"Obsecro te . . ."

MARGINAL PAINTING. Bible moralisée.

LEGEND *"Ce que Moyse apelle tous les bons amis de Dieu senefie l'Apostole qui apelle tous les prélas et dit 'Escommeniez tous les usurieurs, luxurieux et Juix.'"*

Moses, assembling all the faithful Israelites and urging them to massacre the worshipers of the golden calf (Pl. 36), is likened here to the Pope, who convenes all the prelates and commands them to excommunicate usurers, men of bad character, and Jews. Here, three clerics, robed in white albs and wearing stoles, excommunicate two terrified sinners (in the foreground). One of the priests holds in his hand an open book, which, without doubt, is supposed to contain the text of a papal bull. A group of the faithful indicate by a gesture to the condemned that the latter are henceforth banished from the Church. (f. 34)

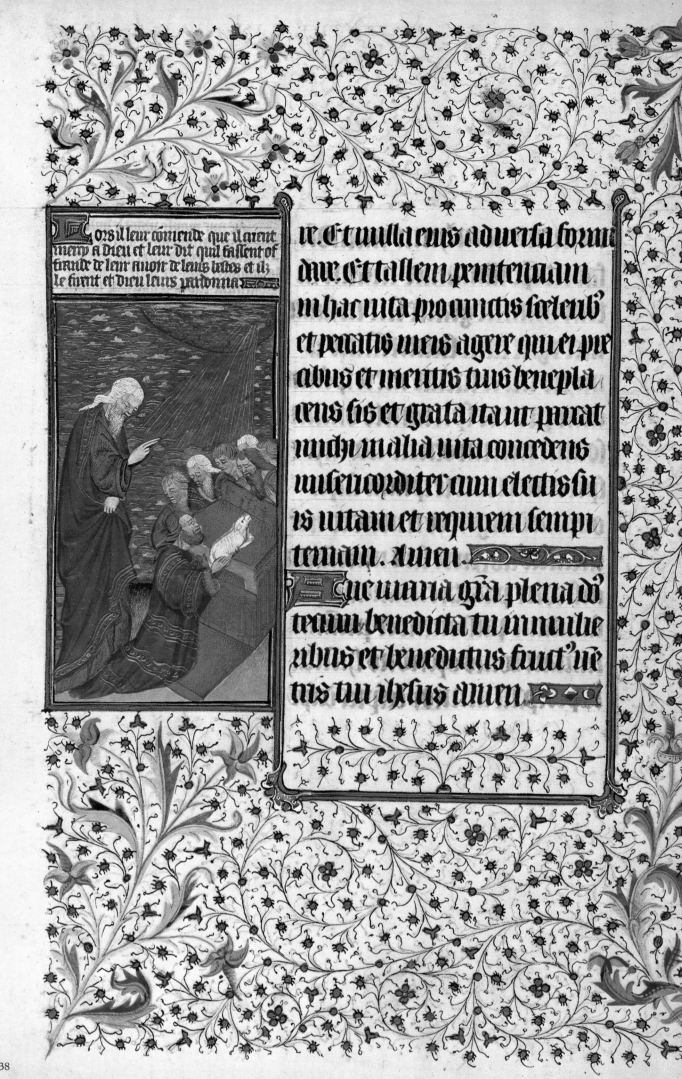

ors il leur commende que il aient
mercy a Dieu et leur dit quil fassent of
frande de leur auoir de leurs lebes et ilz
le firent et Dieu leur pardonna

re. Et a nulla eius aduersa formi
dine. Et talem penitentiam
in hac uita pro cunctis sceleribus
et peccatis meis agere qui ex pre
cibus et meritis tuis benepla
cens sis et grata ita ut procat
mchi in alia uita concedens
misericorditer cum electis su
is uitam et requiem sempi
ternam. Amen.

ue maria gracia plena do
teum benedicta tu in mulie
ribus et benedictus fructus ue
tris tui ihesus amen

Pl. 38

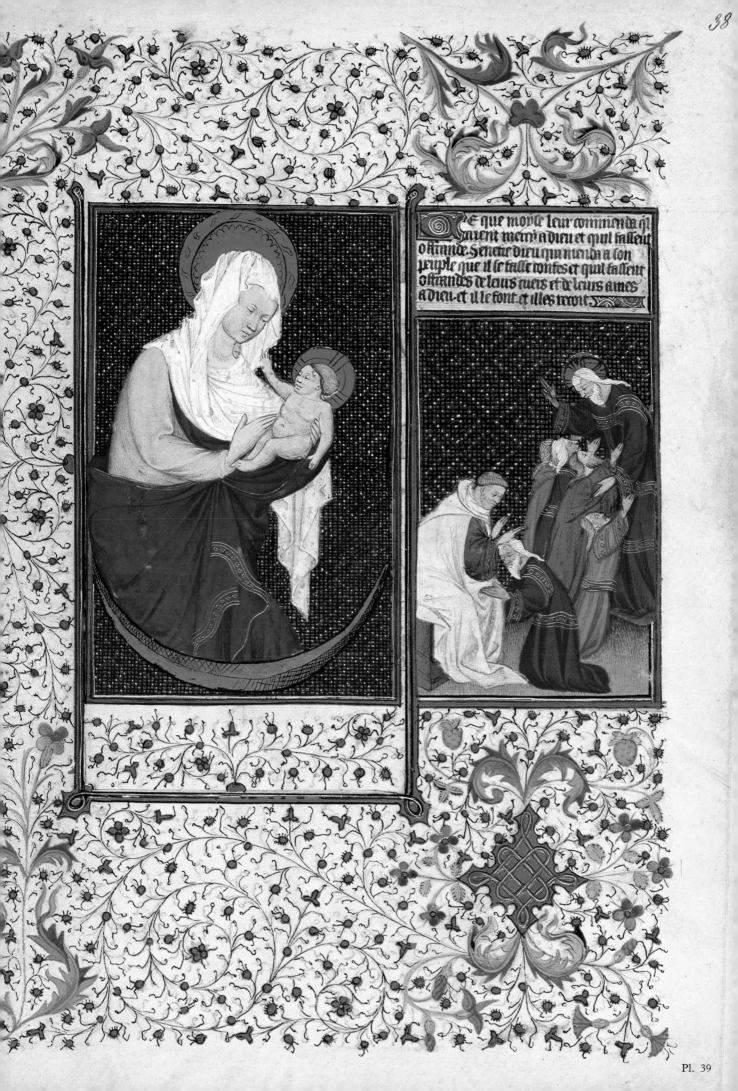

Pl. 39

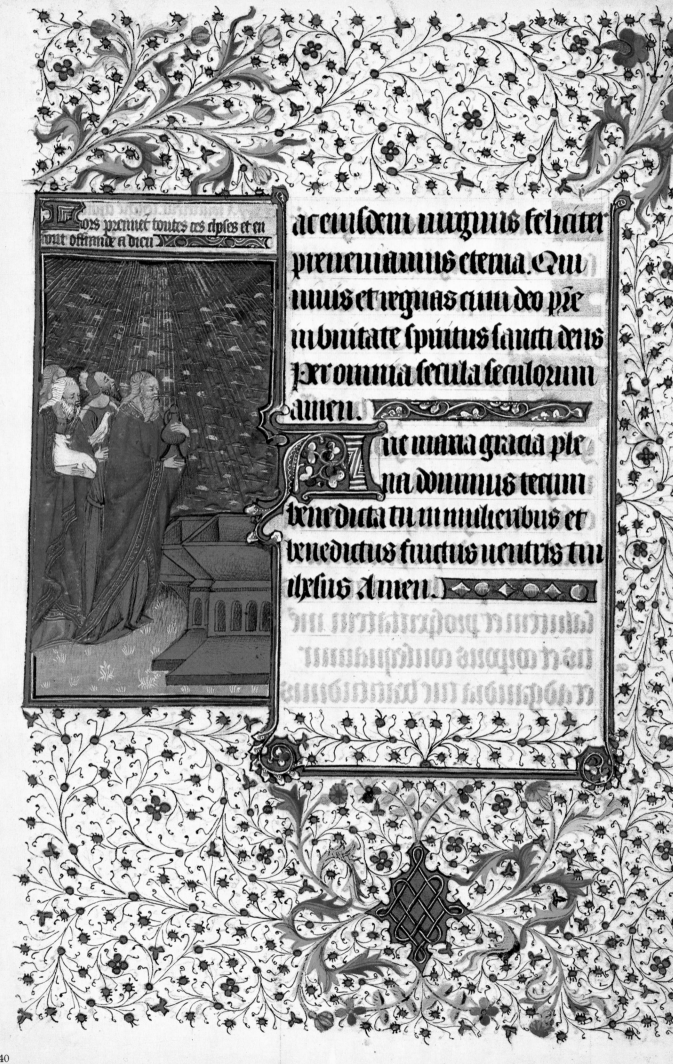

ac eiusdem virginis feliciter
preueniamus eterna. Qui
uiuis et regnas cum deo pa
in vnitate spiritus sancti deus
Per omnia secula seculorum
amen.

ue maria gracia ple
na dominus tecum
benedicta tu in mulieribus et
benedictus fructus ventris tui
ihesus Amen.

Pl. 40

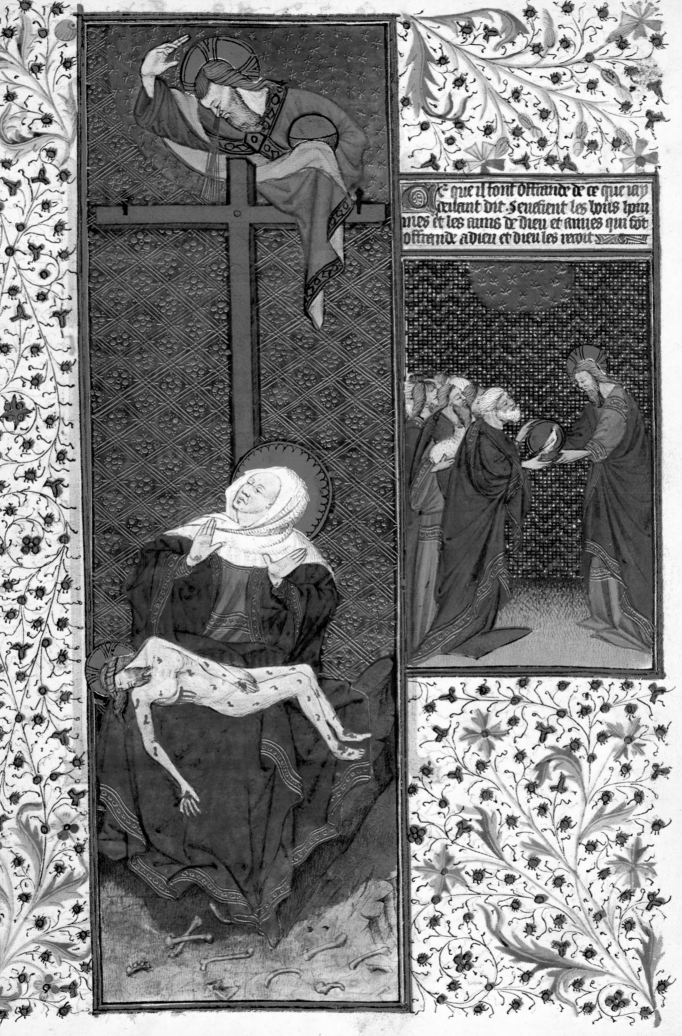

Pl. 41

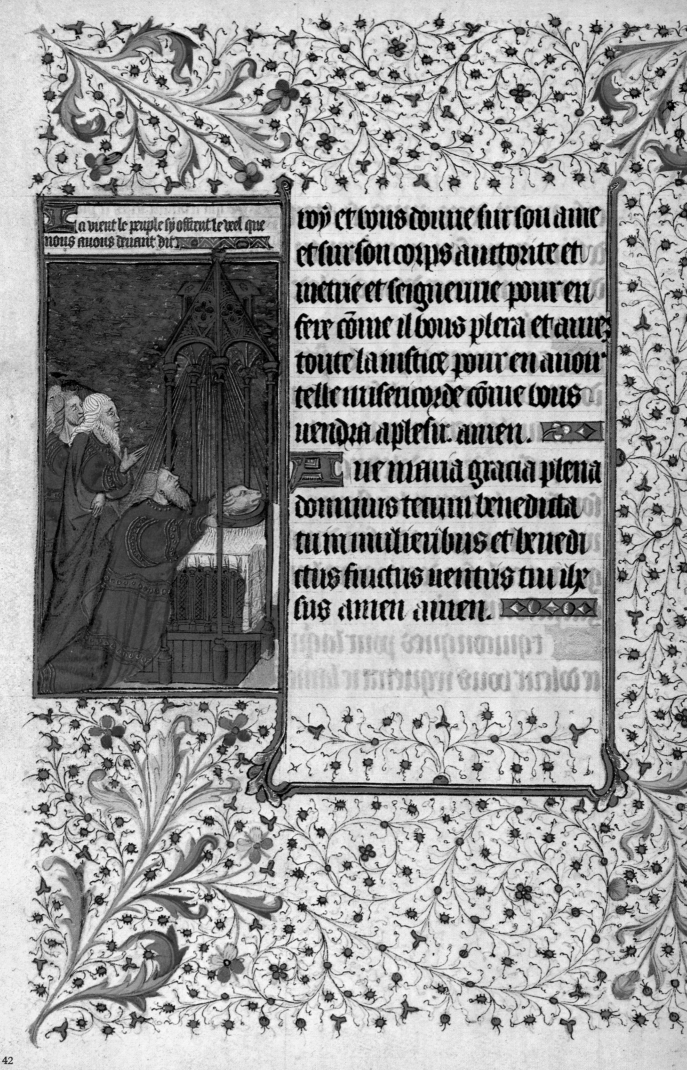

roy et vous donne sur son ame
et sur son corps auttorite et
mettre et seignurie pour en
fere conme il vous plera et auuez
toute la iustice pour en auoir
telle misericorde conme vous
uendra aplesir. amen.

Aue maria gracia plena
dominus tecum benedicta
tu in mulieribus et benedi
ctus fructus uentris tui ihe
sus amen amen.

Pl. 42

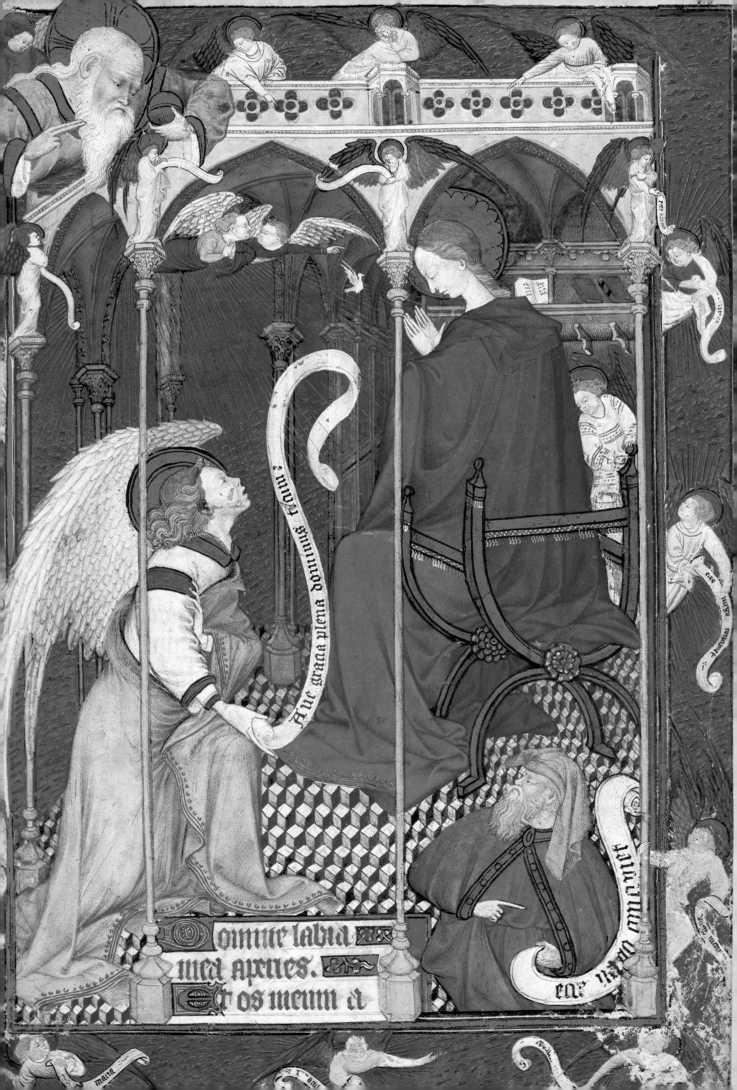

38. *Prayers to the Virgin.*
"O intemerata . . . Ave Maria . . ."

MARGINAL PAINTING. Bible moralisée. Exodus XXXII, 30 and XXXV, 20 and ff.

LEGEND *"Lors il leur commende que il crient merci a Dieu et leur dit qu'il fassent offrande de leur avoir, de leurs bestes; et ilz le firent et Dieu leurs pardonna."*

Two passages from Exodus are condensed here. Moses admonishes the Israelites to beg for Divine pity and to offer to the Lord a part of their goods and their flocks. Obediently, the Israelites (who are represented on the right) carry out Moses' order. One of them is holding a lamb which will be sacrificed in a burnt offering. (f. 37v)

39. *Prayers to the Virgin*

MAIN PAINTING

The iconographic type of Virgin and Child appearing above a crescent moon, or in the center of a circle of luminous rays evoking sunlight, is found very frequently in French illumination of the early fifteenth century. In the *Belles Heures*, in particular, we find several examples (f. 26v, 209, 218). Most often, however, only a bust of the Virgin is represented in such a painting. Here it would seem that the artist was inspired by several different models, or by a composite type unknown to us. In a manuscript of the Milan Ambrosian Library (S.P. 56, f. 22), which originated in the workshop of the Master of the *Boucicaut Hours*, we find a painting wherein the Virgin and Child have substantially the same attitude as in this one, except that the Virgin wears a different costume (conforming to the classical type derived from Byzantine archetypes) and is represented standing, without the crescent moon. Usually the Child is swathed in linen (of which one sees a piece hanging down vertically at the bottom of the composition) and not, as here, in the Virgin's veil.

MARGINAL PAINTING. Bible moralisée.

LEGEND *"Ce que Moyse leur commenda qu'il crient mercy a Dieu et qu'il fassent offrande senefie Dieu qui menda a son peuple que il se fasse confés et qu'il fassent offrandes de leurs cuers et de leurs ames a Dieu et il le font et il les reçoit."*

Moses admonishing the Israelites to implore God's mercy and to offer Him the tithe of their goods and their flocks (Pl. 38), represents, as the legend tells us, God commanding the Christians to confess (as we see in the foreground, on the left) and to offer Him their hearts and their souls. On this condition, He receives and blesses the faithful who have followed these precepts (on the right). (f. 38)

40. *Prayer to Jesus Christ:*
Ave Maria

MARGINAL PAINTING. Bible moralisée. Exodus XXXV.

LEGEND *"Lors prennent toutes ces choses et en font offrande a Dieu."*

Several Israelites solemnly bring up to the altar the first fruits of their wealth, according to the prescriptions of Moses as laid down in Chapter XXXV of Exodus and codified in Leviticus. Relying on the latter text, the artist represented them here with a vase of perfume, a dove, and a ewe. (f. 40v)

41. *The Five Sorrows of the Virgin*

MAIN PAINTING

It is the fifth sorrow of the Virgin which is illustrated here. The French text reproduced in the *Rohan Hours* describes it by having the Virgin herself address her Son: "The fifth sorrow was when you were hanging on the Cross and then, bleeding and disfigured, they laid you in my lap." In accordance with the text and the traditional iconographic representation called the "Vesperbild," the bleeding body of Christ rests on the Virgin's knees, having been taken down from the Cross after His death. With both her hands open in an attitude of anguished prayer, the Virgin lifts her head toward God the Father. Professor Meiss has justly compared this very special iconographic type to a painting from the *Angevin Bible* (f. 138) representing the Slaughter of the Innocents. In MS. 5140 of the Lyons Library (f. 132) we find a faithful replica of the scene reproduced here, except for the fact that God the Father does not appear in it—which makes the attitude of the Virgin less comprehensible.

MARGINAL PAINTING. Bible moralisée.

LEGEND *"Ce qui il font offrande de ce que j'ay devant dit senefient les bons hommes et les amis de Dieu et amies qui font offrande a Dieu et Dieu les reçoit."*

The Israelites offering God the sacrifices represented in the preceding folio (Pl. 40), symbolize the men and women of good will whose gifts and prayers God receives favorably. The artist has represented the Son accepting a bird and a lamb from the hands of two bearded men who might evoke St. Peter and St. Paul. (f. 41)

42. *The Five Sorrows of the Virgin.*
Ave Maria.

MARGINAL PAINTING. Bible moralisée. Leviticus I, 5–9.

LEGEND *"Ici vient le peuple, sy offrent le veel que nous avons devant dit."*

The image presents us with the final phase of the sacrifice of a calf, according to the ritual prescriptions of Leviticus. After the animal has been skinned and quartered, the pieces will be placed in a container; the head and the entrails will be brought up to the altar to be burned. (f. 44v)

43. *Hours of the Virgin*

FULL-PAGE PAINTING

In an Italian-style loggia whose slender colonnettes are surmounted by capitals supporting statues of angels, the Angel Gabriel comes to announce to the Virgin that she will be the mother of the Savior as foretold by the Prophets. On the phylactery unfolding from his right hand, we can read the first words of the angelic salutation: *"Ave gratia plena, dominus tecum. . . ."* (Hail to thee, full of grace, the Lord be with you.) Seated in a curule-shaped chair, the Virgin half-joins her hands in a gesture of acceptance, while turning her head toward the messenger sent from God. Above the roof surmounting the delicate edifice, God the Father contemplates the scene, a terrestrial globe in His left hand, two fingers of His right hand raised in a gesture of benediction. A dove representing the Holy Spirit directs its flight toward the Virgin. Within the loggia, two angels comment upon the event, while other angels poised on the roof point out to each other the participants. Behind the Virgin, an angel seems to keep watch—a detail frequently found in the compositions of the Master of the *Boucicaut Hours* or of his imitators. At the bottom of the image, on the right, the prophet Isaiah points to the phylactery he holds and upon which we can read three words from the famous prophecy: *"Ecce virgo concipiet"* (Behold, a virgin shall conceive). Other angels surround the image outside the frame which encloses it. They also carry phylacteries, whose inscriptions, partially effaced, repeat the prophecy of Isaiah or invocations to the Virgin: *"Maria mater gracie, mater misericordie. Maria Virgo incor[rupta]*. (Mary, Mother of Grace, Mother of Mercy. Mary, Virgin without Sin). The attitude of the Virgin in this Annunciation—represented seated, and in profile—is quite unusual in the iconography of Books of Hours of the period (Introduction I). The aspect given her by the artist is that of another Virgin, painted on folio 227 of the *Rohan Hours* (Pl. 113). As for Gabriel, he is quite close to the angel represented some pages further on, in the painting dedicated to the Visitation (Pl. 45). (f. 45)

Es marchaus qui luurent iosep. Senefie
les diaples dieu qui luurent ihesuuist
ou monde.

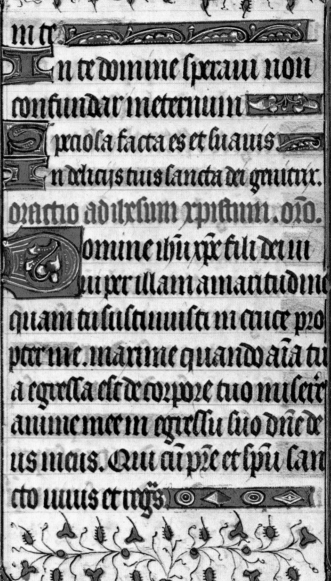

in te

n te domine speraui non
confundar in eternum

praola facta es et biauis

in delitijs tuis sancta dei genitrix.

oracio ad ihesum xpistum. oso.

omine ihu xpe fili dei ui
ui per illam amaritudine
quam tu sustinuisti in cruce pro
pter me. marime quando aïa tu
a egressa est de corpore tuo miseie
anime mee in egressu suo dne de
us meus. Qui cū pre et spu san
cto uiuis et regns

Pl. 44

44. *Hours of the Virgin*

MARGINAL PAINTING. Bible moralisée.

LEGEND *"Les marchans qui livrent Joseph senefie les diciples Dieu qui livrent Jhesu Crist ou monde."*

Prefigured by the Midianite merchants who sold Joseph to the Pharaoh in the episode from Genesis (XXXVII, 28) illustrated on the preceding folios, certain wicked Christians (although disciples of Christ and even ministers of the Gospel), seduced by money, power, or carnal lust, deliver up their Master to the world. Here a women representing the Church, forgetful of her mission, leads Christ by the hand, presenting the Universe to Him. The Universe is depicted in the form of a large circle in whose center houses appear, according to tradition. A wide ring symbolizing the ocean, surrounds the inhabited lands.

(f. 69v)

45. *Hours of the Virgin*

In the Gospel according to St. Luke (I, 39), we are told that Mary, when she was with child, went up into the mountains to visit Zacharias and Elisabeth, her relatives. Elisabeth herself had conceived a child, the future St. John the Baptist. Seeing the Virgin coming, she ran to meet her and felt a movement of the child she was carrying in her womb. She then cried out, addressing the Virgin: "Blessed are you among all women, and blessed is the fruit of your womb"—words which echo those of Gabriel, in the *Ave Maria* prayer or the angelic salutation.

With great breadth of style, the best of the painters who collaborated on the *Rohan Hours* has composed a Visitation here which contrasts strongly with the customary representations of this famous scene, because it includes the personage of Zacharias, while ordinarily only Mary and Elisabeth appear. This expansion of the composition thus makes Elisabeth the central figure of the painting. In the sky, at the center of a cloud of radiant light, four angels observe and comment on the scene. In the foreground, on the left, an angel who has accompanied the Virgin bends one knee to the ground while lifting his head toward the other characters. The Virgin, on the left, a book in her hand, gathers the cloak around her body, which has already grown heavy, with a gesture of delicate modesty.

The face of Zacharias is very similar to those which the same artist gave to the old men he painted in the Presentation at the Temple (Pl. 50). The kneeling angel is visibly inspired by the same model as the Gabriel of the Annunciation (Pl. 43). Elisabeth has a very characteristic profile, found in numerous representations of the same scene—one of the most interesting of which was painted by Jacquemart de Hesdin, in the *Petites Heures* of Jean de Berry (f. 32v). (f. 70)

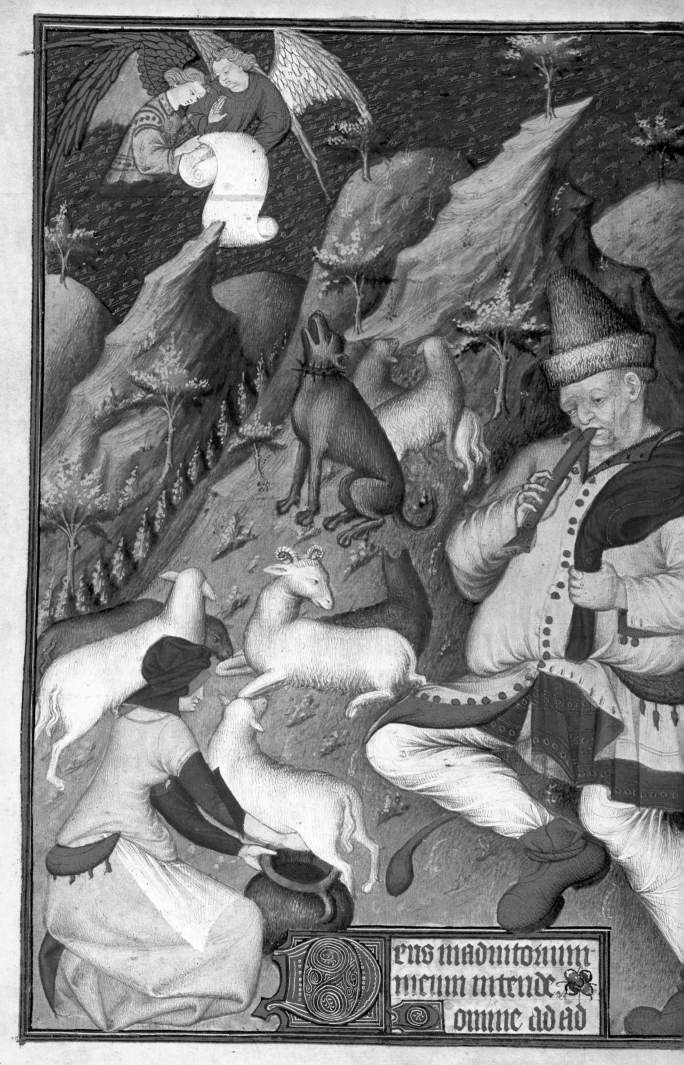

Pl. 46

86

uuandum me festina.

Gloria pri et filio et spiu sco

 sicut erat in principio et nunc

et semper et in secula seculorum

amen. Alleluia

Ueni creator spiritus me

tes tuorum uisita imple

superna gratia que tu creasti pec

tora.

Memento salutis auctor qp no

stri quondam corporis et illiba

ta uirgine nascendo formam

sumpseris

Maria mater gratie mater

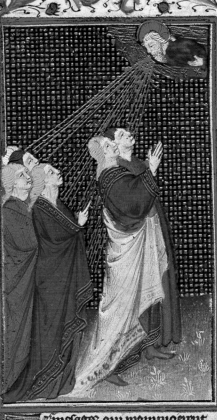

Les mesages qui prounuacerent
le blef. Scuefient les mesages
iheluerist qui distrent quil alaffeit
en pere du ciel pour auoir de son blef
Et il en donna

46. *Hours of the Virgin*

FULL-PAGE PAINTING

In a mountainous landscape (bristling with rocks whose conventional escarpments, borrowed from Italian painting of the preceding century, are beginning to go out of fashion), the ablest Master of the *Rohan Hours* has composed a rustic tableau whose originality is somewhat disconcerting.

The only human figures in this classical scene—the shepherd and shepherdess who occupy the major part of the image—do not seem to be paying any attention to the great news (of Christ's birth) that two angels have just brought to earth. The woman (for which the artist has borrowed a model from the *Très Riches Heures* of Jean de Berry, f. 7v) is too busy milking a ewe to raise her head toward the sky. Her companion, a shepherd in the full vigor of his manhood and of gargantuan proportions (whose strongly defined face under his fur cap was undoubtedly painted from a living model), is dancing clumsily while playing so loudly on his shepherd's pipe that his music must drown out the voices of the angels!

Only the dog who watches over the flock seems to have noticed the arrival of the celestial messengers, but his masters evidently think he is howling at the moon. Do these peasants—as has been said—express a serene delight in the announcement of the good tidings? Or might they not—considering the time of national calamities during which the *Rohan Hours was* executed—rather reveal a certain detachment from everything but their own humble tasks, or perhaps be celebrating the simple joys of daily life? In another Announcement to the Shepherds, painted in the workshop of the Master of Bedford (MS. 1855 of the National Library of Vienna, f. 65v), we can see in the foreground a shepherd and shepherdess who, abandoning those of their companions who give attention to the angels' message, seem concerned only with courting one another. Perhaps we should see in the present painting another reflection of the same state of mind. Furthermore, the Vienna manuscript shows another similarity to the *Rohan Hours*, which will be discussed later (Pl. 50). (f. 85v)

47. *Hours of the Virgin*

MARGINAL PAINTING. Bible moralisée.

LEGEND *"Les mesagés qui pronuncierent le blef senefient les mesagés Jhesu Crist qui distrent qu'il alassent au Pere du Ciel pour avoir de son blef et il en donra."*

This moralization refers to an episode in the story of Joseph (Genesis XLI, 55). Anticipating a famine, Joseph sends messengers throughout the kingdom of Egypt to order the establishment of vast reserves of grain during the period of abundance. Joseph's messengers, as we learn from the legend, represent the faithful whom Christ commands to go to His Father and to seek from Him the grain of His grace, which He will gladly give them. A procession of the faithful, their eyes uplifted, advances toward the Father, who blesses them from on high. (f. 86)

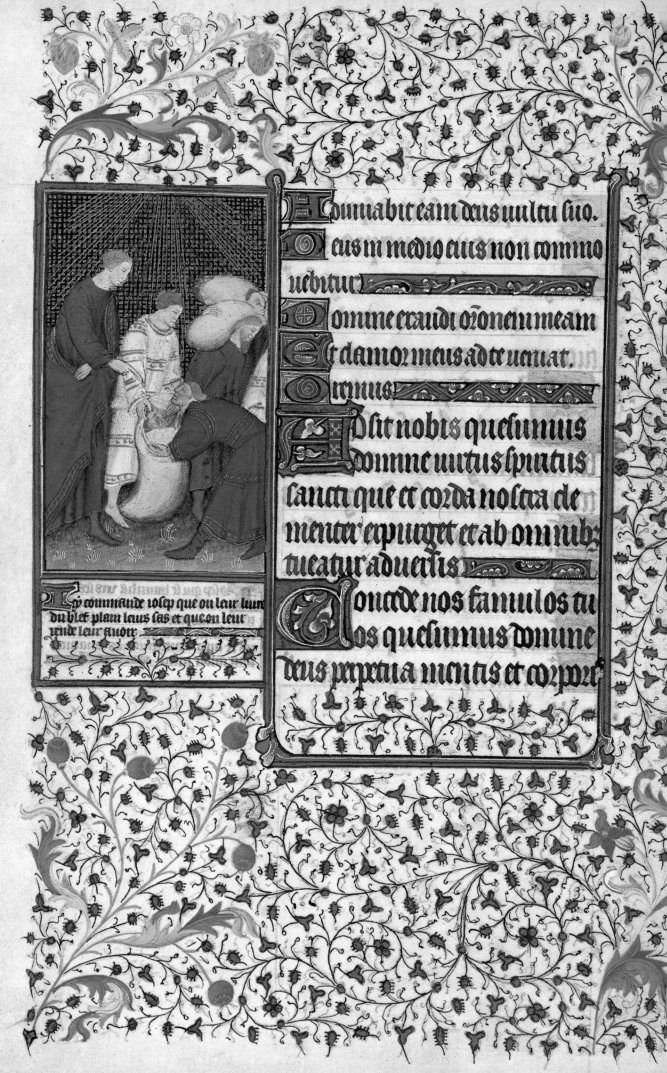

Hominabit eam deus uultu suo.
Deus in medio eius non commo
uebitur.
Domine exaudi orationem meam
Et clamor meus ad te ueniat.
Oremus

Adsit nobis quesumus
domine uirtus spiritus
sancti que et corda nostra de
menter expurget et ab omnibz
tueatur aduersis

Concede nos famulos tu
os quesumus domine
deus perpetua mentis et corpore

Et comande iosep que on leur luns
du blef plain leurs sas et que on leur
rende leur auoir

Pl. 48

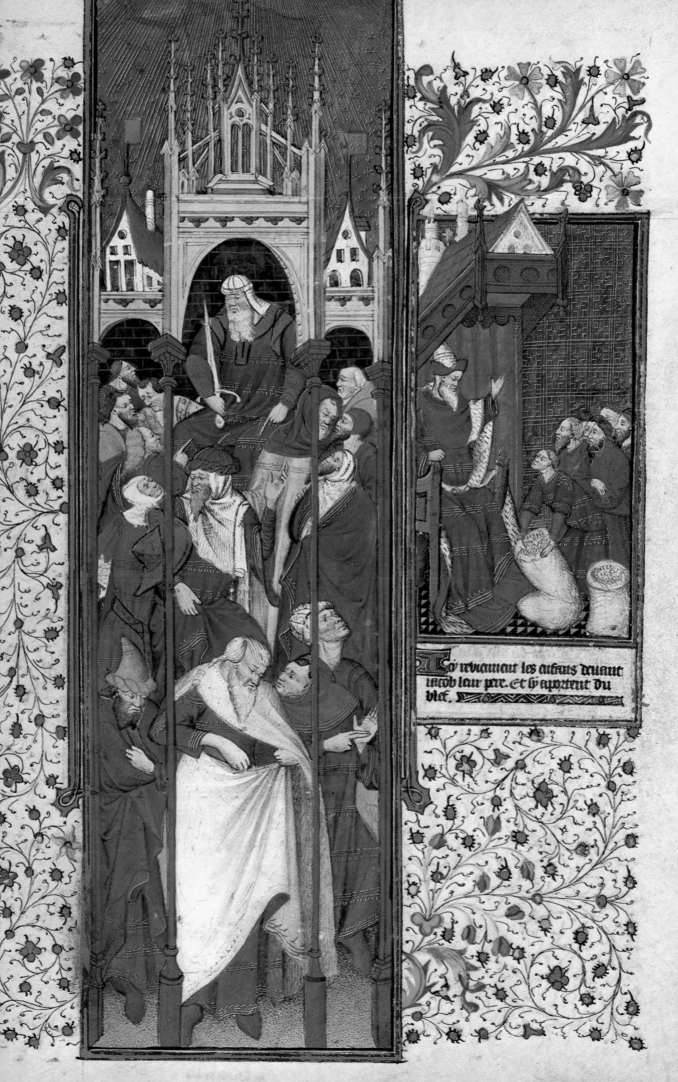

Cô rebiennent les enfaus deuant
Iacob leur pere. Et ly apportent du
blef.

Pl. 49

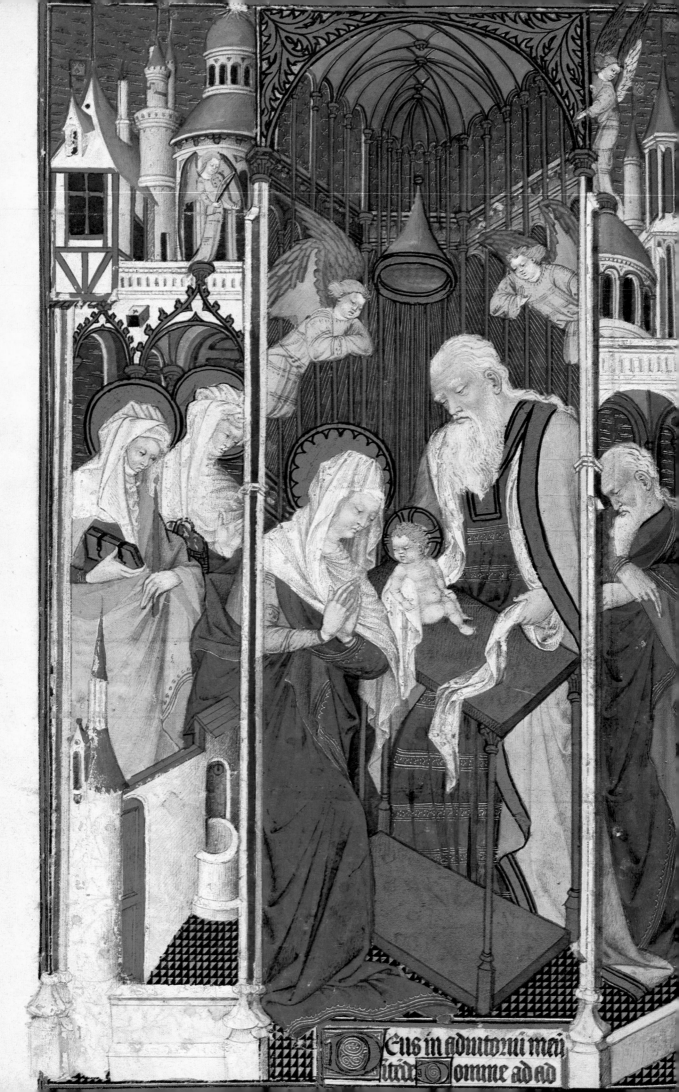

Eus in adiutoriu meu
intende Domine ad ad

Pl. 50

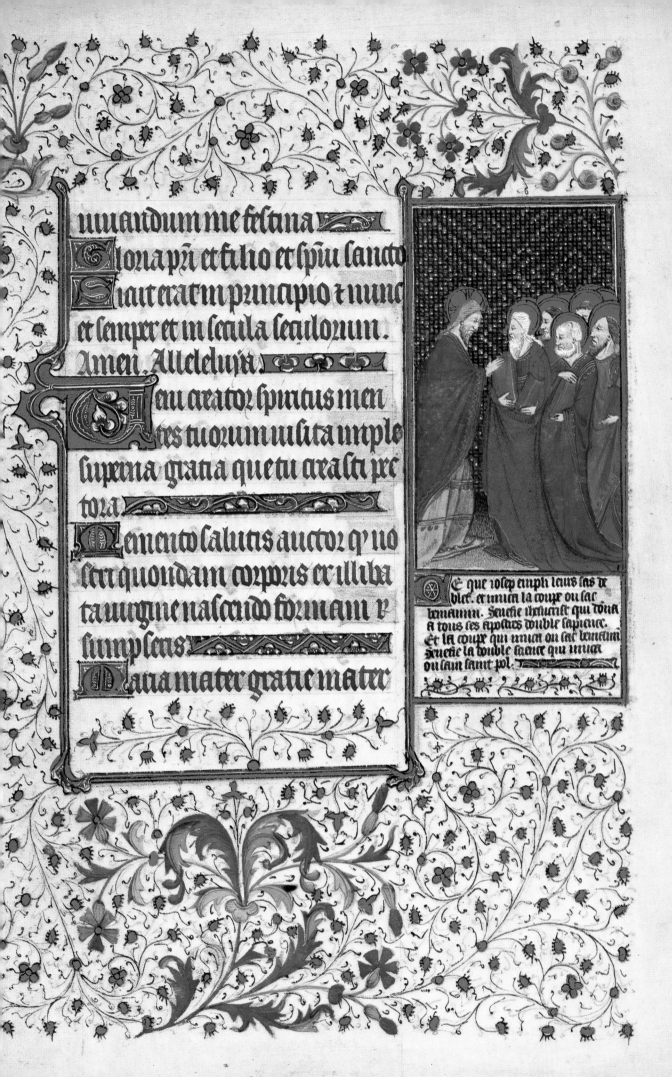

nuuandum me festina

Lona pri et filio et spiu sancto

Siait erat in principio z nunc
et semper et in secula seculorum.
Amen. Alleleluya.

eni creator spiritus men
tes tuorum uisita imple
superna gratia que tu creasti pe
tora

emento salutis auctor q' no
strn quondam corporis ex illiba
ta uirgine nascendo formam v
sumpseras

aria mater gratie mater

E que rosep empli lesus fns de
blet. er unen la coupe ou sac
bernanun. Senefie theurist qui donk
a tous ses apostres double sapience.
Et la coupe qui unen ou sac bernelm
Senefie la double sacure qui unen
ou sam samt pol.

Pl. 51

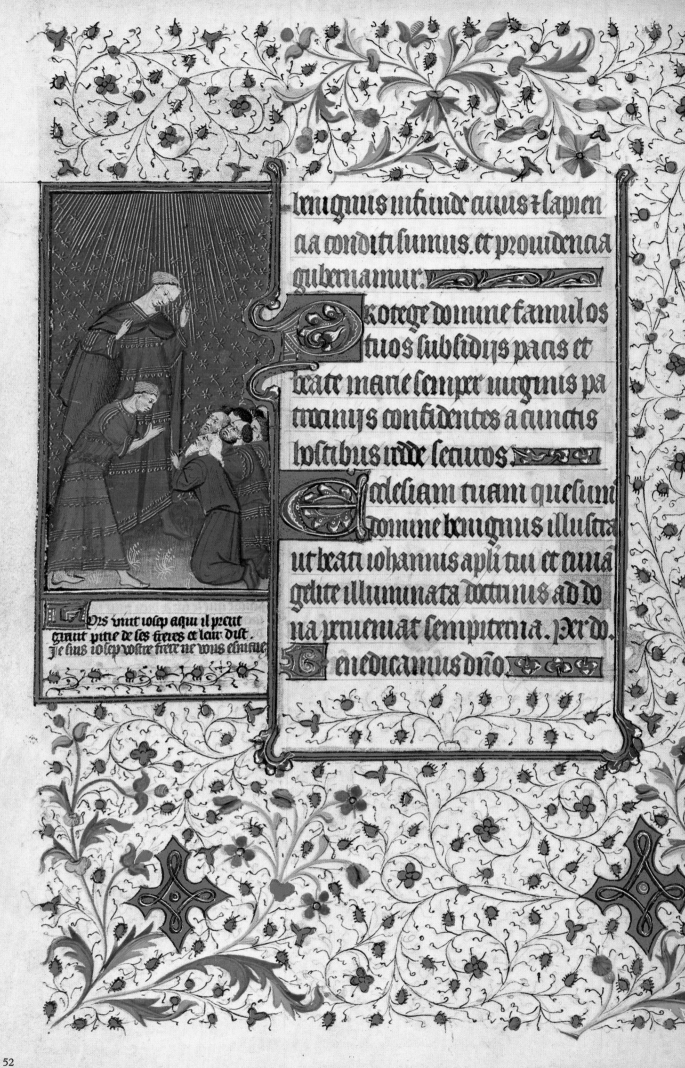

benignius infunde auius + sapien
ua condiu sumus. et prouidenua
gubernamur.

Rotege domine famulos
tuos subsidiis paris et
beate marie semper uirginis pa
trouanis confidentes a cunctis
hostibus uide securos.

Ecclesiam tuam quesum
domine benignus illustra
ut beati iohannis apli tui et euuā
gelite illuminata doctrinis ad do
na prueniat sempiterna. Per do.

Benedicamus dno.

Ors unnt iosep aqui il preut
ginnt pitie de ses freres et lair dist.
Ie suis iosep uostre frere ne uous chule

Pl. 52

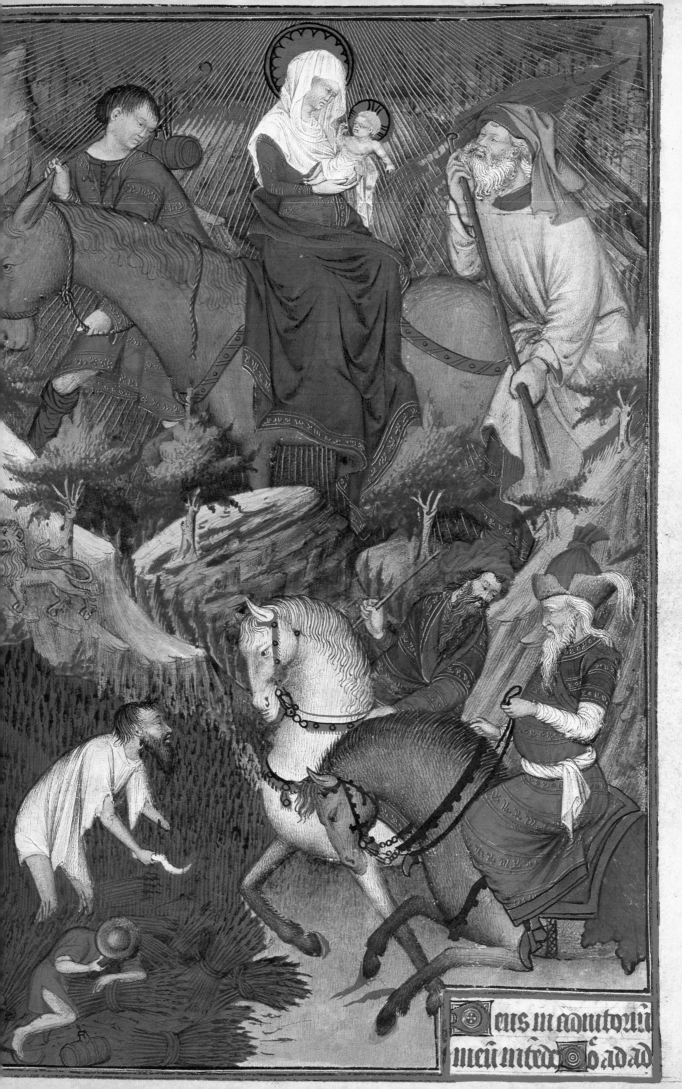

Pl. 53

48. *Hours of the Virgin*

MARGINAL PAINTING. Bible moralisée. Genesis XLIV, 1.

LEGEND *"Icy commande Josep que on leur livre du blef plain leurs sas et que on leur rende leur avoir."*

Joseph, whom his brothers have not yet recognized, commands that an abundant supply of the grain which they had come to buy in Egypt be delivered to them. Furthermore, he has the money they had paid in exchange for the grain put back secretly into the sacks. On the left, Joseph gives his instructions. On the right, two men depart, each carrying a full sack on his shoulder. (f. 89v)

49. *Hours of the Virgin*

MAIN PAINTING

In this rather strangely composed scene, where we see Herod deliberating with the Jewish priests about the fate of an invisible Jesus, the artist seems to have been simultaneously inspired by several motifs borrowed from different pages decorated by the Limbourgs, and of which he seems to have made an amalgam here. Certain details are drawn from the page which the Limbourgs devoted to the death of Simon the magician, in the *Belles Heures* (f. 215). The features given here to one of the characters, on the right of the painting, are either derived directly from that same page in the *Belles Heures*, or from the painting added by the Limbourgs to the *Très Belles Heures de Notre Dame* (p. 225), or else from a common model which they created. The configuration of Herod may be likened to that of the judge presiding at the martyrdom of St. Stephen, in the *Belles Heures* (f. 162), while other personages recall the configurations and attitudes of Pilate's counselors in the same manuscript (f. 138).

MARGINAL PAINTING. Bible moralisée. Genesis XLII, 29 and ff.

LEGEND *"Icy reviennent les enfans devant Jacob leur pere et sy aportent du blef."*

Returning to the home of Jacob, their father (represented here as a sovereign on his throne), Joseph's brothers show the sacks of grain which they were able to bring back from Egypt, thanks to their brother's generosity. (f. 90)

50. *Hours of the Virgin*

FULL-PAGE PAINTING

Although it illustrates but a single moment in an episode from the Gospel (Luke II, 22–32), of which there have been innumerable representations, this painting of the Presentation at the Temple breaks down into three distinct elements, conceived as the panels of a triptych. In the center are the essential subjects: the Virgin, from whose arms the aged Simeon has just received the Child Jesus, whom he has placed on the altar. The dimensions of the figures, the position assigned them, the Child forming a link between His mother and Simeon—all underscore their importance.

Contrary to an iconographic tradition which was very popular in the fifteenth century, and due to a merging of the theme of the Presentation with that of the Circumcision, the aged Simeon is not represented with the attributes of a high priest, and the Child Jesus evidences no fright nor does He make the slightest sign of drawing back. The scene occurs in the choir of a vast Gothic church whose ogives recede on two tiers of slender columns. Golden rays emanating from an invisible source illuminate the nave, wherein flutter two angels whose countenances express their veneration. To the right, in a side aisle or lateral chapel whose vault (lower than that in the central panel) is surmounted by a demi-cupola and two turrets, a figure with a white beard who should undoubtedly be identified as Saint Joseph, attends the scene with a meditative air. To the left, two holy women escort the Virgin. One of them carries two turtledoves in a basket, which the Mosaic law enjoined in such cases as a sacrificial offering of purification. The other, holding a book in her right hand, might be the prophetess Anna who, according to Saint Luke, was in attendance at the Presentation and afterwards praised the Lord "and spoke of him to all that looked for the redemption of Israel."

The architectural decor within which these two women are framed presents a curious characteristic. It is identical, in every respect, to that found in the most beautiful illumination of the *Stuart Hours*, which is preserved in the Fitzwilliam Museum at Cambridge (MS. J 62, f. 141 b). The central subject of this celebrated page, moreover, is a Virgin and Child of a type which is quite similar to that found in the *Rohan Hours* (Pl. 36). See Introduction, II. (f. 94v)

51. *Hours of the Virgin*

MARGINAL PAINTING. Bible moralisée.

LEGEND *"Ce que Josep empli leurs sas de blef et muça la coupe au sac Benjamin senefie Jhesu Crist qui donna a tous ses apostres double sapience. Et la coupe qu'i muça ou sac Benjamin senefie la double science qu'i muça ou sain sainct Pol."*

The episode from Genesis in which Joseph has his brothers' sacks filled with grain and the money given in exchange for it put back into the sacks (Pl. 48), prefigures, as the legend tells us, the twofold wisdom drawn from the Old and New Testaments which Christ has granted to all His apostles. Here we see Christ addressing His apostles, among whom St. Peter and St. Paul may be recognized in the front row. As for the cup which Joseph had hidden in the sack of Benjamin, his youngest brother, this symbolizes the knowledge which Jesus infused into the heart of St. Paul. (f. 95)

52. *Hours of the Virgin*

MARGINAL PAINTING. Bible moralisée. Genesis XLV, 3–5.

LEGEND *"Lors vint Josep a qui il prent grant pitié de ses freres et leur dist: 'Je suis Josep, vostre frere, ne vous esmaiez.'"*

Joseph, who with his great height towers above his brothers, reveals to them his true identity. Overcome with fear, in spite of his reassuring words, they fall to their knees and implore his pity. On the left, Benjamin [?] seems to be urging them to repent. Golden rays falling from a starry sky illuminate this touching scene. (f. 98v)

53. *Hours of the Virgin*

FULL-PAGE PAINTING

In the upper part of the image is depicted the Holy Family's Flight into Egypt, as they flee Herod's henchmen who have been charged with putting to death the newborn Messiah. An angel (represented in the guise of a traveler carrying on his shoulder a stick from which is suspended a small cask) leads the donkey, which serves as a mount for the Virgin and the Child Jesus, by its simple, rustic bridle made of rope. Availing himself of a long staff, St. Joseph follows with great strides, without taking his eyes off them. The Virgin, with a white veil over her head, and her blond hair, conforms to the type depicted in the paintings devoted to the Presentation at the Temple and to her Coronation (Pl. 50 and Pl. 54).

The lower part of the page is devoted to a scene taken from the Apocrypha and often illustrated in Books of Hours dating from the fourteenth century: the miracle of the field of grain. Along the way, the fugitives have crossed a field which has recently been sown, and behind them the grain has sprung up so quickly that it is ready to be harvested by the time Herod's men arrive. The men question a peasant to learn whether he has seen the group they are seeking pass that way. "Yes," the peasant replies, "they crossed this field when the grain had not yet begun to grow." Discouraged, and assuming that the peasant was referring to travelers who had passed there several months before, the pursuers then turn back. The roaring lion which we perceive on the hill to the right of the painting symbolizes Herod, to whom the words of Ezekiel on the "roaring and ravening lion" have often been applied. Curiously enough, and without doubt to emphasize the dominant importance of the figures in the upper part of the painting, the envoys of Herod and the peasants whom they interrogate have been represented on a smaller scale, even though they appear in the foreground. In the preceding century, notably in certain manuscripts emanating from the workshop of Jean Pucelle, the same scene was painted at the bottom of the page, on a very reduced scale.

The two knights who question the peasant have been faithfully copied from one of the Wise Men and a knight in his entourage, painted by the Limbourgs in the *Très Riches Heures* of Jean de Berry (f. 51v). As for the peasants, one could compare them with those who appear to illustrate the same scene in the *Heures à l'usage de Troyes*, in the Walters Art Gallery of Baltimore (MS. 741, f. 54), and in the *Heures à l'usage de Paris*, in the Harvard College Library (MS. Richardson 42), called *Heures de Buz*. These two manuscripts, which are closely related, are generally attributed to the same workshop as that which produced the *Rohan Hours* (Introduction II). (f. 99)

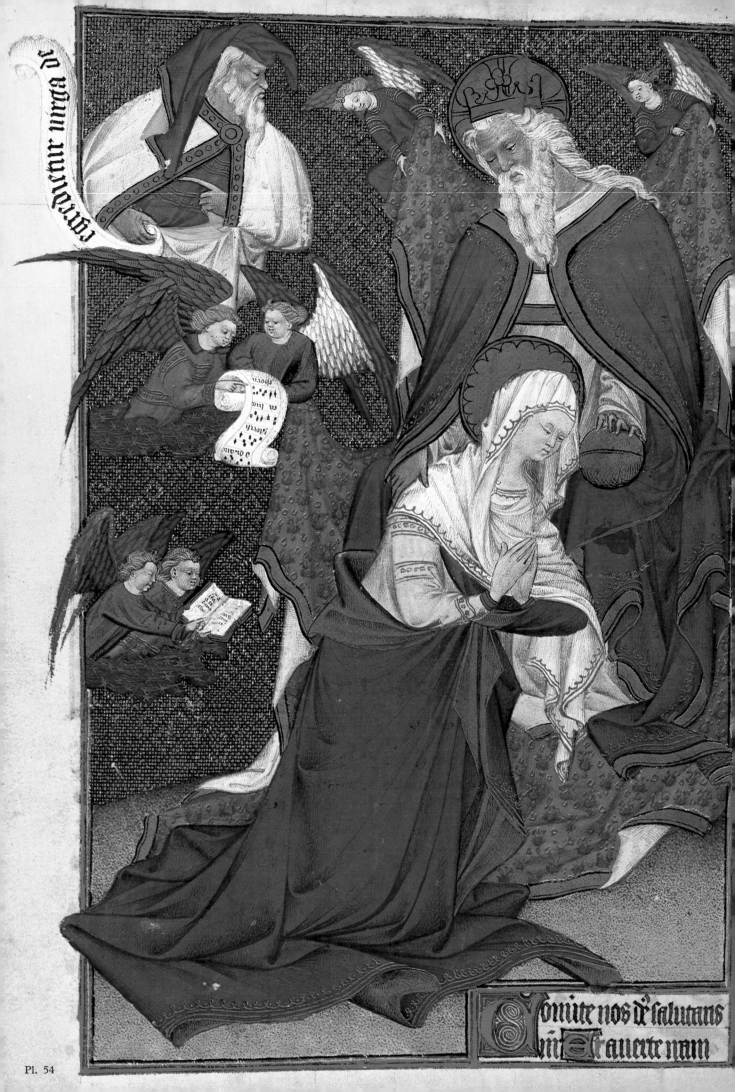

Pl. 54

tuam a nobis

Deus in adiutorium meum
intende

Domine ad adiuuandum
me festina

Gloria patri et filio et spiritu sco

Sicut erat in principio et nunc
et semper et in secula seculorum
Amen. Alleluya

Sancta dei genitrix

Usqz quo domine obliuisce
ris me in finem: usqz quo
auertis faciem tuam a me.

Quandiu ponam consilia m

Et que iosep ueoit son pere iacob.
seuesie christianite qui reuoit sainct
pere et tous les aultres qui gettent uis
les chapeaulx de la uielle loy.

Pl. 55

54. *Hours of the Virgin*

FULL-PAGE PAINTING

The theme of the Virgin receiving, after her Assumption into Heaven, the crown which consecrates her preeminent role in the Incarnation and the Redemption, was illustrated many times in Books of Hours dating from the fourteenth century. It is, nevertheless, treated here in a very original manner, which varies on several important points from iconographic tradition.

The Virgin is not literally crowned here, but only accepted into Heaven, and it is not the Son who receives her, as is customary, but the Father—represented in all His majesty in the guise of an old man with white hair and beard. The artist has given the Virgin the same configurations as in the paintings which he devoted to the Presentation at the Temple (Pl. 50) and to the Flight into Egypt (Pl. 53).

Ordinarily, the composition is of greater breadth, but here the artist has been obliged by the proportions of the page (which he had to cover entirely) to place the Virgin just below the Father, who affectionately rests a hand on her shoulder. The remaining free space to the left of the two principal personages animating the scene has been occupied by the head and shoulders of the prophet Isaiah, holding a phylactery upon which are inscribed a few words from his celebrated prophecy: *"Egredietur virga de radice Jesse."* ("And there shall come forth a stalk out of the root of Jesse.") Below the Virgin, angels sing a hymn to her that is often reserved for the Feast of the Assumption. On the scroll which they hold in their hands we can read a few words: *"O quam magnifica luce choru* [*scabit stirpis David*]." ("Oh, what a splendid light shall shine from David's offspring!") Neumes painted on the scroll constitute an authentic Gregorian melody.

Even further below, two other angels decipher, from the same book, a response from the Office of the Assumption: "Exalta[t]a es super cho[ros an]gelorum."("You have been raised above the choirs of angels.")

(f. 106v)

55. *Hours of the Virgin*

MARGINAL PAINTING. Bible moralisée.

LEGEND *"Ce que Josep reçoit son pere Jacob senefie Jhesu Crist qui reçoit saint Pere et tous les aultres qui gettent jus les chapeaux de la vielle loy."*

This moralization likens the reception of Jacob by his son Joseph (Genesis XLVI, 29) to the welcome into His Church offered by Christ to St. Peter and to all those who free themselves from the overly narrow precepts of the "chapters" of the ancient law, in order to conform henceforth to Christ's teaching. The apostles, among whom we can recognize St. Peter, St. Paul, and St. John—whose resemblance here to the large portraits dedicated to them in succeeding folios may be noted—fling into oblivion a great scroll bearing the inscription "old law," which symbolizes the Mosaic code. The turrets of the castle stronghold within which they shut away the scroll (now useless), are surmounted by pennants bearing the arms of the Rohan, which were added to the painting after the completion of the volume. (f. 107)

qy lui aporent deuant elle et lui
descouurent tout en apert. et la pucel
le qui commande qui soit gardes et
bien nourris. et dit elles tu sens
muens .

animabus famulorum famu
larumq̃ tuarum remissionem
cunctorum tribue pcecatorum
ut indulgentiam quam sem
pr optauerunt pijs supplicati
onibus consequantur. Qui
uiuis et regnas deus. jPer omni
a secula secula seculorum. Ame
fidelium anime per miseri
cordiam dei requiescant in pa
ce. Amen.

Pater noster.

Cy commencent les matines
de lacroix.

Pl. 56

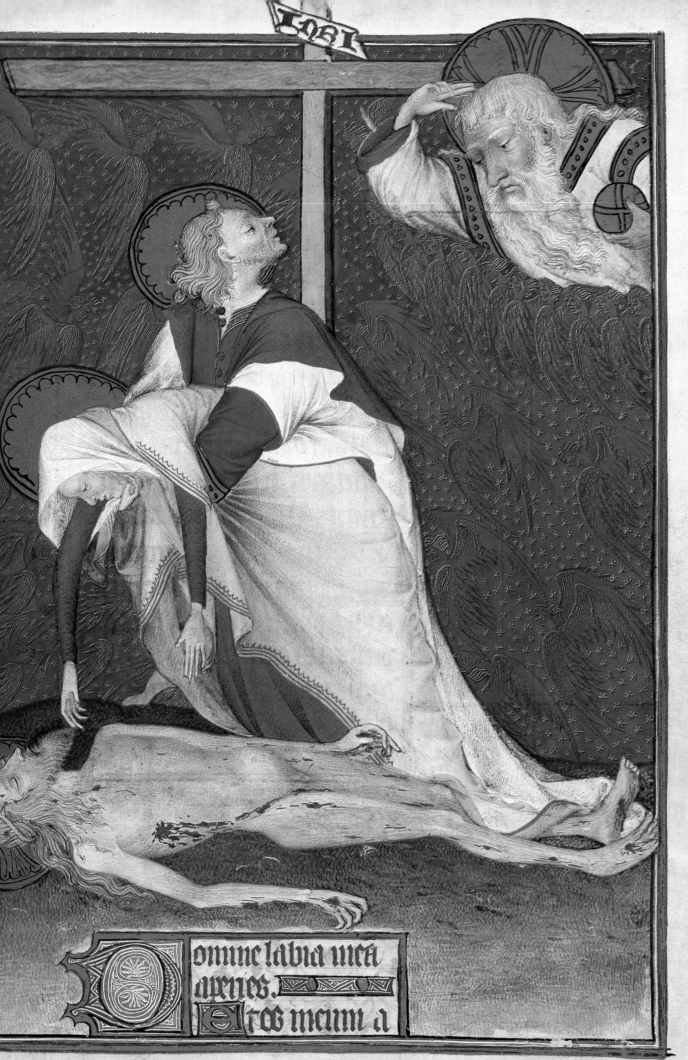

Pl. 57

56. *Litanies. Hours of the Cross*

MARGINAL PAINTING. Bible moralisée. Exodus II, 9–10.

LEGEND *"Icy lui aportent devant elle et lui desceuvrent tout en apart et la pucelle qui commande qui soit gardés et bien nouris et dit: 'Enfes, tu seras miens.' "*

 A servant discreetly presents to Pharaoh's daughter the child Moses, whom she has just rescued from the waters of the Nile, and whose cradle of bullrushes is visible in the foreground. Pharaoh's daughter commands that he be protected and brought up in her father's palace. The legend attributes a speech to her which the biblical text does not directly quote: "Child, you shall be mine." (f. 134v)

57. *Hours of the Cross*

FULL-PAGE PAINTING

This painting of the Lamentation of the Virgin is assuredly one of the most extraordinary in the entire volume. It denotes, in the painter, an artistic temperament of exceptional vigor and originality. Here, as elsewhere, the Master of the *Rohan Hours* cares little for the rules of perspective, and the proportions of several personages are deliberately altered; but this very disdain for established principles serves to heighten the dramatic realism of an almost geometric composition.

The body of Christ, taken down from the Cross and stretched out on the ground, the Virgin who throws herself toward Him, her arms extended, and St. John, who holds the Virgin in his arms—are all arranged here in such a way as to form a large right-angled triangle whose hypotenuse is parallel to the diagonal of the rectangle framing the picture.

Christ is represented naked and bleeding in all his pitiable, wounded humanity. The Virgin, grown older, her hair disheveled under her veil, is about to swoon, and her limp arms seem no longer to have even strength enough to embrace this dearly beloved Son, upon whom she falls rather than throws herself. St. John directs toward God the Father a look which seems filled with bitter reproach. The artist has given him a very individualized physiognomy, found elsewhere in other paintings of the same volume (Pl. 58 and Pl. 63).

The immense head and shoulders of God the Father rise out of a firmament studded with golden stars, where legions of seraphim (lightly sketched in gold) create a delicate fluttering of wings.

The scene is a classic one, but nowhere else does French illuminated art attain a comparable degree of poignant intensity. (f. 135)

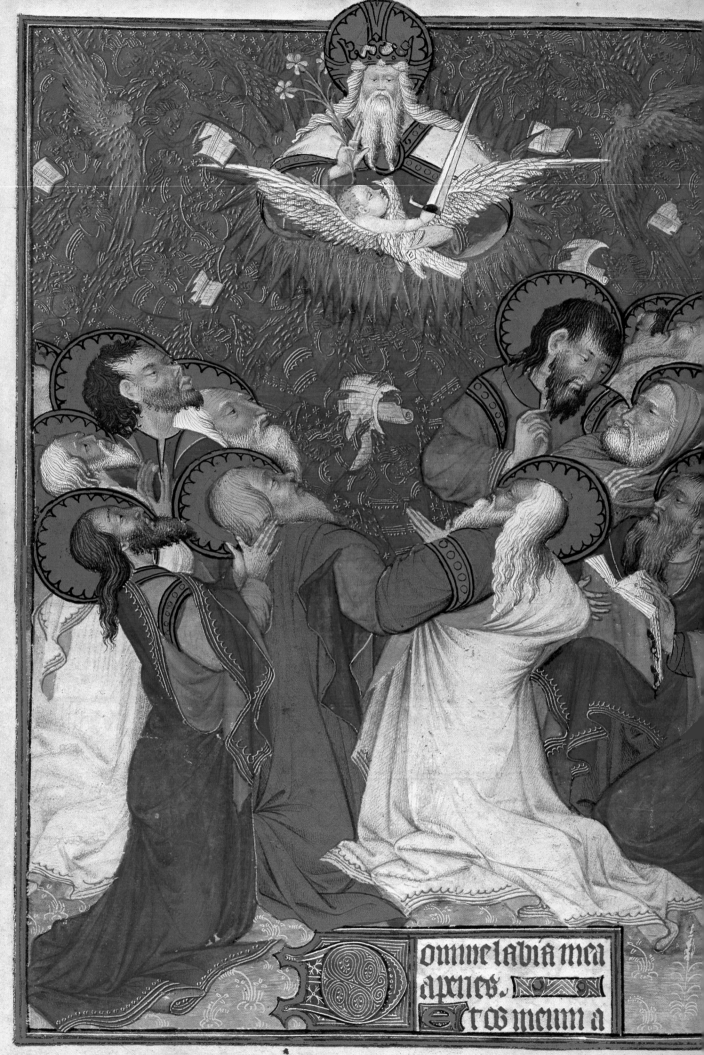

Pl. 58

nunaabit laudem tuam.

Deus m adiutozum
meum mtende.

Domine adiuuandum me
festina

Gloria patri et filio z spiri
tu sancto.

Siait erat m punapio z nūc
et semper et m secula seailozum
amen. Alleluia

Nobis sancti spiritus gra
tia sit data. De qua uir
go uirginum fuit obumbzata
Cum per sanctum angelum

E que moyse garde ses bestes. Senefie
Jhucrist qui garde son peuple. Le
feu qui art en leubeespine. Senefie le feu
qui art en leuuangille sur les Juir. sur
les metaexs qui onques ne aeurent ou
feu de leuuangille.

Pl. 59

CE que moyse fen la douce
leaue deuant pharaon et
celle mnti en sang. senefie les mel
sauges de dieu qui fierent en leaue de
diuinite et de la viue parole de
dieu par deuant le deable. et celle
doulce eaue se mue sur mauueise
gent en sang.

sa sainte grace et misericorde no
doint aier et entendement puis
sance et volente damander nos
vies et dauoir vraye confessio
et repentance et de faire satista
cion de tout queque ie mespris
enuers mon createur et sauue
ihu crist. en telle maniere que
le puisse dignement receuoir a
leure de mon trespassement. si
que ie puisse auoir la ioye pardu
rable. Amen

Aue maria gratia. &c.

Pl. 60

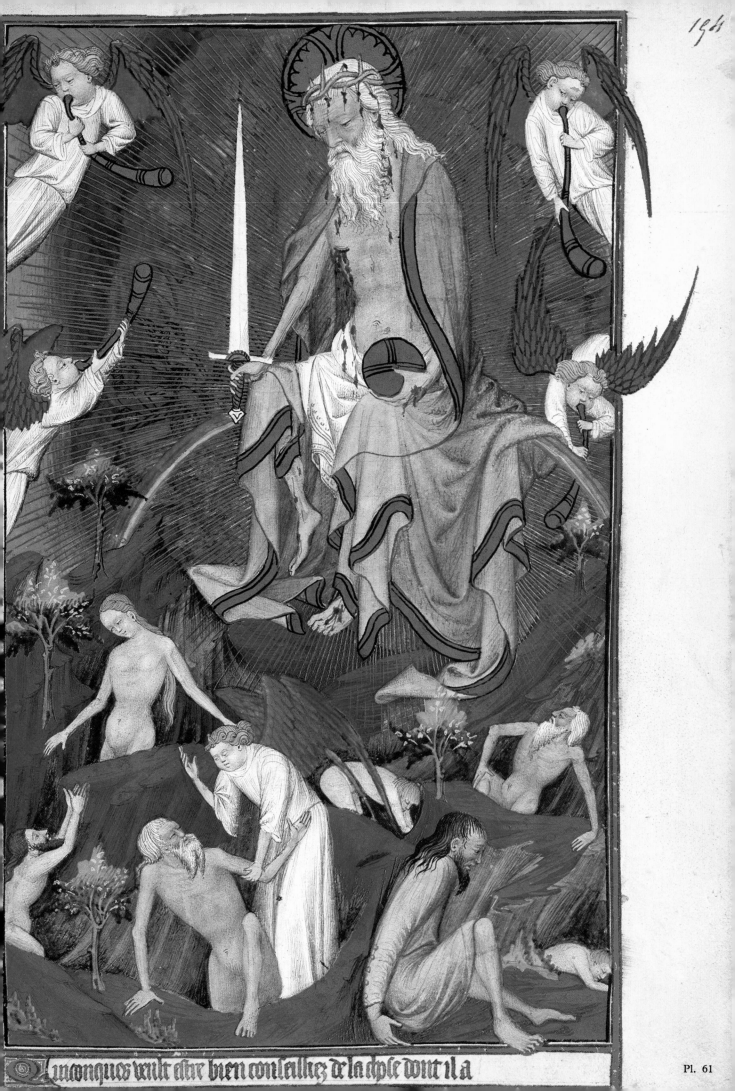

Quiconques veult estre bien conseilliez de la chose dont il a

Pl. 61

Ici se retourna moyse ⁊ sa sœur en une terre par le comandement dieu ⁊ se escrivirent tant de miserieilles quil durent faire mourir Pharaon et ses gens

ques moy en paradis. Sire si vraiement comme ce fut voir ie vous requier que vous me vueilliez consaillier en lonneur de vous et nostre loy.

Pater noster qui es in celis. ⁊⁊

Amie maie croir adorner qui du corps dieu fus a ourner et de la sueur ardulee et de son sanc enluminee par ta vertu par ta puissance deffens mon corps de meschance et mettroie par ton plaisir ⁊ maiz costes puisse mourir. Amen.

Ad vesperas mortuorum aiii. Placebo. psalmus

Pl. 62

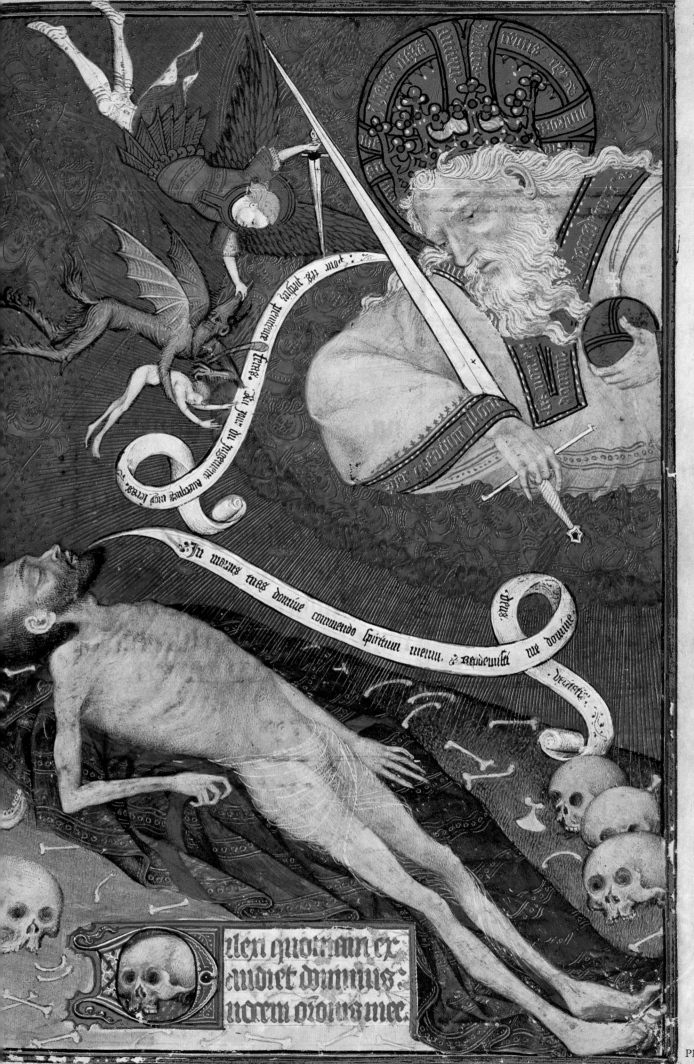

Pl. 63

58. *Hours of the Holy Spirit*

FULL-PAGE PAINTING

At Pentecost, the Apostles were gathered together in the cenacle in Jerusalem, after the Ascension, when the Holy Spirit descended upon them in the form of tongues of flame, to confirm them in their mission. Here, the scene which, in Books of Hours, traditionally illustrates the beginning of the hours of the Holy Spirit, is situated outdoors (as indicated by the small tufts of vegetation appearing in the foreground of the painting) and—a rare occurrence—the Virgin is not present. The Apostles, kneeling, form a large semicircle. The one in the foreground, on the right, dressed in an ample pink cloak is faithfully copied from a figure painted by the Limbourgs at the end of the *Tres Belles Heures de Notre Dame* (p. 240). Above the Apostles, upheld by a flock of fiery seraphim, appear the three Persons of the Holy Trinity, closely joined to one another. The Father, crowned and haloed, holds a flowering branch in His right hand (two of His fingers being extended in a sign of benediction); the Son, whose infant head appears above the broad wings of the dove symbolizing the Holy Spirit, holds in His fist the heavy sword of justice, which the Father supports with His left hand. Numerous angels, whose silhouettes, delicately outlined in gold, barely stand out against the deep azure background of a starred sky which they all but obscure, sing the praises of the Lord. The scrolls and books from which they read their canticles punctuate the painting symmetrically with patches of white. A rather inferior copy of this opulent composition is found in the *Hours of Rene d'Anjou* (f. 87v); in it the Virgin has been discreetly reinserted. In this connection, it will be noted that the Apostle who appears here at the left of the painting and whose individualistic features closely resemble those of the St. John of the Lamentation in the *Rohan Hours* (Pl. 57) was not adopted by the painter of the *Hours of Rene d'Anjou* exactly as he was represented in the earlier painting. Quite possibly, this may be an actual portrait—perhaps even a self-portrait. (f. 143v)

59. *Hours of the Holy Spirit*

MARGINAL PAINTING. Bible moralisée.

LEGEND *"Ce que Moyse garde ses bestes senefie Jhesu Crist qui garde son peuple. Le feu Dieu qui art en l'aubeespine senefie le feu qui art en l'evangille sur les Juix, sur les mescreans, qui onques ne creurent ou feu de l'euvangille."*

The episode of Moses before the burning bush, perceived while he was watching his flock (Exodus III, 1) gives place here to a rather complex moralization. On the left, followed by His apostles, we see Christ who raises His eyes toward the heavens, where a flaming book is falling from the hand (which alone is visible) of God the Father. Three seated figures, who watch Christ with confidence, represent the people of God, whom He protects as did Moses his flock. The flaming book is the gospel; the fire emanating from it without consuming it symbolizes the eternal fire which threatens all those, Jews and unbelievers, who have not accepted the Gospel. (f. 144)

60. *The Fifteen Joys of the Virgin*

MARGINAL PAINTING. Bible moralisée.

LEGEND *"Ce que Moyse feri la doulce eaue devant Pharaon et elle mua en sang senefie les messaigés de Dieu qui fierent en l'eaue de divinité et de la vive parole de Dieu par devant le deable et celle doulce eaue se mue sur mauvaise gent en sang."*

This "moralization" on a text from Exodus (VII, 20) likens the transformation of the water into blood performed by Moses before the Pharaoh to the divine word preached by the Apostles before the demons (represented here opposite Christ and His disciples). We are told that when it falls upon the wicked, this living water of divine instruction is changed into blood, as a curse upon them. The demons hold a scroll on which Christ's words *"Docete omnes gentes"* ("Teach all nations," Matthew XXVIII, 19) have been gratuitously altered to read: *"Ones gemtes docite."* (f. 153v)

61. *The Seven Petitions to Our Lord*

FULL-PAGE PAINTING

At the end of the world, according to the Gospels; the Son of Man will appear on a cloud, manifesting great power and majesty, while angels, sounding the trumpet, will call the elect from the four corners of the earth. The dead will be raised, and after the Last Judgement, they will enter into Paradise, or be forever cast out into the darkness of Hell. In the numerous representations fifteenth-century illuminators have left us of this apocalyptic vision, it is usual to see Christ descending from the clouds, seated as He is here on a rainbow, bleeding, crowned with thorns, and almost naked under an ample cloak which often is nothing more than a shroud. Here Christ has a long white beard, and His white hair is that of an old man—probably to remind us that according to the Apocalypse (Douay: I, 14), the Son of Man will have "a head and hair white as wool and as snow." He holds in His hands the globe and the sword—symbols of His power and His justice. Dwarfed by the grandiose figure of their Judge, the dead emerge laboriously from their tombs. In the foreground, an angel helps an old man (evidently a patriarch) in his effort. Behind them, a young nude female, whose grace recalls certain silhouettes by the Limbourgs, represents, to all appearances, our mother Eve. She looks tenderly at a bearded Adam (redeemed at last from the sin she caused him to commit), who lifts suppliant hands toward his Savior. In contrast with this joy of the elect, two small figures, obviously outcasts, appear to be sinking back into the earth. In the immediate foreground, on the right, a figure seated by himself on the ground might represent all the human beings left alive on Judgement Day. He is clothed (whereas the resurrected figures are naked) and seems to be awaiting in anguish the decision which will seal his fate forever. (f. 154)

62. *The Seven Petitions to Our Lord.*
 Prayer to the True Cross.

MARGINAL PAINTING. Bible moralisée. Exodus X, 13 and ff.

LEGEND *"Icy se retourna Moyse, sy fery en une terre par le commandement Dieu; sy se esmeurent tant de sincerelles qu'il durent faire mourir Pharaon et ses gens."*

At the command of the Lord, Moses, surrounded by Aaron and another Israelite, strikes the earth with his rod before the Pharaoh (recognizable by his crown). Such a cloud of locusts then arises from the ground that the Pharaoh and his people believe their last hour has come. In their terror, the ruler and his courtiers hide their faces in their hands. (f. 158v)

63. *Office of the Dead*

FULL-PAGE PAINTING

This painting of the Last Judgement, undoubtedly the most famous in the *Rohan Hours,* together with that devoted to the Lamentation of the Virgin—Pl. 57, manifests the same vigor and originality as the latter. From a scene quite often found in Books of Hours dating from the years 1415–1420 and whose iconography rapidly became fixed, the artist has succeeded in making a striking composition which marks a turning point in the art and, one might say, in the thought of the fifteenth century. In the midst of a graveyard strewn with skulls and bones, an emaciated corpse forms a long diagonal emphasized by the embroidered drapery upon which he reposes. The artist has given him the same strongly individualistic features as St. John (Pl. 58). God the Father, whose immense head and shoulders fill a vast portion of a sky peopled with a cloud of almost disembodied angels, looks with compassion on the dead man. He holds in His hands the globe and the sword, symbols of His power as Supreme Judge. St. Michael, assisted by angels armed with lances, vigorously attacks a demon who is trying to take possession of the soul of the dead man, represented in the form of an adolescent nude. On the phylactery emerging from the mouth of the dead man can be read the opening words of the prayer for the dying: *"In manus tuas, Domine, commendo spiritum meum; redemisti me Domine, Deus veritatis."* (Into thy hands I commend my spirit; thou has redeemed me, O Lord, the God of truth (Psalms XXX, 6). God answers him in French verse, paraphrasing the words of Christ to the repentent thief: *"Pour tes Péchés pénitence feras. Au jour du Jugement avecques moi seras."* (For your sins you shall do penance. On Judgement Day you shall be with Me.) (f. 159)

transierunt beata maria semper
uirgine intercedente cum omnibz
sanctis ad perpetue beatitudinis
consortium peruenire concedas.

Deum deus omnium
conditor et redemptor
animabus famulorum famu
larumq tuarum remissionem
cunctorum tribue peccatorum
ut indulgentiam quam semp
optauerunt pijs supplicationi
bus consequantur. Qui uiuis z
regnas deus. per oïa sclā sclōr. X.

Diriget.

Ce senetie les faulx prelas
qui usent le corps dieu a
lautel.

Pl. 64

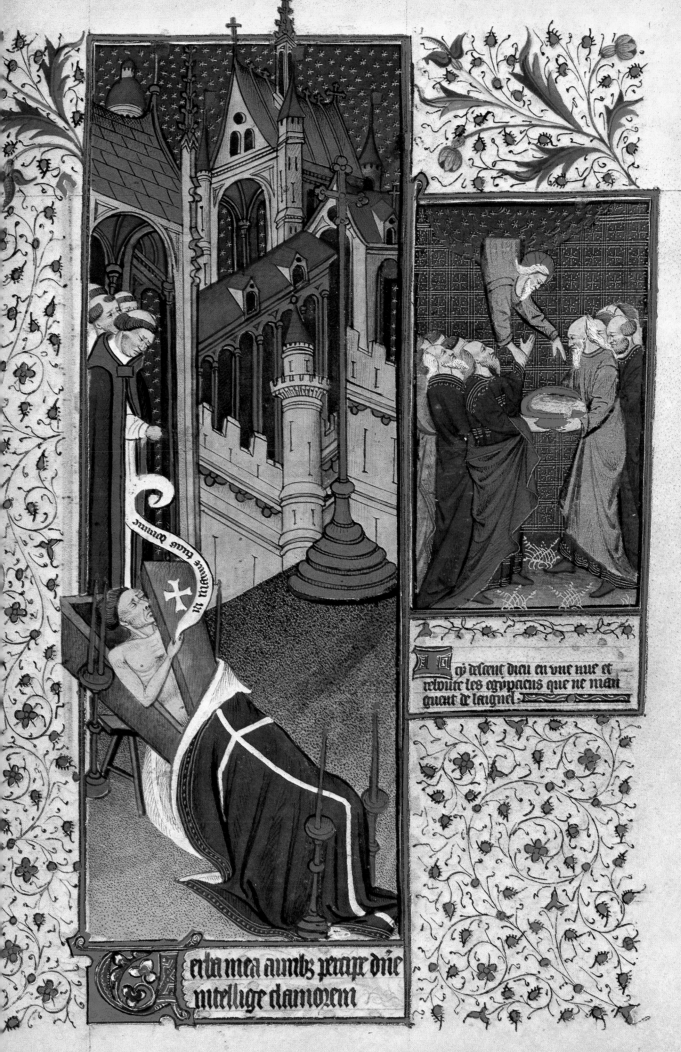

erba mea aurib; percipe dñe
intellige clamozem

Eā qi deseruit dieu en une nue et
reburt les egypciens que ne man
guent de laignel.

Pl. 65

64. *Office of the Dead*

MARGINAL PAINTING. Bible moralisée.

LEGEND *"Ce senefie les faulx prelas qui usent le corps Dieu a l'autel."*

A previous image from the *Bible moralisée* (not reproduced in this edition) represents the Israelites eating the paschal lamb before their departure from Egypt, fully prepared for their long journey (Exodus XII, 11 and 28), in accordance with the Lord's command. This command is likened, in the present moralization, to the obligation of every good Christian to take Communion only when in a state of grace, and thus amounts to a condemnation of those unworthy prelates who are not afraid to celebrate Mass while in a state of mortal sin. Here, under the decorative arches of a Gothic chapel, a group of these perverse "prelates" consecrate the sacred elements, which become the very body of Christ, appearing on the altar in a luminous halo which one of the officiating priests holds in his hands.

(f. 166v)

65. *Office of the Dead*

MAIN PAINTING

A dead man in his coffin (whose lid, half-uplifted, has caused the pall to slip down) is represented outside a church or at the entrance to an enclosed cemetery. Advancing toward him, a procession of monks who will bless him chant the Office of the Dead.

This painting is a transposition of a page of the *Belles Heures of* Jean de Berry (f. 94v) where one sees the corpse of Diocrès, who died under the blow of an unjust accusation, miraculously affirming his innocence, in the choir of a church (Introduction, II).

MARGINAL PAINTING. Bible moralisée. Exodus XII, 48.

LEGEND *"Icy descent Dieu en une nue et reboute les Egypciens que ne manguent de l'aignel."*

The Lord, of whom we see only the head and shoulders emerging from the firmament, appears to a group of Egyptians who, like the Israelites, are preparing to eat the paschal lamb. Restraining the hand an Egyptian is about to plunge into the dish held by one of his compatriots, God forbids them this ritual meal which is reserved to the Israelites. (f. 167)

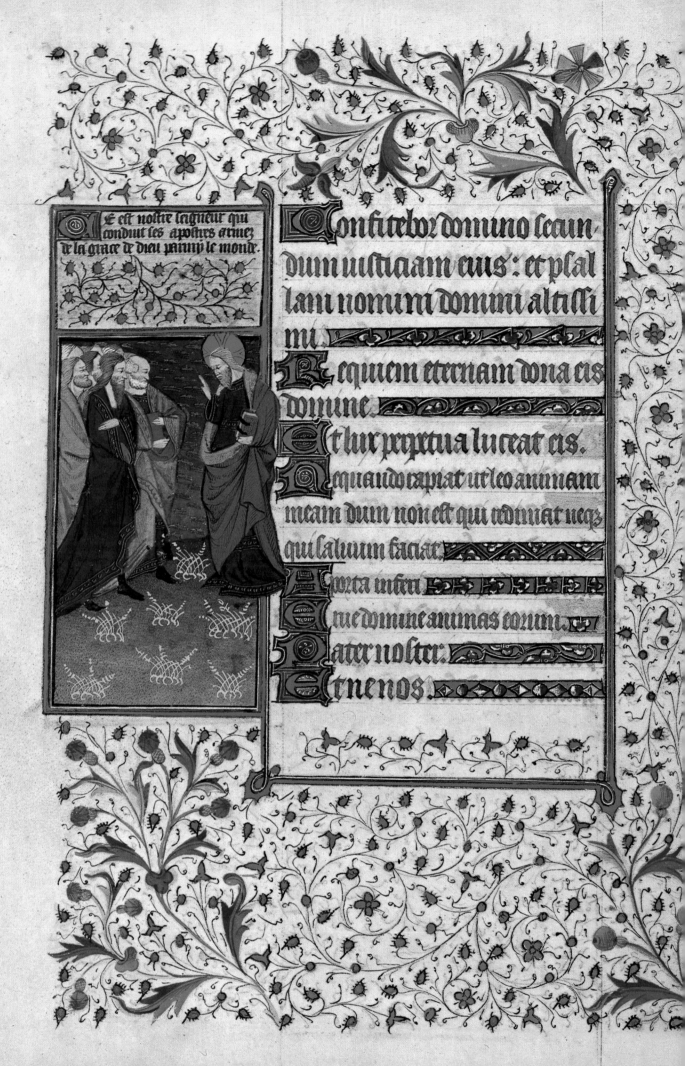

Ce est nostre seigneur qui conduit ses apostres armez de la grace de dieu parmy le monde.

Confitebor domino secundum iusticiam eius : et psallam nomini domini altissimi.

Requiem eternam dona eis domine.

Et lux perpetua luceat eis.

Nequando rapiat ut leo animam meam dum non est qui redimat neque qui saluum faciat.

Porta inferi

Erue domine animas eorum.

Pater noster.

Et ne nos.

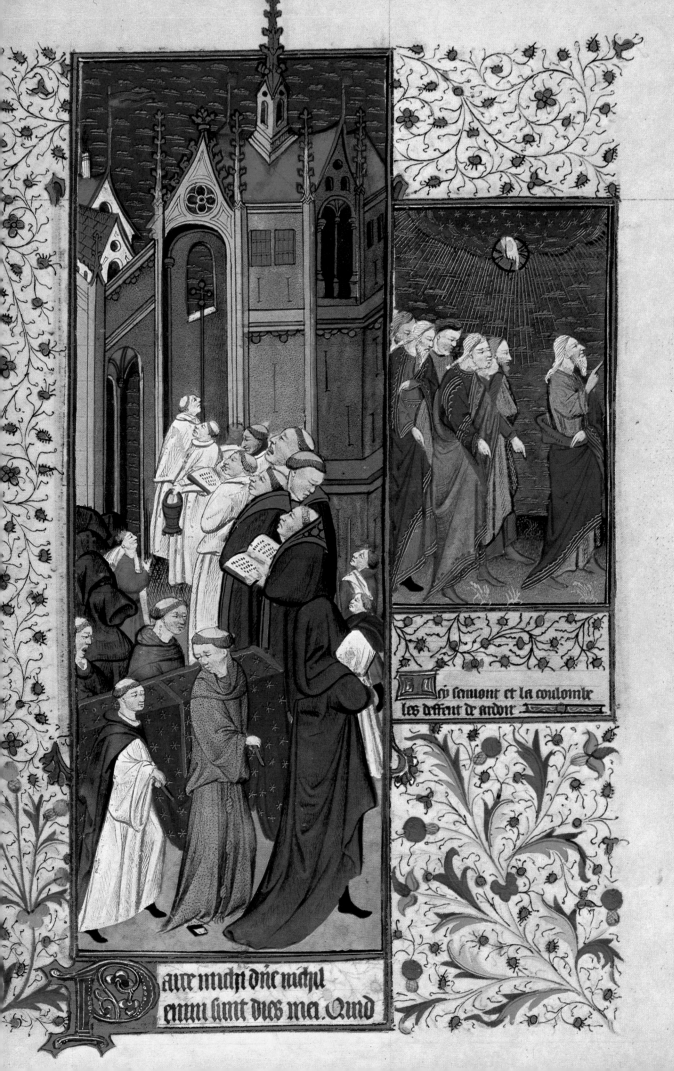

ccy semont et la coulombe
les deffent de ardoir

aute michi dne nichil
enim sunt dies mei. Quod

Pl. 67

66. *Office of the Dead*

MARGINAL PAINTING. Bible moralisée.

LEGEND *"Ce est nostre Seigneur qui conduit ses apostres armez de la grace de Dieu parmy le monde."*

 This moralization on the passage from Exodus (XIII, 21) illustrated in the preceding painting (not reproduced in this edition) compares the Hebrews being guided in the desert by the Lord to the Apostles being led across the world by Christ. On the right, Christ, holding the Gospel in His left hand, motions to the Apostles to follow Him. Leading the way are St. Peter and St. Paul, who also hold books (their Epistles) half-hidden in the folds of their cloaks. (f. 172v)

67. *Office of the Dead*

MAIN PAINTING

A solemn procession conducts a deceased man to the church where his funeral will be held. At the head of the procession, a white-robed monk carries the Cross, another monk behind him carries the basin of holy water, while four others, wearing copes, chant the Office of the Dead. One of them is turned toward the two candle bearers. A mourner follows, wrapped in a long black cloak, a portion of which covers his head. The coffin, draped in a black cloth embroidered with stars, is carried by four monks, among whom a Franciscan and a Dominican are recognizable by their habits. Other mourners bring up the rear of the procession. A small kneeling figure, hands clasped, appears to be asking for a benediction from the bearer of the holy water.

MARGINAL PAINTING. Bible moralisée. Exodus XIII, 21–22.

LEGEND *"Icy s'en vont et la coulombe les deffent de ardoir."*

With Moses marching before them, the Israelites leave Egypt and enter the desert. According to the Bible, a pillar of fire guided them by night and a pillar of cloud by day, preventing them from perishing from the heat or losing their way in the desert. Here the painting has represented only the finger of God (surrounded by a cruciformed halo) which, from the height of heaven, points the way for the fugitives. (f. 173)

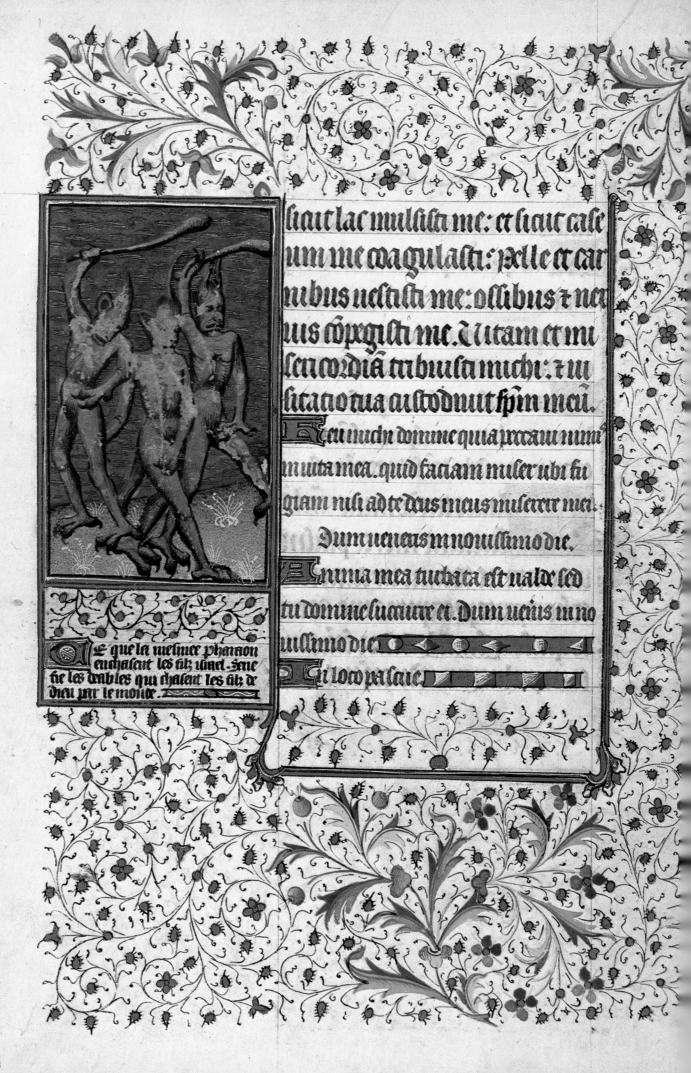

siait lac mulsisti me: et siait case
num me coagulasti: pelle et car
nibus uestisti me: ossibus z ner
uus corpegisti me. Vitam et mi
sericordiam tribuisti michi: z ui
sitacio tua ar stoduuit spm meu.

Leu michi domine quia prcaui nimi
in uita mea. quid faciam miser ubi fu
giam nisi ad te deus meus miserere mei.
Dum ueneris in nouissimo die.

Anima mea turbata est ualde sed
tu domine suaure ei. Dum uenis in no
uissimo die.

Si loco palaie

Pl. 68

Se que la mesnice pharaon
enchasent les fiz uhuel. sene
tie les deables qui chasent les fiz de
dieu par le monde.

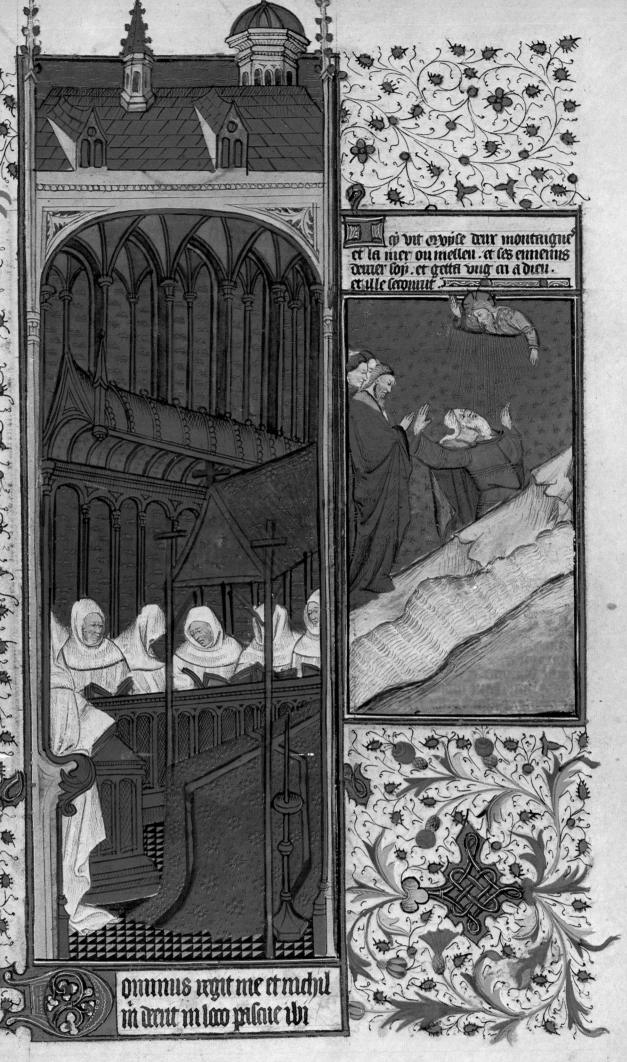

Pl. 69

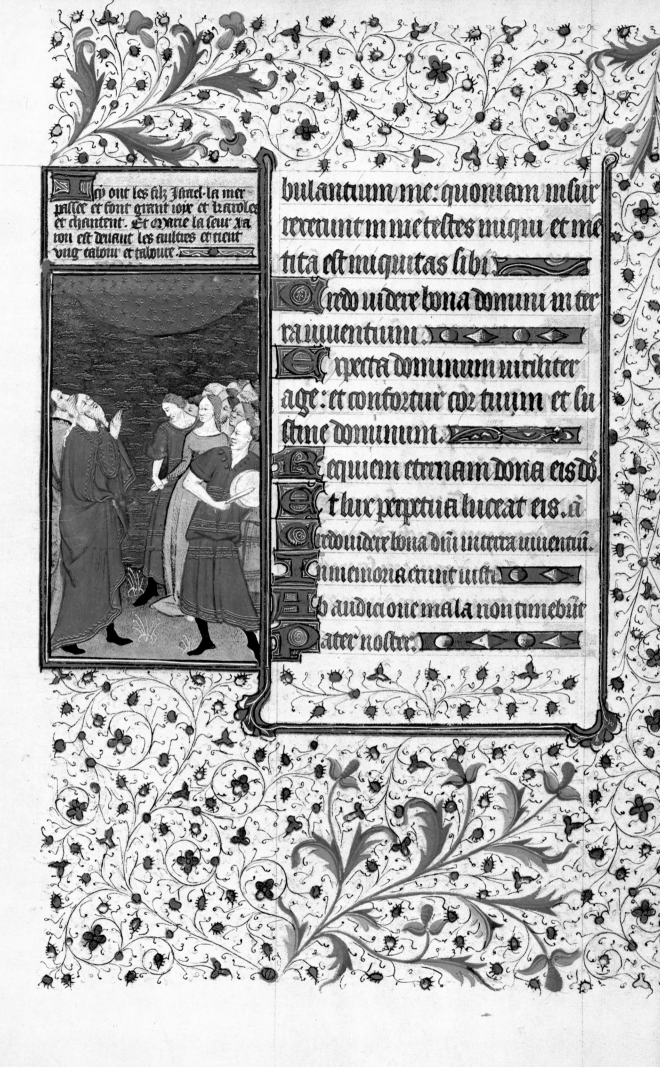

bulantium me: quoniam insur

rexerunt in me testes iniqui et me

tita est iniquitas sibi.

Credo uidere bona domini in ter

ra uiuentium.

Expecta dominum uiriliter

age: et confortetur cor tuum et su

stine dominum.

Requiem eternam dona eis dñ.

Et lux perpetua luceat eis. â

Credo uidere bona dñi in terra uiuentui.

In memoria eterna erit iustus

Ab auditione mala non timebit

Pater noster.

Ici ont les filz Jsrael la mer
passee et font grant ioie et karoles
et chantent. Et marie la seur Aa
ron est deuant les aultres et tient
vng talour et taboure.

Pl. 70

Quantas

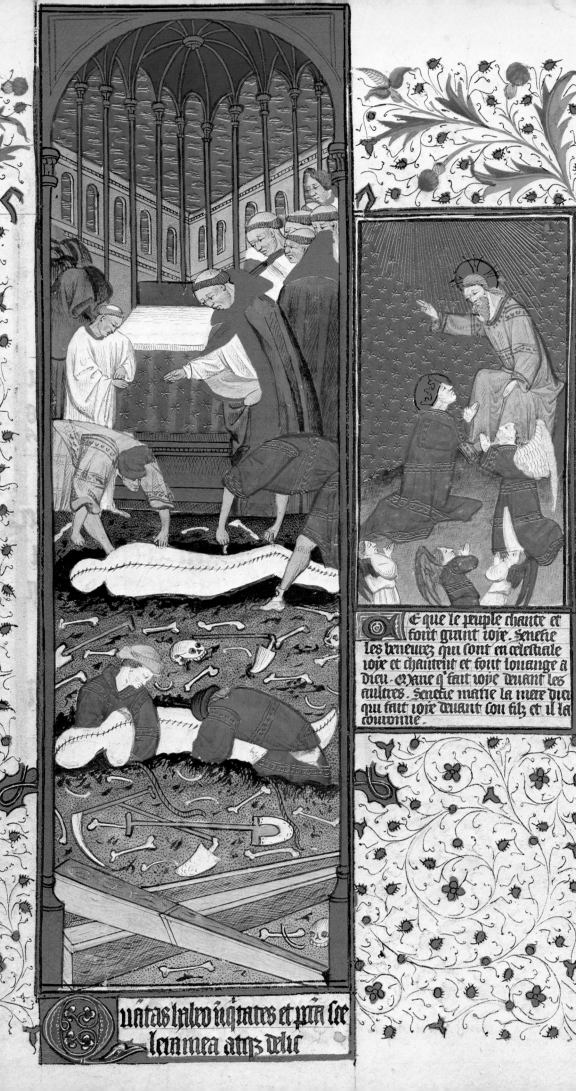

E que le peuple chante et
font grant ioie. Senefie
les beneurez qui sont en celestiale
ioie et chantent et font louange a
dieu. et ane q̃ fait ioie deuant les
aultres. Senefie marie la mere dieu
qui fait ioie deuant son filz et il la
couronne.

Quantas habeo iniquitates et pctã see
leuam mea atq̃ delic

Pl. 71

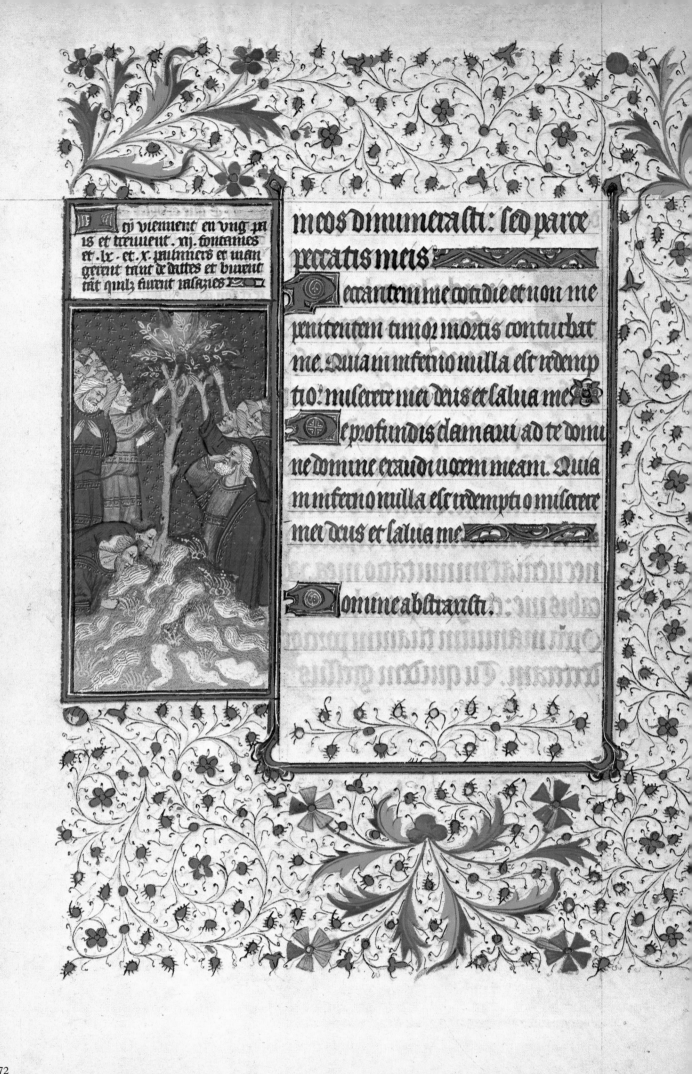

ij vieunent en vng pa
is et trruient . iij. fonteines
et . lx . et . x . puuuers et man
gerent tout de dattes et burent
tant quilz furent rasazies ⁊

m eos dinumerasti : sed parce
peccatis meis

Peccantem me cotidie et non me
pnitentem timor mortis conturbat
me. Quia in inferno nulla est redemp
tio: miserere mei deus et salua me

De profundis clamaui ad te domi
ne domine exaudi uocem meam. Quia
in inferno nulla est redemptio miserere
mei deus et salua me

Domine abstraxisti

Pl. 72

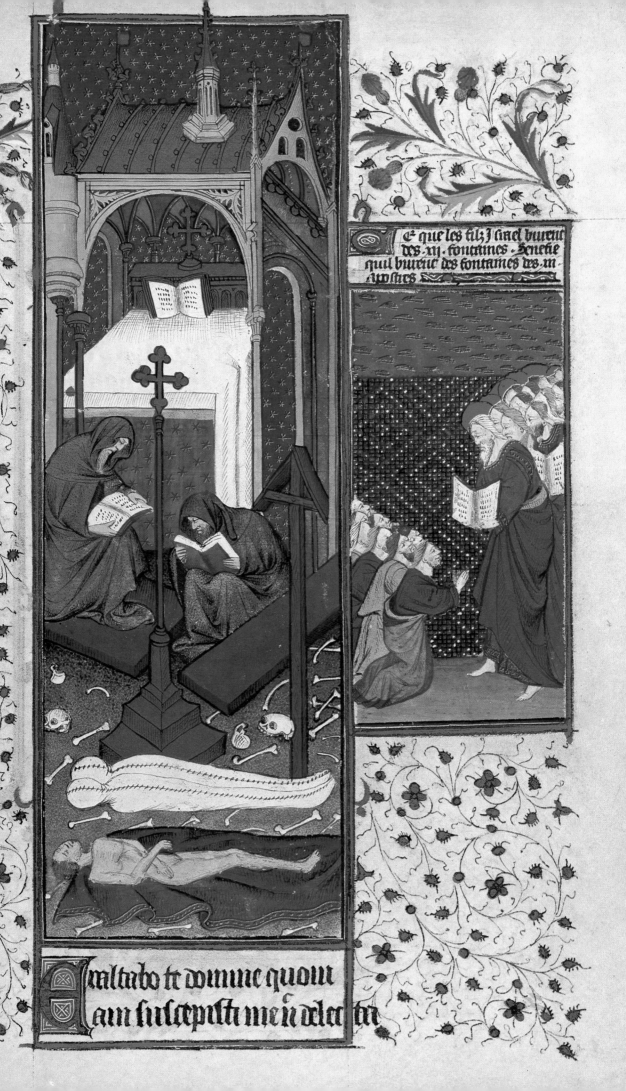

Et que les filz I sirel burent
des xij. fontaines. Senefie
quil burent des fontaines des xij
apostres

Exaltabo te domine quoniam
suscepisti me neq; delecta-

Pl. 73

68. *Office of the Dead*

MARGINAL PAINTING. Bible moralisée.

LEGEND *"Ce que la mesniee Pharaon enchasent les filz Israel senefie les deables qui chasent les filz de Dieu par le monde."*

This moralization on the pursuit of the Israelites by the Egyptians (Exodus XIV, 5–9), illustrated on the preceding folio, likens the Egyptians to the demons who persecute the children of God from one end of the world to the other. The artist has represented three of them here, in a guise as traditional as it is terrifying. (f. 175v)

69. *Office of the Dead*

MAIN PAINTING

In the choir of a church, white-robed monks seated in their stalls chant or recite the Office of the Dead, whose text they follow in their books. Before them, beneath a catafalque, reposes a coffin, covered with a pall embroidered with a large cross. A taper is placed against the base of the catafalque. This composition is closely inspired by the painting illustrating the Mass for the Dead in the *Belles Heures* of Jean de Berry (f. 221). In the latter painting, however, the monks are clad in black robes. The painter of the *Rohan Hours* has raised the mounting of the catafalque to permit a view of the entire row of monks—at the expense, it is true, of an error in perspective. The silhouette of the monk in the left foreground, and the sculptured ornament forming the arms of the stall, imitate very closely the painting by the Limbourgs. The same is true of the whole linear construction of the painting.

MARGINAL PAINTING. Bible moralisée. Exodus XIV, 10–15.

LEGEND *"Icy vit Moyse deux montaignes et la mer ou melleu et ses ennemis derrier soy et getta ung cri a Dieu et il le secourut."*

The legend and its illustration paraphrase rather freely the passage from Exodus where Moses, seeing himself menaced by the pursuing Egyptians, while the sea bars his way, beseeches the Lord to help him. From the height of heaven God addresses a reassuring gesture to him. The biblical text makes no mention of mountains blocking the path of the Israelites on either side, but this detail is already present in the Latin *Bible moralisée* of the thirteenth century. (f. 176)

70. *Office of the Dead*

MARGINAL PAINTING. Bible moralisée. Exodus XV.

LEGEND *"Icy ont les filz Israel le mer passee et font grant joye et karoles et chantent. Et Marie, la seur AAron est devant les aultres et tient ung tabour et taboure."*

Having crossed the Red Sea, the Israelites celebrate their safe passage with songs and dances. On the left, Moses lifts a hand toward heaven, as if to indicate to his people that they must give thanks to God alone. On the right, Mary, the sister of Aaron, plays the timbrel. (f. 181v)

71. Office of the Dead

MAIN PAINTING

In a cemetery adjoining a chapel, four gravediggers (whose tools can be seen lying on the ground) lower two corpses sewn into their shrouds, into the graves just dug. A monk wearing a cape and assisted by an acolyte gives them a final benediction, while other monks chant the Office of the Dead. On the left, some mourners hide their faces beneath their ample hoods. In the foreground, an open casket is placed on the ground, which is strewn with bones.

MARGINAL PAINTING. Bible moralisée.

LEGEND *"Ce que le peuple chante et font grant joye senefie les beneurez qui sont en celestiale joye et chantent et font louange a Dieu. Marie qui fait joye devant les aultres senefie Marie, la Mere Dieu, qui fait joye devant son filz et il la couronne."*

This moralization on the scene from Exodus represented on the preceding folio (Pl. 70), compares the joy of the Israelites after the passage over the Red Sea to that of the elect in Heaven, who sing the praises of the Lord. Aaron's sister prefigures the Virgin Mary (her namesake) who has the joy of finding her Son in Heaven, where He crowns her amid the angels. This scene of the coronation of the Virgin is encountered too frequently in Books of Hours to permit attribution to a precise model, despite certain similarities of composition here to a painting devoted to the same subject by the artist who illustrated a *Golden Legend* (Bibliothèque Nationale MS. fr. 242, f.A.) about 1405. (f. 182)

72. Office of the Dead

MARGINAL PAINTING. Bible moralisée. Exodus XVI, 27.

LEGEND *"Icy viennent en ung païs et treuvent xii fontaines et lx et x paumiers et mangerent tant de dattes et burent tant qu'ilz feurent rasaziés."*

In the course of their exodus the Israelites discover an oasis with twelve fountains and seventy palm trees. They are seen here drinking from the fountains, which gush out of the ground, and appeasing their hunger by eating the dates which grow on a palm three—represented, understandably enough, in the form of a western European tree. (f. 184v)

73. Office of the Dead

MAIN PAINTING

In a graveyard, a naked corpse laid out on an embroidered cloth, and two others (already sewn into their shrouds), await burial. Bones are strewn about on the ground, upon which stands an ornamented cross mounted on a column rising from a majestic pedestal, and a very plain wooden cross which is protected from the elements by a rustic pent roof. In the background, seated amidst the tombstones, two hermits read from large books. Behind them a chapel shelters an altar on which an open gospel [?] rests. This composition is very closely inspired by the painting which the Limbourg Brothers dedicated to the Office of the Dead, in the *Belles Heures* of Jean de Berry (f. 99). The Limbourg painting has also been imitated, even more faithfully, in the *Hours of Martin Le Roy* (f. 159) and in Bibliothèque Nationale MS. lat. 1156A (f. 114), in which the gravestones have been replaced by rocks with triple indentations. It seems that the common model for these last two manuscripts and for the *Rohan Hours* could only have been the *Belles Heures* or a "model" of the Limbourgs which might have found its way to the Rohan workshop.

MARGINAL PAINTING. Bible moralisée.

LEGEND *"Ce que les filz Israel burent des xii fontaines senefie qu'il burent des fontaines des xii apostres."*

The twelve fountains discovered in the desert by the Israelites and represented on the preceding folio (Pl. 72), symbolize the teaching given by the twelve apostles, on the right, who hold open books for the faithful, seen kneeling respectfully on the left. (f. 185)

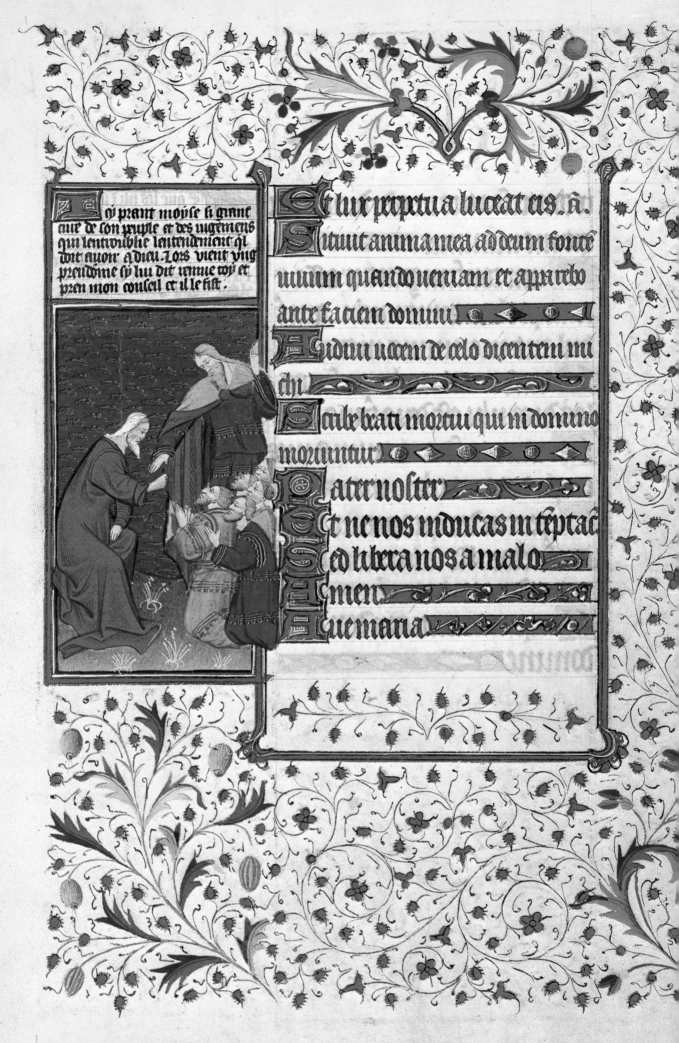

Comment prant moyse si grant
cure de son peuple et des iugemens
qui lentroublie lentendement il
dit auoir a dieu. Lors uient ung
preudomme si lui dit retourne toy et
pren mon conseil et il le fist.

Et lux perpetua luceat eis. â.

Sitiuit anima mea ad deum fontem
uiuum quando ueniam et apparebo
ante faciem domini

Audiui uocem de celo dicentem mi
chi

Scite beati mortui qui in domino
moriuntur

Pater noster

Et ne nos inducas in teptac

Sed libera nos a malo

Amen

Aue maria

Pl. 74

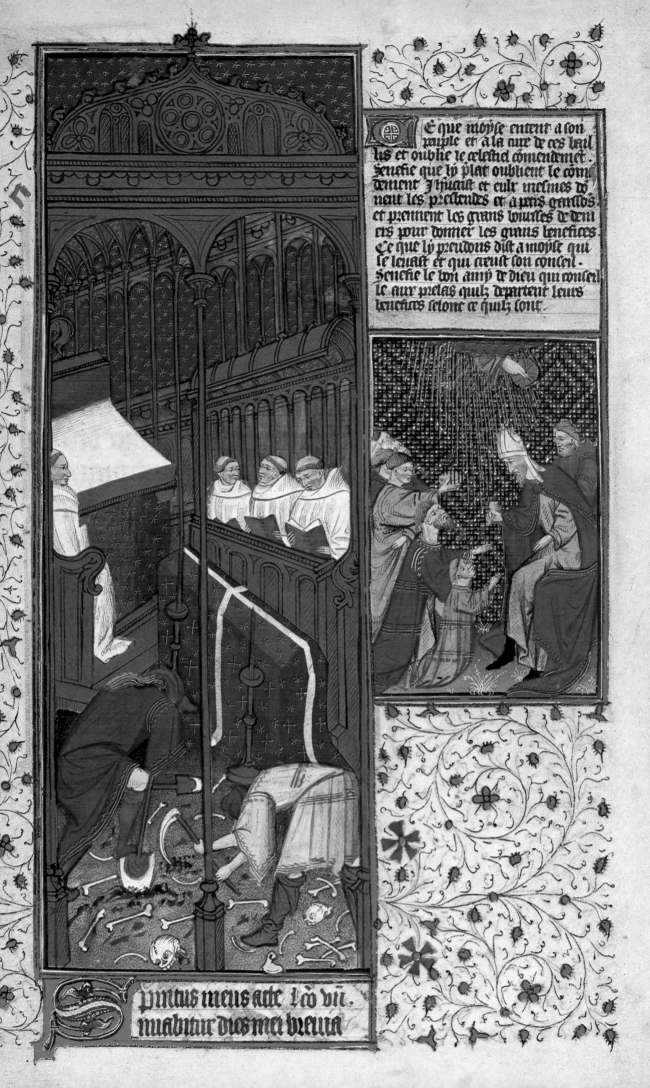

Et que moÿse entent a son
peuple et a la aÿue de ces baïl
lis et oublie le celestiel comendemet.
Senefie que lÿ plat oublient le com
dement Ihuciist et eulx mesmes do
nent les presendes et a pris grandos
et prennent les grans usuríes de deni
ers pour donner les grans benefices
Ce que lÿ preudons dist a moÿse qui
se leuast et qui creust son conceil.
Senefie le bon amÿ de dieu qui conseil
le aux prelas quilz departent leurs
benefices selonc ce quilz sont.

Spũtus meus attenuabit [u
nuabitur dies mei breuia

Pl. 75

74. *Office of the Dead*

MARGINAL PAINTING. Bible moralisée. Exodus XVIII, 13 & ff.

LEGEND *"Icy prant Moyse si grant cure de son peuple et des jugemens qu'il entroublie l'entendement qu'il foit avoir à Dieu. Lors vient ung preudomme sy lui dit: 'Remue toy et pren mon conseil' et il le fist."*

On the left, Moses, overly occupied with the material needs of his people, has forgotten God. A wise man of Israel, standing on the right, admonishes him to change his attitude; this Moses will do.

(f. 191v)

75. *Office of the Dead*

MARGINAL PAINTING. Bible moralisée.

In the choir of a church, white-robed monks, seated in their stalls in front of the altar, chant the Office of the Dead around a coffin covered with a pall and surrounded with candlesticks. In the foreground, two gravediggers begin digging a grave in the cemetery nearby, where the ground is strewn with bones. This painting is directly inspired by the one devoted to the same subject by the Limbourgs in the *Belles Heures* of Jean de Berry (see also Pl. 73).

MARGINAL PAINTING. Bible moralisée.

LEGEND *"Ce que Moyse entent à son peuple et a la cure de ces bailles et oublie le celestiel commendement senefie que ly prelat oublient le commandement Jhesu Crist et eulx mesmes donnent les presbendes et a petis garssons et prennent les grans boursses de deniers pour donner les grans benefices. Ce que ly preudons dist a Moyse qui se levast et qui creust son conseil senefie le bon amy de Dieu qui conseille aux prelas qu'ilz departent leurs benefices selonc ce qu'ilz sont."*

Moses, whom we saw on the preceding folio (Pl. 74), too exclusively concerned with the material needs of the Israelites, symbolizes, the legend tells us, those prelates who forget Christ's commandments, notably by indulging in simony. The one represented here is shown accepting money for granting benefices to the highest bidder, or assigning prebends to persons who are too young, in violation of canon law. Behind this prelate, a man of integrity, inspired by God (whose haloed hand guides him from on high), counsels the corrupt bishop to consider only the merits of the candidates and their aptitude for the duties which they solicit. (f. 192)

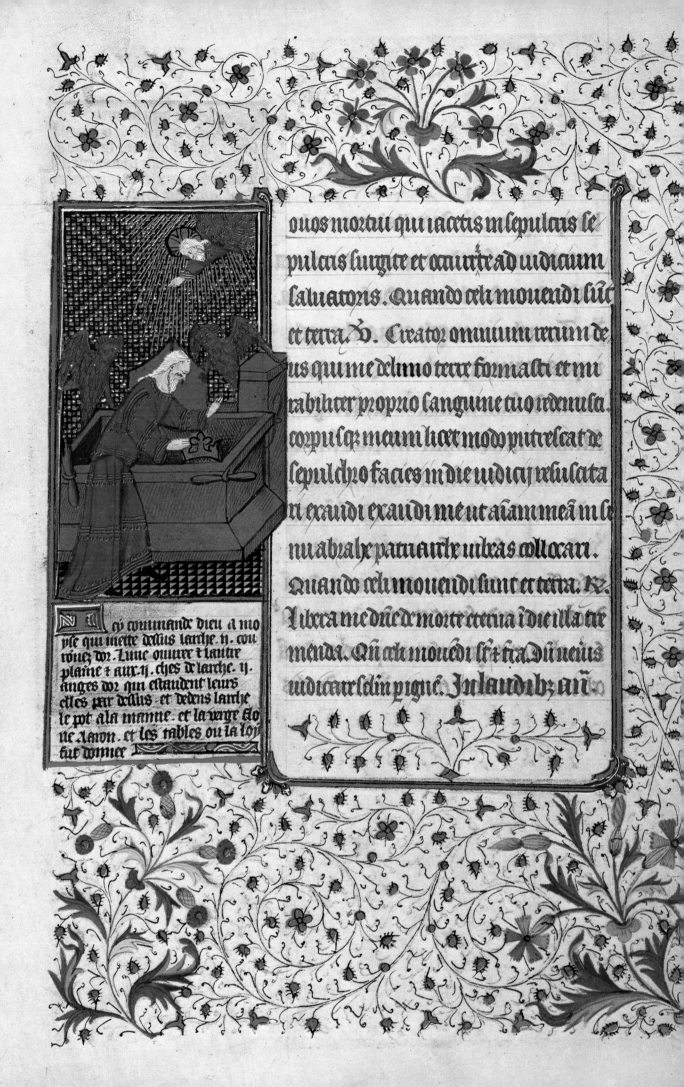

 onos mortui qui iacetis in sepulcris se
pulcris surgite et occurrite ad iudicium
saluatoris. Quando celi mouendi sūt
et terra. ʋ. Creator omnium rerum de
us qui me de limo terre formasti et mi
rabiliter proprio sanguine tuo redemisti.
corpusʒ meum licet modo putrescat de
sepulchro facies in die iudicii resuscita
ri exaudi exaudi me ut aiam meam in se
nu abrahe patriarche iubeas collocari.
Quando celi mouendi sunt et terra. ꝶ.
Libera me dñe de morte eterna ĩ die illa tre
menda. Qñ celi mouendi st̃ t tĩa Dũ neuis
iudicare sclm in igne. In laudibʒ an̄.

Pl. 76

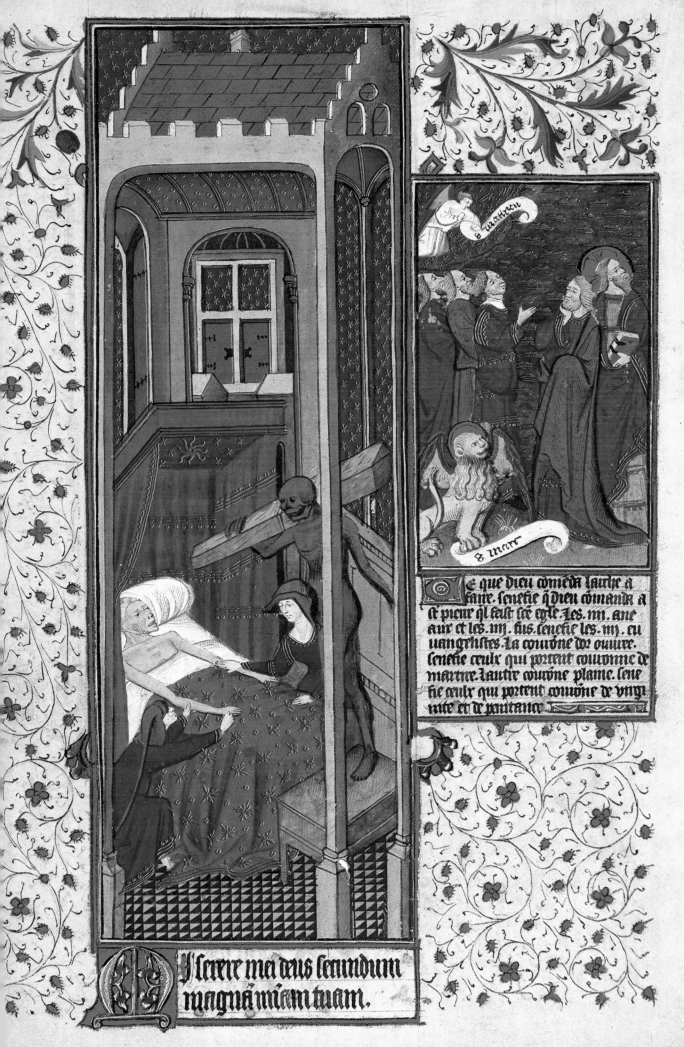

E que dieu cōmēdā lautre a
fatre. senefie q̃ dieu cōmanda a
st pieue q̃l feust sꝭe egl̃e. Les .iiij. ane
aux et les .iiij. bus. senefie les .iiij. eu
uangelistes. La couroñe dos ouurer.
senefie ceulx qui portent couroñe de
martre. Lautre couroñe plarie. sene
fie ceulx qui portent couroñe de virgi
nite et de penitance.

Iserere mei deus secundum
magnam miam tuam.

Pl. 77

76. *Office of the Dead*

MARGINAL PAINTING. Bible moralisée. Exodus XXV, 11 & 18–20.

LEGEND *"Ici commande Dieu à Moyse qui mette dessus l'arche ii couronnez d'or, l'une ouvree et l'autre plaine et aux ii chés de l'arche ii anges d'or qui estandent leurs elles par dessus et dedens l'arche le pot a la manne et la verge florie Aaron et les tables ou la loy fut donnee."*

God, from the height of heaven, gives Moses instructions as to the form which the ark and its accessories must have. It will be surmounted by two crowns of gold—one ornamented, the other plain. Placed above the ark will be two golden angels, who will cover it with their wings. Within the ark will be placed a vessel containing manna, Aaron's rod, which is miraculously flowering, and the Tables of the Law (seen here supported by the two angels). Actually, the text from Exodus speaks only of a single crown; it is the "table" which should bear two of them. Nor is anything further said in the sacred text about either the vessel for the manna or Aaron's rod. (f. 195v)

77. *Office of the Dead*

MAIN PAINTING

In a house whose architecture and furnishings reveal the affluence of the owner, a dying man is stretched out on his bed, attended by two members of his family. His emaciated features are already shriveled with agony. Death appears at the door of the bedchamber, bearing a coffin on his shoulder.

MARGINAL PAINTING. Bible moralisée.

LEGEND *"Ce que Dieu commenda l'arche a faire senefie que Dieu commanda a St. Pierre qu'il feist saincte Eglise. Les iiii aneaux et les iiii fus senefie les iiii euvangelistes. La couronne d'or ouvree senefie ceulx qui portent couronne de martire; l'autre couronne plaine senefie ceulx qui portent couronne de virginité et de penitance."*

The directions given by God to Moses for the construction of the holy ark (Pl. 76), prefigure the command given by Christ (seen here to the right of the painting) to St. Peter (whose back is turned to Him) for the founding of the Church. The four rings and four posts used to support the ark in processions symbolize the four evangelists, two of whom have been represented here in their symbolic form, identified by an inscription carried on a phylactery: a lion for St. Mark, an angel for St. Matthew. Of the two crowns which must be placed on the ark, one, ornamented, represents the martyrs; the other, simpler, represents the elect who have the right to the crown of virginity and penitence.

(f. 196)

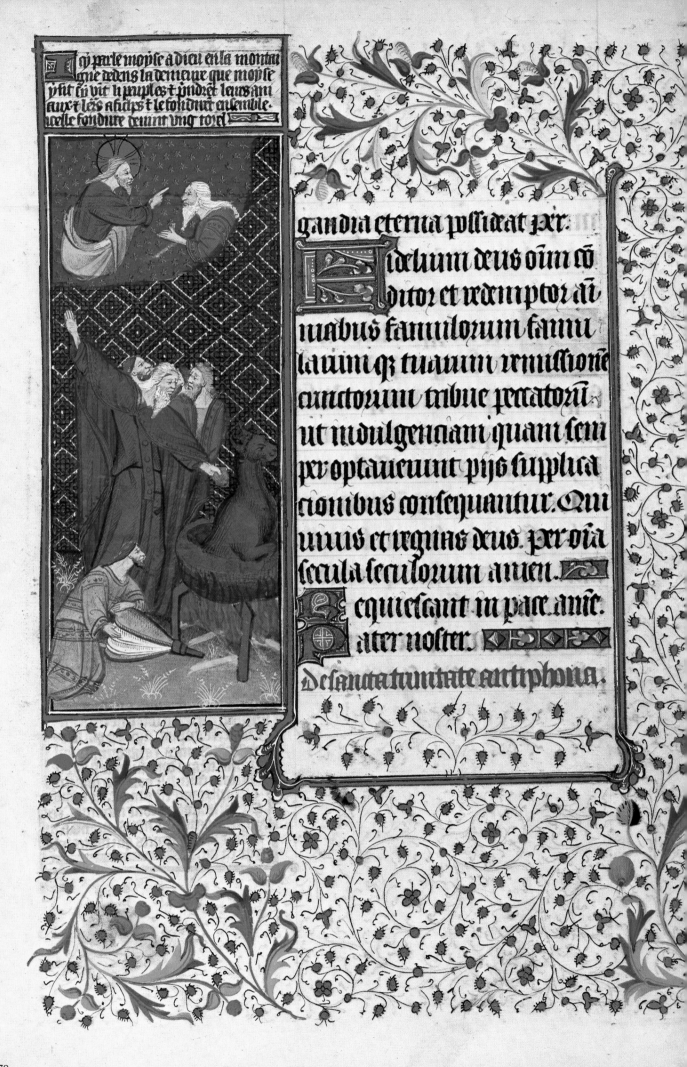

Gaudia eterna possideat per.

Fidelium deus oim co
ditor et redemptor ai
mabus famulorum famu
larum er tuarum remissione
cunctorum tribue peccatorii
ut indulgenciam quam sem
per optauerunt pijs supplica
cionibus consequantur. Qui
uiuis et regnas deus. per oia
secula seculorum amen.

Requiescant in pace. amē.

Pater noster.

De sancta trinitate antiphona.

Pl. 78

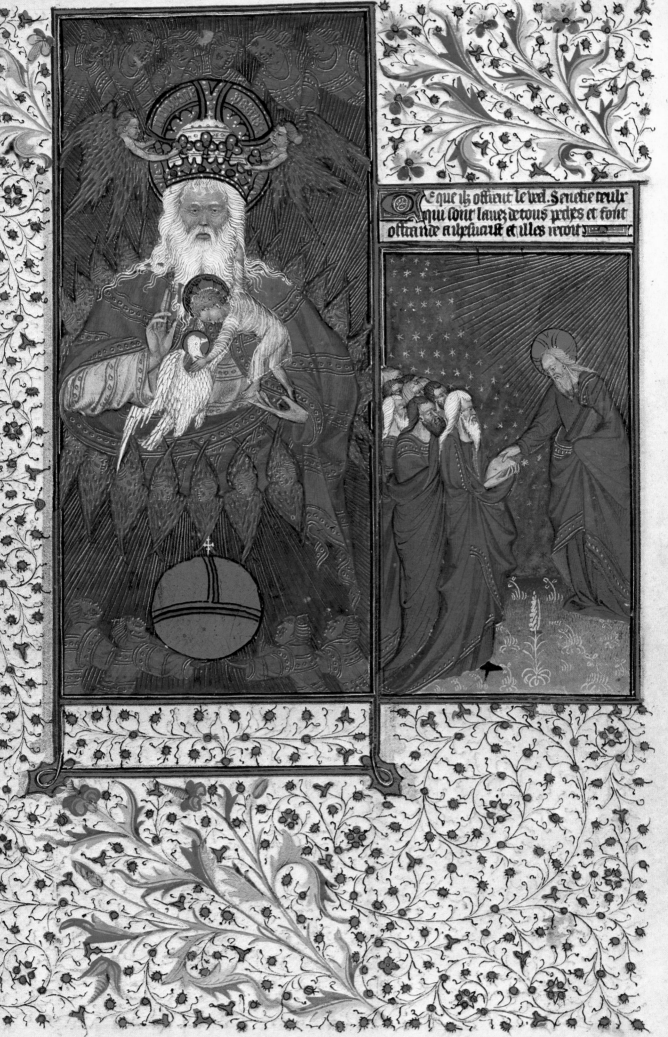

Eque ils offient le veel. Senesie ceulx
qui sont lauez de tous peches et sont
offiande au pelicault et illes veout

Pl. 79

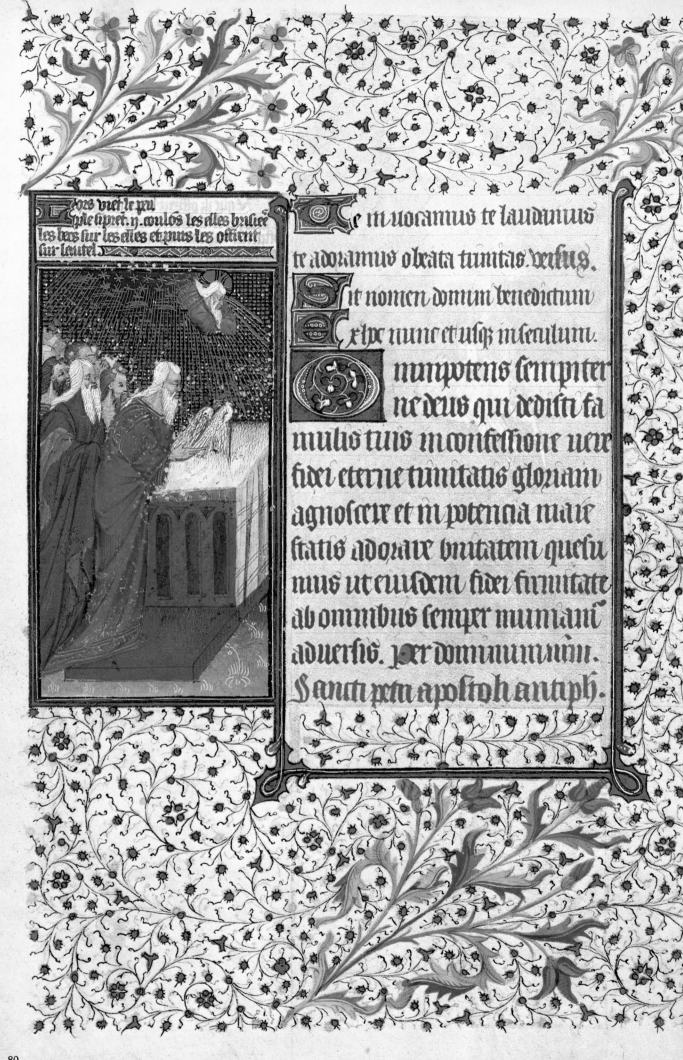

ors vient le pru
ptre si pret. ij. coulós les elles brisie
les bcos sur les elles et puis les offient
sur lentel.

Te in uocamus te laudamus
te adoramus o beata trinitas. verius.

Sit nomen domini benedictum

Ex hoc nunc et ulsq in seculum.

Omnipotens sempiter
ne deus qui dedisti fa
mulis tuis in confessione uere
fidei eterne trinitatis gloriam
agnoscere et in potencia maie
statis adorare unitatem quesu
mus ut eiusdem fidei firmitate
ab omnibus semper muniami
aduersis. per dominum nrm.

Sancti petri apostoli antiph.

Pl. 80

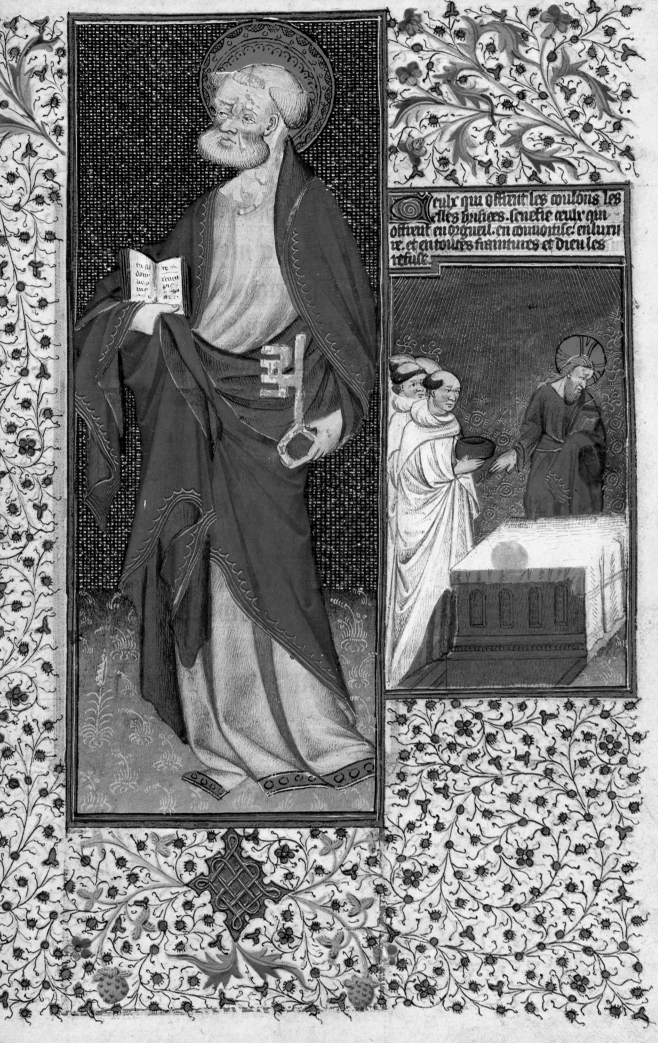

Pl. 81

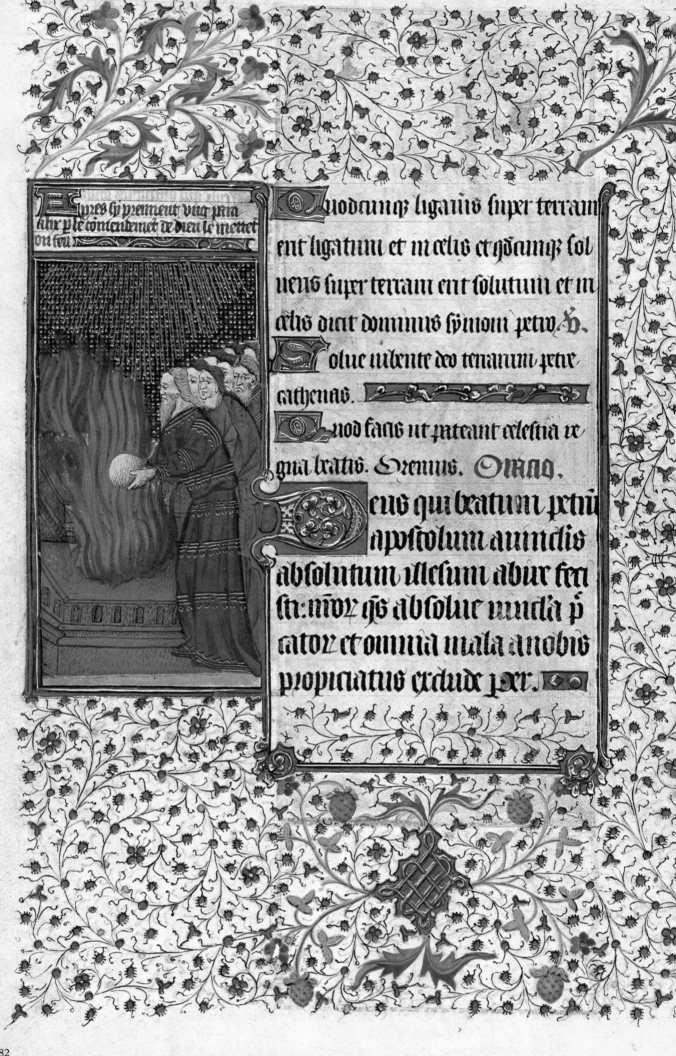

Pl. 82

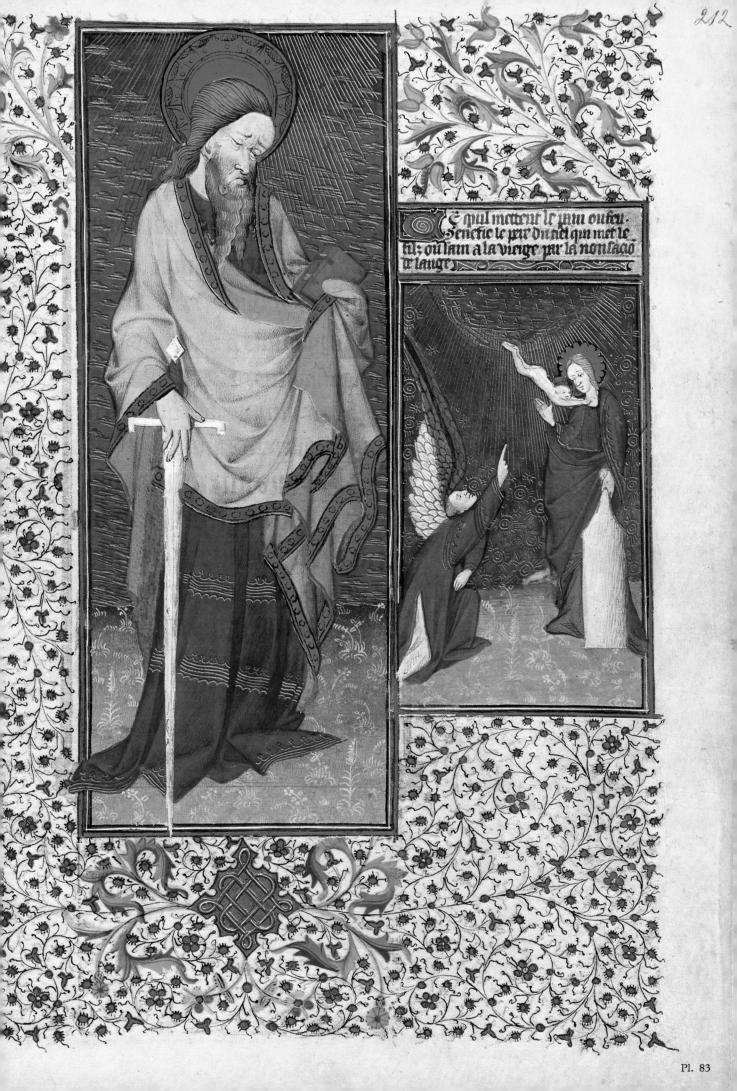

E qui mettent le jnm ou feu.
Senefie le pere du ciel qui met le
fil; ou lam a la vierge par la nonsaciõ
de lange;

Pl. 83

78. *Office of the Dead—Prayers of Intercession*

MARGINAL PAINTING. Bible moralisée. Exodus XXXI and XXXII, 1–4.

LEGEND *"Icy parle Moyse a Dieu en la montaigne dedens la demeure que Moyse y fit, sy vint li peuples et prendrent leurs aniaux et leurs afiches et le fondirent ensemble. Icelle fondure devint ung torel."*

In the upper part of the image, God speaks to Moses on Mount Sinai. Meanwhile, below, the Israelites collect all their rings and jewelry in a huge crucible, to melt them down. With the metal thus obtained, they fashion a "bull" (i.e. the golden calf). On the left, a worker with an enormous bellows tends the fire under the melting pot. (f. 209v)

79. *Prayers of Intercession*

MAIN PAINTING

Dominating the globe surmounted by a cross upheld by angels, the three Persons of the Holy Trinity, encircled by seraphim with widespread wings, appear in an effulgence of golden light. Two seraphim place on the head of the Father a crowned tiara, circled by a halo bearing the inscription *"In nomine Patris"* ("In the name of the Father"). The Son, who has been given the aspect of a child clad in a simple transparent shirt, stands on the hand of the Father, whose great white beard He grasps to keep His balance, while caressing the neck of the Dove symbolizing the Holy Spirit.

MARGINAL PAINTING. Bible moralisée.

LEGEND *"Ce que ilz offrent le veel senefie ceulx qui sont lavez de tous péchés et font offrande a Jhesu Crist et il les reçoit."*

The Israelites, who were shown on the preceding folio (Pl. 78) divesting themselves of their jewels and having them melted down in a crucible to make the golden calf (without having yet thought of worshiping it), are likened to the faithful, absolved of their sins, whom we see here making offerings to Christ, which are pleasing to Him. (f. 210)

80. *Prayers of Intercession*

MARGINAL PAINTING. Bible moralisée. Leviticus I, 14–17.

LEGEND *"Lors vient le peuple, si prent ii coulons, les elles brisiee, les becs sur les elles et puis les offrent sur l'autel."*

Here, the artist has represented the offering of a sacrifice by the Israelites, according to the directions laid down in Leviticus: two doves, their wings broken, their necks twisted so that their beaks rest on their wings, are placed on the altar, in the presence of the faithful, by a priest with a long white beard. From the heavens, God observes the scene benevolently. (f. 210v)

81. *Prayers of Intercession*

MAIN PAINTING

St. Peter is depicted here, in accordance with iconographic tradition, holding a large key in his left hand as a symbol of the power given him "to bind and to loose." In his right hand, he holds an open book. This painting was copied quite faithfully in the *Hours of Martin Le Roy* (f. 165), but there it is supposed to represent St. Thomas. The right hand of the latter saint is very faintly drawn, which undoubtedly indicates that the earlier date should be accorded to the *Rohan Hours*, but his face, nevertheless, seems superior in execution to that of St. Peter in the *Rohan Hours*.

MARGINAL PAINTING. Bible moralisée.

LEGEND *"Ceulx qui offrent les coulons, les elles brisiées senefie ceulx qui offrent en orgueil, en convoitise, en luxure et en toutes fraintures, et Dieu les refuse."*

According to this "moralization" on the Biblical text illustrated in the preceding folio (Pl. 80), the sacrifice of the doves with broken wings symbolizes offerings that are made in a spirit of pride, covetousness, or lust. Here we see the Lord turning away, while pushing back with His hand the offerings some white-robed monks are presenting to Him. (f. 211)

82. *Prayers of Intercession*

MARGINAL PAINTING. Bible moralisée. Leviticus II, 4.

LEGEND *"Aprés sy prennent ung pain alix [sic], par le commendement de Dieu le mettent ou feu."*

Another form of sacrifice ordained in Leviticus is depicted here: the Israelites offer God unleavened bread, which is burned on the altar. (f. 211v)

83. *Prayers of Intercession*

MAIN PAINTING

St. Paul is represented here with a sword, his customary attribute, and a book which he holds respectfully in his left hand, enveloped in the sleeve of his cloak. The artist must have imitated (not without a certain awkwardness) a model either created or adapted by the Limbourgs for the *Belles Heures* of Jean de Berry (f. 159v)—a model also followed by the painter of the *Hours of Martin Le Roy* for his St. Paul (f. 161).

MARGINAL PAINTING. Bible moralisée.

LEGEND *"Ce qu'il mettent le pain ou feu senefie le pere du ciel qui met le filz ou sain a la Vierge par l'anonsacion de l'ange."*

The sacrifice of the unleavened bread burnt upon the altar, whose representation appears in the preceding folio, symbolizes the Son, made incarnate by the will of the Father in the womb of the Virgin Mary. The Son is represented here in the form of an infant, naked and haloed, descending from the sky toward the Virgin, who raises her right hand in a gesture of acceptance. Her left hand rests on an object which is difficult to distinguish—a desk perhaps, or part of a bishop's chair drawn from a model poorly interpreted by the painter. An angel, kneeling, points a finger toward the Son, announcing the Divine will to the Virgin. (f. 212)

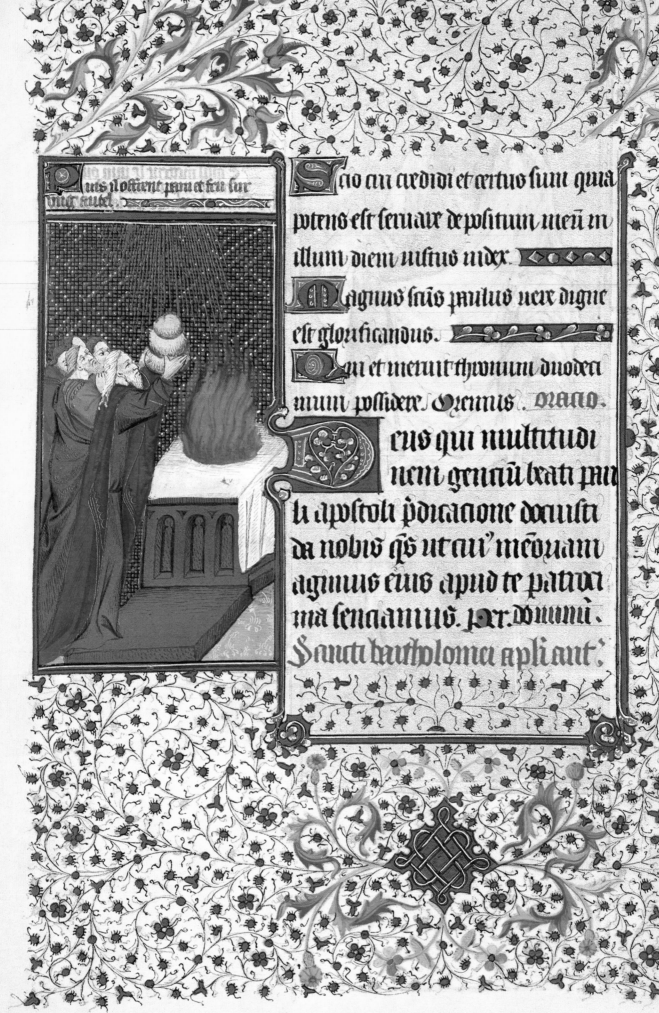

Pl. 84

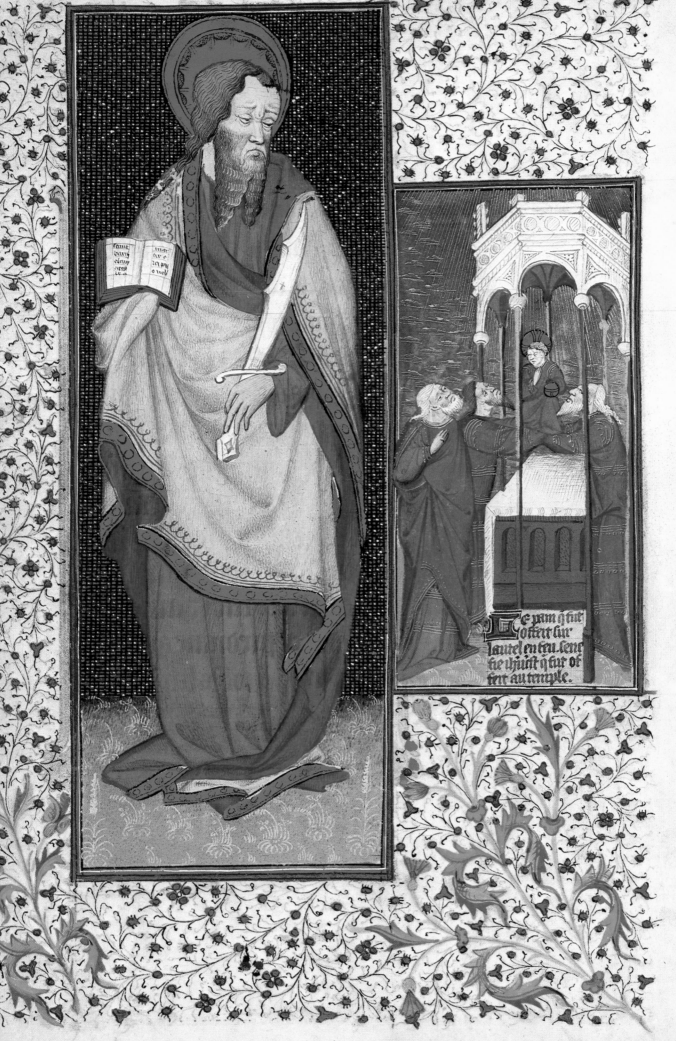

Pl. 85

84. *Prayers of Intercession*

MARGINAL PAINTING. Bible moralisée. Leviticus II [?]

LEGEND *"Puis il offrent pain et feu sur ung autel."*

This is a representation of the ritual offering made by the Israelites of bread and fire upon the altar, according to the directions given in Leviticus. No sentence which applies exactly to this image is to be found in the second chapter of the sacred text. The scribe and the artist were obviously embarrassed by the fact that in the *Angevin Bible* (MS. fr. 9561, f. 80v), which was their guide, the customary biblical reference is missing this time—and with good reason! The explanatory text in French which appears in the *Angevin Bible* was added erroneously to another, which did not apply to the image.

(f. 212v)

85. *Prayers of Intercession*

MAIN PAINTING

St. Bartholomew is depicted here holding a sword in the form of a scimitar in his left hand, to evoke his martyrdom (according to tradition, he was flayed alive). In his right hand, hidden under the sleeve of his cloak, he holds an open book on which can be read: *"Saint Barthelemy apostre et martire, ora pro nobis"* (St. Bartholomew apostle and martyr, pray for us).

A representation of the same saint, closely resembling this one, but with notable differences nonetheless, is found in the *Hours of Martin Le Roy* (f. 168).

MARGINAL PAINTING. Bible moralisée.

LEGEND *"Le pain qui fut offert sur l'autel en feu senefie Jhesu Crist qui fut offert au Temple."*

The bread burned upon the altar by the Israelites (the offering of which was illustrated in the preceding folio), symbolizes Jesus Christ presented at the Temple. We recognize St. Joseph handing Simeon a haloed Child Jesus, seated in majesty on the arms of the two men. His left hand is placed on a globe, the emblem of His omnipotence. Curiously enough, the Virgin has no place in this traditional scene. Her place (Pl. 50) is taken by an old man. (f. 213)

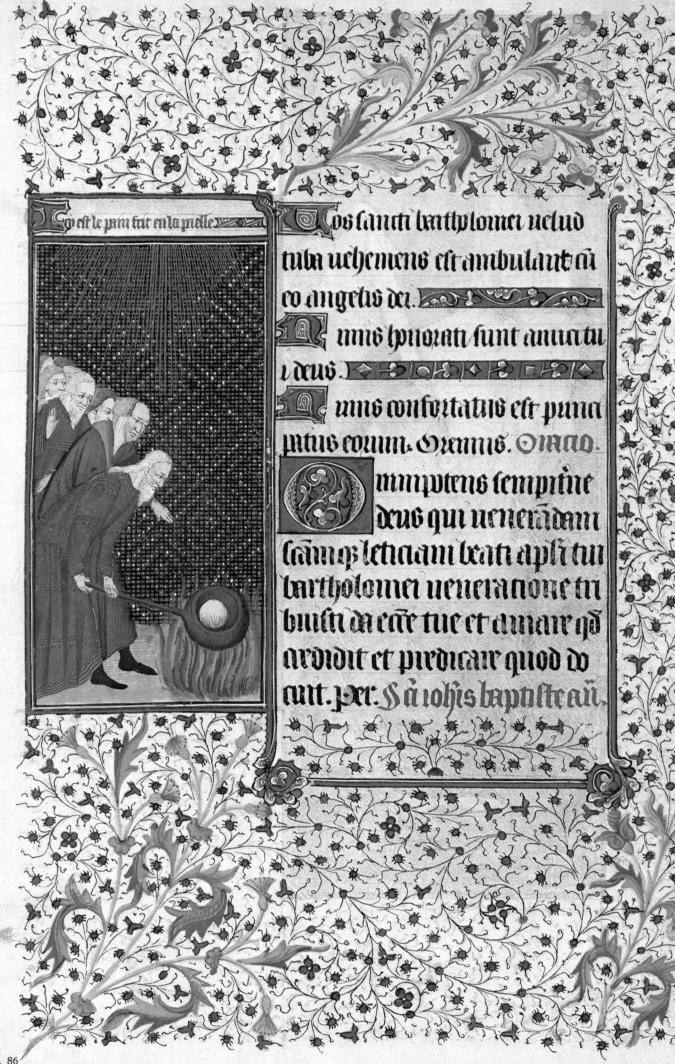

Pl. 86

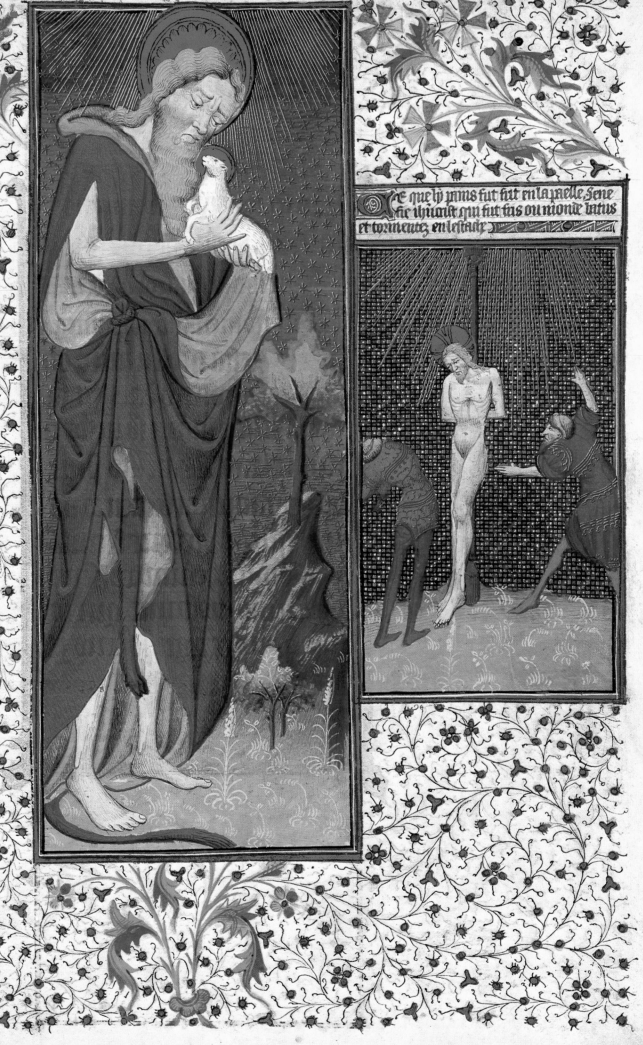

Ce que lij primis fut fait en la paelle. Seue fie ihuxrist epu fut fais ou monde latus et tormentez en lestaige

Pl. 87

86. *Prayers of Intercession*

MARGINAL PAINTING. Bible moralisée. Leviticus II, 5.

LEGEND *"Icy est le pain frit en la paelle."*

 The offering of bread "fried in a pan" is represented here, in accordance with the directions set forth in Leviticus, which state that if the offering is to be of this kind, the bread must be unleavened and sprinkled with oil. (f. 213v)

87. *Prayers of Intercession*

MAIN PAINTING

In a mountainous landscape, the Precursor (St. John the Baptist) is shown wearing an animal skin beneath his cloak (we can perceive the tail and a paw of the animal, evidently a deer). According to iconographic tradition, he holds in his arms a haloed lamb, the symbol of Christ, whose coming he announces. Certain awkward details in the design (notably in the rendering of the saint's left forearm) may be explained by the poor interpretation of a basic model, which might have been that of St. John the Baptist painted by the Limbourgs in the *Belles Heures*.

MARGINAL PAINTING. Bible moralisée.

LEGEND *"Ce que ly pains fut frit en la paelle senefie Jhesu Crist qui fut fris ou monde, batus et tormentez en l'estache."*

The sacrifice of the bread "fried in a pan," which we saw depicted on the preceding folio, prefigures Jesus Christ, who was *"fris,"* beaten and tormented *"en l'estache,"* that is to say, when he was tied to the column of the Praetorium. The scene is consistent with the traditional representations of the Flagellation, where Christ is seen amid His executioners. One of them is very awkwardly drawn in this picture. (f. 214)

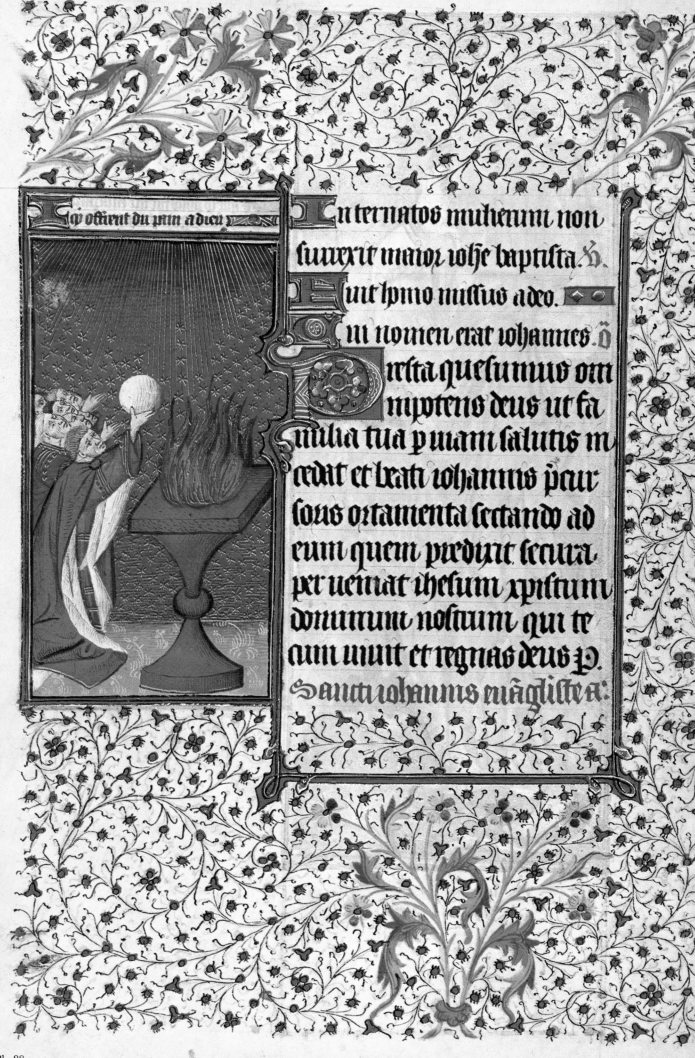

qi offrent du pain a dieu

n ternatos mulierum non
surrexit maior iohe baptista. D.
uit hpmo missus a deo.
ui nomen erat iohannes.
resta quesumus om
nipotens deus ut fa
milia tua p uiam salutis in
cedit et beati iohannis prcur
sonis ortamenta sectando ad
eum quem preduxit secuta
per ueniat ihesum xpistum
dominum nostrum qui te
cum uiuit et regnas deus p.
Sancti iohannis euagliste ra:

Pl. 88

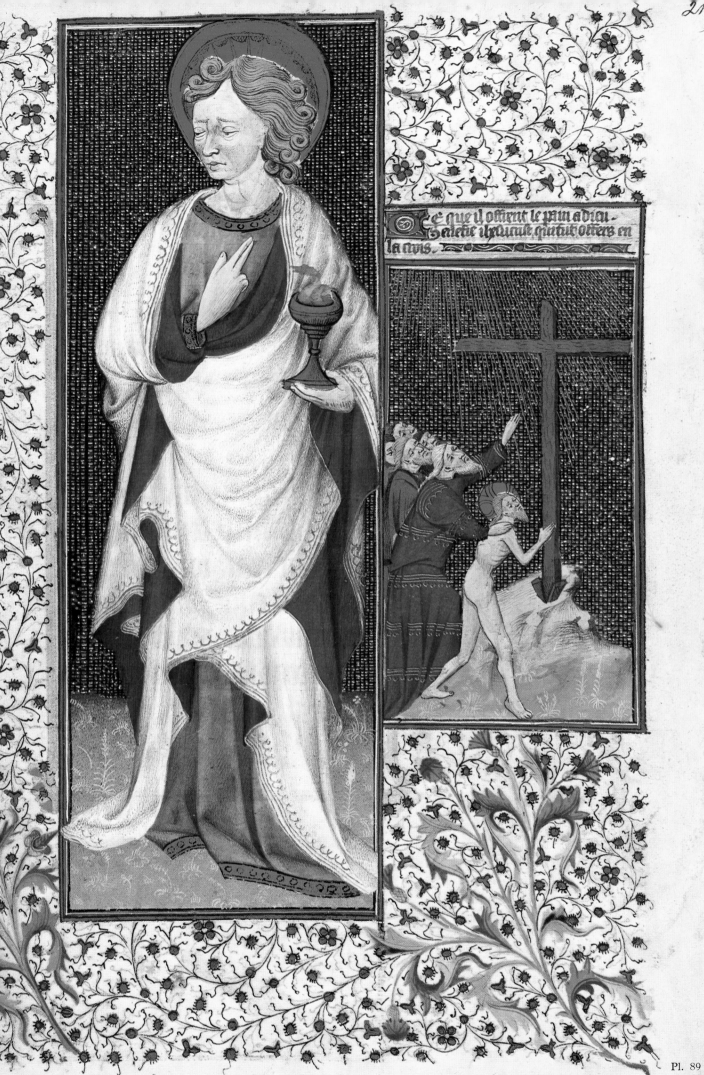

e que il offient le pain a dieu
e die il reluaut quil oit offers en
la crois.

Pl. 89

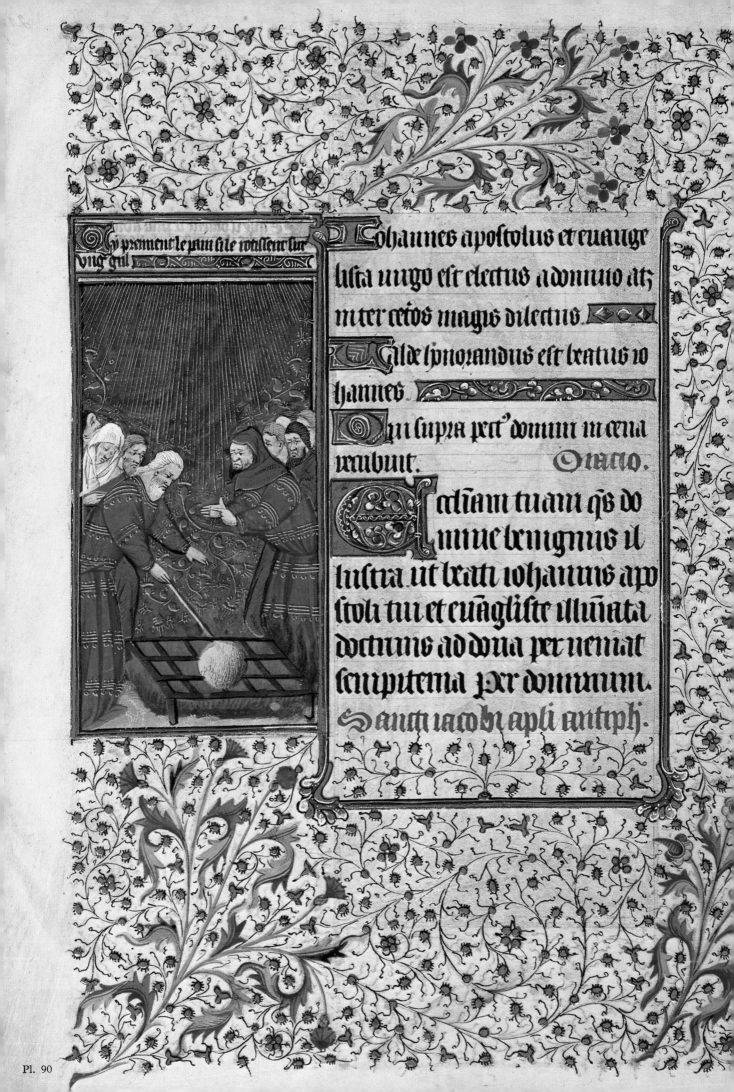

Ci prennent le pain file rotisleur sur
ung gril

Iohannes apostolus et euange
lista uirgo est electus a domino atz
inter ceteros magis dilectus.

Vilde sipnorandus est beatus io
hannes

Qui supra pect' dominm in cena
recubuit. Oracio.

Ecclesiam tuam qs do
mine benignus il
lustra ut beati iohannis apo
stoli tui et euangeliste illuminata
doctrinis ad dona per ueniat
sempiterna per dominum.

Sancti iacobi apli antiph.

Pl. 90

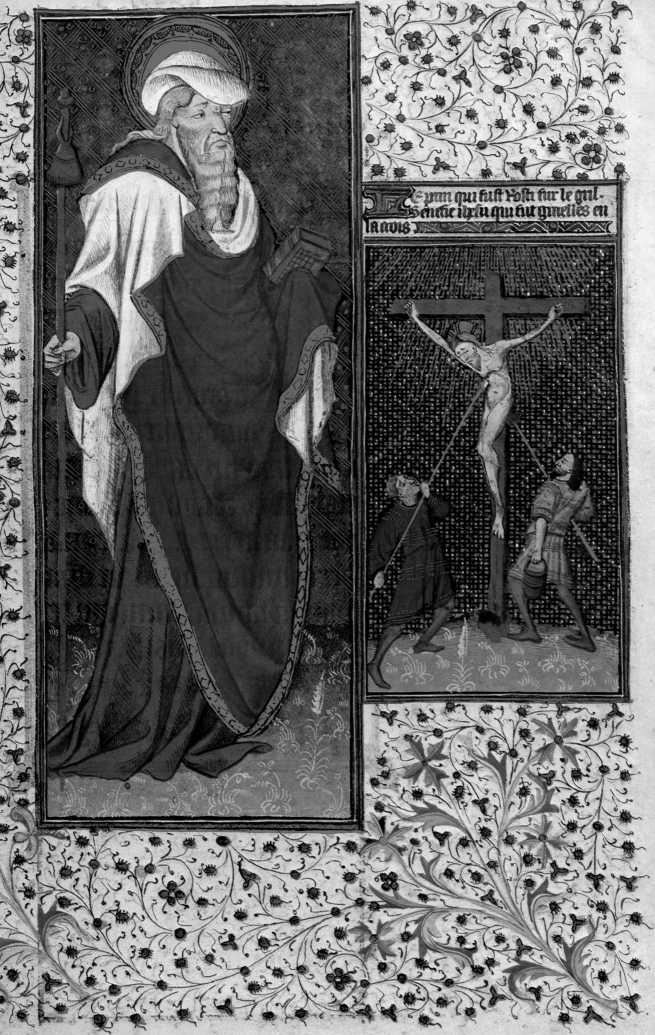

Eynn qui fust Rosti sur le gril.
Senefie itelu qui tut ginelies en
la rois.

Pl. 91

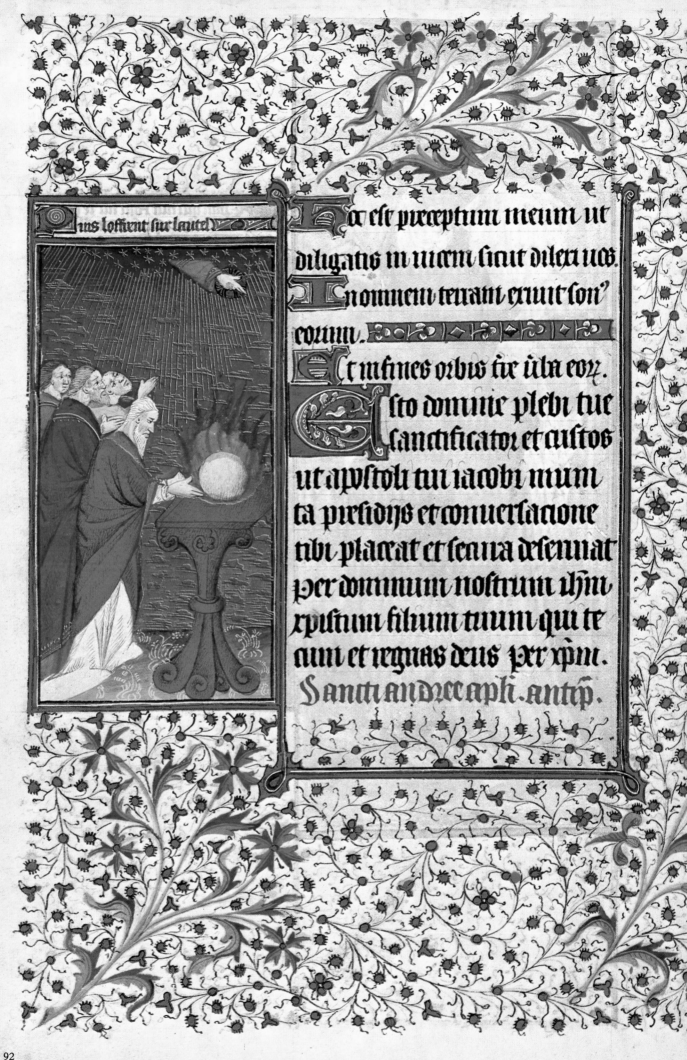

Hoc est preceptum meum ut
diligatis in invicem sicut dilexi vos.
In omnem teram exivit son'
eorum.
Et infines orbis tre ula eo‹.
Esto domine plebi tue
sanctificator et custos
ut apostoli tui iacobi intum
ta presidiis et conuersacione
tibi placeat et seruia deseruiat
per dominum nostrum ihm
xpistum filium tuum qui te
cum et regnas deus per xpm.
Sancti andree aphi. antip.

Pl. 92

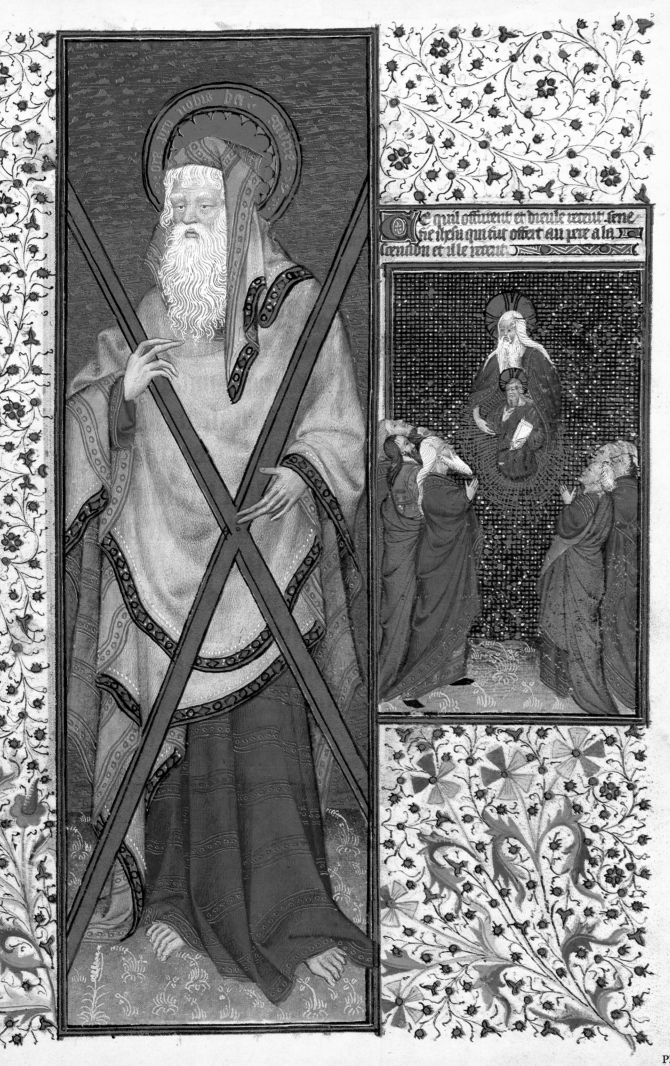

Pl. 93

88. *Prayers of Intercession*

MARGINAL PAINTING. Bible moralisée. Leviticus II, 8–9.

LEGEND *"Icy offrent du pain à Dieu."*

The offering of the bread is represented here according to the instructions in Leviticus. A priest (behind whom the Israelites are praying, their clasped hands pointing heavenward) prepares to place a loaf of bread in a large fire burning on an altar made of a rectangular stone slab resting on a circular base, like a baptismal font. (f. 214v)

89. *Prayers of Intercession*

MAIN PAINTING.

St. John the Evangelist is represented here, according to the iconographic tradition based on the legend, holding a cup in his left hand, from which a small serpent is about to slip away. The serpent symbolizes the poison from which God, by means of a miracle, permitted the saint to escape.

MARGINAL PAINTING. Bible moralisée.

LEGEND *"Ce que il offrent le pain à Dieu senefie Jhesu Crist qui fut offers en la crois."*

This "moralization" on the biblical text illustrated in folio 214v, shows a group of Jews driving a naked and haloed Christ toward a high cross erected upon a knoll. The face of Christ expresses a resigned sadness; His hands are clasped in silent prayer. From the sky, where the Father remains invisible, falls a shower of golden rays which illuminate the checkered background of the image. A parallel is quite naturally drawn between the sacrifice of Christ upon the Cross and the ritual offering of bread upon the altar as prescribed in Leviticus. (f. 215)

90. *Prayers of Intercession*

MARGINAL PAINTING. Bible moralisée. Leviticus II, 7.

LEGEND *"Cy prennent le pain, si le rotissent sur ung gril."*

Here the artist has represented the offering of bread roasted on a gridiron, according to the prescriptions in Leviticus. To the left, the priest is roasting a round loaf of dough which he turns with a long stick. The position of his left hand, which is resting on the stalk of a plant, is doubtless a reminder that in this sacrifice the bread must be sprinkled with oil. On the other side of the gridiron, in the foreground, stands the man in whose name the sacrifice is being offered. The movement of his hands indicates that perhaps only a designated portion of the bread thus offered is to be returned to the priests and Levites. (f. 215v)

91. *Prayers of Intercession*

MAIN PAINTING

St. James the Apostle wears a pilgrim's hat and carries a pilgrim's staff, but he lacks his traditional attribute, a shell. A book in his left hand reminds us that one of the canonical epistles was composed by him. A very similar representation of the same saint is found in the *Hours of Martin Le Roy*.

MARGINAL PAINTING. Bible moralisée.

LEGEND *"Le pain qui fust rosti sur le gril senefie Jhesu qui fut graellés en la crois."*

On the Cross, Christ has just consummated His Passion. One of His executioners still holds the reed he used to offer Christ a sponge dipped in vinegar. With his lance, another executioner has just pierced Christ's side, from which a stream of blood flows down to the foot of the Cross. The sacrifice of Christ—"singed" or "burned" on the Cross, as the legend tells us—is compared to the one represented in the preceding folio, the nature of which was prescribed in Leviticus. (f. 216)

92. *Prayers of Intercession*

MARGINAL PAINTING. Bible moralisée. Leviticus II, 8.

LEGEND *"Puis l'offrent sur l'autel."*

Four Jewish priests offer God (whose hand alone appears in the starred firmament) a sacrifice which they burn on an altar of quite unusual form, its rectangular table being supported by a sort of stone tripod ornamented with spiral scrollwork. The verse from Leviticus which seems to illustrate the painting is, in fact, applicable to all kinds of sacrifices, not solely to roasted bread. (f. 216v)

93. *Prayers of Intercession*

MAIN PAINTING

This majestic figure of St. Andrew as an old man with a white beard is the work of an artist other than the one to whom we are indebted for the preceding effigies of saints. It is to this artist, that we owe, among others, the main painting of folio 106v (Pl. 54). The illuminator who painted the St. Andrew of the *Hours of Martin Le Roy* (f. 162), was obviously inspired by the present painting, or at least by a common model. The fingers of the saint are treated in an identical manner in both paintings. St. Andrew carries the oblique cross upon which he suffered his martyrdom and to which he has given his name. On the border of the halo surrounding his head can be read an invocation: *"Ora pro nobis beate Andree"* (St. Andrew, pray for us).

MARGINAL PAINTING. Bible moralisée.

LEGEND *"Ce qu'il offrirent, et Dieu le receut, senefie Jhesu qui fut offert au Pere a l'Ascension et il le receut."*

Before the eyes of the disciples, separated into two groups on the left and right of the painting, God the Father receives into His arms the Son who has just ascended to Him in a luminous mandorla. The Ascension is thus likened to the ritual sacrifice represented in the preceding folio, wherein the smoke from the sacrifice rises up to God, who finds it pleasing. (f. 217)

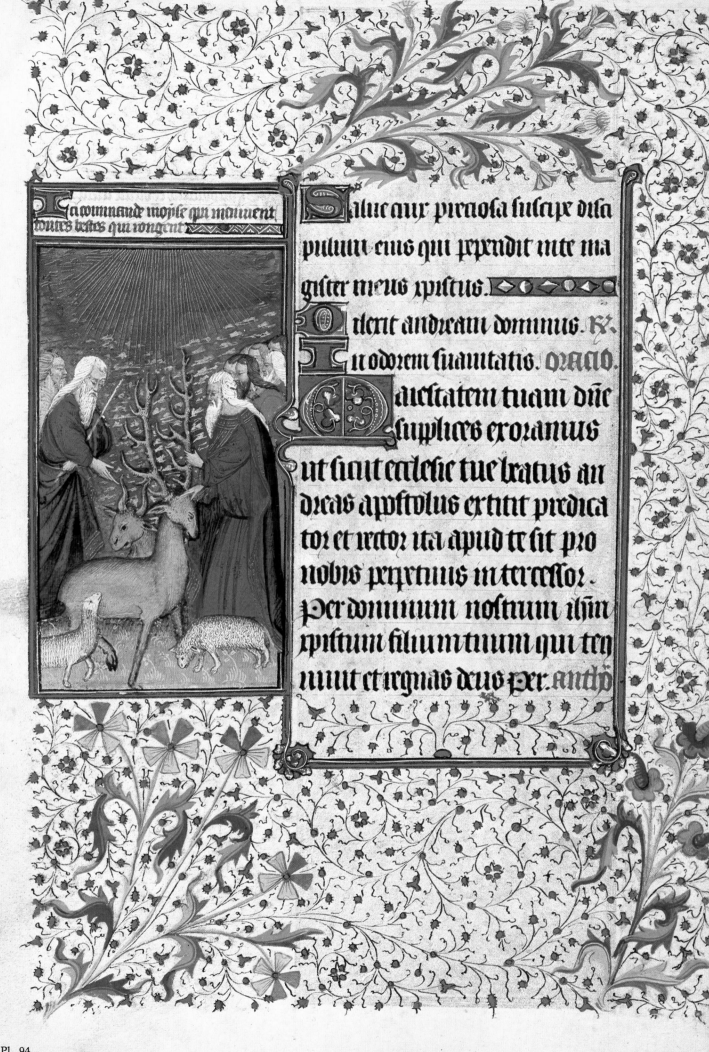

Sa commande moyse qui monstrent
toutes bestes qui rongent

Salue aux preciosa suscipe disci
pulum eius qui pependit ante ma
gister meus xpistus.

Oderit andream dominus. R.
In odorem suauitatis. ORACIO.

Maiestatem tuam dñe
suppliers exoramus
ut sicut ecclesie tue beatus an
dreas apostolus extitit predica
tor et rector ita apud te sit pro
nobis perpetuus intercessor.
Per dominum nostrum ihm
xpistum filium tuum qui te
nuit et regnas deus per. antho

Pl. 94

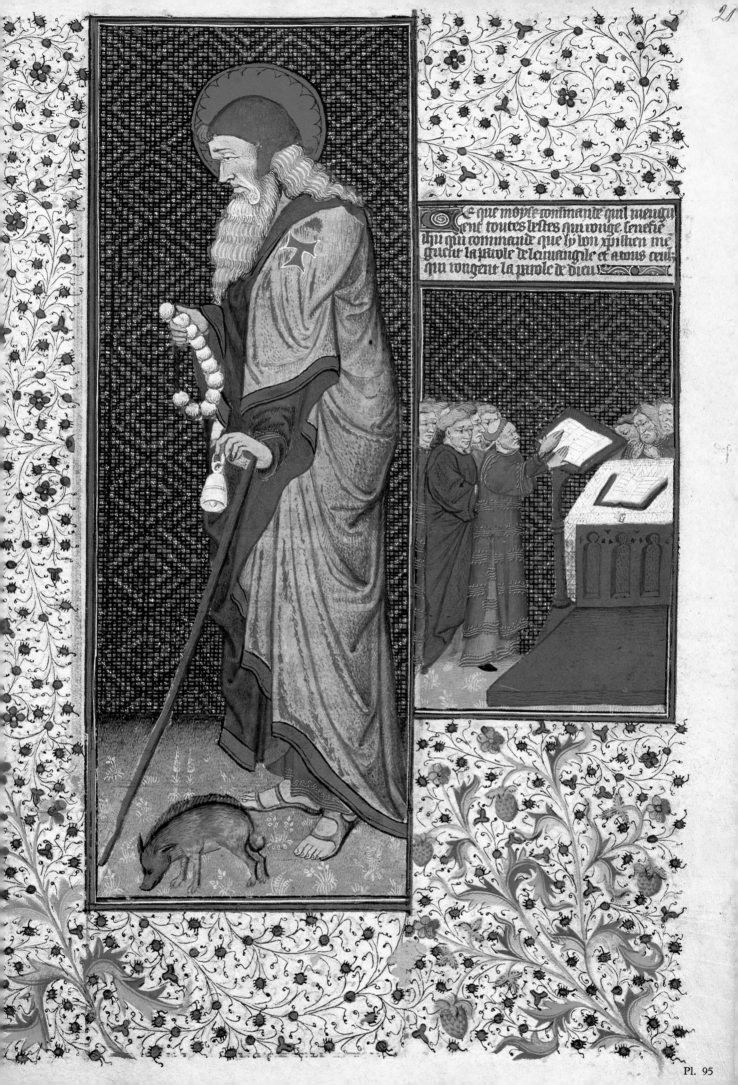

Pl. 95

94. *Prayers of Intercession*

MARGINAL PAINTING. Bible moralisée. Leviticus XI, 3.

LEGEND *"Ici commande Moyse qu'i menjuent toutes bestes qui rongent."*

Moses, on the left, with his staff in his hand, points out to the Israelites some of the animals whose flesh they may eat; that is, animals that chew the cud and are cloven-footed. Here we can distinguish a deer, an ox, and two sheep.

(f. 217v)

95. *Prayers of Intercession*

MAIN PAINTING

Leaning on a staff, a small bell in one hand and a rosary with large beads in the other, St. Anthony is represented with his faithful companion, a partly-tamed boar. In keeping with a firmly-established iconographic tradition, he wears, on his cloak, an emblem in the form of the Greek letter *tau* or of a crutch (which, under little known circumstances, had been adopted by the Order of St. Anthony, and had eventually been extended to all institutions bearing his name, in particular, to numerous hospitals).

MARGINAL PAINTING. Bible moralisée.

LEGEND *"Ce que Moyse commande qu'il menguent toute bestes qui ronge senefie Jhesu qui commande que ly bon Christien men-guent la parole de l'Evangile et a* [sic] *tous ceulx qui rongent la parole de Dieu."*

The order given by Moses to the Israelites to eat the flesh of all ruminants ("all beasts that chew the cud") prefigures the command given by Jesus Christ to Christians to consume the Divine Word contained in the Gospel. Here, on the left, some clerics, standing at a lectern beside an altar upon which rests another open book, are reading a text to which the faithful listen with devotion. (f. 218)

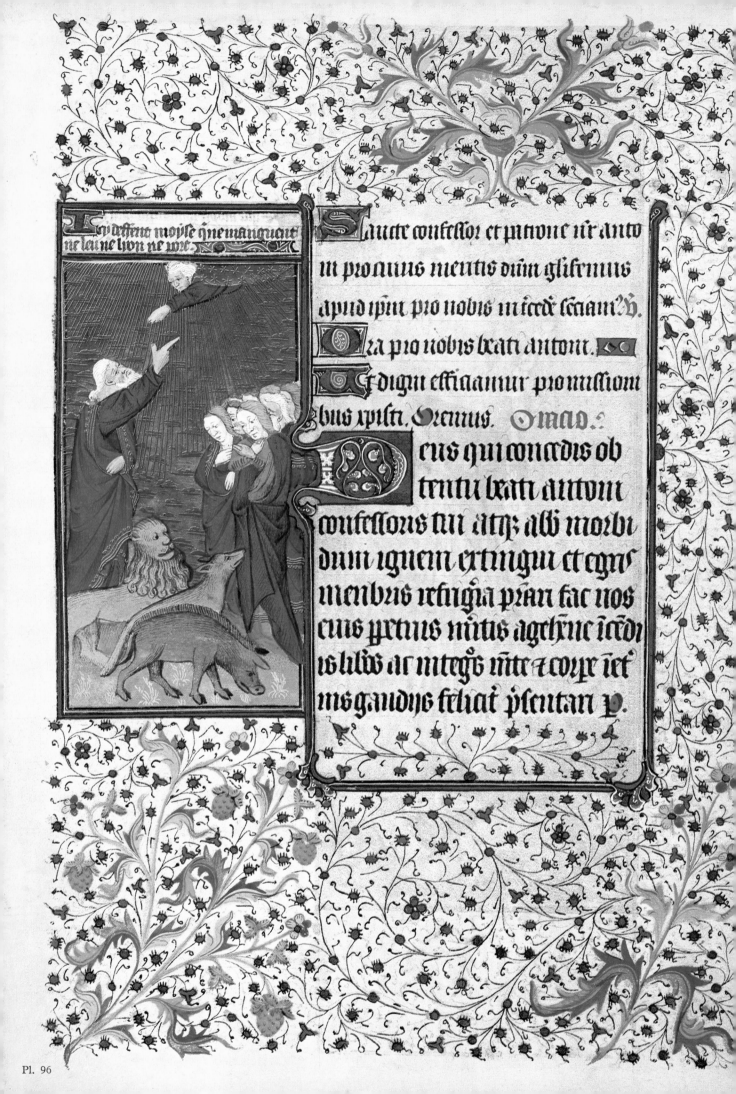

Icy deffent moyse que nemangucitne leu ne lyon ne porc.

Sancte confessor et patrone noster Anto
ni procinus mentis domini glisennus
aptud ipsum pro nobis interede sciamus. B.
Ora pro nobis beati antoni.
Et digni efficiamur pro missioni
bus xpristi. Oremus. Oratio.
Deus qui concedis ob
tentu beati antoni
confessoris tui atque album morbi
dum ignem extingui et egris
menbris refrigia prestari fac nos
eius precibus mitis agere ne iccidi
is laliis ac integris mente et corpore let
ius gaudiis feliciter presentari. P.

Pl. 96

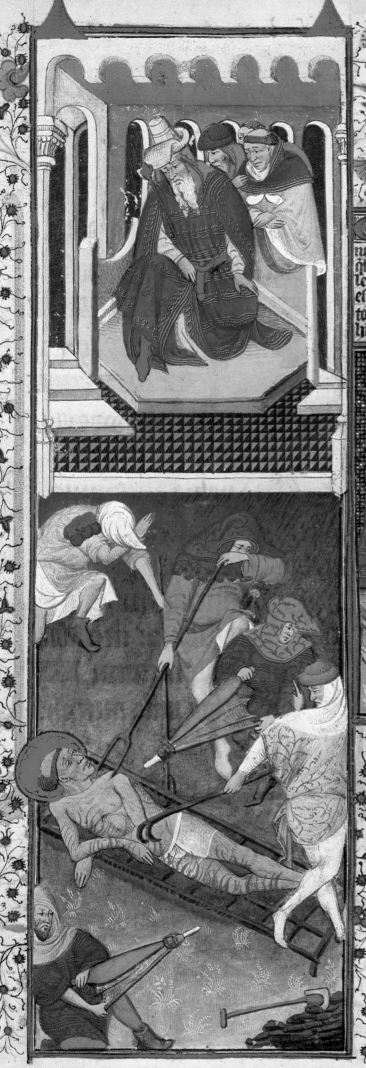

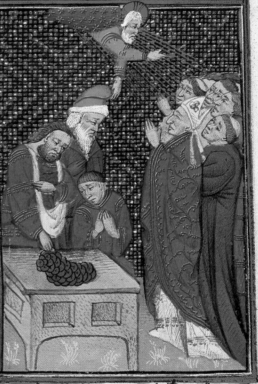

ce que moyse deffent qu'il ne men
guet ne loup ne lyon ne porc. se
nefie qu'il ault qui deffent aux bons xpiens
qu'il ne manguent rien de tapine. Le lyons est
le mauuais porc qui tout deuore. Le loup
est le mauuais prelat qui entent a la glo
tonie et laisse la parole de dieu. Le porc est
li vsuriers qui foulle en tre

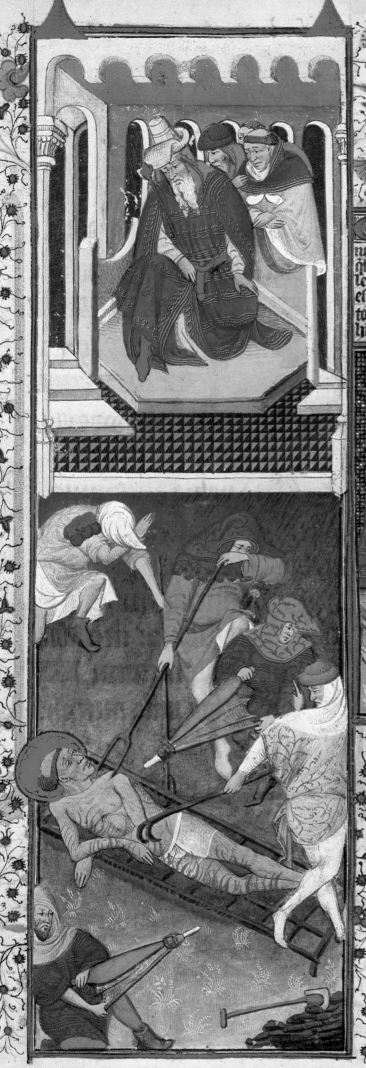

Pl. 97

96. *Prayers of Intercession*

MARGINAL PAINTING. Bible moralisée. Leviticus XI, 6.

LEGEND *"Icy deffent Moyse que ne manguent ne leu, ne lyon, ne porc."*

 Moses, on the left, inspired by God (who emerges from the firmament in a halo of luminous rays), forbids the Israelites, grouped on the right of the picture, to eat the flesh of the lion, the wolf, or the hog represented in the center. Actually, the text of Leviticus mentions neither the wolf nor the lion among the animals whose flesh is forbidden to the Hebrews, and this passage is not illustrated in the great Latin *Bible moralisée* of the thirteenth century. A translator's error, that had already found its way into the legends of the *Angevin Bible* (which the illustrator has followed here), caused the confusion of the Latin word *lepus* (hare) with *lupus* (wolf). (f. 218v)

97. *Prayers of Intercession*

MAIN PAINTING

For this composition devoted to the torment of St. Lawrence on the grid, two models have been employed. The painter has somewhat awkwardly superimposed on two levels the scene of the martyrdom—of which an exact replica is found in MS. 5140 of the Library of Lyons (f. 64)—and a representation of the tyrant who ordered it done.

For the first, he has added to the model which inspired him, the supplementary figure of an executioner who hides his face on the left side of the picture (and who does not appear in the Lyons manuscript). The artist has thus managed to fill the free space resulting from the relatively greater height of the composition.

For this personage, he may have had recourse to a small sketch of the Limbourgs who, in the *Belles Heures* of Jean de Berry, painted several figures which are quite similar (especially the sleeping soldier in front of St. Jerome's hermitage in folio 185v).

The upper part of the composition is directly inspired by a painting of the Limbourgs, similarly devoted to the appearance of Jesus before Pilate, in the *Belles Heures* (f. 135). The tyrant whose counselors (among them a clerk wearing the two tassels of a master of theology) prompted his cruel decision, is easily recognizable.

MARGINAL PAINTING. Bible moralisée.

LEGEND *"Ce que Moyse deffent qu'il ne menguent ne loup, ne lyon, ne porc, senefie Jhesu Crist qui deffent aux bons Christiens qu'il ne manguent rien de rapine. Le lyons est le mauvais prince qui tout dévore. Le loup est le mauvais prélat qui entent a la glotonnie et laisse la parole de Dieu. Le porc est ly usuriers qui foulle en boe."*

Just as Moses forbade the Israelites to eat the flesh of the wolf, the lion, and the hog (Pl. 96), so Christ forbade His disciples to display covetousness or to live by means of "rapine," that is, from ill-gotten gains. The lion is likened to the wicked prince who oppresses his subject; the wolf to the evil prelate who sins through lust and gluttony; the hog to the usurers who are ready to make money from anything.

To the right, we see good Christians, among them a bishop and two tonsured monks, who are all praying to the Lord. To the left, a man fills his beggar's sack with gold. A white-bearded moneylender and a kneeling clerk avidly contemplate a pile of coins lying on top of a chest. God blesses the first group and, with His hand, appears to restrain the others. (f. 219)

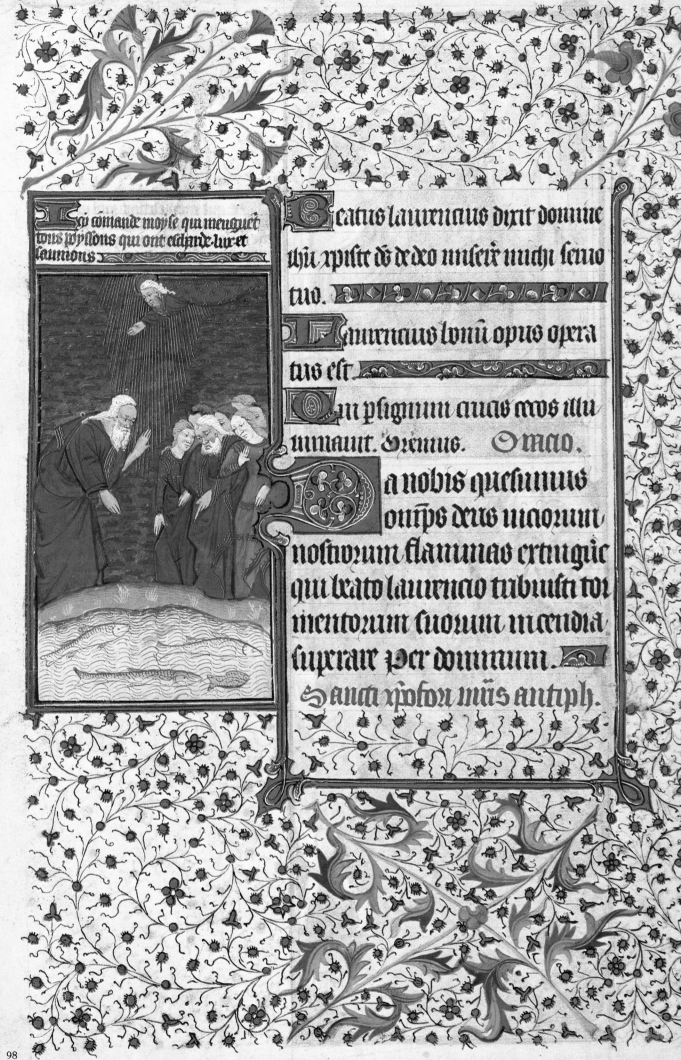

Cy commãnde moyse qui meuguct
tous phylisons qui ont eschãde lur et
leurmons

Beatus laurencius dixit domine
ihu xpiste ds de deo miserir michi servo
tuo.

Laurencius bonu opus opera
tus est.

In psignum cuius cecos illu
minauit. Oremus. Oratio.

Da nobis quesumus
omps deus vinorum
nostorum flammas extingie
qui beato laurencio tribuisti tor
mentorum suorum incendia
superare per dominum.

Sancti xpofon mus antiph.

Pl. 98

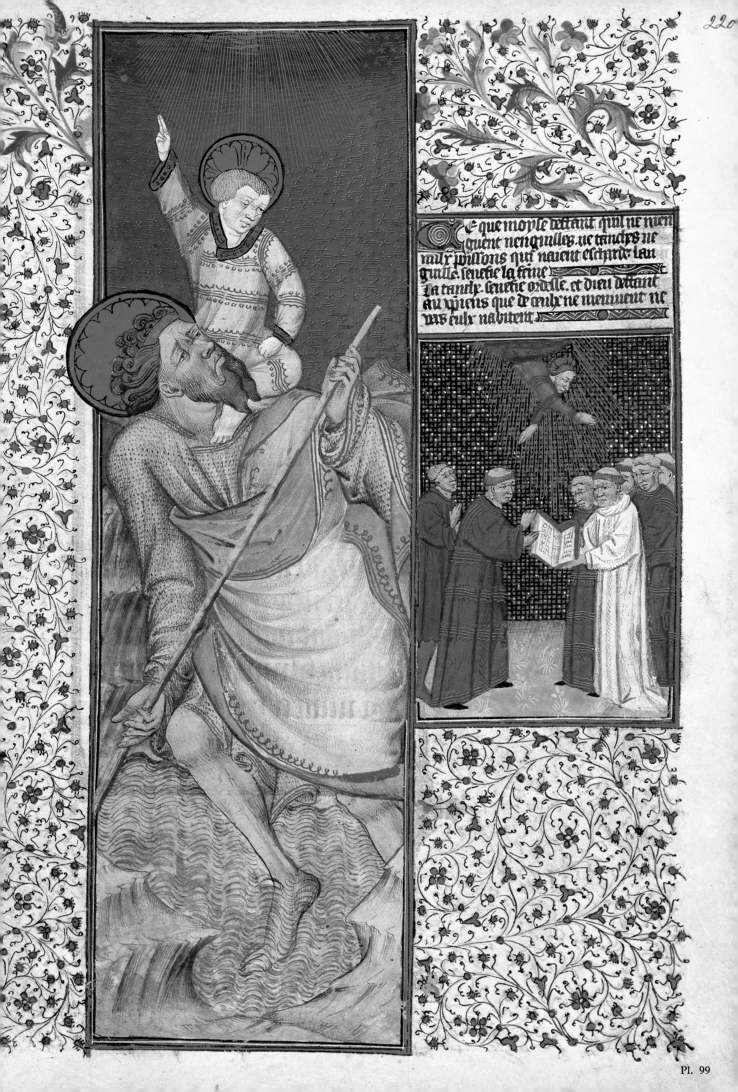

que moult deffault qual ne nuen
quent nengmlles ne tanches ne
nulx poissons qui naient escharde lau
gmlle. senerie la feine
la tanche. senerie ordelle. et dieu deffant
au psiens que de culx ne menuuent ne
vis culx nabitent

Pl. 99

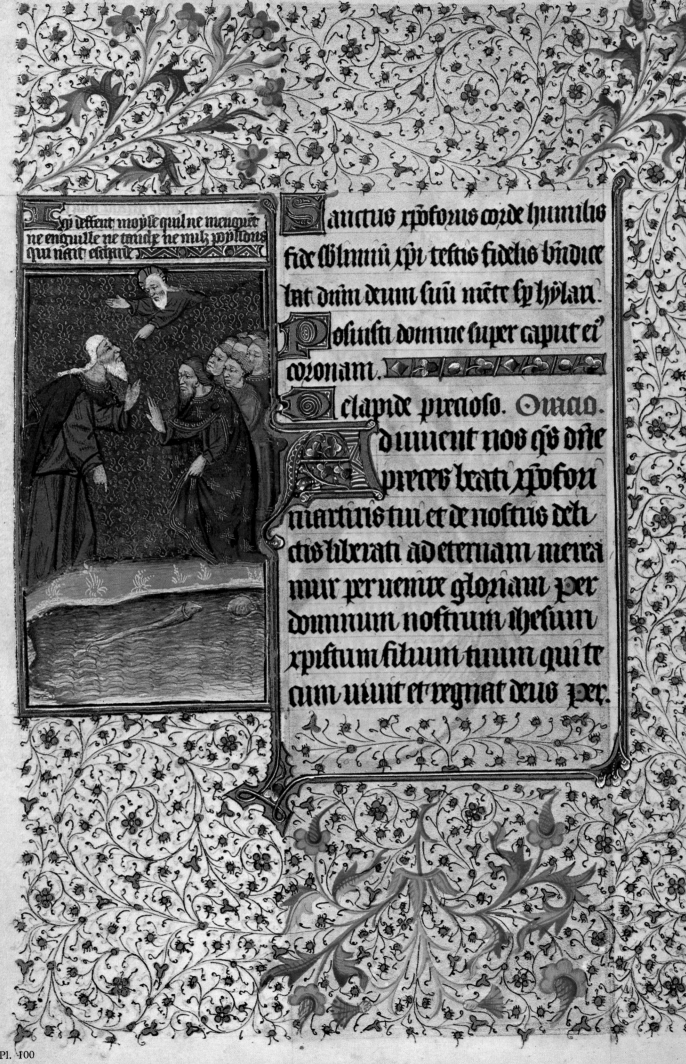

Pl. 100

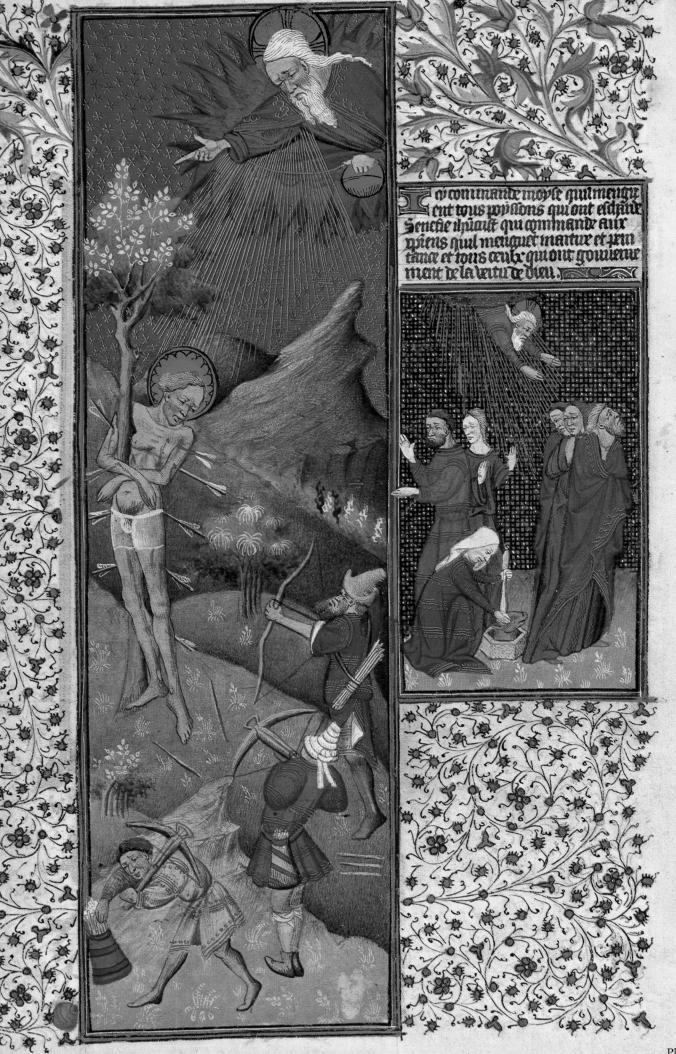

Pl. 101

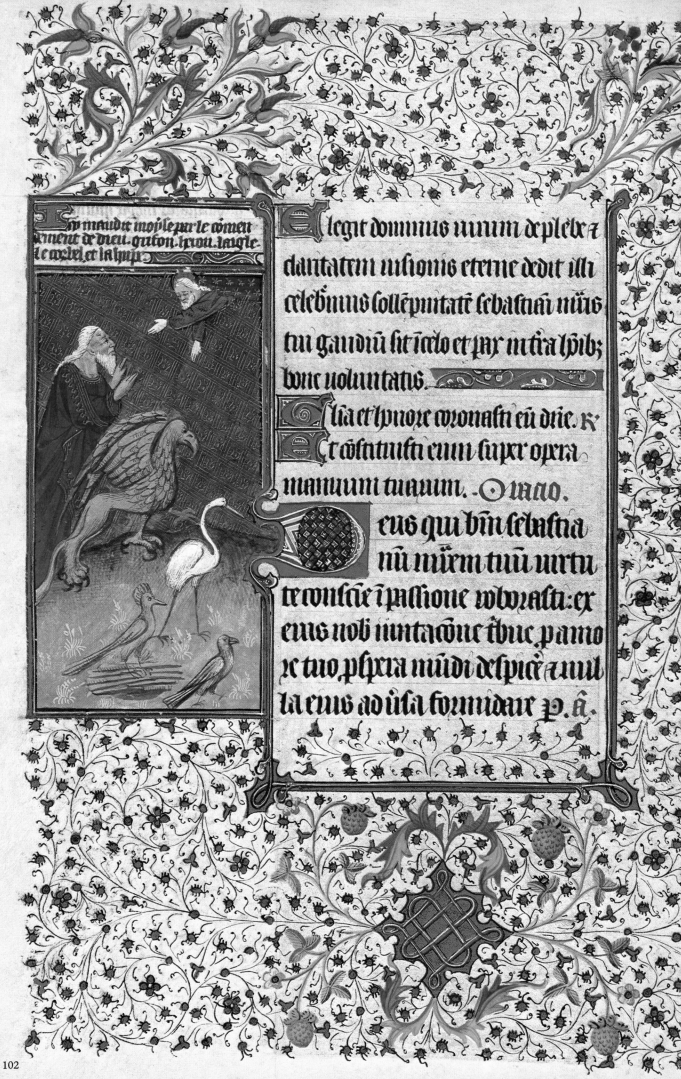

Pl. 102

222

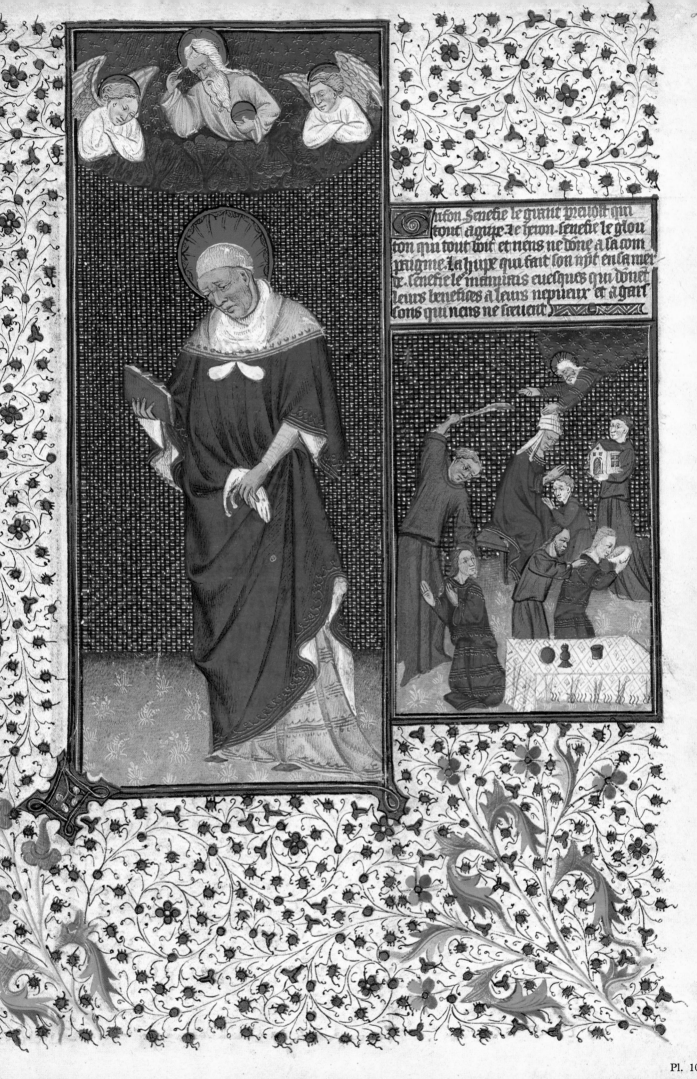

nton. Senefie le gniuit meiloit qui
tout agine. le heron. senefie le glou
ton qui tout woit et nens ne dône a la com
pngme. La hupe qui fait son nit enla mer
re. senefie le maunuais euesques qui dônet
leurs benefices a leurs neptieux et a garl
cons qui nens ne sieuienr

Pl. 103

98. *Prayers of Intercession*

MARGINAL PAINTING. Bible moralisée. Leviticus XI, 9–10.

LEGEND *"Icy commande Moyse qu'i menguent tous poyssons qui ont escharde, lux et saumons."*

Moses, on the left, bending over and pointing to the waters of a river or of the sea in which various types of fish can be seen swimming, shows the Israelites, on the right, the kinds of fish whose flesh they may eat: all those having *"eschardes"* or scales, such as the pike and salmon. Actually, the text of Leviticus speaks of aquatic animals having fins and scales, but does not mention particular kinds of fish.

(f. 219v)

99. *Prayers of Intercession*

MAIN PAINTING

In accordance with tradition, the good giant, St. Christopher, is represented fording a stream, carrying on his sturdy shoulders a child who is none other than Christ. The artist may perhaps have been inspired, but very freely, by the St. Christopher painted by the Limbourgs in folio 155 of the *Belles Heures* and, at the same time, by a quite different model—certain details of which, found here, were also utilized in MS. 5140 of the Lyons Library.

MARGINAL PAINTING. Bible moralisée.

LEGEND *"Ce que Moyse deffant qu'il ne menguent n'enguilles, ne tanches, ne nulx poissons qui n'aient escharde: l'anguille senefie la femme; la tanche senefie ordesse et Dieu deffant au Christiens que de ceulx ne menjuent ne vers eulx n'abitent.*

This moralization on the injunction in Leviticus not to eat certain fish (Pl. 98) is not clear because the legend is incomplete. In the *Angevin Bible*, we read that the eel signifies the *"escolorgent"* woman, that is to say, according to its basic meaning, "slippery," and by extension, "wanton" or "of bad character." The scribe of the *Rohan Hours*, not understanding this adjective, simply skipped over it. The tench is compared to "filth," that is, to fornication with prostitutes. It is notable that the thirteenth-century Latin *Bible moralisée* does not go into such details, nor does the sacred text itself. God is represented here giving His commandments to the Christians, among whom we can distinguish several monks. It is through another error that this image was placed here—the illustration for folio 221 (Pl. 101) should actually have been found on this page.

(f. 220)

100. *Prayers of Intercession*

MARGINAL PAINTING. Bible moralisée. Leviticus XI, 10.

LEGEND *"Icy deffent Moyse qu'il ne menguent ne ne enguille, ne tenche, ne nulz poissons qui n'ait escharde."*

This scene, which is very similar to the one appearing on the reverse side of the preceding folio (Pl. 98), illustrates the injunction given the Israelites not to eat the flesh of fish having no scales. Here the *Bible moralisée* actually introduces an addition to the sacred text, which does not expressly name any forbidden species.

(f. 220v)

101. *Prayers of Intercession*

MAIN PAINTING

Bound to a tree in the midst of a mountainous landscape, blood streaming from his almost completely nude body, St. Sebastian serves as the target for his executioners, one of whom the artist has represented as being armed with a long bow, the other two with crossbows. The third executioner, in the foreground, on the left, takes an arrow from his quiver to reload his weapon. The same composition is found, in a somewhat simplified form, in MS. 5140 of the Lyons Library.

MARGINAL PAINTING. Bible moralisée.

LEGEND *"Icy commande Moyse qu'il manguent tous poyssons qui ont escharde, senefie Jhesu Crist qui commande aux Christiens qu'il menguent martire et penitance et tous ceulx qui ont gouvernement de la vertu de Dieu."*

The absence of any agreement between the image and the legend is explained by the error already pointed out in folio 220 (Pl. 99). In point of fact, we can see here, on the left, a man tempted by two unsavory women, who have already been compared to the eel and the tench. Following the precepts of the Lord, the good Christians turn away from them in disgust. The woman in the foreground who seems to be pounding a calf's head with a mortar, corresponds to another error of interpretation by the painter. In his model, i.e., the *Angevin Bible* (f. 82v), one can see a woman using a stick to try to immobilize an eel (in a dish), as slippery as herself. The legend for the present folio actually constitutes a moralization on the text illustrated in folio 219v (Pl. 98). (f. 221)

102. *Prayers of Intercession*

MARGINAL PAINTING. Bible moralisée. Leviticus XIII, XV, XIX.

LEGEND *"Icy mzudit Moyse par le commendement de Dieu, grifon, heron, l'aigle, le corbel et la hupe."*

Moses, at the command of God, who speaks to him from heaven, forbids the Israelites to eat the flesh of certain birds, four of which are represented here: the "griffin" (a fabulous animal, half-eagle, half-lion), the heron, the crow, and the hoopoe. The artist has represented the latter on her nest, which she, alone among all the birds, has the reputation for fouling with her own dung. (f. 221v)

103. *Prayers of Intercession*

MAIN PAINTING

Born at Tréguier, St. Yves (who is represented here in his doctor's costume) was the object of a special cult in the west of France, which is recalled by the prayer addressed to him, whose text begins on the following folio with these words: *"Yvo, signifer Britannie..."* ("St. Yves, standard-bearer of Brittany"). It would be hazardous, however, based upon this alone, to ascribe a regional origin to the *Rohan Hours*, since St. Yves was revered throughout northern France, including Paris itself.

MARGINAL PAINTING. Bible moralisée.

LEGEND *"Grifon senefie le grant prevost qui tout agripe. Le heron senefie le glouton qui tout boit et riens ne donne a sa compaignie. La hupe qui fait son nyt en sa merde senefie les mauvais evesques qui donnent leurs benefices a leurs nepveux et a garssons qui riens ne scevent."*

The various unclean birds represented in the preceding folio (Pl. 102), are likened here to various kinds of sinners. The griffon symbolizes the high officers of kings or lords who mistreat and despoil those under their administration (shown on the left of the painting). The heron is the glutton who eats and drinks greedily at his own table without offering anything to his guests (below, on the right). The hoopoe, fouling its own nest, is compared to those bishops, forgetful of their duties, who—by nepotism or simony—confer benefices on their own relatives or on ignorant young men (background, on the right). The hand of God appears to weigh heavily upon one of these wicked prelates who is in the process of conferring a benefice. (f. 222)

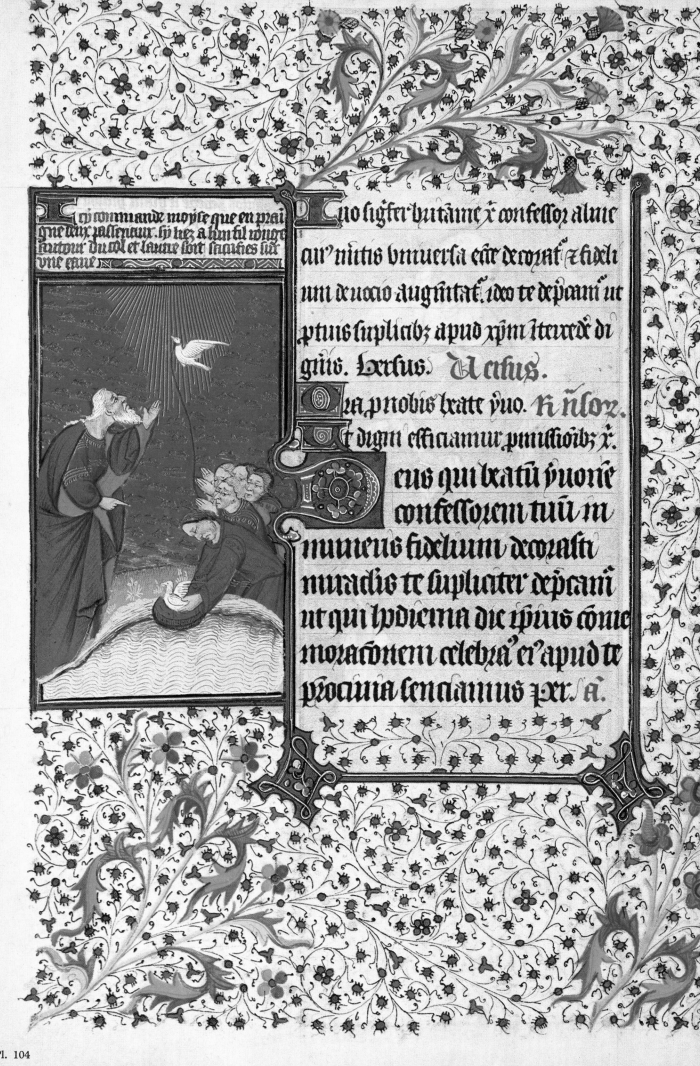

cy commande moyse que en prai
gne deux passeraux. hy hez a him ful rouge
soitpur du col et lautre soit sacufies sur
one caue

uo sigfter butanne x confessor aluie
aur mitts bmuerfa ecce decoraf z fideli
um deuoao augmntaf. ideo te depcani ut
ptuis suplicabz apud xpm iteurede di
gnus. Uerfus. Uersus.

ra pnobis beate yuo. R nloz.
t dignm esficiamur pmiffiorbz x.
eus qui beatu yuonem
confessorem tuu m
numens fidelium decorasti
niuadis te fupliciter depcani
ut qui hodierna die iptus come
moraonem celebra er apud te
pceuuia senciamus per. a.

Pl. 104

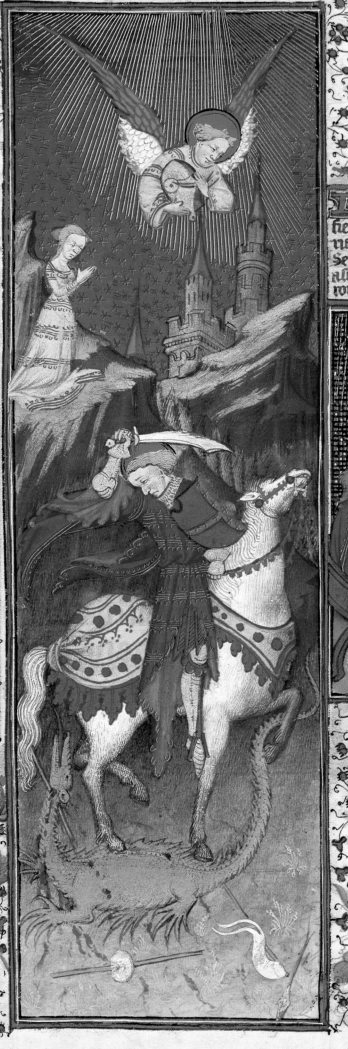

y pillaraux qui fur faamfies sur
leaue senesie qui auoit qui fut sacri
fies sur leaue du monde. Ly second passe
raux qui ot le fil rouge et sembla quitte
senesie ihu qui qui quittement sen ale
a son pere. Ly tirs senesie la aroix: le fil
rouge le sanc quil espandu

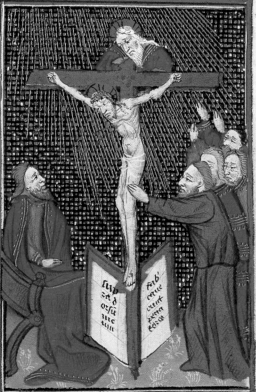

Pl. 105

104. *Prayers of Intercession*

MARGINAL PAINTING. Bible moralisée. Leviticus XIV, 4–7.

LEGEND *"Icy commande Moyse 'que en praingne deux passeriaux; sy liez a l'un fil rouge autour du col et l'autre soit sacrifiez sur une eaue."*

 Moses, on the left, instructs the Israelites in the method of performing the ritual offering of two sparrows. Leviticus describes in detail the conditions for this sacrifice: one of the birds must be sacrificed "in an earthen vessel above spring water" (which is what is happening in the foreground); the other will be freed after having been dipped in the blood of the first. The biblical text, however, makes no mention of the "red thread" which, according to the legend, should be attached to the second bird. This added detail springs from an imperfect interpretation or from an interpolation already encountered in the Latin *Bible moralisée*. The *Angevin Bible* incorrectly gives as a reference for its text, Chapter XIII of Leviticus. (f. 222v)

105. *Prayers of Intercession*

MAIN PAINTING

This representation of St. George imitates, down to the very details (e.g., the attitude of the horse, his harness, the appearance of the dragon), a model created by the Limbourgs in the *Belles Heures* (f. 167). The composition, however, has here been made more compact and laterally compressed, due to the very different proportions imposed upon each image by the makeup of the page in the book.

MARGINAL PAINTING. Bible moralisée.

LEGEND *"Ly passeriaux qui fut sacrifiez sur l'eaue senefie Jhesu Crist qui fut sacrifiés sur l'eaue du monde; ly second passeriaux qui ot le fil rouge et s'envola quitte senefie Jhesu qui quittement s'en ala a son Pere; ly fus senefie la croix; le fil rouge le sang qu'il espandy."*

This moralization on the sacrifice of the two sparrows illustrated in the preceding folio (Pl. 104), likens it to that of Christ on the Cross, "above the water of the world." The sparrow that flies away prefigures Christ returning to His Father. The wood mentioned in the text from Leviticus (but omitted in the legend for the preceding image) represents the Cross; the "red thread," the stream of blood flowing from Christ's wounds. Here, He is represented on the Cross, above which the Father appears. The disciples are weeping on the right, while a seated figure on the left is the incarnation of all those who are responsible for His death. At the foot of the Cross, in a large open book, is an inscription whose text is taken from Psalm 128: "*Suprá dorsum meum fabricaverunt peccatores*" ("The wicked have wrought upon my back . . ."). (f. 223)

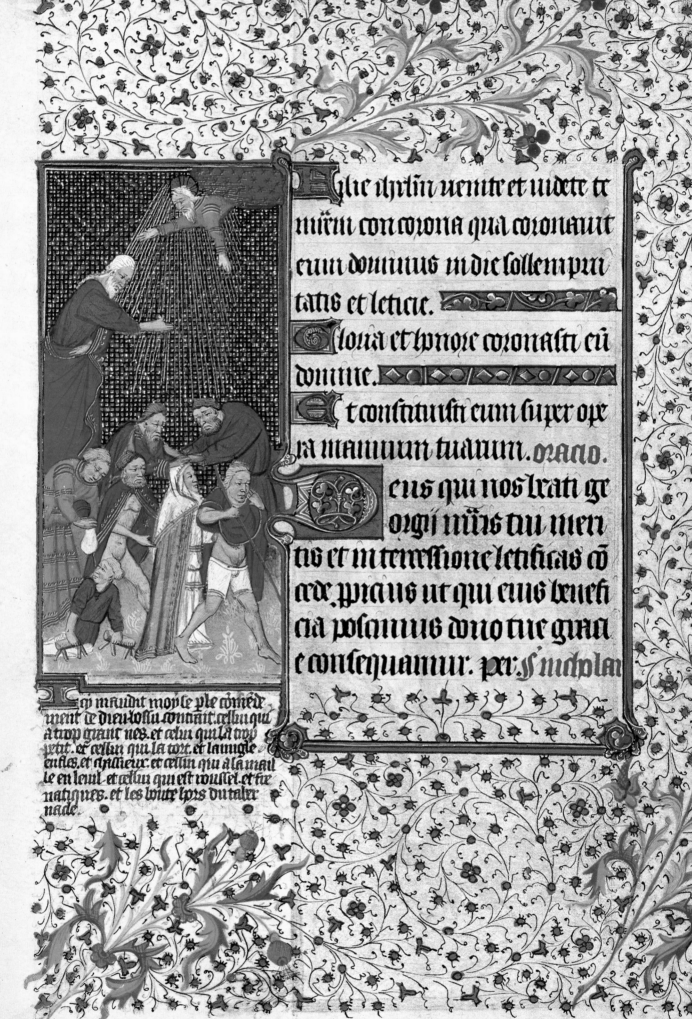

glie ꝯhſtin uenitc et uidete ce
miſem con corona qua coronauit
eum dominus in die ſollempni
tatis et leticie.

Gloua et honore coronaſti eũ
domine.

Et conſtituiſti cum super ope
ra manuum tuarum. oꝛacio.

eus qui nos beati ge
oꝛgij mꝛtis tui meri
tis et interceſſione letiſicas co
cede. picius ut qui eius beneſi
cia poſcimus dono tue gꝛaci
e conſequamur. per ſ̃ nicholaꝛ

eꝰ mꝛudit moꝩſe ẏle coméde
ment ꝺe dieu loſſu conꝺrait. cellui qui
a tꝛop gꝛant nes. et celui qui la tꝛop
petit. et cellui qui la tort. et la uugle
en tlos. et cꝛaſieux. et cellui qui a la mꝛil
le en leuil. et cellui qui est ꝛouſſel. et he
natiques. et les loute lpꝛs ꝺu taler
naꝺe.

Pl. 106

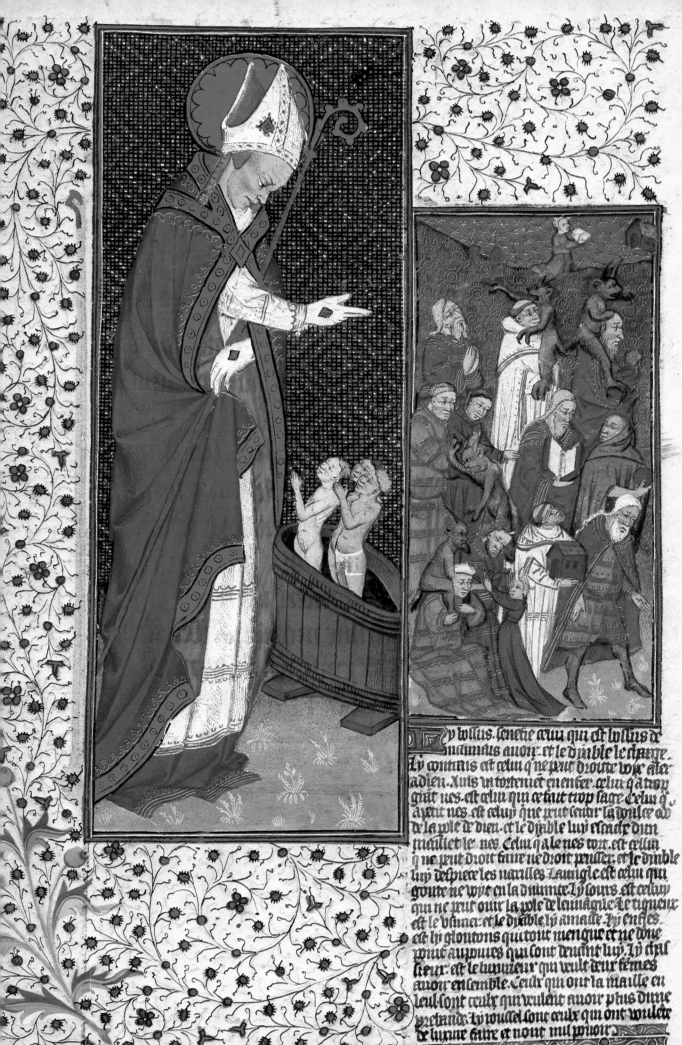

ly bolus. senefie celui qui est bolus de
maumus auoir. et le diable le charge.
Ly contrais est celui q̃ ne peut droite voie aler
a dieu. Auis un torternet enfer. celui q̃ a trop
grant nes. est celui qui se tient trop sage. Celui q̃
apetit nes. est celuy q̃ ne peut sentir la doulteur
de la loie de dieu. et le diable luy esrache ou
maillet le nes. Celui q̃ a le nes tort. est celui
q̃ ne peut droit faire ne droit priser. et le diable
luy despiece les narilles. Laurigle est celui qui
goute ne voie en la diuinite. Ly sours. est celuy
qui ne peut ouir la loie de leuaigile. Le tigneur
est le vsurier. et le diable ly amace. Ly entres
est ly gloutons qui tout menque et ne done
point auxpoures qui sont deuant luy. Ly chal
sieux. est le luxurieur qui veult deux femmes
auoir ensemble. Ceulx qui ont la maille en
leul sont ceulx qui veulent auoir plus dune
prebende. Ly roueel sont ceulx qui ont uoulu
de luxure faire et nont nul pooir.

Pl. 107

106. *Prayers of Intercession*

MARGINAL PAINTING. Bible moralisée. Leviticus XXI, 18–20.

LEGEND *"Icy maudit Moyse par le commandement de Dieu, bossu, contrait, cellui qui a trop grant nés et celui qui l'a trop petit et cellui qui l'a tort et l'avugle, enflés et chassieux et cellui qui a la maille en l'euil et cellui qui est roussel et frenatiques et les boute hors du tabernacle."*

Freely interpreting the text from Leviticus, this painting shows us Moses "cursing" (that is, in actual fact, merely excluding from the priesthood) those who are afflicted with certain physical mal-formations, such as the lame; the deformed; those whose noses are too big, too small, or crooked; the blind; those suffering from dropsy; those whose eyes are bleary or have a film over them; the eunuchs (the word *"roussel"* or red-headed is an erroneous reading from the *Angevin Bible*); and the lunatics.

Persons suffering from these various infirmities are represented in the foreground. Moses waves them away, at the command of God the Father, whose head and shoulders emerge from a cloud.

(f. 223v)

107. *Prayers of Intercession*

MAIN PAINTING

St. Nicholas, as bishop, is represented here at the moment when, according to a well-known legend, he restores to life the three children whom a wicked butcher had cut to pieces and placed in his salting-tub as quarters of meat. For this composition, the artist, while reversing the image, has clearly been inspired by the one which the Limbourgs had dedicated to St. Ambrose in the *Belles Heures* (f. 172). The latter work shows St. Ambrose, Bishop of Milan, baptizing three youths who have been immersed up to their waists in a wooden tub.

MARGINAL PAINTING. Bible moralisée.

LEGEND *"Ly bossus senefie celui qui est bossus de mauvais avoir et le dyable le charge; ly contrais est celui qui ne pout droitte voye aler a Dieu, ains va tortement en enfer. Celui qui a trop grant nés est celui qui ce fait trop sage. Celui qui a petit nés est celuy qui ne peut sentir la doulce odour de la parole de Dieu et le dyable lui escache d'un maillet le nés. Celui qui a le nés tort est cellui qui ne peut droit faire ne droit pensser et le dyable luy despiece les narilles. L'avugle est celui qui goute ne voyt en la divinité. Ly sours est celluy qui ne peut ouïr la parole de l'Euvangile. Le tigneux est le usurier et le dyable ly amasse. Ly enflés est ly gloutons qui tout mengue et ne donne point au povres qui sont devant luy. Ly chassieux est le luxurieux qui veult deux femmes avoir ensemble. Ceulx qui ont la maille en l'eul sont ceulx qui veulent avoir plus d'une prébande. Ly roussel sont ceulx qui ont voulenté de luxure faire et n'ont nul povoir."*

The illustration to which this long legend is devoted is a "moralization" on the text from Leviticus refusing entry to the priesthood to men having certain physical defects (Pl. 106). Such defects are likened, one by one, to moral blemishes which mark those thus afflicted as the prey of the Devil. The cripple, upon whose shoulders a devil has fastened himself, represents the person who has become rich by dishonest means. The deformed person symbolizes someone who cannot follow the right path which leads to God. The one with too large a nose represents the man who makes too much of his own wisdom. The one whose nose is too small represents the man who cannot savor the sweetness of the Divine word: the Devil will crush his nose with a hammer. The one with the crooked nose represents the man who can neither think nor act aright: the Devil will tear away his nostrils. The blind man symbolizes someone who understands nothing of the Divine teaching; the deaf man, one who refuses to listen to the Gospel. The man who has a skin disease is likened to the usurers; the man with dropsy, to the glutton. The rheumy-eyed man represents the lecher who cannot content himself with one legitimate wife. The man with a film over his eyes symbolizes one who covets several prebends. The red-headed fellow (*"roussel"*), is likened to the man who indulges in lascivious thoughts, but is unable to execute them—which, of course, makes no sense. In the *Angevin Bible* the word, incorrectly copied here, was *"rancol"* or *"rancoil,"* a rare word meaning a eunuch or impotent man. (f. 224).

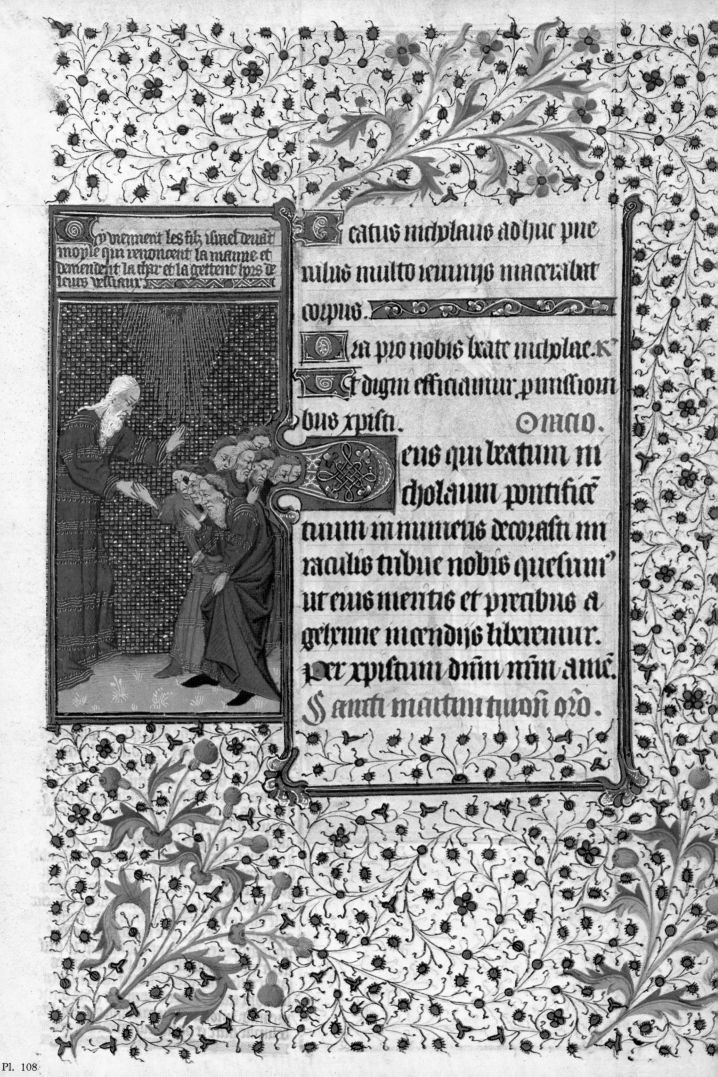

Cy vienment les filz ysrael deuāt
mople qui venonōent la manne et
demendēt la char et la gettēc tpis de
leuis velissour

eatus nicholaus adhuc pue
rulus multo ieiunijs macrabat
corpus.

Ora pro nobis beate nicholae. K

Et digni efficiamur pmissioni
bus xpisti. ORACO.

eus qui beatum ni
cholaum pontifice
tuum innumeris decorasti mi
raculis tribue nobis quesum
ut eius meritis et precibus a
gehenne incendijs liberemur.
per xpistum dominum nostrum amen.

Sancti martini tuosi oro.

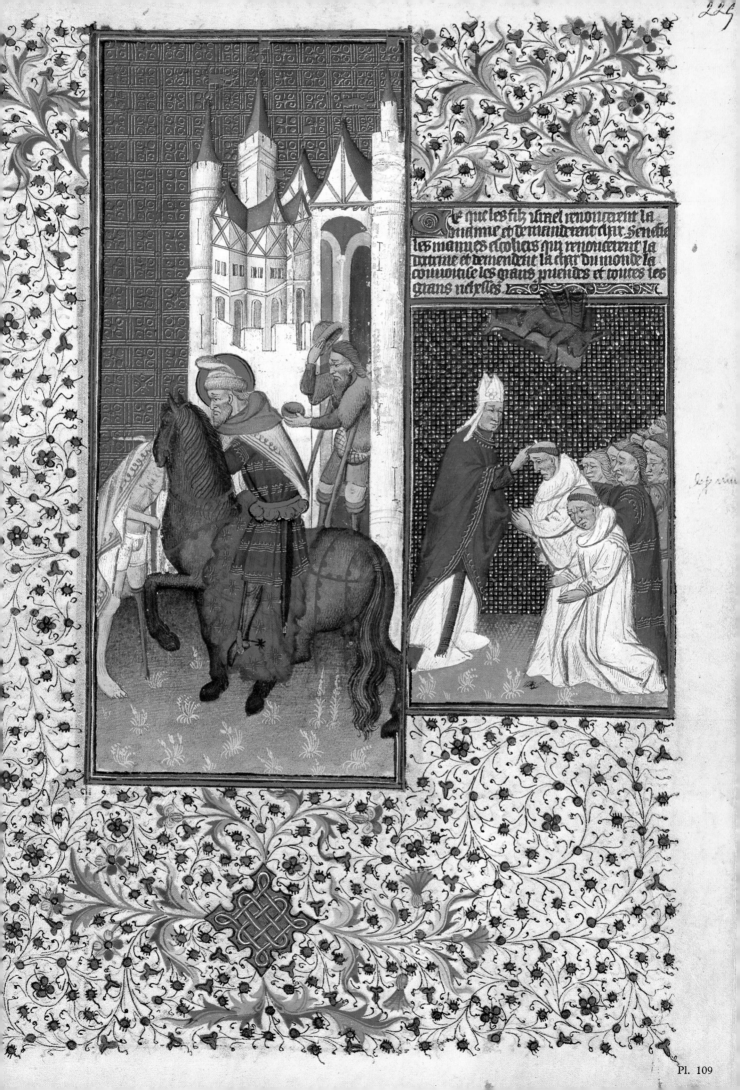

Pl. 109

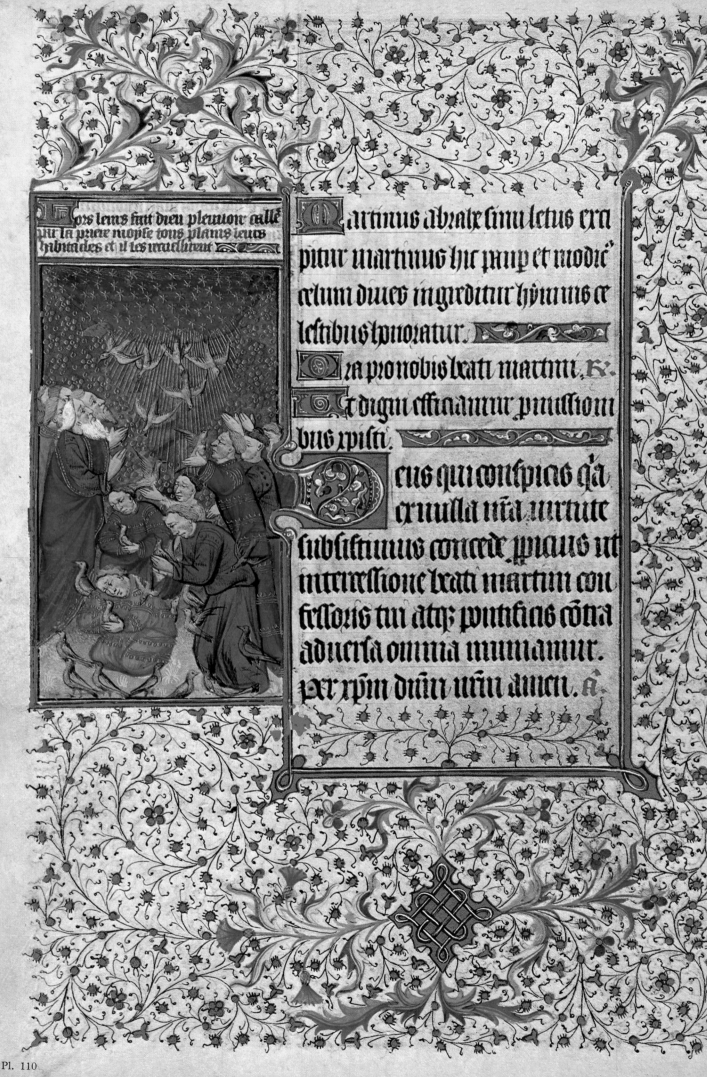

Pl. 110.

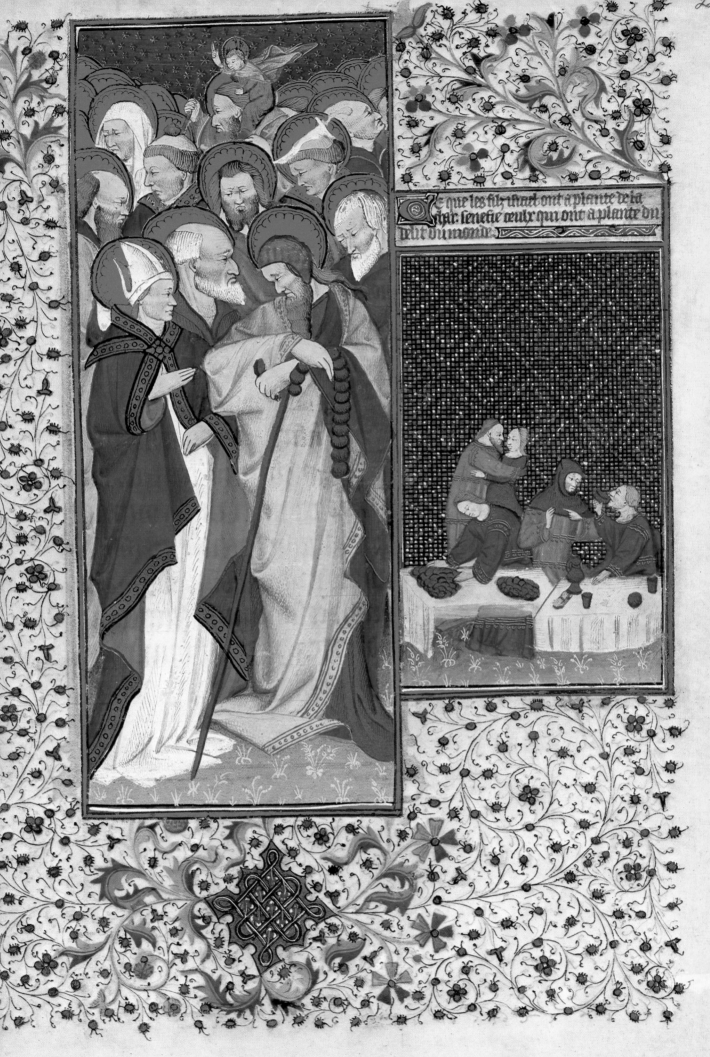

e que les filz ihrael ont a plante de la
char. senefie œulx qui ont a plante du
delit du monde.

Pl. 111

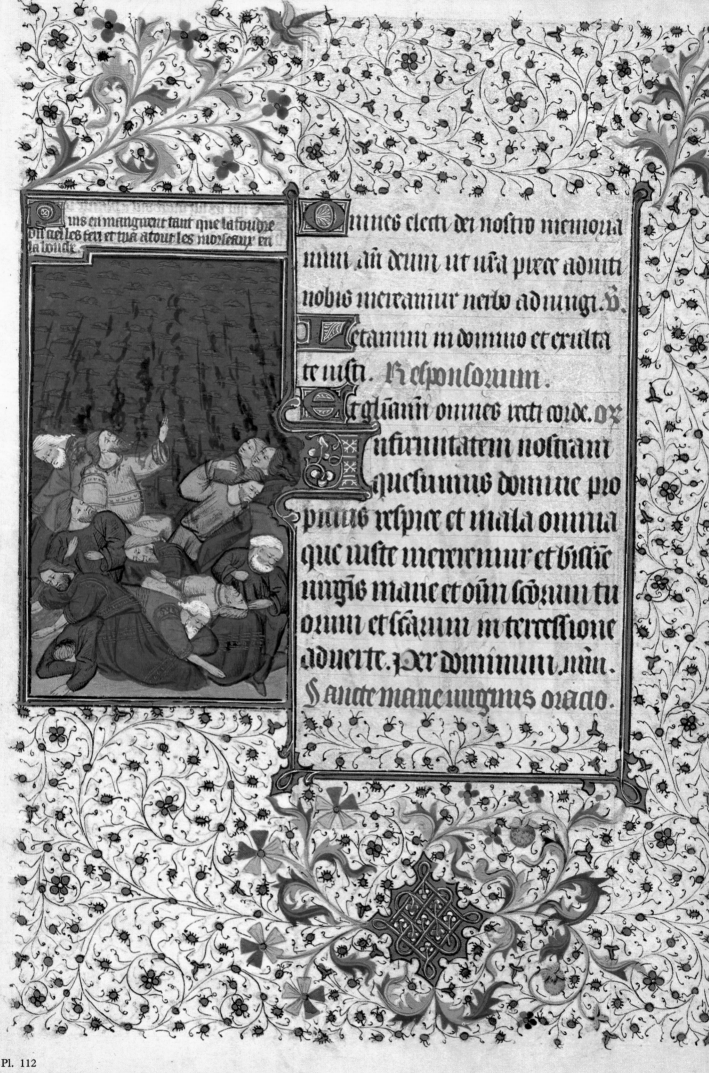

ins en mangirent tant que la fouдre
on act les feu et tua atout les morseaux en
la louдe.

mnes electi dei nostro memoria
num ad deum ut usa pietce admit
nobis mercamur nedo adiungi. ꝟ.
Letanium in domino et exulta
te iusti. Responsorium.
Et glianir omnes recti corde. or
nfirmitatem nostram
quesumus domine pro
pnius respice et mala omnia
que iuste meremur et bistie
ungis manie et onin scorum tu
orum et scamum in teressione
aduerte. Per dominum min.
Sancte marie uiginis oracio.

Pl. 112

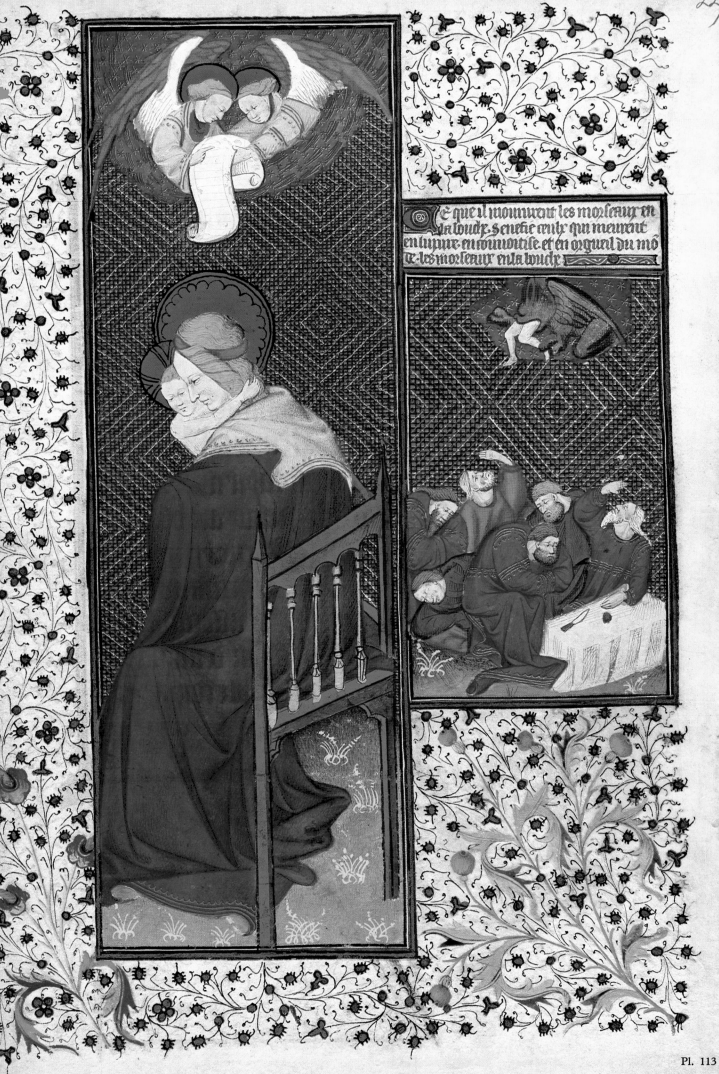

e que il moeurent les morseaux en
la bouche. Senefie ceulx qui meurent
en luxure en mimortise. et en orgueil du mõ
de. les morseaux en la bouche.

Pl. 113

108. *Prayers of Intercession*

MARGINAL PAINTING. Bible moralisée. Numbers XI, 4.

LEGEND *"Cy viennent les filz Israël devant Moyse qui renoncent la manne et demendent la char et la gettent hors de leurs vessiaux."*

Here, the Israelites show their ingratitude to God by declaring that they are tired of the manna with which He has nourished them for a long time, and by vehemently demanding meat from Moses.

Actually, the sacred text does not say that the Israelites "threw away" the manna; but the thirteenth-century Latin *Bible moralisée* specifies that "the sons of Israel came before Moses, saying that they were sick of the manna, which they declared to be inedible." The painting from the thirteenth century represented them, as the legend indicates, emptying out onto the ground the vessels containing the manna. That detail has not been visually depicted here. (f. 224v)

109. *Prayers of Intercession*

MAIN PAINTING

This representation of St. Martin cutting off a piece of his cloak to give to a beggar is obviously inspired by the painting devoted to the same subject by the Limbourgs in the *Belles Heures* (f. 169). The decor has, however, been transformed here by the artist. Furthermore, he has turned the head of St. Martin's horse to the right, to avoid completely concealing the beggar, whom he was forced to bring closer to the saint because of the slightly narrower width of the composition here. With a characteristic taste for crude, if not actually repugnant, detail, he has provided wooden legs and a pair of crutches for the second beggar (behind the first one), who holds out his cup for alms. This detail was not included by the Limbourgs.

MARGINAL PAINTING. Bible moralisée.

LEGEND *"Ce que les filz Israel renoncerent la manne et demanderent char senefie les mauvés escoliers qui renoncerent la doctrine et demandent la char du monde, la convoitise, les grans provendes et toutes les grans richesses.*

The Israelites whom we saw in the preceding folio (Pl. 108), declaring that they were tired of manna, represent the wicked clergymen and monks who turn away from the pure doctrine and come before their bishop to demand the material goods of this world in the form of riches and valuable prebends. The Devil, in the upper part of the picture, prepares to sweep down upon them, after having inspired their desires. (f. 225)

110. *Prayers of Intercession*

MARGINAL PAINTING. Bible moralisée. Numbers XI, 31–32.

LEGEND *"Lors leur fait Dieu pleuvoir calles par la priere Moyse tout plains leurs habitacles et ils les recuellirent."*

Responding to the plea of Moses (on the left), God brings forth a shower of quail, which He lets fall over the camp of the Israelites (whose tents, mentioned in the legend, have not been represented). They gather up the quail with joy. (f. 225v)

111. *Prayers of Intercession*

MAIN PAINTING

In the foreground, we can recognize St. James, St. Nicholas, and St. Peter, generally painted with the same faces the artist gave them when he represented these saints in single portraits. Behind them are St. Christopher and St. Stephen, among others.

MARGINAL PAINTING. Bible moralisée.

LEGEND *"Ce que les filz Israël ont a planté de la char senefie ceulx qui ont a planté du delit du monde.*

The Israelites, who received meat in abundance when God sent down a shower of quail upon their camp (Pl. 110), are intended to remind us of those who enjoy the goods and pleasures of this world to satiety. On the left, an individual who is piling up gold pieces on a table evokes the joys that wealth can procure. The one on the right, who dines alone at a well-laid table without offering any food to a man who seems to be pointing to himself to indicate that he is hungry, symbolizes selfishness and gluttony. Behind them, a man and woman in a deep embrace embody the pleasures of the flesh.

(f. 226)

112. *Prayers of Intercession*

MARGINAL PAINTING. Bible moralisée. Numbers XI, 33.

LEGEND *"Puis en mangirent tant que la foudre du ciel les feri et tua a tout les morseaux en la bouche."*

The Israelites gorge themselves so gluttonously on the quail which the Lord sent them that they provoke His wrath. Lightning from heaven strikes them and causes them to perish while they still have their mouths full. The text of the Vulgate speaks only of "a great calamity" which befell the guilty ones, but the thirteenth-century Latin *Bible moralisée* states that they were struck by lightning.

(f. 226v)

113. *Prayers of Intercession*

MAIN PAINTING

This painting almost surely constitutes an adaptation by the artist of an earlier, quite different model, which he endeavored to modify, not without a certain awkwardness. In a "Flight into Egypt" illustrating a leaf from the *Heures de Buz*, in the Harvard College Library, we find a representation of the Virgin whose relationship to this one is obvious, even though she is riding side-saddle on a donkey and the lower part of her body is hidden by the animal. In the present painting, one is struck by the anatomically improbable position of the Virgin's left knee: everything would lead one to think that an unskilled artist had somehow or other completed a model for which he left out the lower part—and for good reason. The rather surprising sketch of the seat on which the Virgin is sitting might also be explained by a less than successful transposition of the model mentioned above, which is also found, in reverse, in the "Flight into Egypt" of the *Heures d'Anjou* (f. 62).

MARGINAL PAINTING. Bible moralisée.

LEGEND *"Ce que il moururent les morseaux en la bouche senefie ceulx qui meurent en luxure, en convoitise et en orgueil du monde, les morseaux en la bouche."*

Various sinners, some of whom are still seated at the table, are seen being brutally struck down by death, just as the Israelites had been struck by lightning (Pl. 112). The Devil, whom we can see at the top of the picture, greedily devours their souls, represented by a little naked figure whose legs are protruding from the Devil's jaws.

(f. 227)

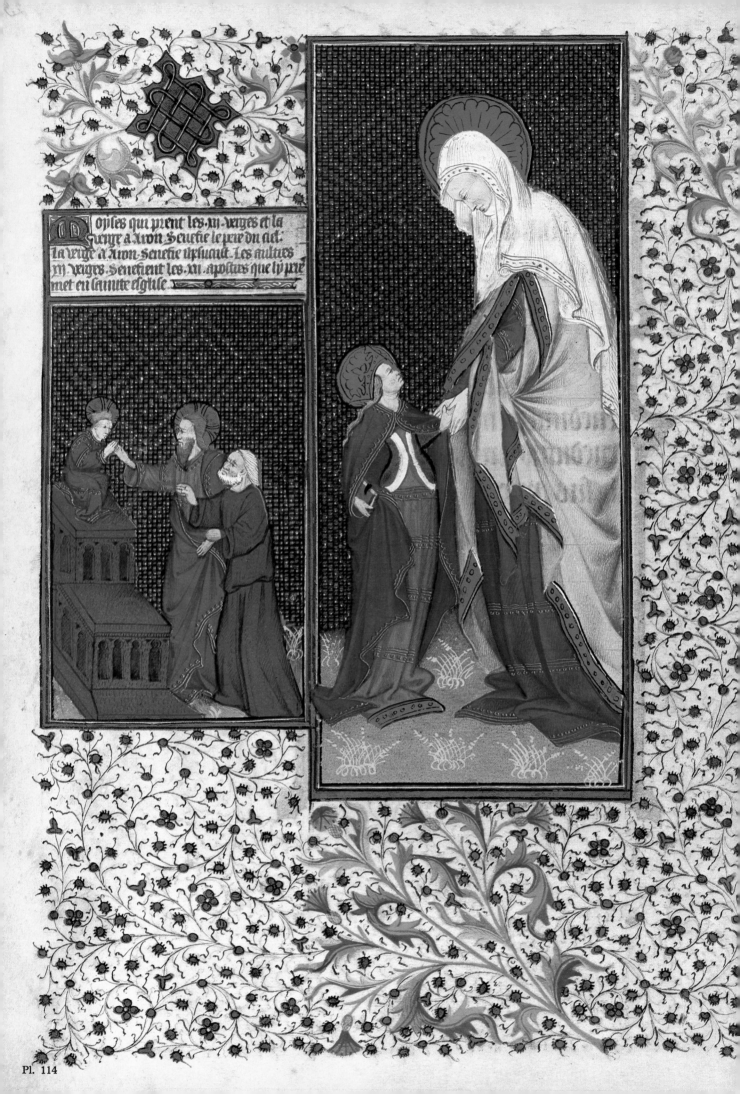

Pl. 114

eleste beneficium intuuit i
anima de qua nata est nob virgo in. H.

Diffusa est gra in labiis tuis. R.

Propterea bndixit te ds ieternum.
Deus qui beate anne tan
tam graciam dona
re dignatus es ut beatissimam
mariam virginem tuam insuo vir
glioso portare mereretur. da nob
pintercessione eius et filie tue
pinacois beniudicam et eiri
memoria pio amore ompletium
eius pcibz ad celeste ihrlm puc
nire valeamus. Per. katherina

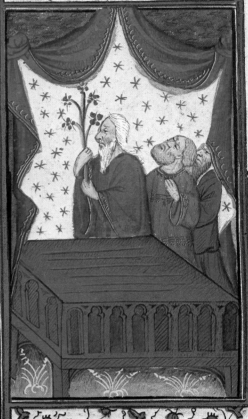

Apres vient moyse si trait la ver
ge a Aron pres de larche toute floune
de feuilles. et de flours. et de fruit. et la
resgardent et monstre sen esmerueilla er
tout le peuple qui dauier en estoit.

Pl. 115

114. *Prayers of Intercession*

MAIN PAINTING

This composition, whose theme is seldom encountered in Books of Hours of the period (although a manuscript in a private collection in New York contains a very similar illustration, which Professor Meiss attributes to a pupil of the Master of the *Boucicaut Hours*), shows the Virgin, whose slight stature indicates her youth, affectionately placing her hand in those of her mother, St. Anne. The artist, in painting this scene, undoubtedly had in mind the moment when the Virgin was about to leave her parents to be brought up and instructed in the Temple. The book which she holds in her right hand might serve to confirm this interpretation.

MARGINAL PAINTING. Bible moralisée.

LEGEND *"Moyses qui prent les xii verges et la verge a Aron* [sic] *senefie le Pere du ciel; la verge a Aron senefie Jhesu Crist; les aultres xii verges senefient les xii apostres que ly Pere met en saincte esglise."*

This painting constitutes a moralization on the passage from Numbers (XVII, 6), where it is stated that Moses received the rods from the chiefs of the twelve tribes of Israel and that of Aaron and placed them all in the Tabernacle. These twelve rods represent, according to the legend, the twelve Apostles, and the thirteenth (Aaron's rod), Jesus Christ Himself. Moses, who brought them together, represents God building His Church with the Son and the twelve Apostles. Here, the Father, standing, extends His right hand toward the Son, represented as a child seated on a sort of altar with several tiers, symbolizing the Church. The Son watches an old man with a white beard, who is recognizable as St. Peter, the chief of the Apostles.

(f. 230v)

115. *Prayers of Intercession*

MARGINAL PAINTING. Bible moralisée. Numbers XVII, 8–9.

LEGEND *"Aprés vient Moyse, si trait la verge a Aron hors de l'arche toute flourie de feuilles et de flours et de fruit et la resgardent et moult s'en esmerveilla et tout le peuple qui darrier lui estoit."*

Moses, upon withdrawing Aaron's rod from the Ark, finds it laden with leaves, flowers, and fruit. The Israelites who accompany him marvel, as does Moses, at this miracle. (f. 231)

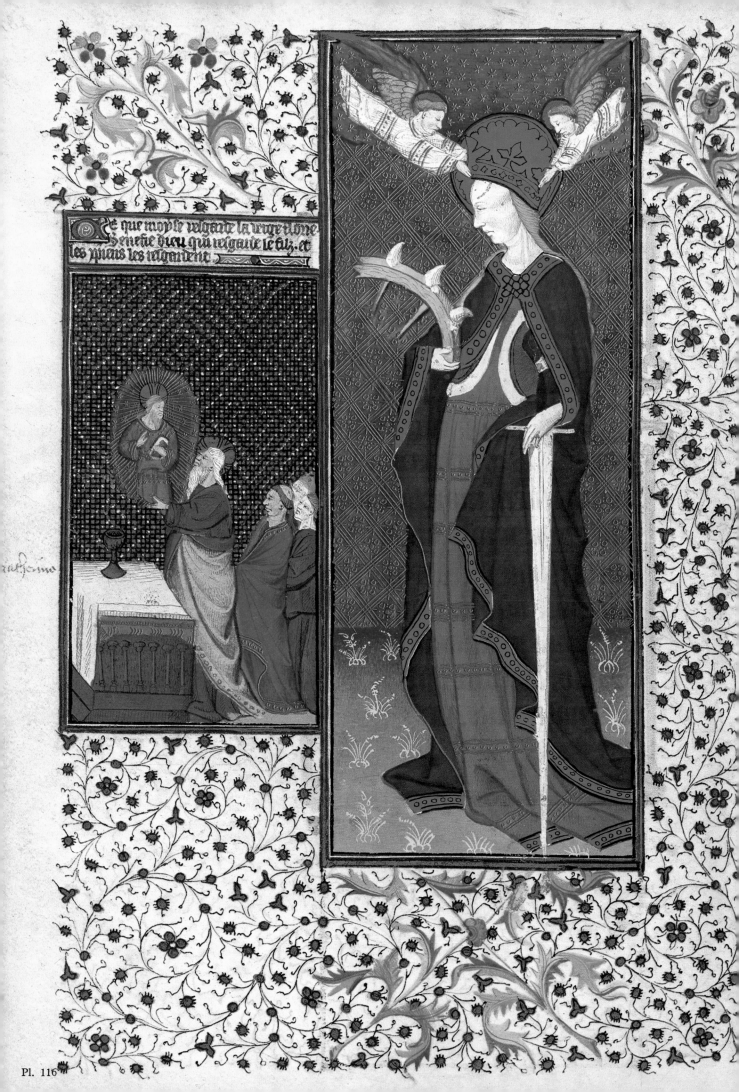

Pl. 116

Urgo sancta katherina grecie
gemma uirr alexandrina costi re
gis erat filia.

Uffusa est gña in labijs tuis pr
optea bndixit te ds ieternum. oz
ens qui dedisti legem
moysi in summitate
montis synai ieode loco pscds ã
gelos tuos corpus ve katherine
uigis et mris tue mirabili col
tocasti ibuc ipo dne ut eri mtis
precibus interressione admonte
qui xps est ualeamus puenire
p dominum. margarete uig. a:

Cy vient moyse qui prent la verge et la
remet arier en larche par le commen
dement de dieu

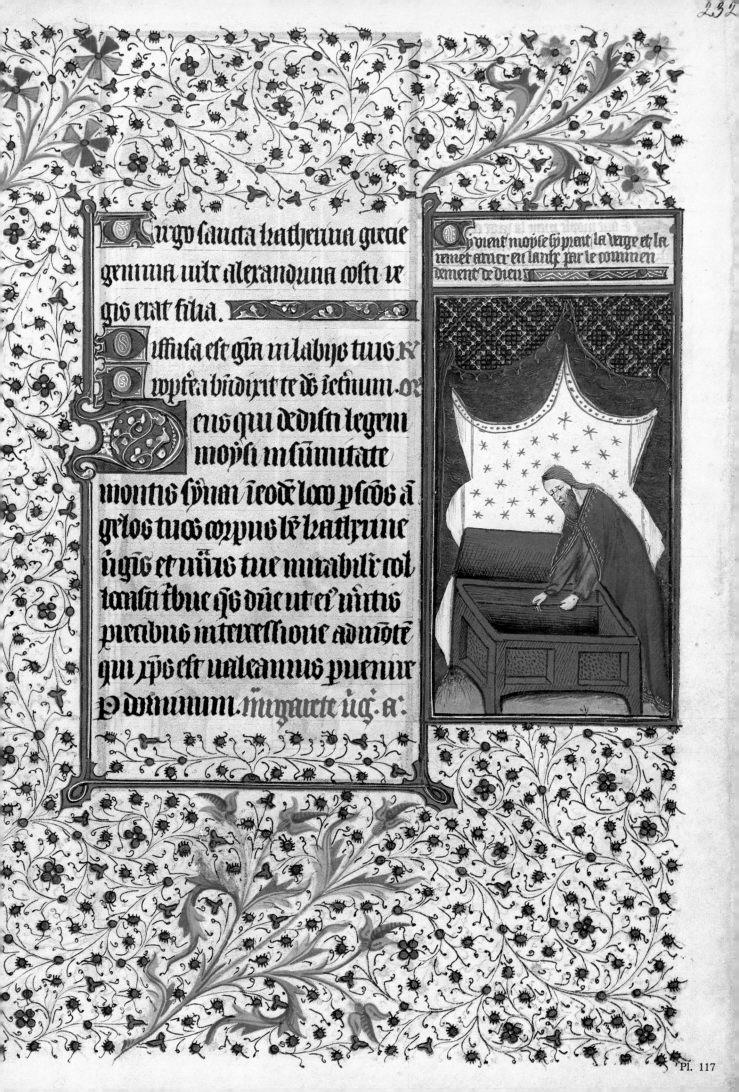

Pl. 117

116. *Prayers of Intercession*

MAIN PAINTING

Saint Catherine, as we learn from the *Golden Legend,* lived in Alexandria at the time of the Emperor Maxentius and was the daughter of "King Costus." Here, she is represented standing, her left hand resting on a sword, which recalls the weapon used to behead her at the Emperor's order. In her right hand we see a piece of the wheel fitted with sharp spikes which the tyrant had prepared for her torture and which the angels broke in response to her prayer. Two angels place a crown on the head of the saint.

MARGINAL PAINTING. Bible moralisée.

LEGEND *"Ce que Moyse resgarde la verge florie senefie Dieu qui resgarde le Filz et les Christiens les resgardent."*

Moses, contemplating Aaron's rod miraculously blooming with leaves, flowers, and fruit (Pl. 115), is intended to suggest God the Father contemplating His Son. The Son appears in a mandorla, above an altar on which a chalice has been placed. This decor evokes for us the mystery of Transubstantiation: in the Eucharist, the Son appears to the faithful, in accordance with the will of the Father, under the appearance of bread and wine. The tonsured clergyman whom we can see behind the Father is the visible celebrant of the mass, a ritual which he performs in the presence of the faithful, behind him. The artist has, with only the most minor changes, reutilized the same composition as that found in the marginal painting for folio 232v (Pl. 118). (f. 231v)

117. *Prayers of Intercession*

MARGINAL PAINTING. Bible moralisée. Numbers XVII, 10–11.

LEGEND *"Cy vient Moyse, sy prent la verge et la remet arrier en l'arche par le commendement de Dieu."*

At the command of the Lord, Moses (whose silhouette stands out against the wide draperies of the Tabernacle) puts Aaron's rod back into the Ark, so that it may be kept "as a token of the rebellion of the children of Israel." (f. 232)

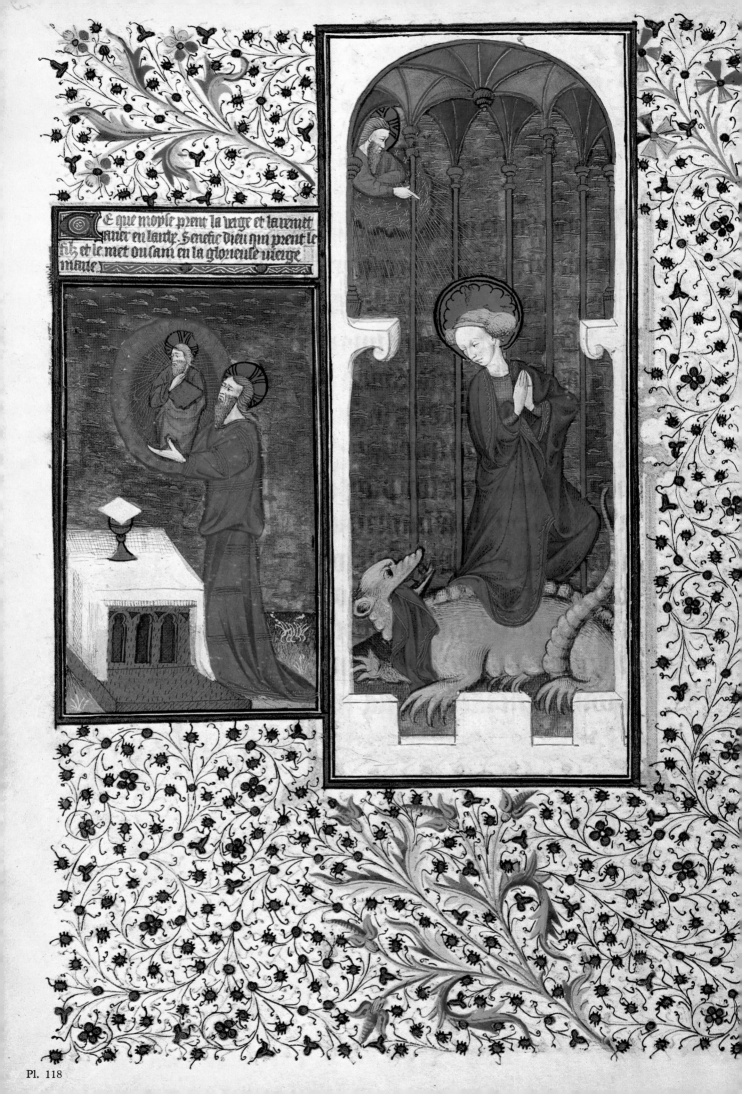

E que moyse prent la verge et la remet
aner en laitte. Senefie dieu qui prent le
filz et le met ou sam en la glorieuse vierge
marie.

Pl. 118

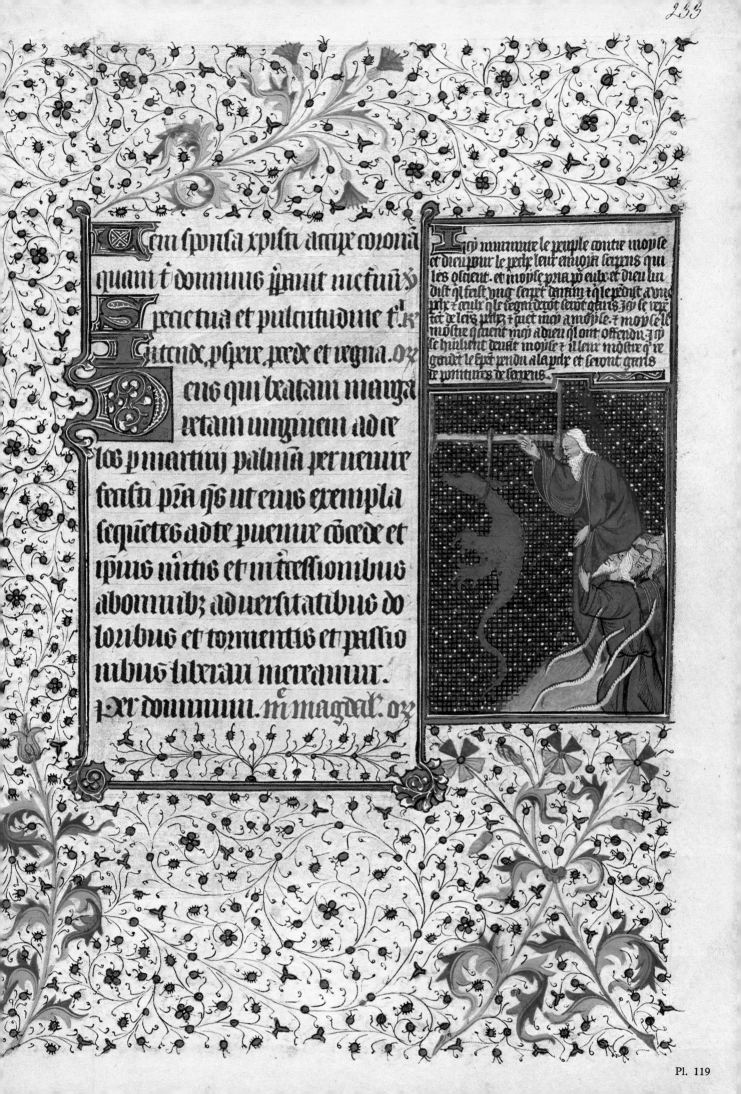

Cum sponsa xpisti digne coronā
quam t dominus ipaut nictuis
pretie tua et pulcritudine t[?]
Intende pspere pcede et regna. O[?]
eus qui beatam marga
retam unginem ad ce
los p martiriu palma puenire
fecisti pta qs ut eius exempla
sequetes ad te puenire cōcede et
ipius nitis et intercessionibus
ab omnib; aduersitatibus do
loribus et tormentis et passio
nibus liberan mereamur.
p dominum. m magdał. o[?]

Ici murmure le peuple contre moyse
et dieu pour le peche leur enuoia serpens qui
les occient. et moyse pria pou eulx. et dieu lui
dist qil feist ung serpet dairam tq le regdt a ung
pux tceulx qle regardoit seroit garis. Ici le repe
sente de leur péchiez tquet moy a moyse. tmoyse le
mostre q querent mci a dieu qil ont offendu. Ici
se humilient deuant moyse tilleur mostre q re
gardt le scpt pendu a la pdce et seront garis
de pointures de serpens.

Pl. 119

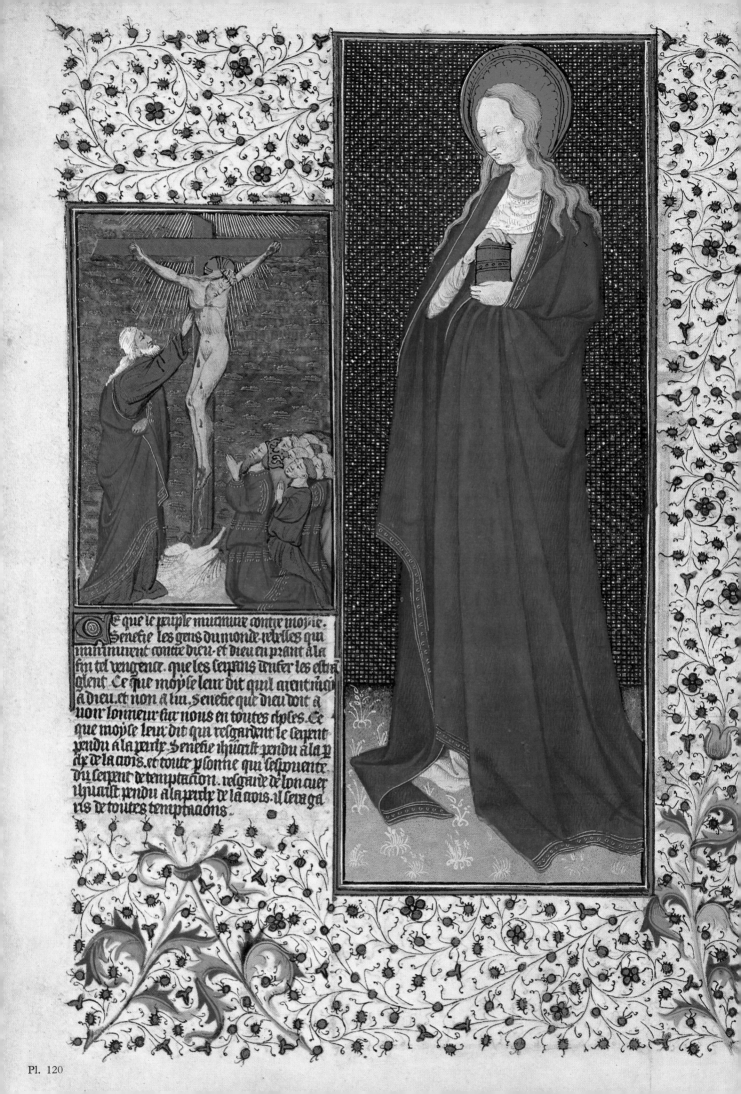

Ce que le peuple murmure contre moyse.
Senefie les gens du monde rebelles qui
murmurent contre dieu. et dieu en prant a la
fin tel vengence. que les serpens tuelet les estra-
glent. Ce que moyse leur dit quil aient regart
a dieu. et non a lui. Senefie que dieu doit a
uoir lonneur sur nous en toutes choses. Ce
que moyse leur dit quil resgardent le serpent
pendu a la pche. Senefie ihucrist pendu a la p-
dix de la crois. et toute psonne qui lespouente
du serpent de temptacion. resgarde de son cuer
ihucrist pendu a la pche de la crois. il sera ga-
ris de toutes temptacions.

Pl. 120

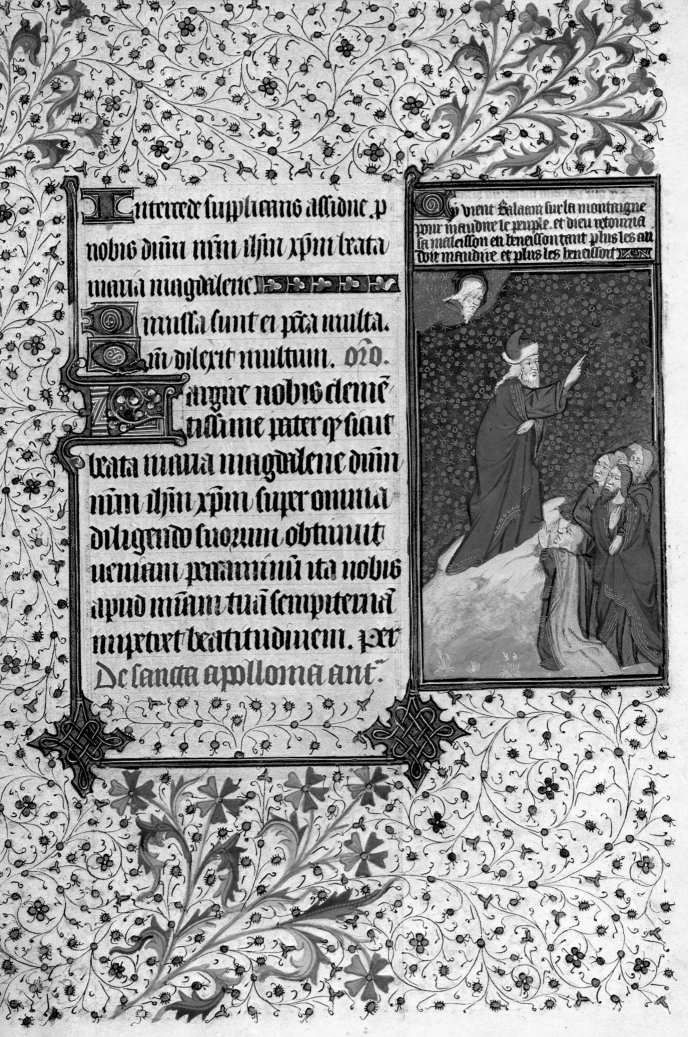

Enterrede supplicans assidue .p
nobis diim mm ihsm xpm beata
maria magdalene. Remissa sunt ei pccata multa.
m dilexit multum. ozo.

argue nobis clemē
tissime pater qp sicut
beata maria magdalene diim
mm ihsm xpm super omnia
diligendo suorum obtinuit
ueniam peccaminū ita nobis
apud mram tuam sempiternal
impetret beatitudinem. per

De sancta apollonia ant.

Cy vient Balaam sur la montaigne
pour maudire le peuple. et dieu retourna
sa malesson en benesson tant plus les an
doir maudire et plus les benesloit

Pl. 121

118. *Prayers of Intercession*

MAIN PAINTING

In an architectural decor which evokes a castle by its battlements and, at the same time, a chapel—by the vaults and colonettes which form its background, open to the sky—St. Margaret is represented escaping miraculously from the entrails of the dragon which had devoured her. The presence of God, whose head and shoulders appear in the upper part of the painting, underscores the miraculous character of this episode. An almost identical representation of the saint is found in MS. 5140 of the Lyons Library (f. 70). The dragon in that manuscript has the same countenance and attitude as the one represented here.

MARGINAL PAINTING. Bible moralisée.

LEGEND *"Ce que Moyse prent la verge et la remet arrier en l'arche senefie Dieu qui prent le Filz et le met ou sein en la glorieuse Vierge Marie."*

The illustration here corresponds only vaguely to the legend. According to the legend, Moses, whom we saw putting Aaron's rod back into the Ark of the Tabernacle (Pl. 117), symbolizes the mystery of the Incarnation, wherein the Father placed the Son in the womb of the Virgin Mary. Actually, we see the first two persons of the Holy Trinity represented somewhat as in folio 231v (Pl. 116), before an altar whose veiled chalice evokes for the second time the mystery of the Eucharist.

(f. 232v)

119. *Prayers of Intercession*

MARGINAL PAINTING. Bible moralisée. Numbers XXI, 4–9.

LEGEND *"Icy murmure le peuple contre Moyse et Dieu, pour le péché, leur envoya serpens qui les oscient et Moyse pria pour eulx et Dieu lui dist qu'il feist ung serpent d'arain et qu'i le pendist a une perche et ceulx qui le regarderont seront garis. Icy se repentent de leurs pechez et crient mercy a Moyse et Moyse leur monstre que crient mercy a Dieu q'il ont offendu. Icy se humilient devant Moyse et il leur monstre qu'i regardent le serpent pendu a la perche et seront garis de pointures de serpens."*

The legend and image condense here several successive episodes from the Book of Numbers. Against the rebellious Israelites, God raised up venomous serpents (seen here on the right of the painting). Moses, full of pity, implores God's pardon for his people, whereupon God commands him to fashion a serpent of brass and hang it from a gibbet. Here we see Moses, after having carried out God's command, explaining to the Israelites that in looking upon the serpent of brass they will be cured of the bites inflicted upon them by the venomous serpents. Kneeling, the Israelites acknowledge their wrongdoing. To represent the serpent, or rather the dragon of brass, the artist has used a silvery paint which has become blackened with time, as happens with this type of pigment. (f. 233)

120. *Prayers of Intercession*

MAIN PAINTING

St. Mary Magdalene is represented here holding in her hands a vase of perfume, in accordance with the tradition which has identified her with the woman who, in the house of Simon the leper, had anointed the head of Christ with the contents of a vase of precious ointment (Matthew XXVI, 6–7).

MARGINAL PAINTING. Bible moralisée.

LEGEND *"Ce que le peuple murmure contre Moyse senefie les gens du monde rebelles qui murmurent contre Dieu et Dieu en prant a la fin tel vengence que les serpens d'enfer les estranglent. Ce que Moyse leur dit qu'il crient mercy a Dieu et non a lui senefie que Dieu doit avoir l'onneur sur nous en toutes choses. Ce que Moyse leur dit qu'i resgardent le serpent pendu a la perche senefie Jhesu Crist pendu a la perche de la crois et toute personne qui s'espovente du serpent de temptacion resgarde de bon cuer Jhesu Crist pendu a la perche de la crois, il sera garis de toutes temptacions."*

The rebellion of the Israelites (Pl. 119), is the image of the rebellion of sinners against God, who will punish them with the torments of Hell, as He punished the Israelites with the bites of the venomous serpents He had raised up against them. Moses admonition that they seek mercy from God, rather than from him, is intended to remind us that God has supremacy over every creature. As for the serpent of brass that was hung on a gibbet, it represents Jesus, whom we see here expiring on the Cross. Those who, fearing temptation, will contemplate His image, as do good Christians (represented here on their knees, to the right of the picture), thus heeding the counsel of God (on the left), will be delivered from the temptations which assail them. (f. 233v)

121. *Prayers of Intercession*

MARGINAL PAINTING. Bible moralisée. Numbers XXIII.

LEGEND *"Cy vient Balaam sur la montaigne pour mudire le peuple et Dieu retourna la maleisson en beneïsson; tant plus les cuidoit maudire et plus les beneïssoit."*

The legend rather freely summarizes a whole chapter from the Book of Numbers. The prophet Balaam, wearing a Jewish headdress, is represented here standing on a mountain. He threatens the frightened Israelites, one of whom, kneeling, clasps his hands in a gesture of supplication. God, whose face alone appears in the heavens, watches the scene. (f. 234)

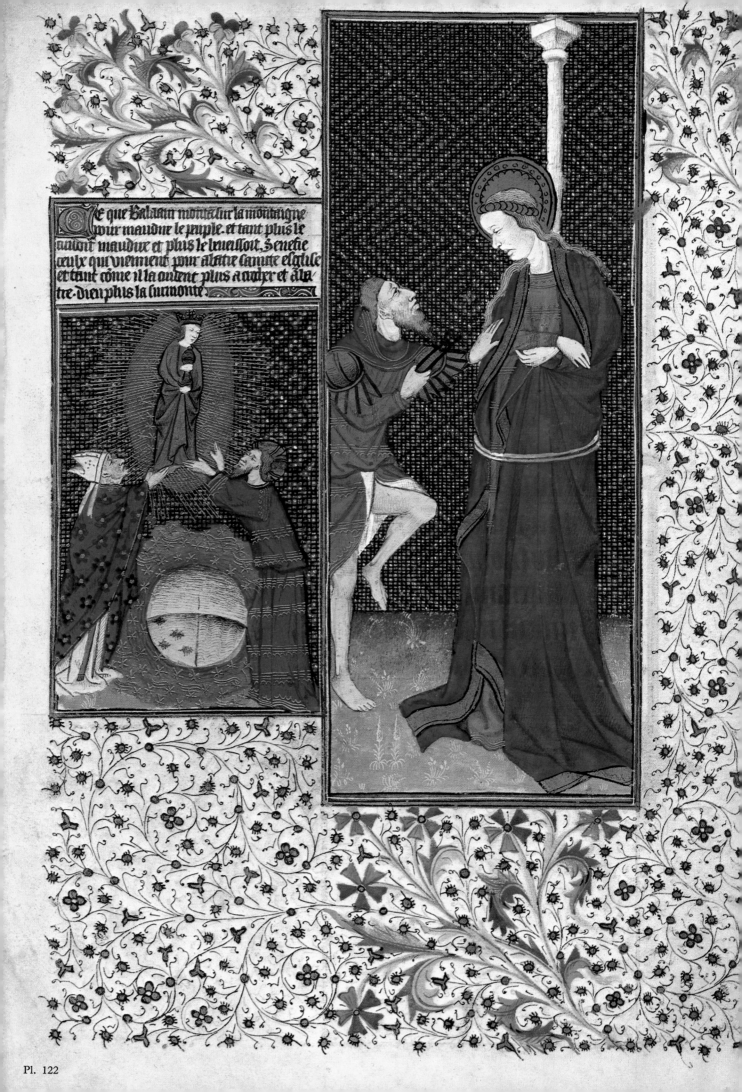

e que Balaam montast sur la montaigne
pour maudire le peuple. et tant plus le
vouloit maudire et plus le beneïssoit. Senefie
ceulx qui viennent pour abatre sainte eglise
et tant côme il la cuident plus a cuider et à la
tre. dieu plus la surmonte.

Pl. 122

eata apolonia mrtyr, pdioso susti
uuit tyrānū dēteg eius cū malleis fer
reis sͦ frerūt leo touīto orauit dñm
ducēs ut quicūqᵹ nomen suuū pro
dolore dēcaium muocauit maluuī
mdentibus non sentiret.

ra pro nobis beata apolonia

t digni efficiamur promissi
ombus xpīsti. O raio:.

eus propicius ēsẽi
uū nominibus tui a
mote beata apolonia uirgo
et mrtir amarecū atᵹ hz
ribilem dēcaium excusionē

Pl. 123

122. *Prayers of Intercession*

MAIN PAINTING

Here again, in representing the martyrdom of St. Apollonia, the artist was inspired by a model created by the Limbourgs in the *Belles Heures* (f. 17), but by one that was drawn to illustrate the torture of St. Catherine. He has, however, been the victim of his excessive fidelity: the attitude of the torturer is, in fact, completely illogical here. It was natural for the tormentors of St. Catherine to be represented with a knee upraised, since they propped themselves against the body of the saint to better bind her to a pillar. On the other hand, this torturer, who is about to use the pincers he is holding to pull out St. Apollonia's teeth, has no reason to balance himself on one foot as he is doing.

MARGINAL PAINTING. Bible moralisée.

LEGEND *"Ce que Balaam monta sur la montaigne pour maudire le peuple et tant plus le cuidoit maudire et plus le beneïssoit senefie ceulx qui viennent pour a-batre saincte esglise et tant comme il la cuident plus acrocher et abatre, Dieu plus la surmonte."*

Here, the artist has represented Christ and a bishop raising up the church, in the guise of a woman crowned and standing in a mandorla, above a sphere surrounded by water, which symbolizes the world (and its dangers). We are told in the legend that the more Balaam cursed the Israelites, the more God blessed them (Pl. 121), and that, in the same manner, the efforts of those who seek to destroy the Church come to nothing, due to the grace of God, who sustains the Church and raises it up even higher. (f. 234v)

123. *Prayers of Intercession*

MARGINAL PAINTING. Bible moralisée. Numbers XXV, 1–3.

LEGEND *"Lors vint Balaam et deceut les filz Israel et leur fist aourer ung Dieu de luxure et les fist gesir avec femmes."*

The prophet Balaam, on the left, urges two kneeling Israelites to adore an idol, represented in the form of a statue of a nude man, resting upon a pillar. Yielding to the evil counsel which has been lavished upon them, a man and a woman embrace voluptuously, on the right, before a group of spectators.

In actual fact, the legend and the image perpetuate a misinterpretation already encountered in the thirteenth-century Latin *Bible moralisée*, which was no doubt derived from an incorrect reading or from a defective manuscript of the sacred text. The latter indicates that the Israelites, once they were settled in Shittim, gave themselves over to debauchery with the women of Moab and, upon their invitation, worshiped their god, the Baal of Peor. The prophet Balaam plays no part in this episode, but the resemblance of his name to that of the idol undoubtedly explains the error. (f. 235)

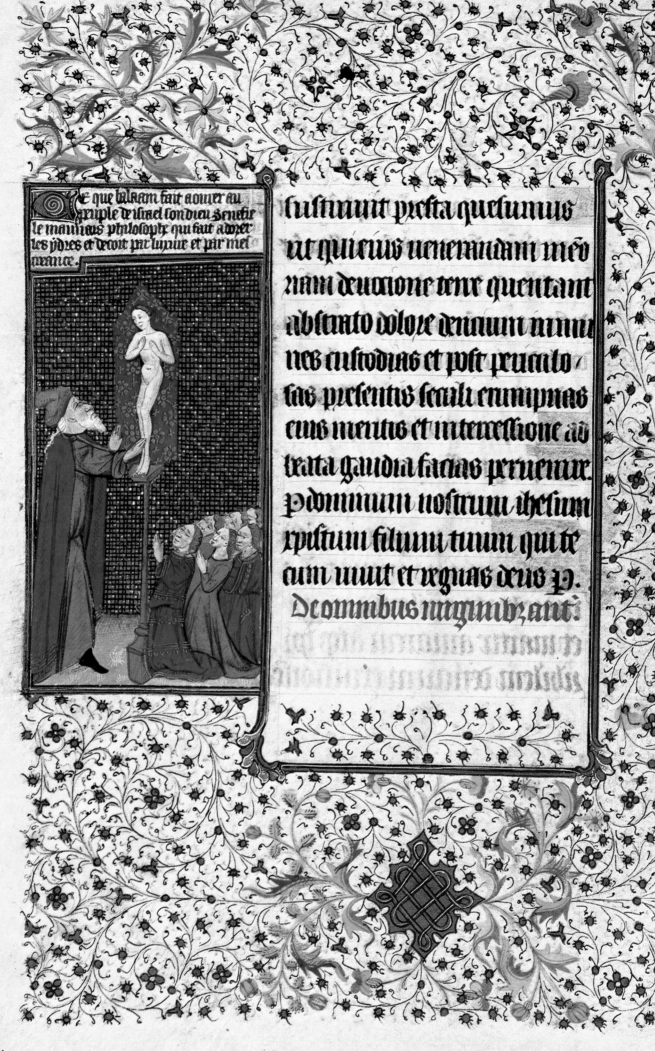

Ce que balaam fait adourer au
peuple de israel son dieu Et estie
le mauuais philosophe qui fait adorer
les ydres et deçoit par lymure et par mel
dorance.

sustinuit presta quesumus
vt quieius venerandam meo
riam deuocione venz quentant
abstrato dolore deniuum minui
nes custodias et post presento
tas presentis seculi erumpnas
eius meritis et intercessione ad
trata gaudia facias peruenire.
P dominum nostrum ihesum
xpistum filium tuum qui te
cum viuit et regnas deus P.
De omnibus virginibz anti
et virtutis arminum criatur ipi
xpistum amauitur et fortem omisda

Pl. 124

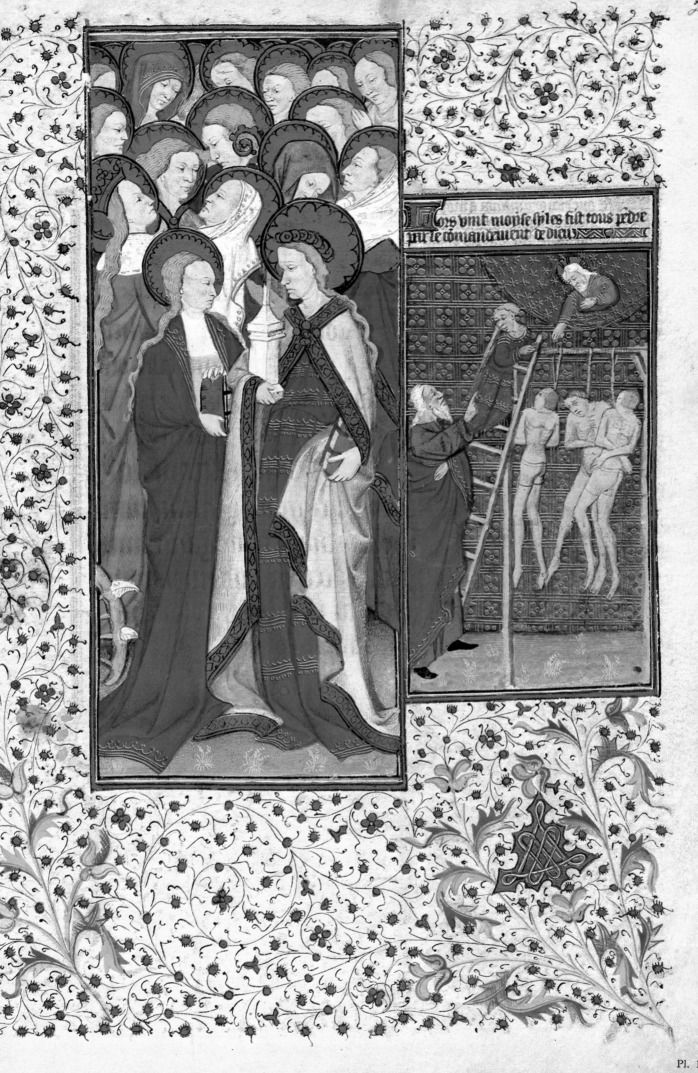

Pl. 125

124. *Prayers of Intercession*

MARGINAL PAINTING. Bible moralisée.

LEGEND *"Ce que Balaam fait aourer au peuple de Israel son Dieu senefie le mauvais philosophe qui fait adorer les ydres* [sic, pour idoles] *et deçoit par luxure et par mes creance."*

 Balaam, who was shown urging the sons of Israel to worship false gods in the preceding image (Pl. 123), is likened here to those corrupting philosophers who, by flattering their hearers' instincts for lust and unbelief, incite them to accept perverse theories—symbolized in this painting by a statue of a nude woman.

 (f. 235v)

125. *Prayers of Intercession*

MAIN PAINTING

To mark the beginning of an antiphon dedicated to the virgins canonized by the Church, the artist has represented numerous female saints here, among whom we can recognize, in the foreground, St. Mary Magdalene and St. Barbara. On the left, a little to the rear, is St. Catherine, crowned. The spiked wheel prepared for her torture is partly visible on the left, in the foreground.

Some of the faces of the saints forming this composition are repetitions of earlier models. For example, this St. Catherine reproduces the one used by the Limbourgs in the Celestial Court with which they decorated folio 218 of the *Belles Heures* of Jean de Berry. Similarly, the veiled head of the saint appearing in the center of the painting between St. Mary Magdalene and St. Barbara faithfully reproduces that of St. Margaret in that same Celestial Court. These models have also been used elsewhere in the *Rohan Hours* (Pl. 34, f. 29v).

MARGINAL PAINTING. Bible moralisée. Numbers XXV, 4–5.

LEGEND *"Lors vint Moyse, sy les fist tous pendre par le commandement de Dieu."*

Moses, on the left, carrying out the command of the Lord—who directs an avenging hand toward the guilty ones from heaven—enjoins an executioner to proceed with the hanging of three Israelites guilty of having paid homage to the Baal of Peor and of having fornicated with the Moabite women (Pl. 123). (f. 236)

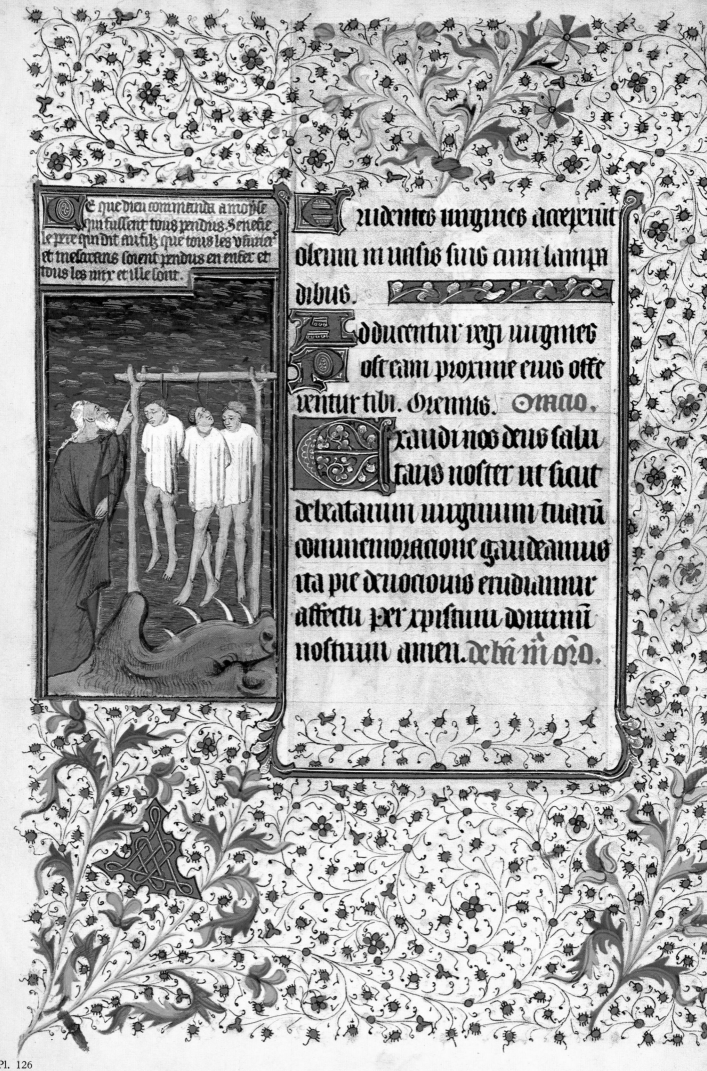

Ce que dieu commanda a moise
qu'ilz fussent tous pendus. Et ie die
le pere que dit au filz que tous les usurier'
et tresoriers soient pendus en enfer et
tous les miex et ille sont.

rudentes virgines acceperunt
oleum in vasis suis cum lampa
dibus.

Adducentur regi virgines
post eam proxime eius offe
rentur tibi. Oremus. Oratio.

Exaudi nos deus salu
taris noster ut sicut
de beatarum virginum tuarum
commemoratione gaudeamus
ita pie devotionis erudiamur
affectu per christum dominum
nostrum amen. de bea' m' ora.

Pl. 126

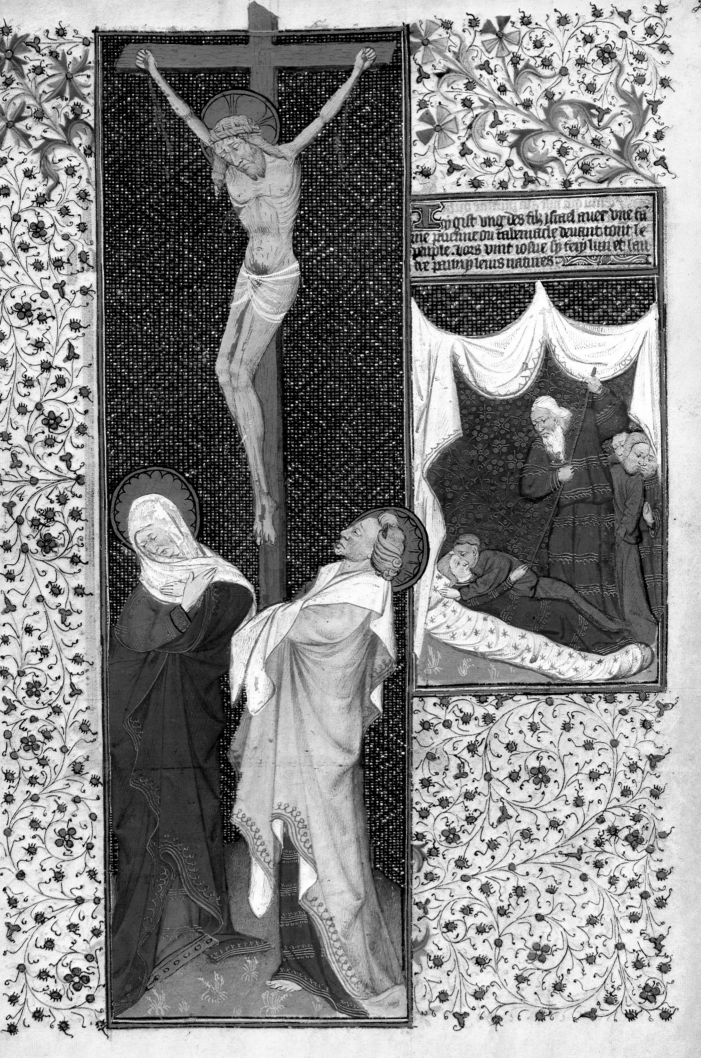

Ly qst vng des filz ifrael mier vne tu
ne puchue ou tabernacle deuant tout le
puple. vois vint iosue ly serp̃ luit et leu
ne pultipliens natiues·

Pl. 127

126. *Prayers of Intercession*

MARGINAL PAINTING. Bible moralisée.

LEGEND *"Ce que Dieu commanda a Moyse qu'i fussent tous pendus senefie le Pere qui dit au Filz que tous les usuriers et mescreans soient pendus en enfer, et tous les Juix, et il le sont."*

Moses, who at the Lord's command has ordered the hanging of all Israelites guilty of having worshiped the Baal of Peor (Pl. 125), prefigures God the Father—represented here, on the left of the picture, announcing to the Son (whom the artist did not include in the composition) that usurers, unbelievers, and Jews will be "hanged in Hell." Three men dressed in simple smocks such as were worn by condemned men in the middle ages, are shown here hanging from a gibbet, whose base rests on the monstrous jaws of a demon—a classical representation of Hell. (f. 236v)

127. *Prayers to the Virgin*

MAIN PAINTING

This painting illustrates the text which appears on the reverse side of the present folio: *"Stabat mater dolorosa/Juxta crucem lacrimosa . . ."* ("The sorrowing Mother was standing at the foot of the Cross, weeping . . ."). The personages in the scene are represented in the traditional attitudes given them by countless contemporary illuminators. Here, St. John has a very different physiognomy from that given him by the painter of the pages devoted to the Pentecost and to the Lamentation of the Virgin over the body of her Son (Pl. 58 and Pl. 57). Clearly we are dealing with two different artists; this one, easily recognizable by his very special manner of painting hair in great twists of ringlets, executed most of the images of saints preceding this last painting in the volume.

MARGINAL PAINTING. Bible moralisée. Numbers XXV, 7–8.

LEGEND *"Icy gist ung des filz Israel avec une famme parvenue ou tabernacle devant tout le peuple. Lors vint Josué, sy fery l'un et l'autre parmy leurs natures."*

This scene represents the cruel punishment inflicted upon two fornicators. After an Israelite had dared to commit adultery with a Midianite harlot within the walls of the Tabernacle, under the very eyes of Moses and the faithful, the two guilty persons had had their sex pierced by an outraged Israelite named Phinehas. It is thus by mistake that this act of vengeance has been attributed here to Joshua—an error that was already present in the *Angevin Bible*. (f. 237)

Appendix

LIST OF PLATES

List of Related Manuscripts
and Iconographic Documents Cited

Amiens, Municipal Library, MS. Lescalopier 17. Book of Hours.

Baltimore, Walters Art Gallery, MS. 741. Book of Hours for use of Troyes.

Brunswick, Herzog Anton Ulrich Museum. *The Miracle of Bethesda.* Drawing.

Cambridge (England), Fitzwilliam Museum, MS. J.62. Book of Hours for use of Paris, called the *Hours of Isabelle Stuart.*

Cambridge (Massachusetts), Harvard University, Houghton Library, MS. Richardson 42. Book of Hours, called the *Heures de Buz.*

Chantilly, Condé Museum, MS. 65. Book of Hours, called the *Très Riches Heures de Jean de Berry.*

Chantilly, Condé Museum, MS. 67. Book of Hours.

Lisbon, Gulbenkian Foundation. Book of Hours, called *Lamoignon,* or the *Hours of Isabelle of Brittany.*

London, British Museum, MS. Add. 18850. *The Bedford Book of Hours.*

London, British Museum, MS. Add. 29433. Hours for use of Paris.

London, British Museum, MS. Harl. 1526–7. *Bible moralisée* from the thirteenth century.

Lyons, Municipal Library, MS. 5140. Book of Hours for use of Paris.

Milan, Ambrosian Library, MS. S.P.56. Book of Hours.

New York, The Cloisters, MS. 54.1.1. Book of Hours called the *Belles Heures de Jean de Berry.*

Oxford, Bodleian Library, MS. 270[B]. *Bible moralisée* from the thirteenth century.

Paris, Bibliothèque Nationale, Est., Ea 5 rés. *Virgin and Child.* Wood-cut in colors (1420–1430). Northern France or the Rhineland.

Paris, Bibliothèque Nationale, MS. fr. 166. *Bible moralisée* of Jean de Berry.

Paris, Bibliothèque Nationale, MS. lat. 919. Book of Hours called the *Grandes Heures de Jean de Berry.*

Paris, Bibliothèque Nationale, MS. lat. 1156[A]. Book of Hours, called the *Hours of René d'Anjou.*

Paris, Bibliothèque Nationale, MS. lat. 11560. *Bible moralisée* from the thirteenth century.

Paris, Bibliothèque Nationale, MS. lat. 18014. Book of Hours, called the *Petites Heures de Jean de Berry.*

Paris, Bibliothèque Nationale, MS. n.a.lat. 3093. Book of Hours, called the *Très Belles Heures de Notre Dame de Jean de Berry.*

Paris, Bibliothèque Nationale, MS. n.a.lat. 3107. Book of Hours, called the *Hours of Saint Maur.*

Paris, Bibliothèque Nationale, MS. fr.414. *Golden Legend.*

Paris, Bibliothèque Nationale, MS. fr. 9561. *Bible historiée toute figurée,* also known as the *Angevin Bible.*

Paris, Bibliothèque de l'Arsenal, MS. 647. Hours for use of Troyes. Fragment (vid. Princeton).

Paris, Bibliothèque Sainte-Geneviève, MS. 1278. *Book of Hours of Notre Dame.*

Princeton, Princeton University Library, MS. Garrett 48. Hours for use of Troyes. Fragment (vid. Paris, Arsenal).

Vienna, National Library, MS. 1855. Book of Hours.

Private collection. Hours for use of Angers, called the *Hours of Martin Le Roy.*

SELECTED BIBLIOGRAPHY

It would seem redundant to cite here once again the innumerable books and articles in which the *Rohan Hours* is either mentioned or partially reproduced. The following list is limited to published works dealing specifically with this manuscript and to related documents.

Durrieu, Paul, *Les Heures à l'usage d'Angers de la collection Martin Le Roy*, Paris (Société française de reproduction de manuscrits à peintures), 1912.

_____, "Le maître des *Grandes Heures de Rohan*," *Revue de l'Art Ancien et Modern,* vol. 2 (1912), p. 175.

Heimann, Adelheid, "Des Meister der *Grandes Heures de Rohan* und seine Werkstatt," *Stadel Jahrbuch*, vol. 7–8 (1932), p. 1 and ff.

_____, "The Giac Book of Hours," *Burlington Magazine,* vol. 71 (1937), 82–83.

The International Style. The Arts in Europe around 1400. Baltimore. The Walters Art Gallery, 1962.

La Bible moralisée conservée à Oxford, Paris et Londres . . . accompagnée d'une notice par le comte A. de Laborde, 5 vol. Paris (Société française de reproduction de manuscrits à peintures), 1911–1927.

Leroquais, Victor Chanoine, *Les Livres d'heures manuscrits de la Bibliothèque nationale.* vol. 1. Paris, 1927.

Meiss, Millard, *French Painting in the Time of Jean de Berry: The late XIVth century and the Patronage of the Duke.* 2 vol. London, 1967.

_____, *French Painting in the Time of Jean de Berry: The Boucicaut Master,* London, 1968.

_____, "French and Italian Variations on an Early Fifteenth-Century Theme: St. Jerome and his Study," in *Essais en l'honneur de Jean Porcher*, extract from *Gazette des Beaux-Arts* (1963), 147–170.

_____, *The de Lévis Hours and the Bedford Workshop* (Yale lectures in medieval illumination), New Haven, 1972.

Miner, Dorothy, "Since de Ricci: Western Illuminated MSS. Acquired Since 1934." A report in two parts. Part II, in The Journal of the Walters Art Gallery, vol. 31–32 (1968–69), vid. pp. 78–81.

Panofsky, Erwin, "Reintegration of a book of hours executed in the workshop of the *Maître des Grandes Heures de Rohan,*" *Medieval Studies in Memory of A. Kingsley Porter*, vol. 2, Cambridge (1939), 479 and ff.

_____, "The de Buz Book of Hours," *Harvard Library Bulletin,* vol. 3 (1948–49), 163–182.

Porcher, Jean, *Les Belles Heures de Jean de France, duc de Berry*, Paris, 1953.

_____, *The Rohan Book of Hours,* London, 1959.

_____, "Two Models for the *Heures de Rohan,*" *Journal of the Warburg and Courtauld Institutes,* vol. 8 (1945), 1–6.

Treasures from Medieval France, Cleveland, Cleveland Museum of Art (1967), vid. p. 284.

The Très Riches Heures of Jean, Duke of Berry, New York, 1969.

DISCARD

BETHANY
COLLEGE

LIBRARY